UTAH

A Portrait

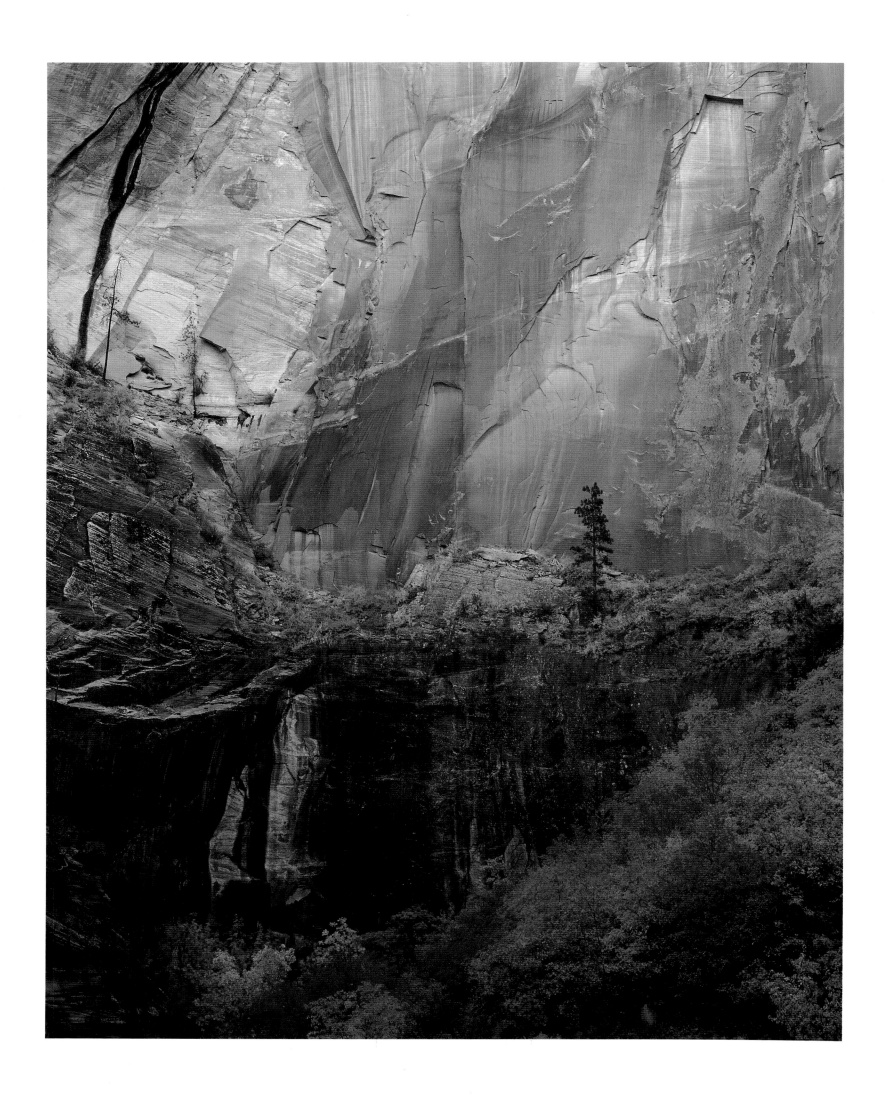

UTAH

A Portrait

Text by William B. Smart
Photographs by John Telford

University of Utah Press
Salt Lake City

Library of Congress Cataloging-in-Publication Data

Smart, William B. (William Buckwater), 1922–
 Utah : a portrait / William B. Smart, John Telford.
 p. cm.
 Includes bibliographical references (p.).
 ISBN 0-87480-451-5
 1. Utah—Civilization. 2. Utah—Pictorial works. I. Telford,
John, 1944– . II. Title.
F826.S644 1995
979.2—dc20 94-48005

Frontispiece: Cable Mountain, East Rim Trail, Zion National Park
Above photograph: Grass and rocks, Reds Canyon, San Rafael Swell
Opposite page photograph: Pictograph, Jones Hole, Dinosaur National Monument

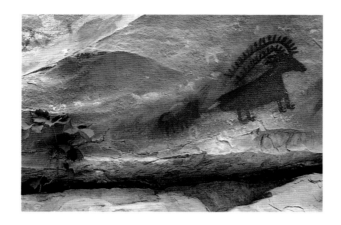

TO THOSE WHO CAME:

 —Who left their millennia-old handprints and rock art, their kivas, granaries, and mud-and-wattle dwellings . . .

 —Who dared seek the far horizons, revealing the rivers and valleys and mountain passes in their search for fur or fortune, discovery or adventure . . .

 —Who planted their roots and built a commonwealth where they could live their religion in peace and security . . .

 —Who have added their diverse cultures and values to the mosaic that is Utah today . . .

 this book is dedicated.

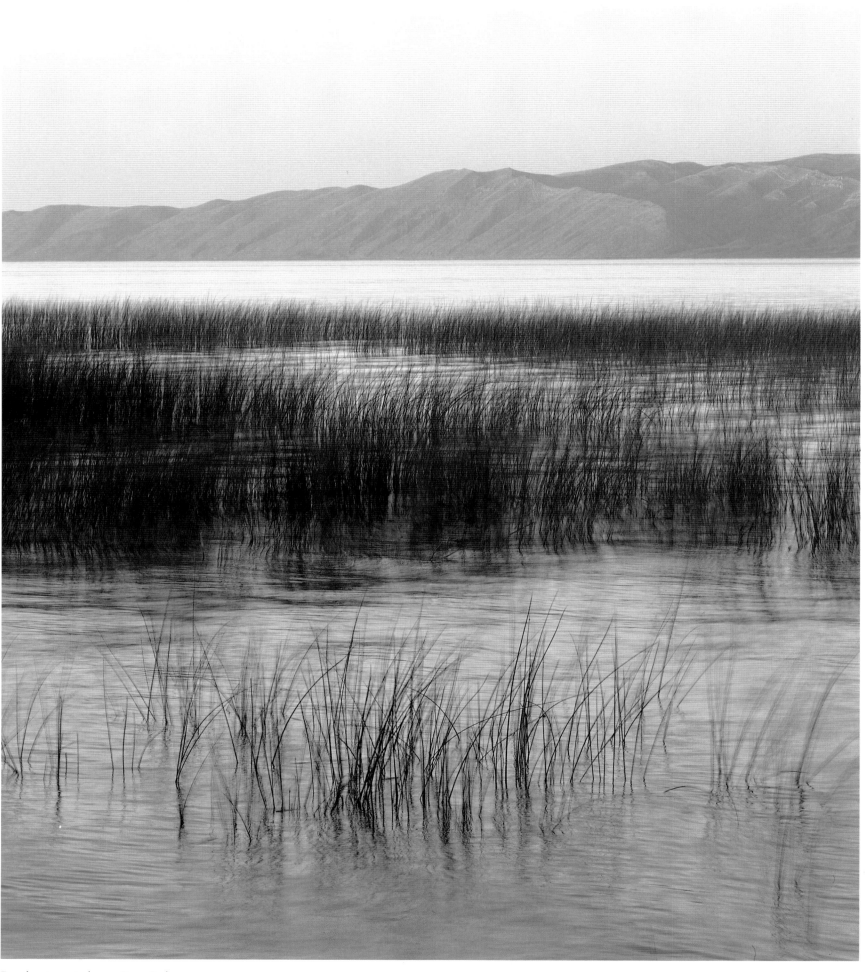

Reeds at west shore, Bear Lake

Acknowledgments

Special thanks are given by the publisher to the

GEORGE S. AND DOLORES DORÉ ECCLES

FOUNDATION

for its generous support of this project.

Thanks are also extended to Fuji Film Corporation
and to Inkley's, Incorporated of Salt Lake City
for their assistance to the photographer, John Telford.

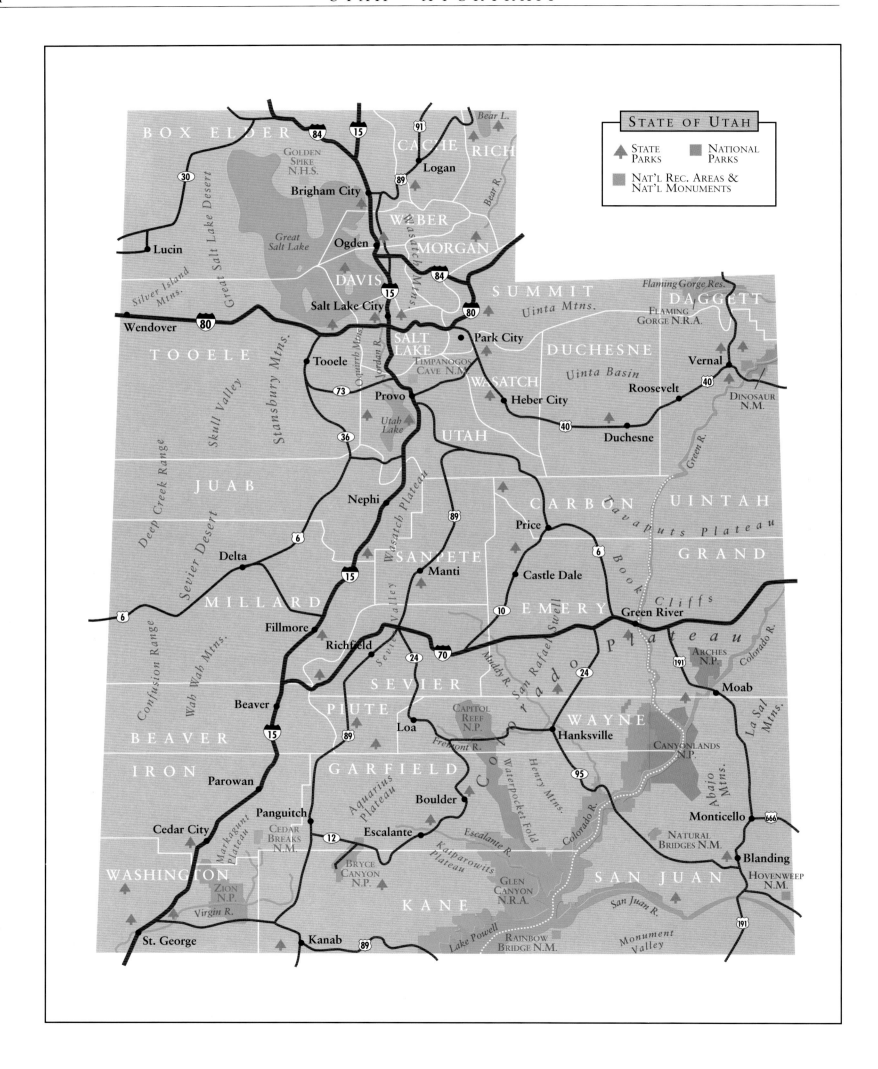

Contents

Maples and aspens, Squaw Peak, Wasatch Mountains

Foreword

READING THE MANUSCRIPT for *Utah: A Portrait* sent the blood racing through my veins. The book is adventure, history, and a series of exciting vignettes, not to mention the brilliant photographs of Utah's spectacular scenery. This is a revealing look at Utah: hikes through the canyons of the Escalante south of the San Rafael Swell; . . . down the Subway in the Kolob region of Zion's Canyon, over the Pine Valley Mountains; . . . a trek in the Stansbury Mountains southwest of the Great Salt Lake; . . . struggling in the mud to Duck Lake in the Uinta Mountains; . . . canoeing and rafting Utah's exciting rivers. There is an account of wrestling jeeps over Elephant Hill in what became Canyonlands National Park, . . . mountain biking on Boulder Mountain . . . exploring in Nine Mile Canyon, . . . putting up with an old Essex touring car on the way to an uncle's hardscrabble farm in the Uinta Basin. The style is trenchant and graphic, with a directness, vitality, and drive appropriate to the special place that is Utah.

Utah: A Portrait also presents informative historical highlights, charming quotations from participants in pioneering expeditions, day-by-day accounts of early-day explorers and surveyors, and personal descriptions of events occurring on the Domínguez-Escalante Trail, the Mormon Trail, and other lesser-known places throughout the state.

Here are words of the Spanish Fathers who traveled across the state in 1776; of Jedediah Smith, the rugged frontiersman who carried his Bible with him as he wandered over the region in 1826–27; of John C. Frémont, who explored on behalf of the federal government in 1842 and 1843; and of John Wesley Powell, the one-armed scientist who went down the Green and Colorado rivers in 1869 and 1871. Some of what they saw, and what we can still see, is reproduced in the magnificent photographs of John Telford.

Human migrants came into what is now Utah as early as 15,000 years ago. As they roamed in search of game and edible seeds and nuts, some sought temporary shelter in natural caves along the edge of the great inland sea, Lake Bonneville. In later millennia, far to the south and east of the remnant of the huge lake, more advanced "ancient ones" lived in superb, communal cliff dwellings. They raised corn, squash, beans, pumpkins, and made beautiful baskets and pottery, exquisite jewelry, and cleverly designed atlatls, or throwing sticks.

The first white men known to have visited Utah were two groups of Spaniards. Juan Mariá Antonio Rivera visited the eastern Utah area first, in 1765, but more elaborate documentation is available for the remarkable expedition of two Spanish Franciscans, Fray Francisco Atanasio Domínguez and Fray Silvestre Vélez de Escalante, who, with a handful of companions, journeyed in 1776 from Santa Fe, crossed the Colorado Plateau, and wandered through much of Utah before they returned to Santa Fe. They produced the earliest detailed map of much of what became Utah.

British and American trappers came into the area from 1820 to 1840. They included such fur trappers and mountain men as Jedediah Smith, Jim Bridger, William L. Ashley, Pete Skene Ogden, Etienne Provost, and William S. Sublette. They charted the rivers and streams of the region, discovered mountain passes and the Great Salt Lake, and initiated serious threats to the self-sufficient lifeways of the Indians. After 1840,

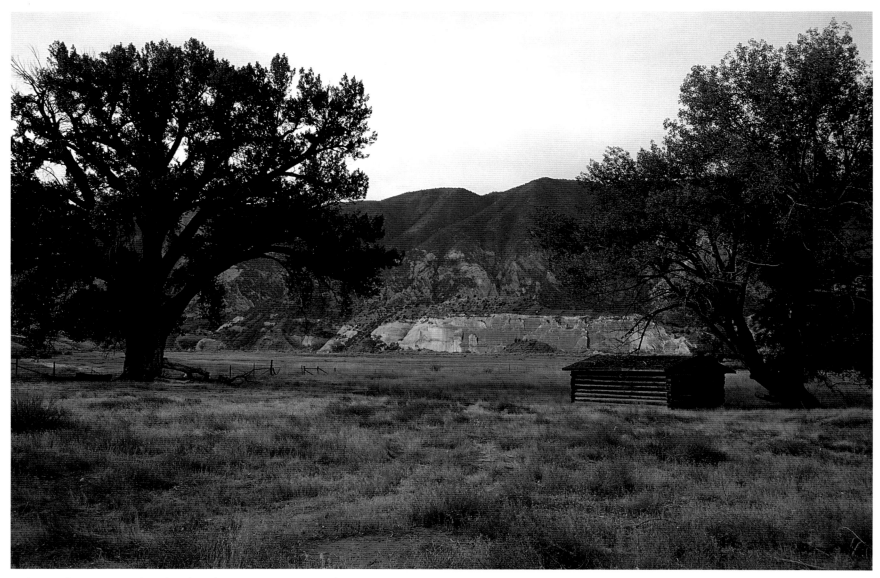

Cabin and cottonwoods, Island Park, Dinosaur National Monument

many overlanders bound for California and Oregon passed through portions of Utah.

The Mormons—members of the Church of Jesus Christ of Latter-day Saints—who began coming to the area in July 1847, sent out scores of exploring parties and established about 400 settlements throughout the region in the last half of the nineteenth century. Their villages ranged from Bluff in the Colorado Plateau area, to St. George in the southwest, to Grouse Creek in the extreme northwest, and to Randolph and Vernal in the northeast. Non-Mormons also settled the state to mine, graze livestock, and engage in trade, banking, and politics. There was both group colonization and also the establishment of scattered individual farm and ranch homesteads. Cooperative canals, roads, fences, and mills were common, as were cooperative livestock herds.

The first generation of settlers maintained a self-sufficient agricultural economy, to which was added mining in the 1870s and 1880s. There was a large in-

vestment in mines, mills, smelters, and agricultural processing plants at the turn of the century, and the state's economy became highly commercialized and specialized. The federal government helped with the construction of dams and reservoirs after the passage of the Reclamation Act in 1902. During World War II new industries were built in Utah: industrial plants, military training bases, military supply and repair depots. Beginning in 1956 the federal government and defense contractors built a major missile complex, among numerous other projects. Utah became the locus of many eastern corporations, and a major center for trucking and air travel.

With the erection of ski facilities at Alta beginning in the 1930s and expanding later to Snowbird, Park City, and Snow Basin starting in the 1950s, and with the creation of Lake Powell and Flaming Gorge reservoirs and Canyonlands National Park, tourism and recreation became and remain major industries. Utah is rich in outdoor opportunities, with hunting, fishing,

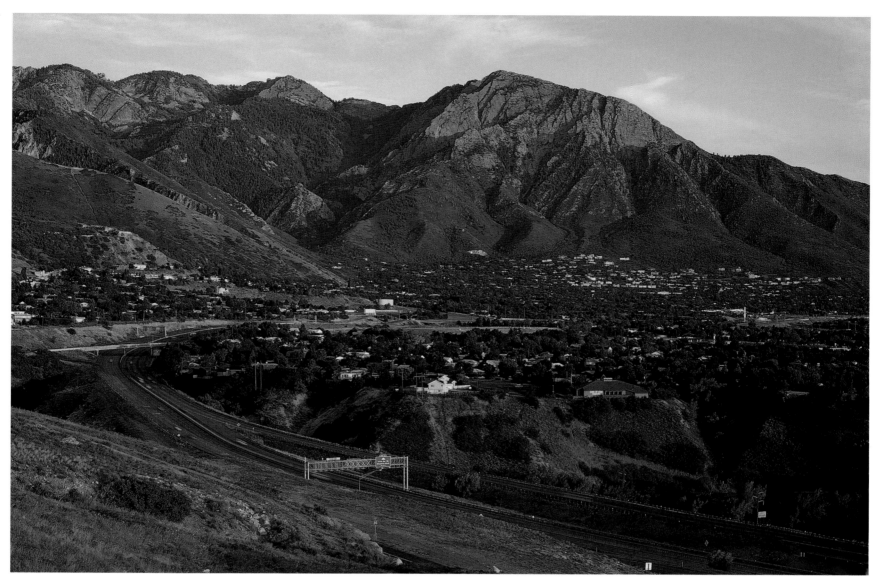

Mount Olympus and I-215, Salt Lake City

boating, hiking, biking, and skiing. Utah's generally sunny skies, coupled with steep slopes and dry snow, have made the skiing incomparable. Utah's attractiveness as a place to live and work and play has brought many residents and businesses to the state.

To these attractions one should add the cultural programs: the Utah Symphony, Utah Opera, Ballet West, Pioneer Memorial Theater, Promised Valley Playhouse—all in Salt Lake City; the Utah Shakespearean Festival in Cedar City; the Utah Festival Opera Company and Festival of the American West in Logan; the American Fork Pageant of the Arts (*tableaux vivente*); Salt Lake Buzz (baseball); Utah Grizzlies (hockey); Utah Jazz (basketball); and many other agencies and enterprises of cultural and recreational worth.

In certain respects, Utah is a land of paradoxes: it is mountains and snow; it is desert and sun. The towering Uinta Mountains that extend east across northern Utah often are crowned with snow even in hot summers.

The Wasatch Mountains, which extend some two hundred miles from the northern border to Nephi in central Utah, have several peaks in excess of 10,000 feet, and Mount Nebo is 11,877 feet. In the recesses of these mountains are deposits of gold, silver, lead, copper, and other valuable minerals. In the Uinta and Wasatch ranges originate the streams that provide the water used to irrigate crops, supply industry, and make life possible for most of Utah's residents. South of the Uintas and the Wasatch lie the High Plateaus that stretch all the way into Arizona, with summits reaching elevations in excess of 11,000 feet; to the east lies the Uinta Basin, the site of an enormous ancient sea or lake; and the canyonlands of the Colorado Plateau, with mountain grazing lands, volcanic ranges, and spectacular scenery. It is land that also is rich in coal, oil, natural gas, oil shale, asphalts, gilsonite, uranium, and vanadium.

Utah is mountainous, striated with canyons filled with wildlife; but Utah is also desert. The Great Salt

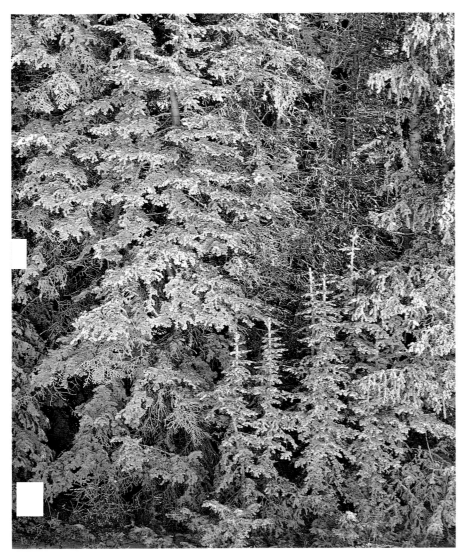

Snow-covered trees, Cedar Breaks National Monument

Lake Desert in western Utah, remnant of a prehistoric sea, is punctuated with patches of greasewood, creosote bush, and cedar. Beaver Dam Wash in southern Utah is less than 2,000 feet above sea level. Rainfall varies from more than fifty inches per year in the high Uintas to five inches a year in the western deserts.

Another paradox is the people. Seventy percent of them are Mormons, serious about their religion but often possessing a contagious sense of humor inherited from their pioneer ancestors. Utahns are also a practical people. The wiser ones appreciate the state's pluralism: the substantial numbers of Navajo, Ute, and Paiute Indians; Mexican-Americans, Greeks, Italians, eastern Europeans, and those of South Sea Islands ancestry, among the many others who have chosen to live here. There is variety and social richness in Utah. Pioneer values are perpetuated, but new ways are also welcomed.

William B. Smart and John Telford are appropriate persons to present *Utah: A Portrait*. Bill is descended from early Mormons who pioneered in the settlement of Nauvoo, Illinois; Winter Quarters, Nebraska; American Fork, Utah; Franklin, Idaho; and the Uinta Basin. His grandfather was president of Wasatch (1901) and Uintah (1906) LDS stakes and was the first president of Duchesne (1910) and Roosevelt (1920) stakes. His parents, Thomas L. and Nellie B. Smart, were raised in Provo, then moved to Reno, Nevada, and finally settled in Portland, Oregon, when son Bill, the fourth of six children, was fourteen. At Reed College, one of the leading liberal arts colleges in the nation, young Bill found intellectual stimulation and social enrichment. He played basketball, squash, pinochle and whist, skied, and enjoyed a varied social life.

College was interrupted by World War II. Bill was assigned to a succession of camps and centers of special training, including a stint at the University of Wyoming. There he met Donna Toland, an honors student from Afton, Wyoming. They became engaged, and were married shortly after Bill was commissioned a second lieutenant. After his discharge they went back to Portland, where Bill completed his undergraduate degree and was awarded a Phi Beta Kappa key for outstanding scholarship. In Portland they began their family, which eventually included five children. Their marriage has been a happy partnership.

For a year and a half, Bill worked as a reporter for the Portland *Oregonian,* and, among other things, earned national notoriety for his report of a flood that ripped through the Pacific Northwest in May 1948. Later that year, he was invited to join the *Deseret News.* Through the years, he moved from reporter to editorial writer, to editor and general manager, to senior editor. His assignments took him to Europe, behind the Iron Curtain to Leipzig, East Germany; to China, Pakistan, India, Nepal, Tibet, Fiji, New Zealand, the Antarctic, and the South Pole; to Cuba and South America; and to various conventions, seminars, and conferences in leading cities throughout the United States. He served fourteen years as editor and general manager—longer than any person in the 144-year history of the *Deseret News.*

Bill has also been active in the LDS Church. He directed the remarking of the Pioneer Trail, was a member of the Board of the Boy Scouts of America, and was on the national Explorer committee. He is a director of the Grand Canyon Trust, the Snowbird Institute, and helped found the Coalition for Utah's Future. He was chairman or president of the Provo–Jordan River Parkway Foundation, the Utah Innovation Foundation, the Institute for Studies in the Humanities, and a director of the Western States Art Foundation, Hansen Planetarium, and the Pioneer State Theater Foundation. Donna has been a high school teacher, skilled writer, and editor for the University of Utah, and she has served the LDS Church, as well.

Sometimes with government officials, and sometimes with Donna and/or professional associates, Bill has roamed over Utah with backpack, horse, jeep, canoe, and skis. Utah, he found, was unusually blessed. His assignments with the *Deseret News* and his penchant for hiking and skiing not only enabled him to explore many of the crevices, canyons, peaks, and flatlands in Utah but, with his interest in history, led him to chronicle his adventures. His books have included *China Notebook* (1978), *Old Utah Trails* (1988), and *Lake Powell: A Different Light* (1994).

John Telford has been photographing the landscape since he attended Brigham Young University in 1968. He completed the M.F.A. degree at the University of Utah in 1988. Telford has focused his cameras primarily on his native Utah, including more than twenty years in the canyons of the Colorado Plateau. Three books featuring those photographs include *Coyote's Canyon*, with photographs by John Telford and stories by Terry Tempest Williams (1992); *Shadows of Time: The Geology of Bryce Canyon National Park*, written by Frank DeCourten; and *Lake Powell: A Different Light*, with text by William Smart. In addition, the *Great Salt Lake Portfolio*, with a foreword by Wallace Stegner, was published in 1979.

The combination of talents and skills these two individuals have brought to the project make *Utah: A Portrait* at once that rare book that is both very personal in its essence yet remarkably broad in its appeal. It is a beautiful tribute to and celebration of the state of Utah as it marks its first 100 years of statehood.

—Leonard J. Arrington

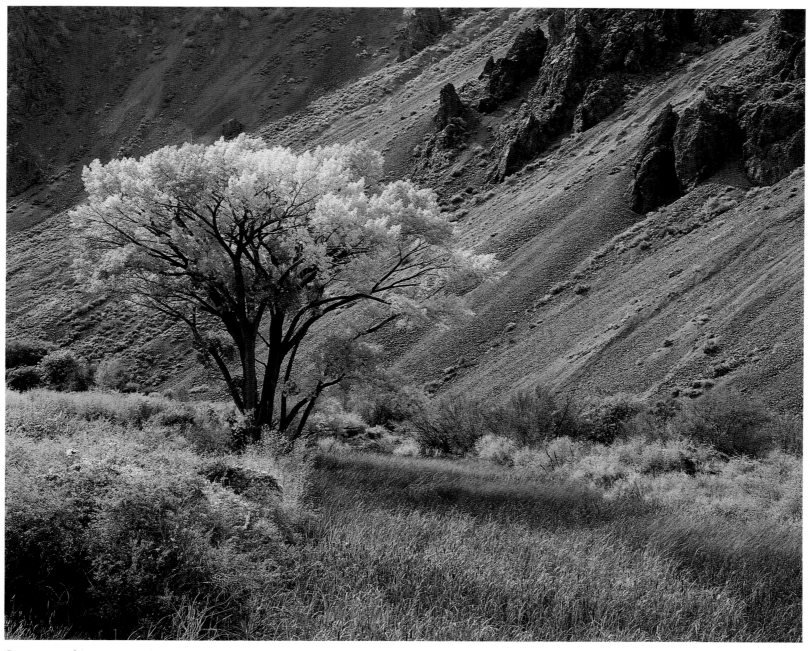

Cottonwood in autumn, Sevier River Canyon

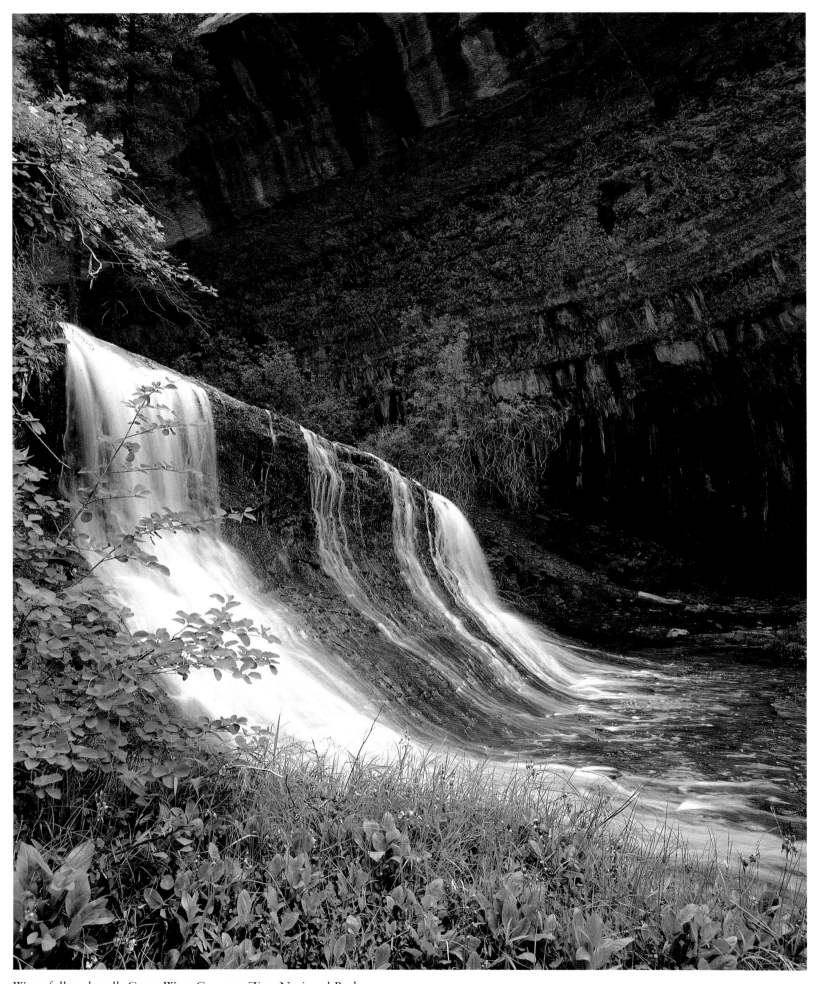

Waterfall and wall, Great West Canyon, Zion National Park

Preface

THIS BOOK RECOUNTS A LOVE AFFAIR with a land and its people. As with any meaningful and lasting love affair, the beloved is complex and challenging, sometimes contrary, often surprising, always beguiling.

The land, Utah, stretches from lichen-covered boulders on 13,000-foot Uinta peaks in one corner of the state to Joshua trees and desert tortoises at 1,650-foot elevation in the opposite corner; from glistening salt flats and lonely desert peaks in another corner to deep, shadowed canyons, vermillion mesas, and Navajo hogans in the fourth. The chain of mountain ranges and high plateaus running north-south through the middle of the state acts as a geologic hinge. To the west lies the Great Basin with its alkaline playas, long, lonely desert valleys, cinder cones and lava beds and stark mountain ranges. On the east sprawls the Colorado Plateau with its dinosaur graveyards, its buttes and spires and silt-bearing rivers carving a maze of cliff-walled canyons that hold the world's largest concentration of national parks and monuments and the second-largest man-made reservoir. The creation-story of Utah's astonishingly diverse land forms is fascinating, not less so because it is unfinished.

Diversity of land nurtures diversity of people. Where the Wasatch and other mountains hold water and deliver it to fertile valleys below, scientists and technicians do world-class work in biomedical and computer software laboratories. Educational, religious, and government installations flourish. In these and in the service, marketing, financial, technological, light manufacturing and other businesses that cluster there, the great majority of Utah's people make their living. Elsewhere, hardrock miners work in a diminishing in-

dustry, and farmers and ranchers struggle against weather, market vagaries, and increasing government restrictions. And, out on the fringes, Native Americans—Utes in the northeast, Navajos in the southeast, Shivwits in the southwest, and Goshutes in the west—subsist in varying degrees of poverty. All are part of the human mosaic that is Utah.

In this rich diversity of land and people I lived the first part of my life, but knew little of it. For fifteen years, my Utah was bounded by Hobble Creek Canyon on the south, Utah Lake and Saltair on the west, Ensign Peak and Beck's Hot Springs on the north. It ex-

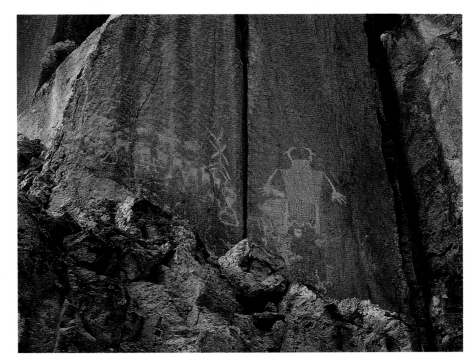

Petroglyphs, Fremont Indian State Park

Lake Powell, Glen Canyon National Recreation Area

panded only upward to the summit of Mount Timpa-nogos and eastward to the Uinta Basin where my grandparents lived.

Parental employment changes took me to Reno and then to the Pacific Northwest. Following college graduation there, I agreed to join the staff of the *Deseret News,* but only for a year before going on to graduate school. During that year as a newspaperman I moved around the state enough to sense its grandeur and to fall in love with its land and, later, its people. I never escaped; that year has turned into nearly half a century. Travel to and writing about far places on the planet have broadened and sharpened my perspective, but this has only deepened my affection for this state, my home.

I came early within the orbit of Arnold R. Standing, assistant Intermountain Region forester. For fifteen years, until his death in 1967, we drove or prodded horses or hiked together to and through Utah's remote places. He never stopped teaching; much if not most of what I know about Utah's land and people and their proper relationship I learned from this dear friend.

There were others. My first experience with Wasatch skiing was with F. C. Koziol, supervisor of the Wasatch National Forest. The light that day was flat under a grey sky, but, accustomed to the heavy crud of Oregon's Mount Hood, I revelled in Alta's powder. Never having enjoyed such skiing, I was astonished at Kozy's suggestion after a couple of runs that we bag it and come back on a better day. We did—many of them. Others who taught me the lore and glory of the Wasatch included George Watson, unelected "mayor" of Alta, who presided from his miner's shack at the foot of Collins Gulch; Alf Engen; and Dick and Ann Nebeker.

Lynn Fausett, the artist, showed me the beauty of the canyon country. Bates Wilson showed me some of its secret places when Canyonlands National Park was still but a dream in his mind. In later years, Lynn Lyman, in his eighties and a first-generation descendant of Hole-in-the-Rock pioneers, drawled out the history and lore of that expedition and canyon country in general while calmly pushing his jeep through what I thought to be impossible places.

Rancher-historian Montell Seely educated me about Castle Valley; the BLM's Paul Andrews, Dick Wilson, and Kim Bartel the Book Cliffs; Gregory Crampton, Alva Matheson, and Bart Anderson Utah's southwest; David Miller, Jesse Jennings, and others the Salt Desert. Other companions of trail, slope, and saddle who have shared with me their knowledge and insights include Grant Williams, Tom and Camille DeLong, Dave Evans, Bob Bowen, Jim Barker, Jim Clayton, Gale Dick.

I am indebted, of course, to the historians, authors, and journal keepers whose works are listed in the bibliography. Among them I must single out Ann and LeRoy Hafen, whose multivolume editing of explorers' journals is a historical treasure, and Wallace Stegner, whose brilliant, insightful writing has long been an inspiration and whose friendship born of time on the trail together has been a joy.

William Lee Stokes, Utah's preeminent geologist and long my mentor in things geologic as well as spiritual, carefully critiqued—and corrected—the first section of this book. Any geological errors are due not to his failure as a teacher but mine as a student.

Fred Esplin of KUED and Nana Anderson of the University of Utah Press conceived this project and have been unfailing in their support. Dean May's early review of the manuscript was helpful and encouraging.

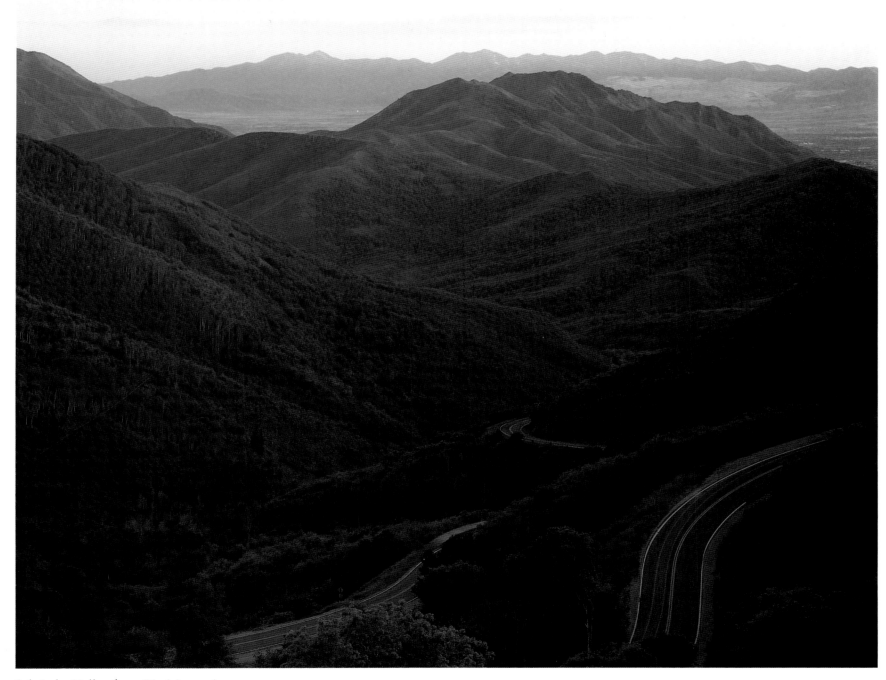

Salt Lake Valley from Big Mountain

Richard Firmage's deft and sensitive editing and design were invaluable. The financial support of the U.S. West and the George and Dolores Doré Eccles foundations made publication possible and is greatly appreciated.

John Telford's photography give life and immediacy to these pages and an appreciation of the majesty, diversity, and beauty of Utah that is second only to seeing the country oneself. Indeed, those who study his photographs will, when they do see the land firsthand, perceive it with fresher and deeper insight. Collaboration with John has been happy and satisfying.

Finally, to my wife Donna and our children who endured those long, dusty, sometimes scary rides in that battered green Blazer, those interminable hikes, those no-see-ums and deer files, those sandy, smoky campfire meals, and who from the experience have themselves become passionate lovers of the land, my thanks.

—William B. Smart

Opposite page, above: Junipers, West Desert
Opposite page, below: Factory Butte, near Cainville

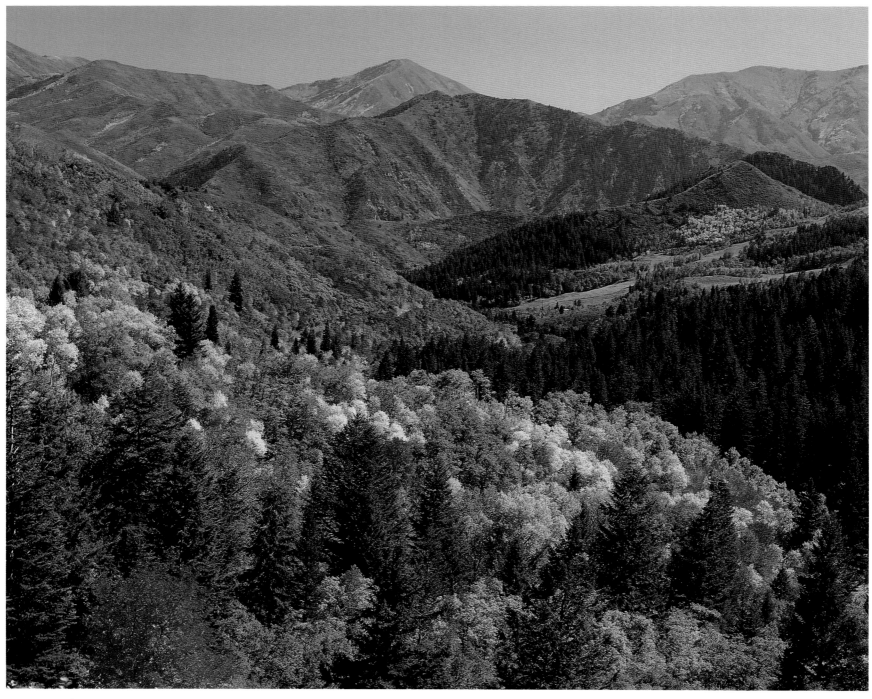

Autumn, Alpine Loop

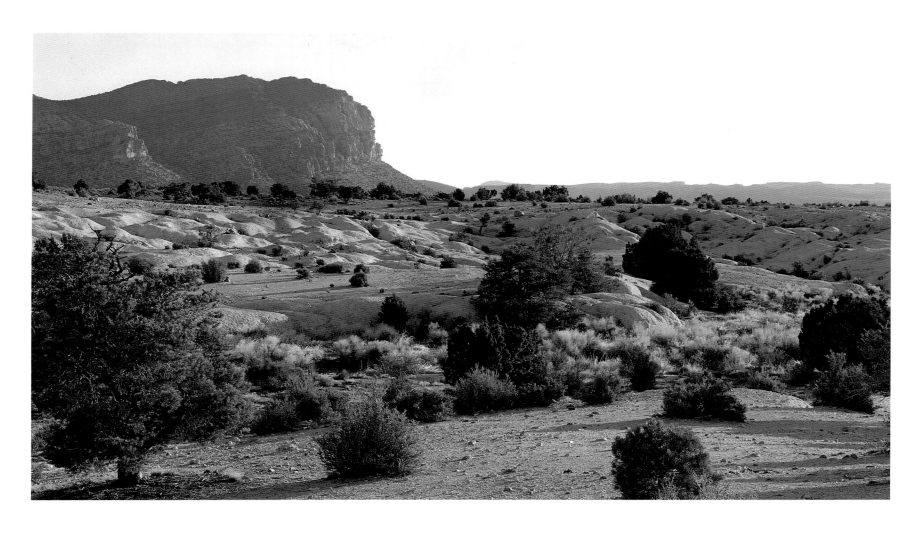

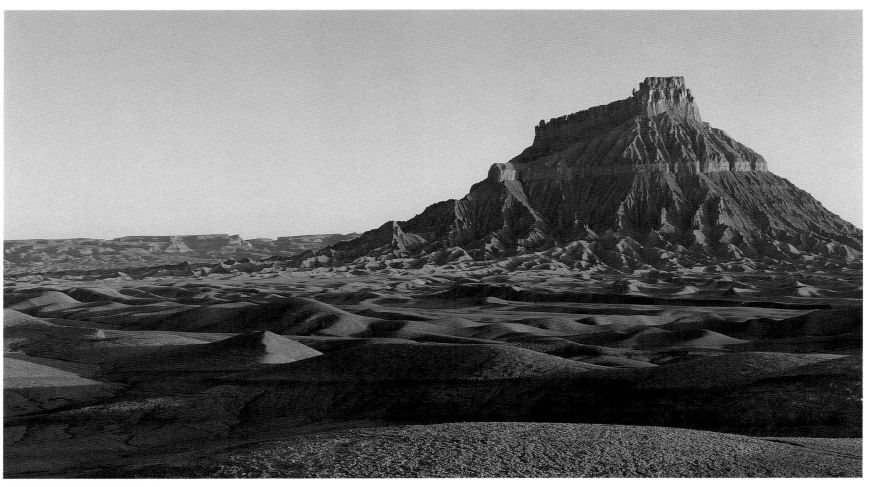

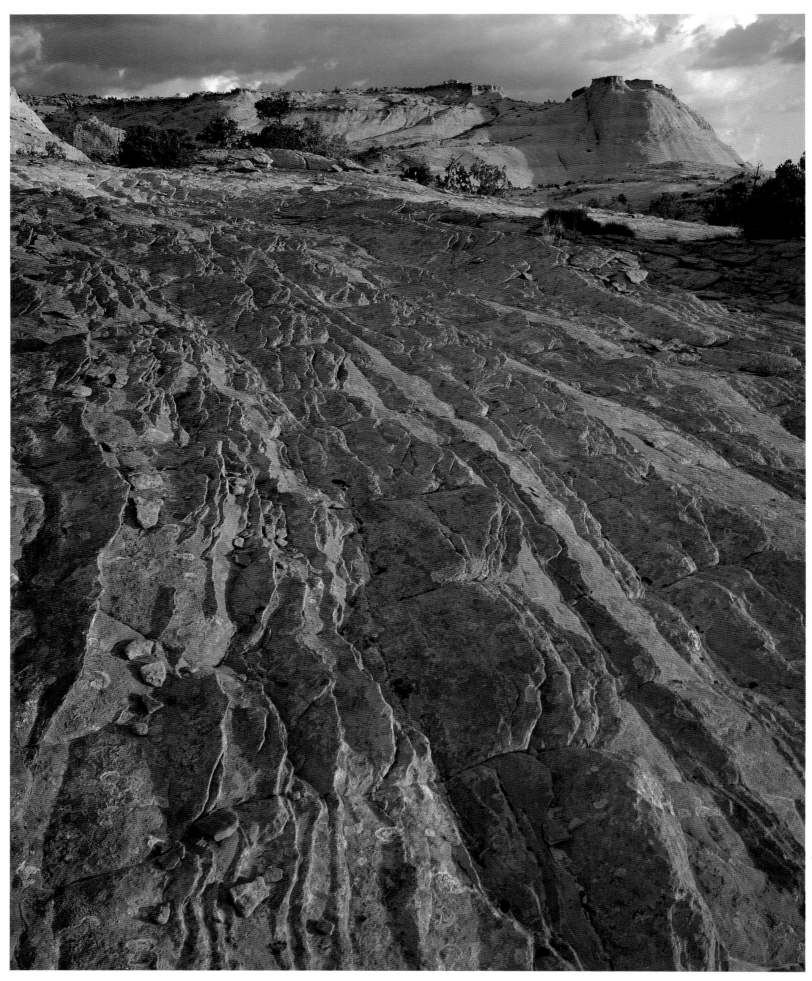

Crossbedded sandstone reef, Escalante area

UTAH

A Portrait

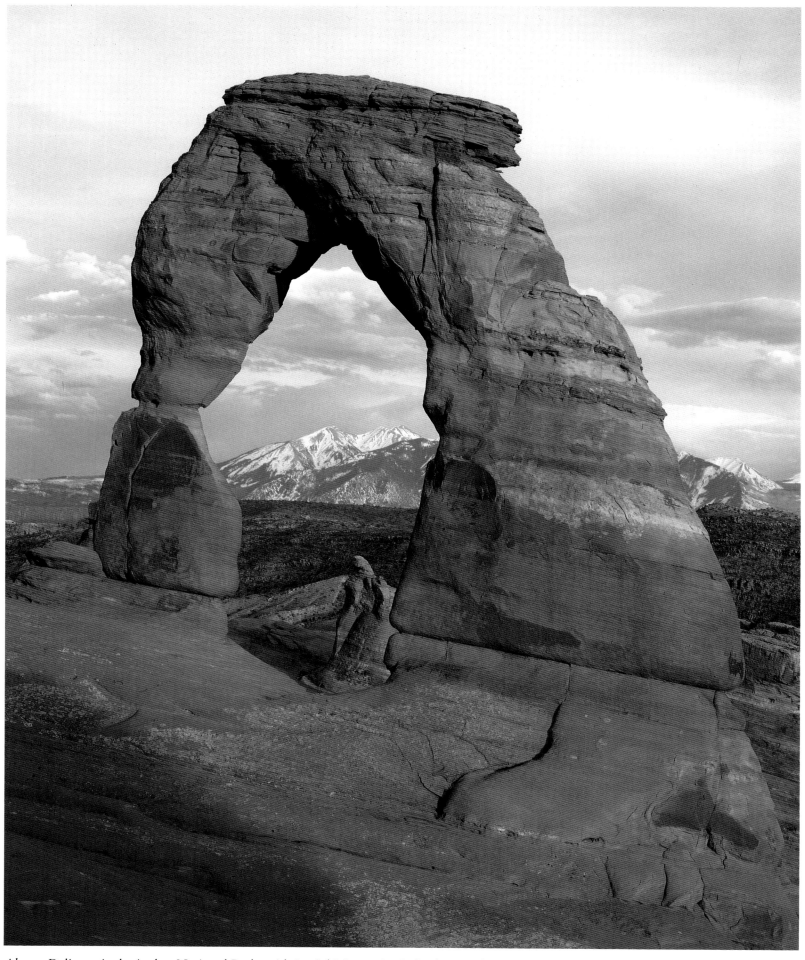

Above: Delicate Arch, Arches National Park, with La Sal Mountains in background
Opposite page: Handprint pictographs, Chesler Park, Canyonlands National Park

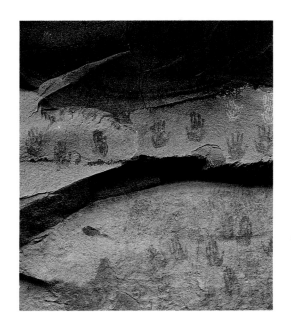

THE SOUTHEAST QUARTER

After crossing the San Juan, in about Lat. 38 N., and approaching the valleys of the Sheetskadee [Green] and Grand—the great mountain tributaries of the Colorado—the country becomes generally sterile, and broken in every direction by deep ravines with perpendicular banks, opposing almost insurmountable obstacles to the traveller's progress; compelling him to search many days before he can find a feasible passage across. . . . The traveller crosses vast barren plains utterly destitute of water, and upon which vegetation is so scarce that there will hardly be a blade of grass to a square mile of surface! Occasionally wild sage . . . is met with, but almost destitute of foliage. This, and the bare stems of other equally naked bushes, constitute the only food of wayfaring animals on these wastes.

—Dr. J. H. Lyman, traveller on the Spanish Trail, 1841

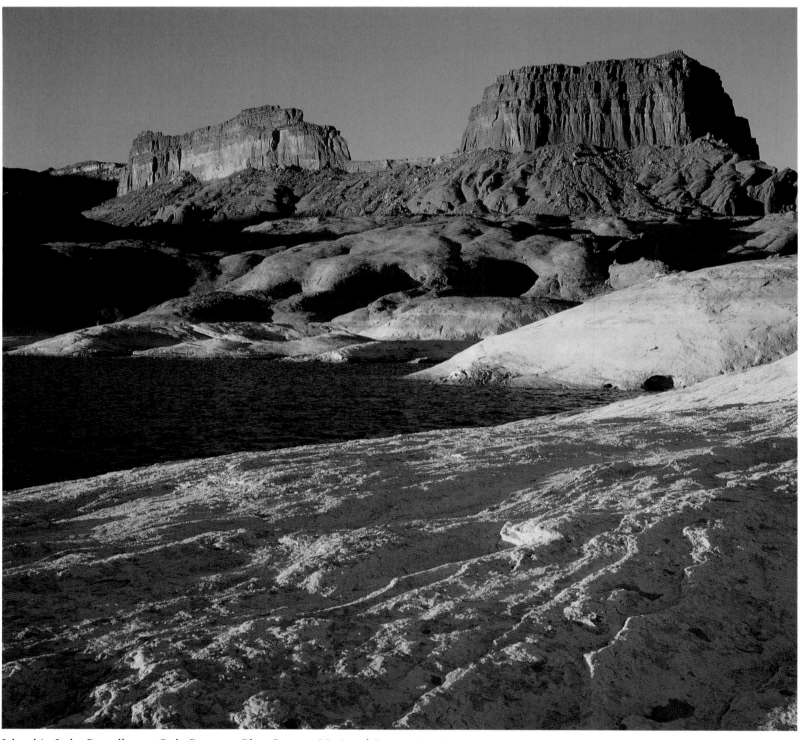

Island in Lake Powell near Oak Canyon, Glen Canyon National Recreation Area

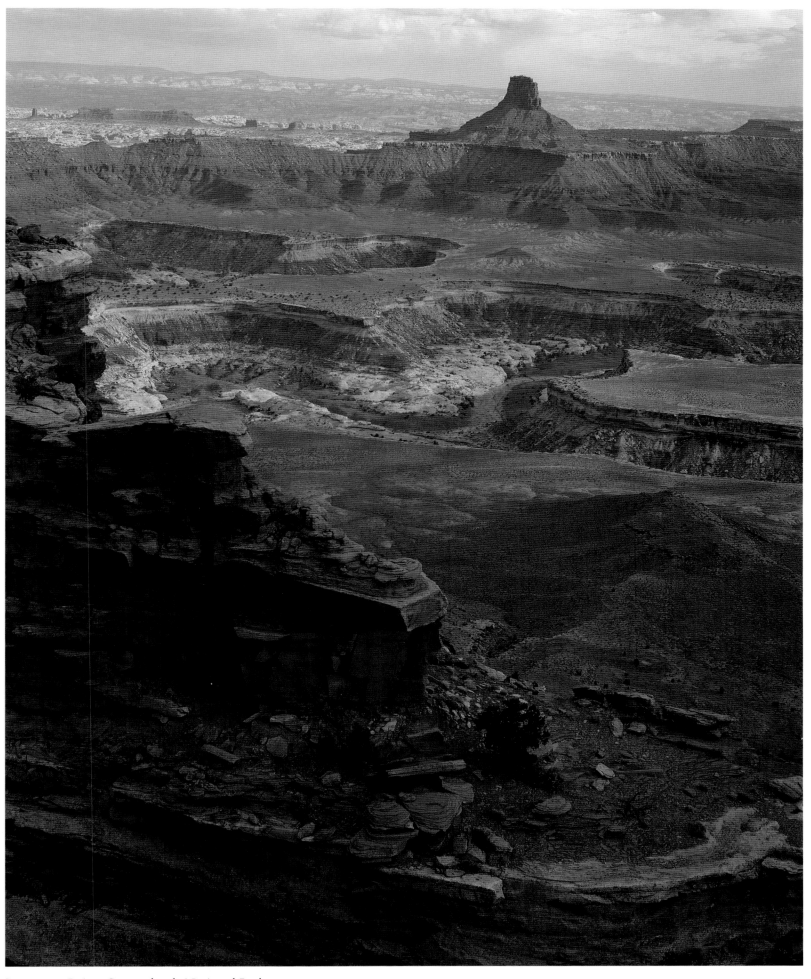

Panorama Point, Canyonlands National Park

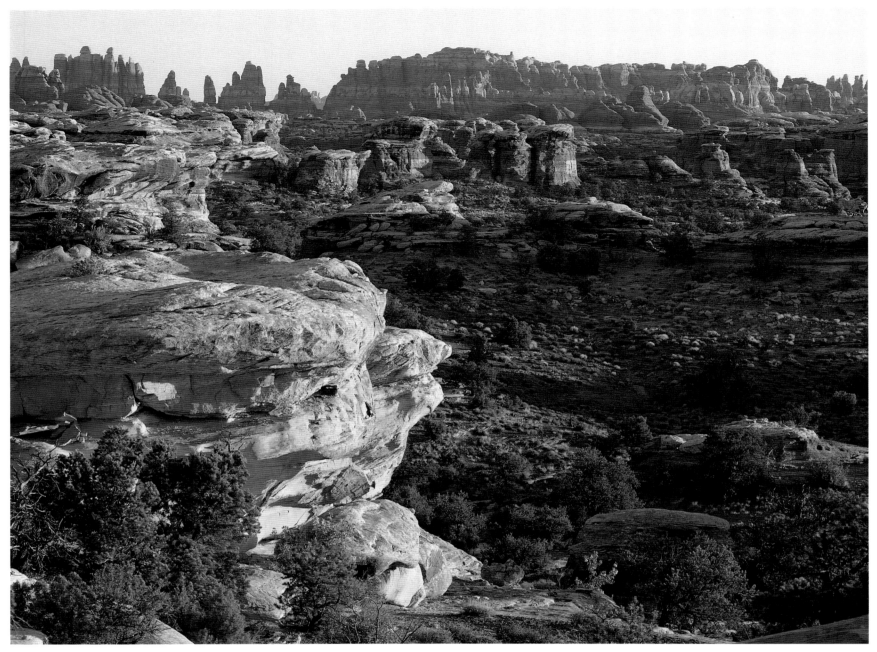

The Needles from the Tanks, Canyonlands National Park

From this point [Hatch Point] *the view swept westward over a wide extent of country* [the Needles district of Canyonlands], *in its general aspects a plain, but everywhere deeply cut by a tangled maze of cañons, and thickly set with towers, castles, and spires of most varied and striking forms; the most wonderful monuments of erosion. . . . Toward the west the view reached some thirty miles, there bounded by long lines and bold angles of mesa walls similar to those behind us, while in the intervening space the surface was diversified by columns, spires, castles, and battlemented towers of colossal but often beautiful proportions, closely resembling elaborate structures of art, but in effect far surpassing the most imposing monuments of human skill. In the southwest was a long line of spires of white stone, standing on red bases, thousands in number, but so slender as to recall the most delicate carving in ivory or the fairy architecture of some Gothic cathedral; yet many, perhaps most, were over five hundred feet in height, and thickly set in a narrow belt or series some miles in length. Their appearance was so strange and beautiful as to call out exclamations of delight from all our party.*
—John Newberry, geologist with the Macomb railroad survey, 1859

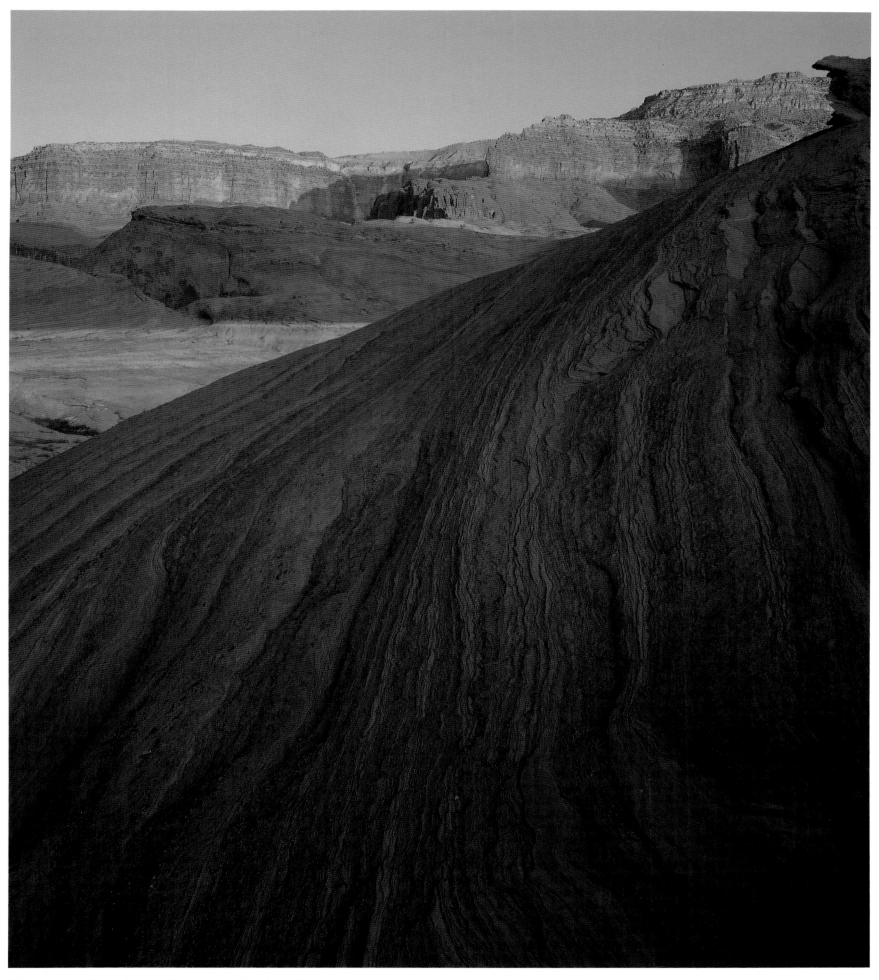

Slickrock at Miners Stairs, Glen Canyon National Recreation Area

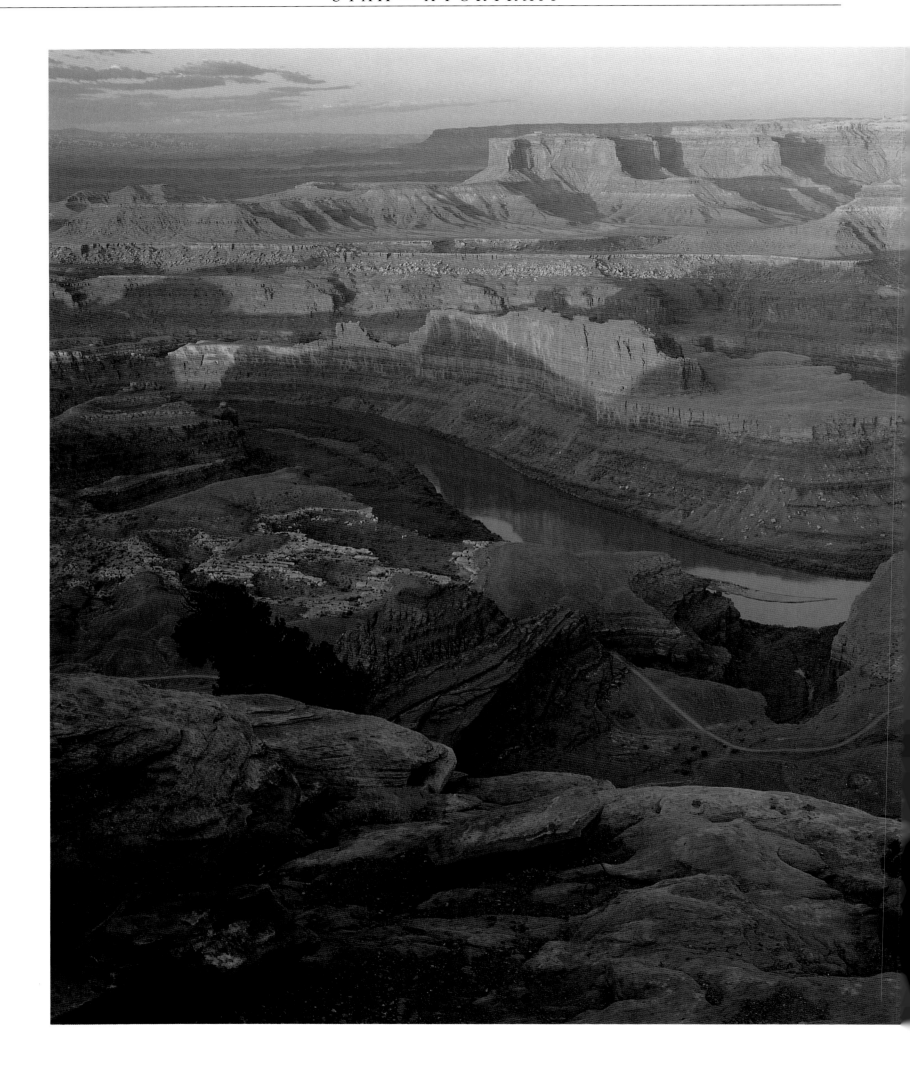

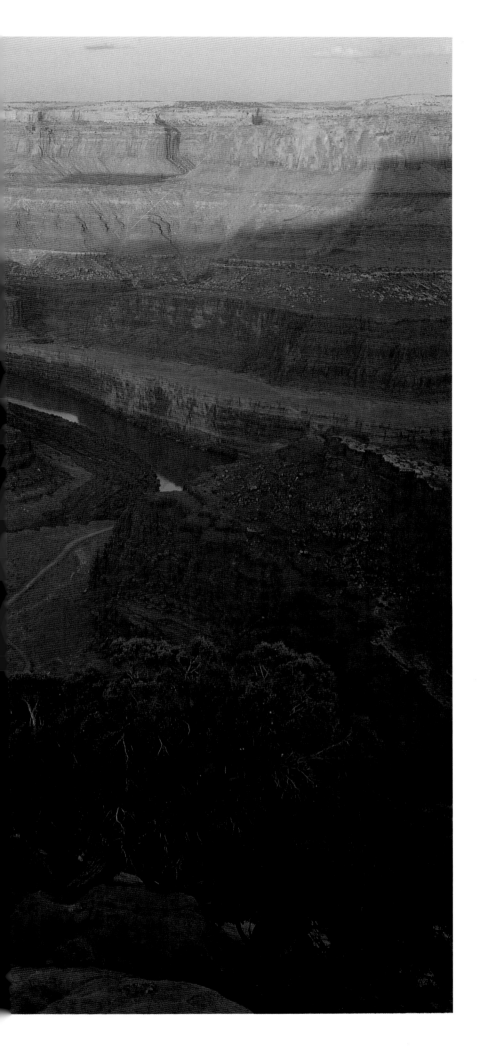

Sunrise, Dead Horse Point, Dead Horse Point State Park

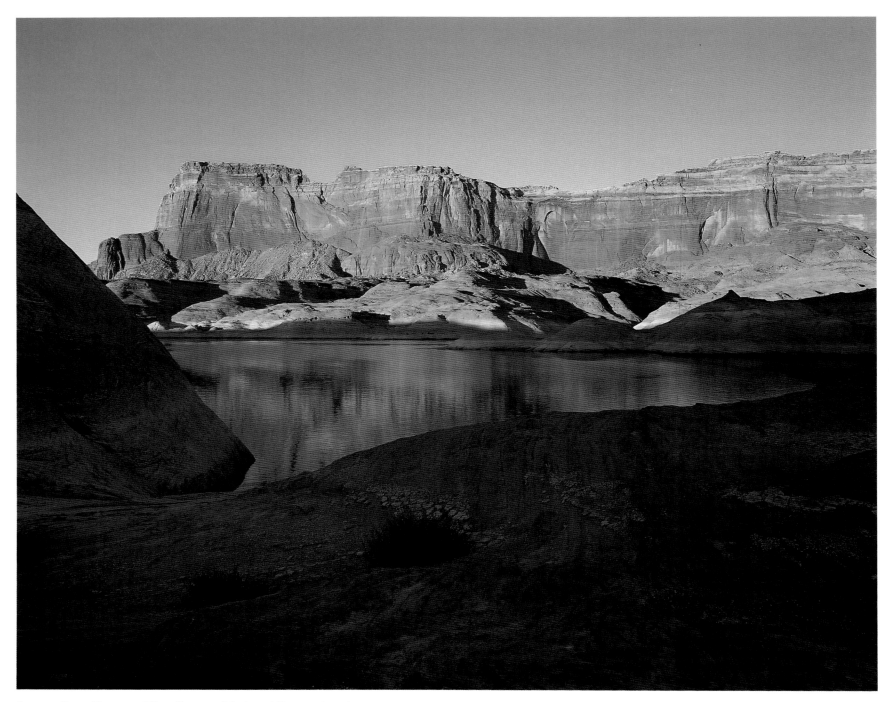

Sunset, Face Canyon, Glen Canyon National Recreation Area

[A]*ll the streams cut deeper and still deeper, until their banks are towering cliffs of solid rock. These deep, narrow gorges are called canyons.*

For more than a thousand miles along its course the Colorado has cut for itself such a canyon. . . . The Virgen, Kanab, Paria, Escalante, Fremont, San Rafael, Price, and Uinta on the west, the Grand, White, Yampa, San Juan, and Colorado Chiquito on the east, have also cut for themselves such narrow winding gorges, or deep canyons. Every river entering these has cut another canyon; every lateral creek has cut a canyon; every brook runs in a canyon; every rill born of a shower and born again of a shower and living only during these showers has cut for itself a canyon; so that the whole upper portion of the basin of the Colorado is traversed by a labyrinth of these deep gorges. . . .

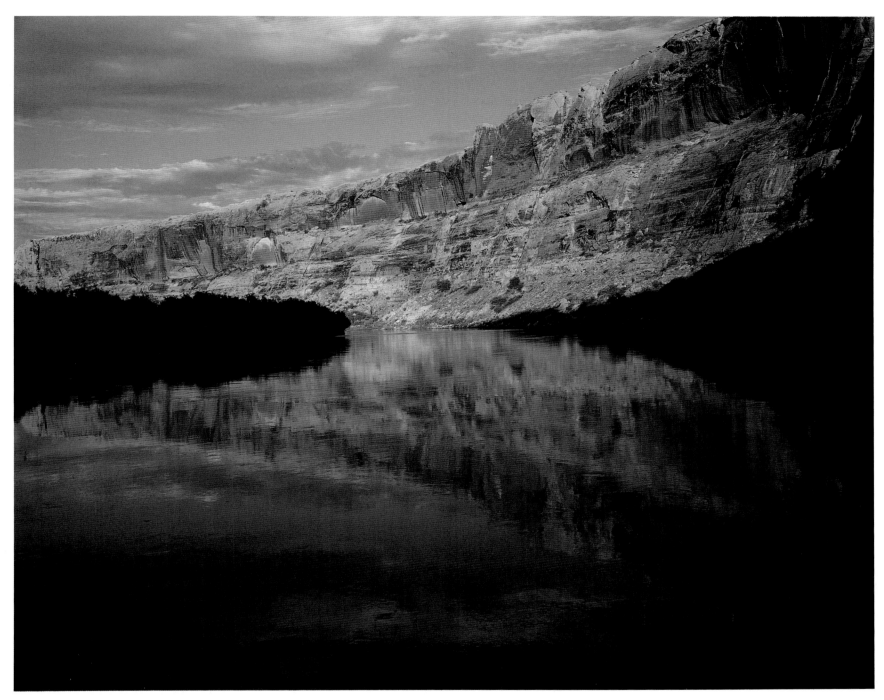

Green River at Labyrinth Canyon

All the scenic features of this canyon land are on a giant scale, strange and weird. The streams run at depths almost inaccessible, lashing the rocks which beset their channels, rolling in rapids and plunging in falls, and making a wild music which but adds to the gloom of the solitude. The little valleys nestling along the streams are diversified by bordering willows, clumps of box elder, and small groves of cottonwood.

After the canyons, the most remarkable features of the country are the long lines of cliffs. These are bold escarpments scores or hundreds of miles in length,—great geographic steps, often hundreds or thousands of feet in altitude, presenting steep faces of rock, often vertical. . . . By these gigantic stairways [one] may ascend to high plateaus, covered with forests of pine and fir. . . .

On the walls, and back many miles into the country, numbers of monument-shaped buttes are observed. So we have a curious ensemble of wonderful features—carved walls, royal arches, glens, alcove gulches, mounds, and monuments. From which of these features shall we select a name? We decide to call it Glen Canyon.

Past these towering monuments, past these mounded billows of orange sandstone, past these oak-set glens, past these fern-decked alcoves, past these mural curves, we glide hour after hour, stopping now and then, as our attention is arrested by some new wonder.

—Major John Wesley Powell,
Exploration of the Colorado River and Its Canyons, 1872

Below: Sunrise, Peek-a-boo area, Canyonlands National Park
Opposite page: Maidenhair fern and seep at Cottonwood Canyon,
Glen Canyon National Recreation Area

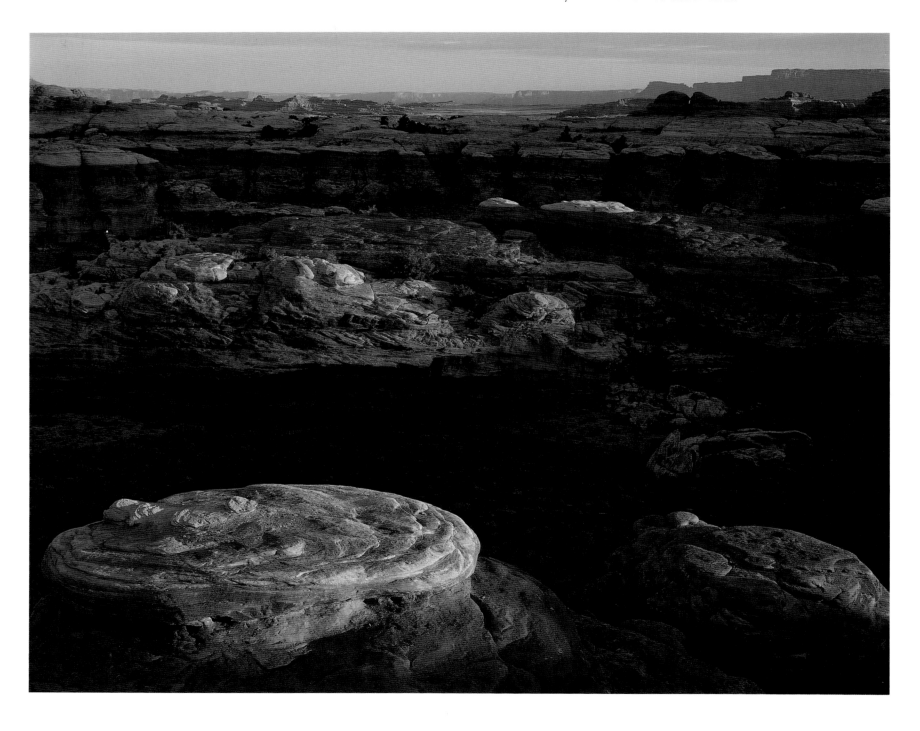

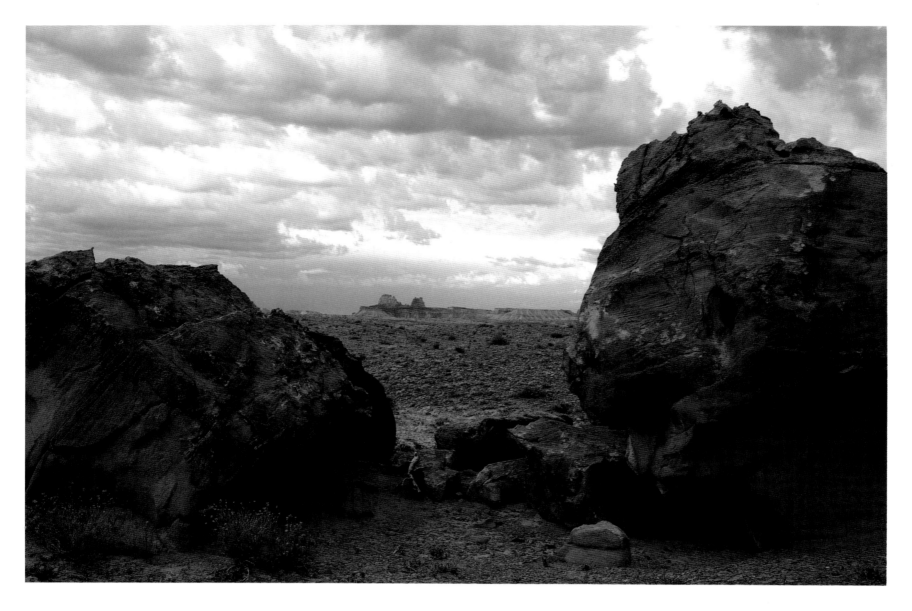

Above: Gathering storm over San Rafael Swell
Left: Sandstone formation, Reds Canyon, San Rafael Swell
Opposite page: Temple Mountain, San Rafael Desert

It is lovely and terrible wilderness . . . harshly and beautifully colored, broken and worn until its bones are exposed, its great sky without a smudge or taint from Technocracy, and in hidden corners and pockets under its cliffs the sudden poetry of springs. Save a piece of country like that intact, and it does not matter in the slightest that only a few people every year will go into it. That is precisely its value. . . . But those who haven't the strength or youth to go into it and live with it can simply sit and look. They can look two hundred miles, clear into Colorado; and looking down over the cliffs and canyon of the San Rafael Swell and the Robber's Roost they can also look as deeply into themselves as anywhere I know. And if they can't even get to the places on the Aquarius where the present roads will carry them, they can simply contemplate the idea, take pleasure in the fact that such a timeless and uncontrolled part of the earth is still there. . . . We simply need that wild country available to us, even if we can never do more than drive to its edge and look in. For it can be a means of reassuring our-selves of our sanity as creatures, a part of the geography of hope.
—Wallace Stegner, *The Sound of Mountain Water*, 1969

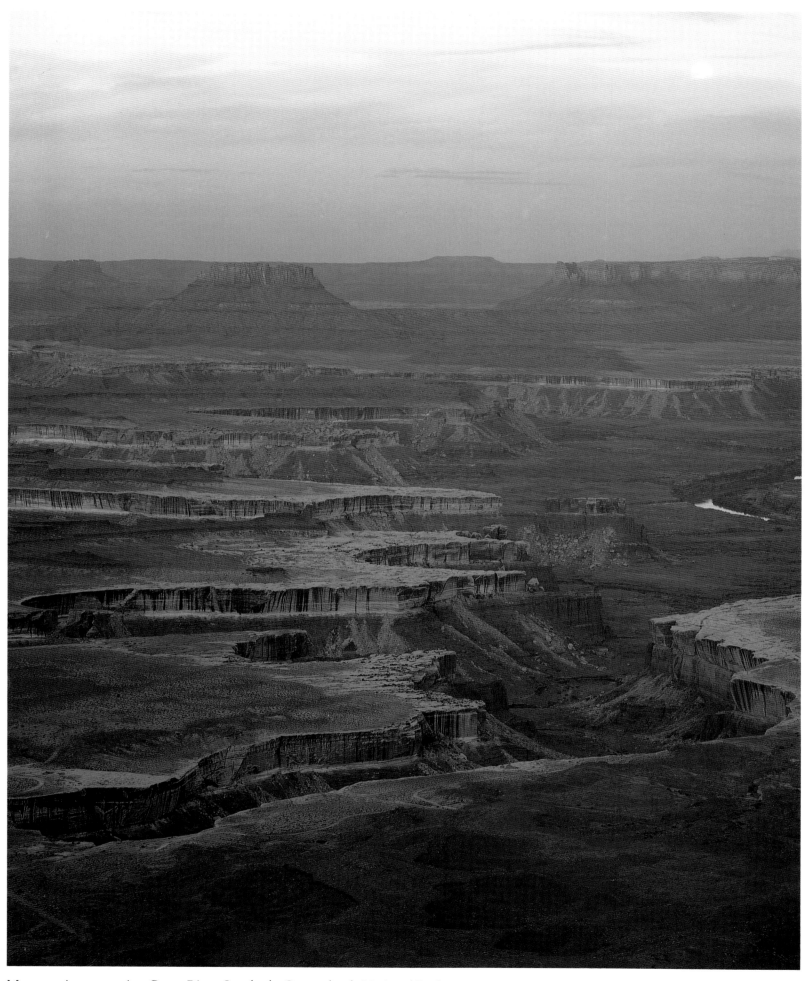

Moon setting at sunrise, Green River Overlook, Canyonlands National Park

The Southeast Quarter

STAND ON A HIGH POINT—Boulder Mountain will do, or Dead Horse Point, or the La Sals or Abajos or almost anyplace—and look out over the red-rock wilderness that is southeastern Utah, and you'll be looking at an open textbook of the awesome geologic forces that, over a couple of billion years, shaped the land.

You'll be looking at one of the last-known and, until the past quarter century, least-known areas in the continental United States. You'll be looking at topography that dictates more severely than almost any other place the shape of human habitation and use of the land—from the long-vanished Anasazi Indians who once lived there to the campers, backpackers, river runners, and mountain bikers who swarm there today.

This is the Colorado Plateau. Its 107 million acres sprawl over northeastern Arizona, northwestern New Mexico, southwestern Colorado, and, especially, southeastern Utah. About a third of the Plateau, the heart of it, lies in Utah, and most of that is in the southeastern quarter of the state.

And what land it is—mysterious, forbidding, aggravating, compelling—as visually astonishing as any place on earth. For ten million years its major architect, the Colorado River, has worked to grind and carve and shape the land. So have that river's major tributaries—the Green, the San Juan, the Escalante, the Dirty Devil—and myriad creeks and washes, carving canyons of infinite variety and beauty. And the sculpting goes on. As any hiker or river runner knows who has seen the cliff-scar of a fresh rockfall or been awed by the power of a flash flood, wind and water continue to reshape cliffs, canyons, bridges, alcoves, monuments, spires, goblins, and petrified sand dunes.

Pine-covered mountains—Navajo, the Abajos, the La Sals, the Henrys—soar up in splendid isolation from the red-rock wilderness. The twisted and tortured San Rafael Swell cuts diagonally across the northwestern corner, the Waterpocket Fold the middle, the

Ice in streambed, Bullet Canyon, Grand Gulch

17

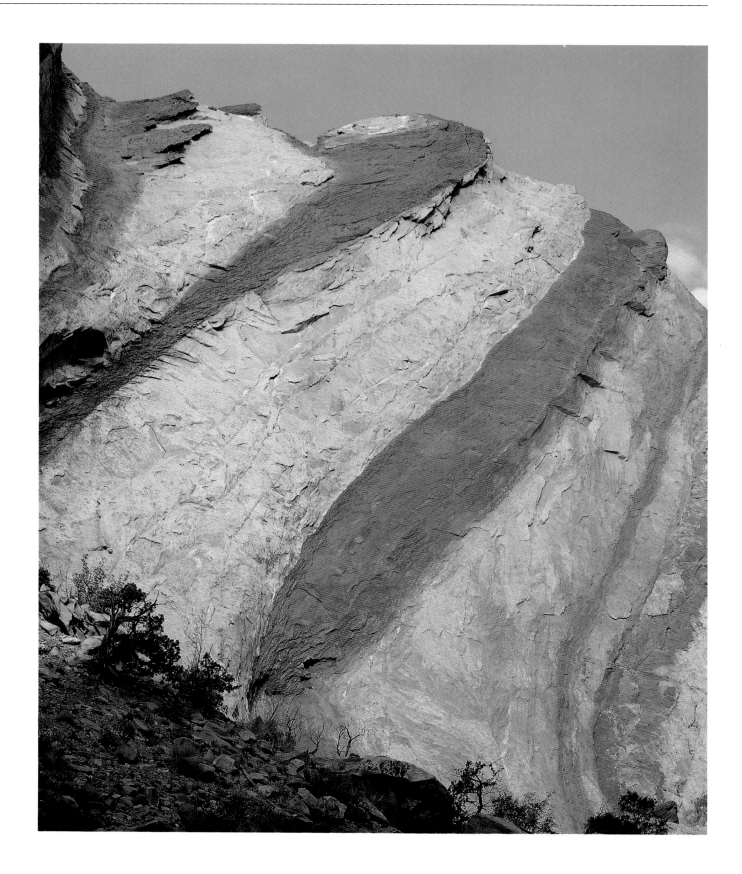

Sandstone
formation, San
Rafael Reef

Kaiparowits Plateau and Monument Upwarp the south. And brooding over the country on the west are the high plateaus: the Fishlake, the Awapa, and the Aquarius, which at from 9,000 to 11,000 feet is said to be the largest high and open flat-top mountain on the continent.

How did it all get this way? The question has to nag at anyone who enters and gets close to this country.

Fossils give the most intriguing clues: a reef of millions of fossilized oyster shells in the Waterpocket Fold; the sharks' teeth you can find, scrabbling on your hands and knees, in the clay hills and flats out of Hanksville; petrified logs in the Circle Cliffs; rich coal beds in the Kaiparowits; dinosaur tracks and bones, fossilized coral, imprints of palm leaves and other tropical plants. Where did they come from? And those soaring

Left: Sandstone, Death Hollow
Below: Vishnu Schist rock and grass, Westwater Canyon

cliffs, cross-bedded sandstone, arches and hoodoos and monuments in all the shades and hues of pink and red, yellow and green, purple and grey; those great boulders lacquered with the shiny purples and blacks of desert varnish: what stories of creation do they tell?

An intriguing fact about the Colorado Plateau is that through the one and a half billion years geologists can read in its exposed and unexposed rocks, it has existed as a unified geologic province, undivided by the kind of mountain-building that has creased and split and folded the earth's crust elsewhere. Still, its story, as played out over unimaginably long aeons of time, is complex. It goes somewhat as follows.

In the Precambrian era, from some two billion to 570 million years ago, great thicknesses of sedimentary muds were transformed into the gneisses, schists, and quartzites that became the bedrock of the Plateau. These oldest of all rocks are best seen in the Grand Canyon, but there is a smaller outcrop in Westwater Canyon, near the Utah-Colorado border.

The Precambrian was followed by some 300 million years of the Paleozoic era, during which much of the Plateau, like most of Utah, was covered by the eastern shallows of the Pacific Ocean. Enormous limestone deposits accumulated under the marine waters. The earth's equator probably ran through the Plateau during this period, before the North American continent drifted north.

Some 245 million years ago, what is known as the Triassic period opened the Mesozoic era. The climate of the area was moist and warm. Plant life was lush. Dinosaurs originated in this period and left a few bones and many tracks to intrigue explorers today.

In the succeeding Jurassic period, about 200 million years ago, immense subterranean forces began to slowly raise the bedrock. The ocean retreated, leaving vast interior deserts and alluvial plains where dinosaurs became even more numerous. An immense mountain chain rose in western Utah and eastern Nevada. For some fifty million years, in the closing stages of the Jurassic period, these mountains milked moisture from the westerly winds, leaving the Colorado Plateau region a desert. Though the winds didn't bring rain, they did bring sand. Blown off the western mountains, it piled up sandbars and dunes to depths of 2,000 feet. Minerals in moisture seeping

through the sand bound the granules together into thick layers that became the Wingate, Kayenta, and Navajo sandstones—the stuff of which the cliffs and spires, arches and bridges of the Plateau country are made. You can see the pattern of sand dunes today in the cross-bedded slopes, the checkerboard mesas, and in the shapes of arches themselves.

By the close of the Jurassic period, about 144 million years ago, erosion had melted away the Nevada-Utah mountains, and warm winds again brought moisture. Swamps and sluggish rivers covered the region. For another 78 million years—the Cretaceous period—shallow seas advancing up from the Gulf of Mexico and down from the Arctic covered the Plateau, depositing deep beds of Mancos Shale and who knows how many million shark teeth. Lush swamps and tropical jungles became the coal deposits that developers covet today.

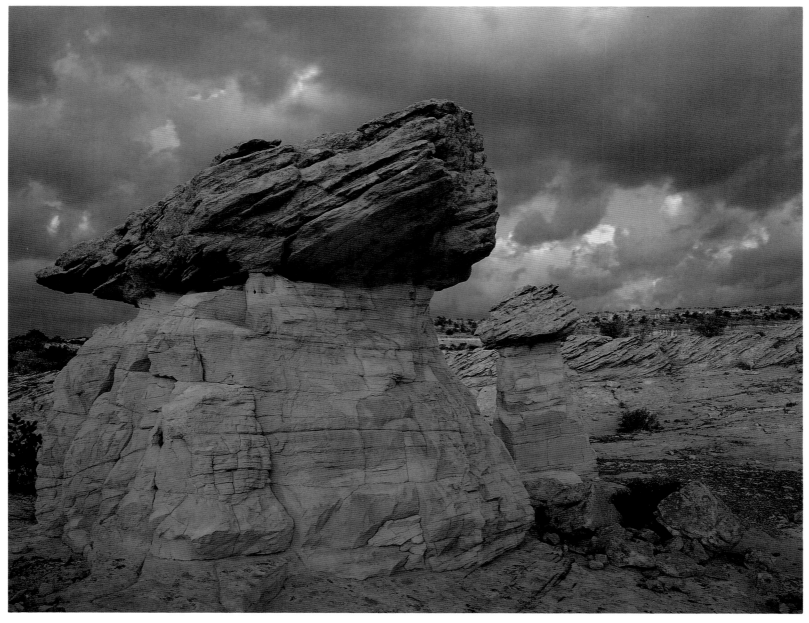

Sandstone formations, Escalante area

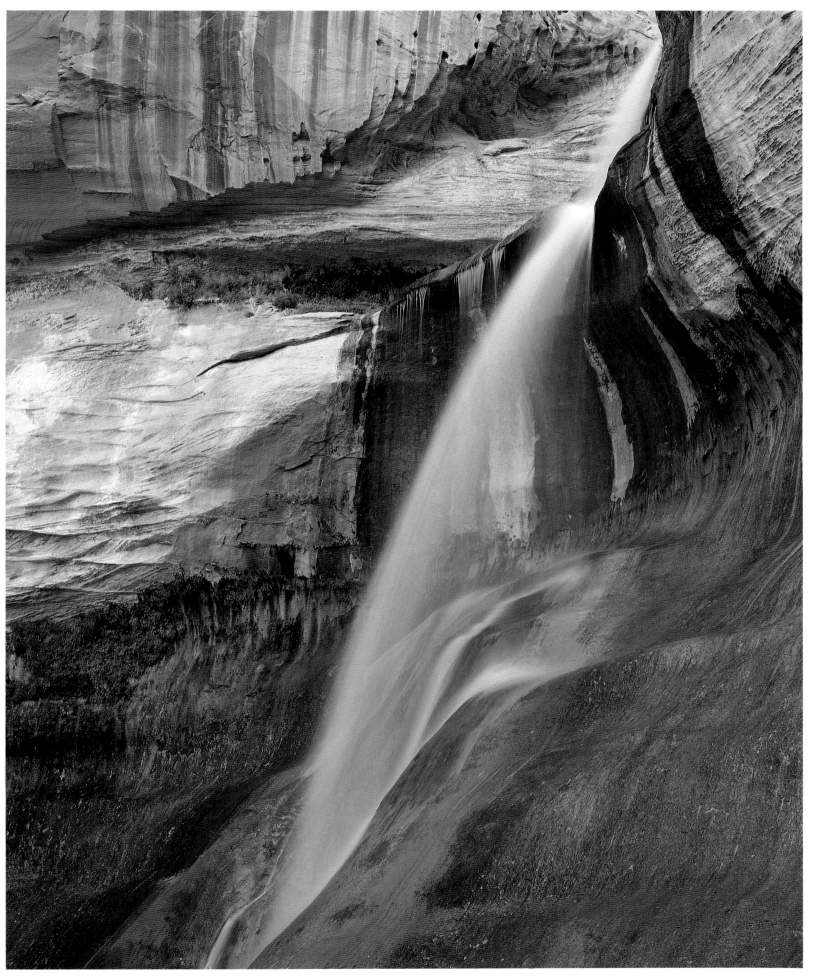

Lower Calf Creek Fall, Calf Creek Recreation Area

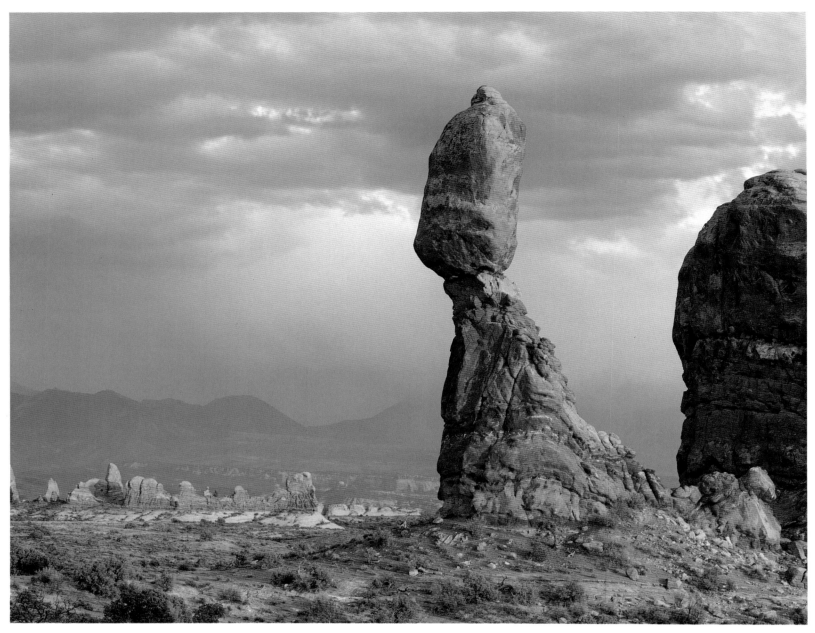

Balanced Rock, Arches National Park

The stage now was set for the great period of carving and shaping that has made the Plateau an unmatched scenic wonder. About 10 to 15 million years ago, continental plate activity raised the western part of the North American continent 10,000 feet above sea level. Sluggish streams became rushing rivers that drained the swamps and washed away thousands of feet of accumulated sediments before cutting into the underlying layers of Triassic and Jurassic sandstone. Nowhere on earth is the transformation of a sluggish, meandering stream into a deeply entrenched, rushing river more dramatically demonstrated than in the Goosenecks of the San Juan River near Mexican Hat.

Sandstone varies greatly in thickness, hardness, and permeability to percolating water. The hard, cliff-forming sandstones—Kayenta, Wingate, and especially Navajo—fracture along vertical planes and peel off in great slabs and blocks when underlying softer rock is eroded away. Thus were formed the naked cliffs of Zion, Capitol Reef, and Canyonlands national parks, as well as those of Glen Canyon, Rainbow Bridge, and Dead Horse Point. The Permian sandstones that form the spires and totems of Monument Valley are much older, but the process is the same.

More rounded and feminine is the Entrada Sandstone of the late Jurassic period, seen most spectacularly in Arches National Park and Goblin Valley. Water is the chief architect there. It seeps down through porous layers of sandstone until it reaches an impermeable layer, along which it spreads until it reaches an outseep. Weakened sections of stone fall away, and gradually there are formed the arches, alcoves, and amphitheaters with which the Plateau is so abundantly blessed.

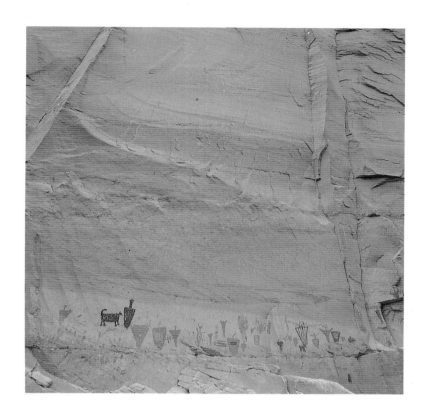

Right: Pictographs, Horseshoe Canyon, Canyonlands National Park
Below: Turret Arch through North Window, Arches National Park

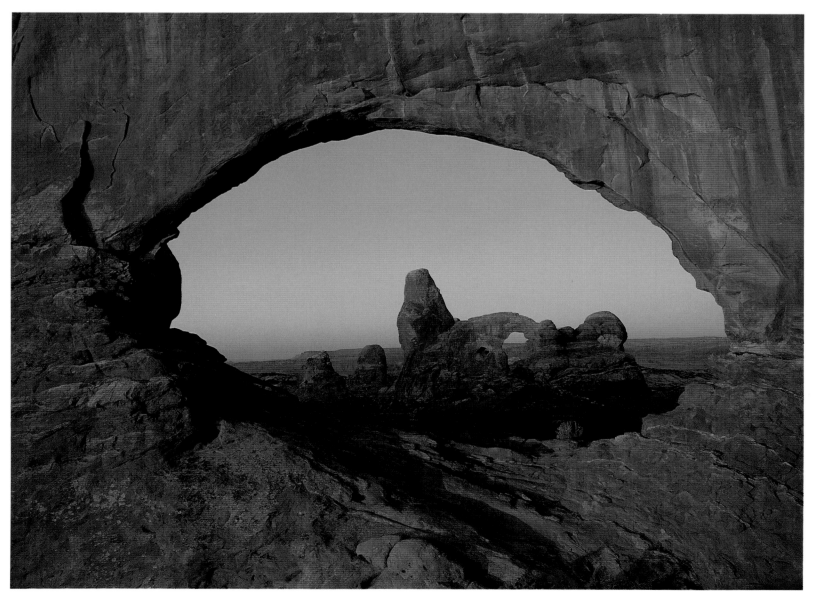

This is the general outline of how the Colorado Plateau of southeastern Utah came to be. But there are sub-chapters. Millions of years of erosion have left the 11,000-foot Aquarius and other high plateaus as remnants of a great uplift that raised the entire area to that height and above during the early Tertiary period—perhaps 65 million years ago. Off their slopes pour streams and washes that have helped carve the region's maze of canyons. Later, some 40 million years ago, subterranean pressures from the west created the tortured mazes and hogback ridges of the San Rafael Swell, Capitol Reef, Circle Cliffs, and Comb Ridge—uplifts that were on their way to becoming mountains but didn't quite make it.

And what of those lonely, isolated mountains that are such a distinctive part of the canyon country? They had their own special creation but also didn't quite achieve what they set out to be. In the volcanically active mid-Tertiary period, some 25 million years ago, pressures within the earth's mantle pushed up great masses of hot, plastic magma. Never able to break through the thousands of feet of sandstones and other sediments to become active volcanoes, the laccoliths, as they are called, arched and fractured the rock above. These covering rocks later eroded away, leaving the now-cooled magma bulges as the mountains we know as Navajo, the Abajos, the La Sals, the Henrys, and, in the southwest, the Pine Valley Mountains. From them too flow streams and washes that shape the marvelous topography that is the Colorado Plateau.

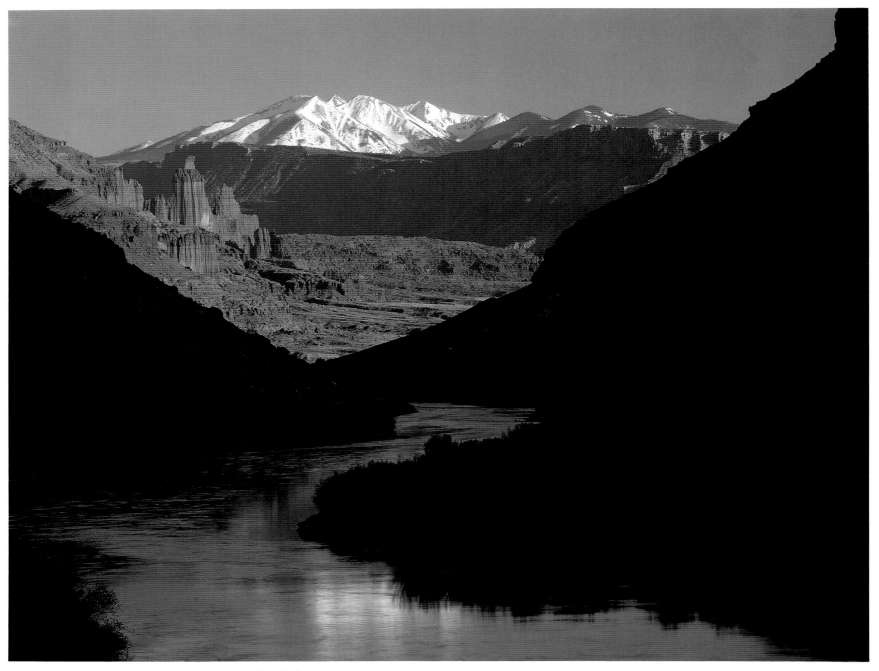

Sunset, Fisher Towers, Colorado River, and La Sal Mountains

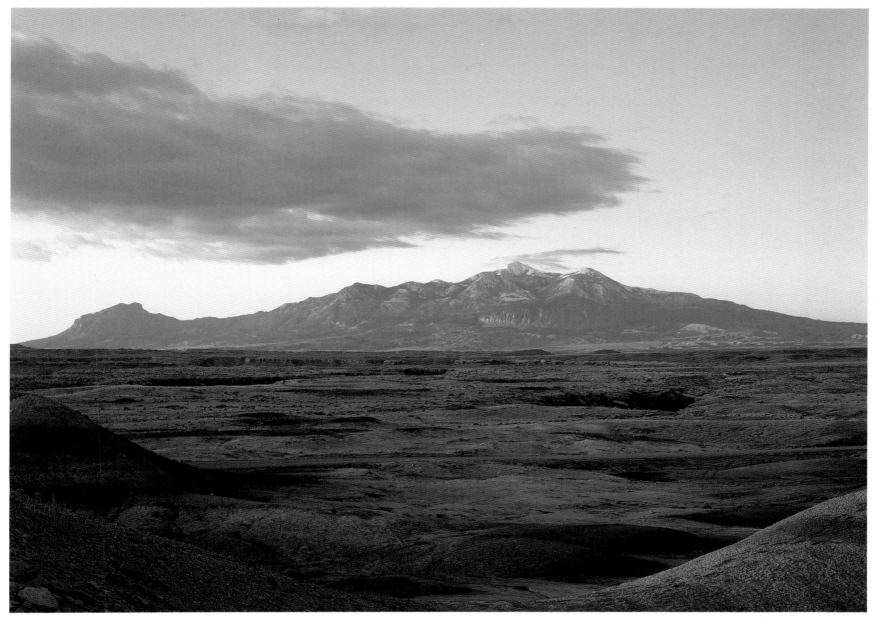

Sunrise, Henry Mountains

The Land Today

And so southeastern Utah stands today. The verb is deliberately chosen. The area's verticality is its most striking feature. Nowhere else on the continent exists such an astonishing landscape of cliffs and canyons, buttes and mesas, hoodoos and spires and monuments.

It's lonely country. A dozen communities, most of them tiny, cling to its perimeter. For 120 miles, from the settlements at the foot of the high plateaus on the west to those below the La Sal and Abajo mountains on the east, except for the little town of Hanksville and the marinas around Lake Powell, only a few isolated ranches break the solitude. In all southeastern Utah, an area twice the size of Vermont, only one community, Moab, has as many as 5,000 people, and the total population of the region barely reaches 30,000.

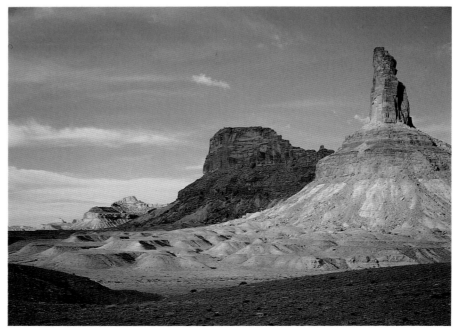

Bottle Neck Peak, San Rafael Swell

That is because it's also dry country. Annual rainfall averages less than ten inches over the region. The amount varies greatly with altitude, of course, as the evergreen forests on the high mesas and mountains and the shadscale and cactus in the lower country attest. But don't be misled. Even in the lower canyons, where rainfall rarely reaches five inches a year, there are seeps and springs and lush little pockets of maidenhead fern and, to the discomfort of many hikers, poison ivy. Backpackers who know where to look wash off the sweat of the hike in waterpocket bathtubs or certain secret pools at the base of towering cliffs. There are places where the only way to get from here to there is to put your backpack on an inflated Ensolite pad and swim it through arms'-width canyons filled with water dozens or—who knows?—hundreds of feet deep. And anyone who has slogged through quicksand left by the latest flash flood cannot doubt that somewhere up there it rains.

You seldom feel it in the lower country, though. With a blue sky and hot sun overhead, you can watch clouds boil over and rain pour on the Abajos a half-dozen miles away. You can watch rain pour out of lightning-ripped clouds only to evaporate before reaching the thirsty ground.

About that sun: nowhere more than in desert country does it dictate the rhythm of daily life. You welcome it in the early morning when, even in midsummer, nighttime temperatures can drop 50 degrees or more. You hide from it in midday and afternoon when shade is the difference between cool comfort and desiccating, potentially fatal heat. It is no coincidence that

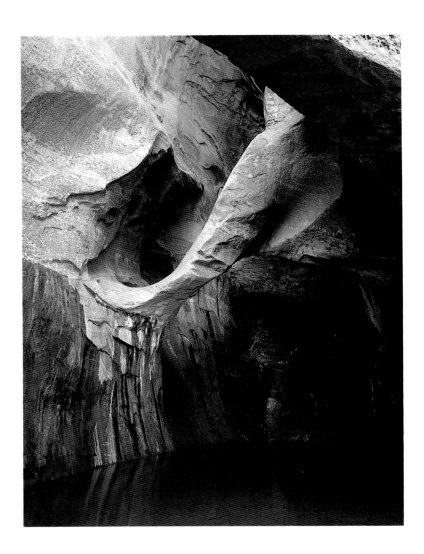

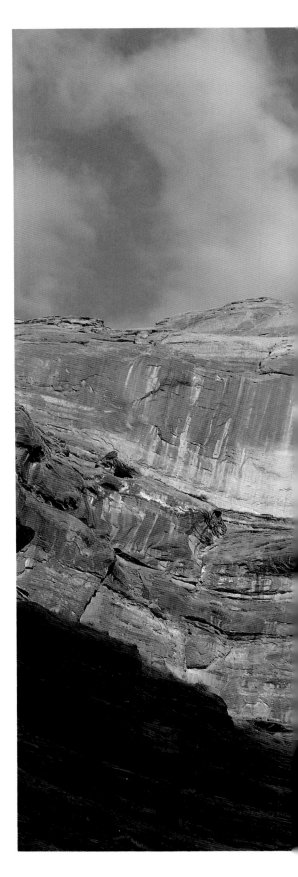

Left: Hanging arch and pool, Stevens Canyon, Escalante area
Right: Sandstone wall, Escalante Canyon

the Anasazi dwellings and chipping grounds you find in the plateau country almost always face east or southeast.

There is something else the sun contributes to the canyon-country experience: desert varnish. The term is often applied to the tapestry streaks left on canyon walls where water has washed different-colored mater- ial down the cliff face from a formation above. But true desert varnish is something else. It is literally "sun- burned rock." Scientists don't agree on how the man- ganese and iron that form the rich browns, purples, and blacks of desert varnish get there—whether the minerals come from within the rock, are splashed there by rainfall, or come somehow from the soil on which

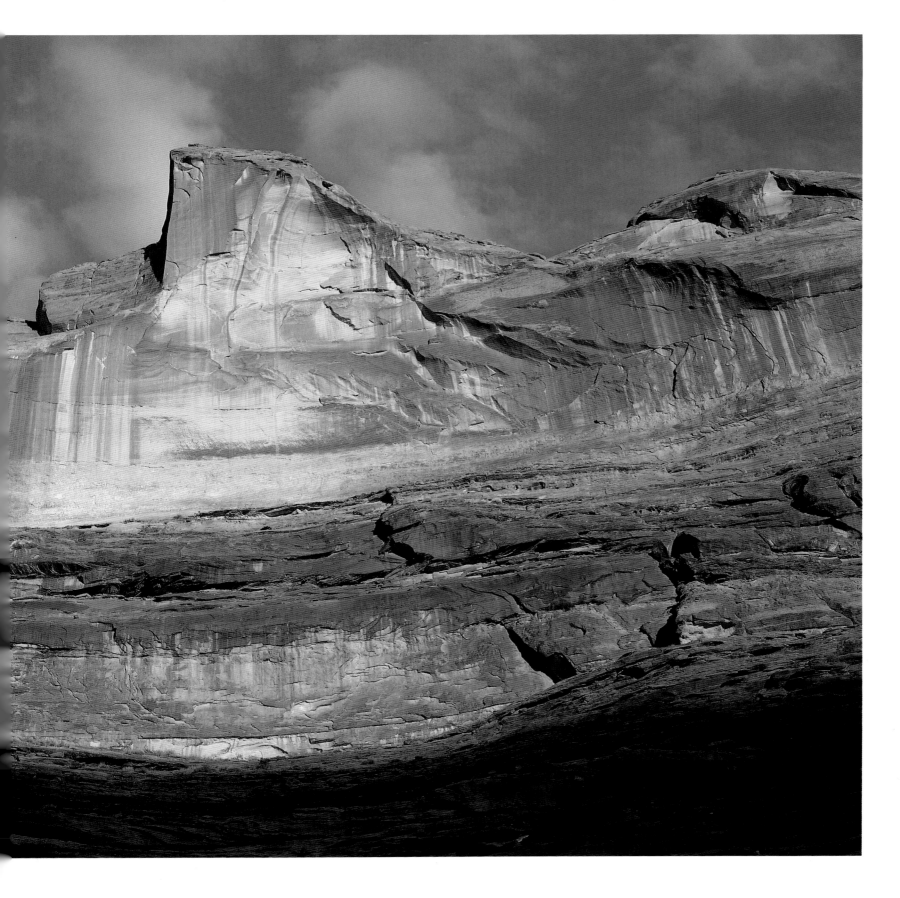

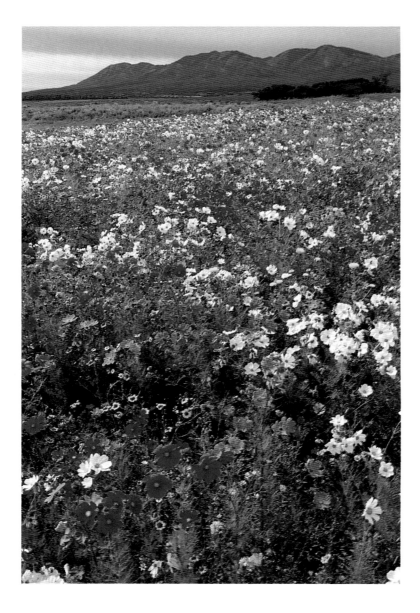

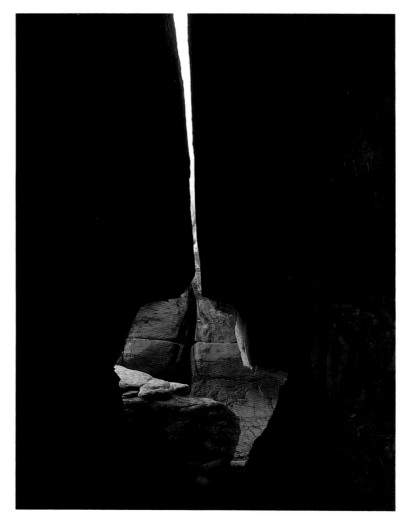

Left: Wildflowers in field near Monticello, with Abajo Mountains
in background
Above: Joint Trail, Canyonlands National Park

the rocks lie. But they agree that it is the hot desert sun
that burns the minerals into the rock, leaving shiny,
lustrous surfaces that provided irresistible "canvases"
for Anasazi, Fremont, or Archaic artists hundreds of
years ago and, shamefully, a few vandals today.

Temperature, altitude, and moisture dictate the
shape and extent of plant and animal life in canyon
country. From the aspen-splashed fir- and spruce-tim-
bered heights of 11,000-foot plateaus and mountains,
life zones progress downward through ponderosa pine,
pinyon-juniper, sagebrush, rabbitbrush, and blackbrush
to sparse shadscale and cactus at elevations around
3,000 feet. The deep canyons have their own plant
colonies. Exquisite hanging gardens adorn water seeps
on canyon walls. Willows and cottonwoods line stream-
beds. So does the tamarisk that a misguided someone
brought over from Europe to Mexico in the past cen-
tury; it now chokes watercourses throughout the
Southwest.

And there are flowers—1,000 or more species that
botanists have identified. Why do they add such special

delight to the canyon country experience? Perhaps be-
cause their beauty is so fleeting; you have to be there at
just the right time or you'll miss it. Perhaps it's the sur-
prise of such beauty in so harsh a land; perhaps it's the
drama of their setting: Yucca—food, soap, laxative,
and footwear to the ancients—with its golden spikes
silhouetted against a sapphire sky; yellow or magenta
prickly-pear blossoms accenting rippled red sand; scar-
let paintbrush clinging to lichen-crusted ledges; or
sweet-scented, trumpet-shaped blossoms of the hallu-
cinogenic jimsonweed nestling at the base of a tower-
ing cliff. Whatever. In my case, forty years ago it took
only the early-morning splendor of an ocean of scarlet
gilia sweeping out to the spires of Chesler Park to hook
me, lifetime, on canyon country.

You'll not see lots of wildlife out there; much of it
moves by night, and what doesn't is remarkably well
camouflaged. But you'll know creatures are there.
Those tracks in the moist sand could be coyote or fox
or badger—or someone's dog. Or, if the pugmarks are
round and without clawprints, think of skunks or ring-

tailed cats or bobcats or even cougars. Mule deer tracks you'll recognize, of course, but in certain areas they could be antelope or, if you're high up in the rim-rock, bighorn sheep. What you *will* see are lizards, skittering into sandstone crevices or, in the case of the handsome and bolder collared lizard, challenging you with its territorial push-ups.

And there are birds. You're seldom out of sight and hearing of birds. Red-tailed hawks and golden eagles float over the buttes and mesas, and the American raven flings back its raucous insults as it flaps down the canyon. Yet if there is a signature sound of this country, it is the early-morning song of the canyon wren. Nature knows no lovelier sound than those clear, descending notes announcing the arrival of another day.

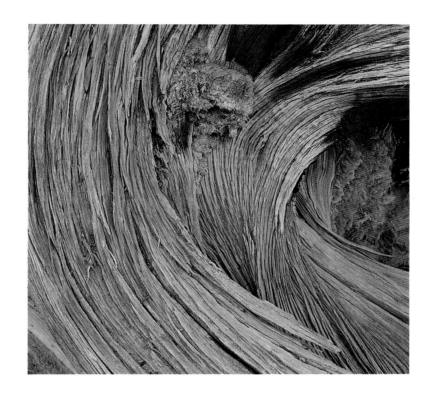

Right: Detail of Utah juniper in Arches National Park
Below: The Castle in snow, Capitol Reef National Park

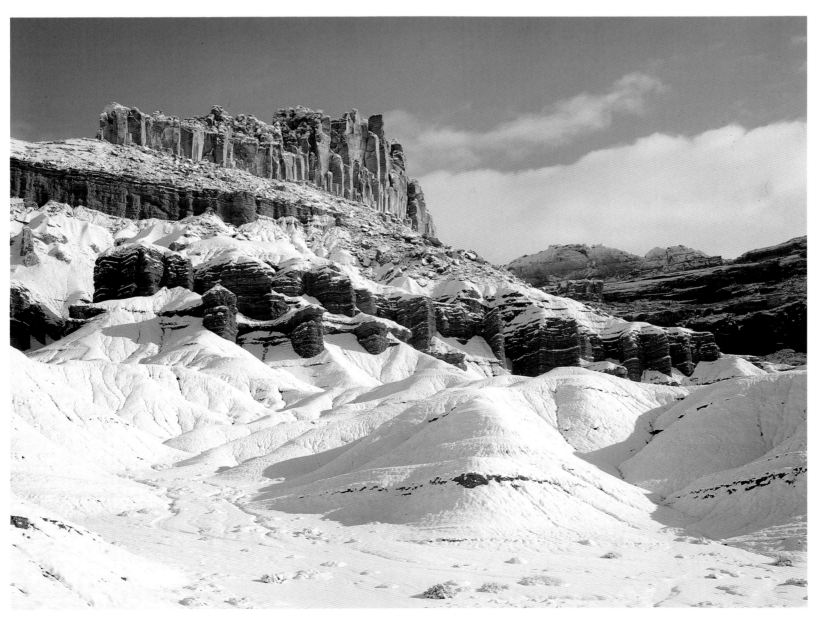

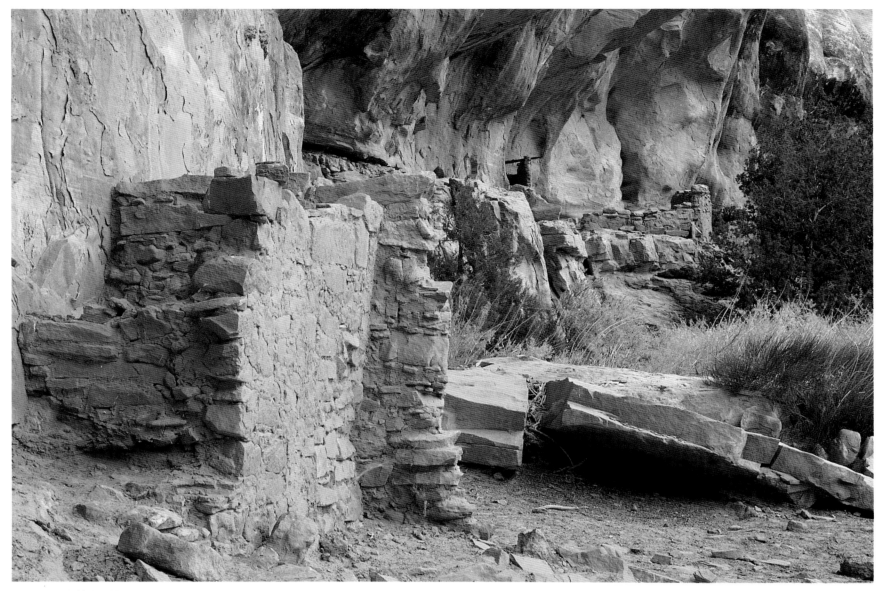

Anasazi cliff dwelling, Grand Gulch

Humans on the Land

Except for its verticality, nothing so characterizes canyon country as the sense one has in it of peering through the mists of prehistory into ages past. You get that from dinosaur tracks and fossilized oyster shells, of course. But you get it more hauntingly as you match your fingerprints with those left a thousand years ago by fingers smoothing the walls of a mud-and-wattle dwelling. Or as you grind your own pocketful of corn on a Grand Gulch metate with a mano once held by hands now a millennium dead. Or as you try to puzzle out the message of strange and wonderful figures pecked or painted on rocks and cliff faces. As well might one travel Egypt without seeing the pyramids or China the Great Wall as travel canyon country without immersing oneself in the mystery of its Anasazi dwellings and rock art.

It takes time and effort, though. Small but excellent museums in Blanding and Boulder tell the Anasazi story, and the finest ruins in Utah, at Hovenweep National Monument, are easily accessible by auto. But most of the hundreds of known sites—places like the Great Gallery in Barrier Canyon, the Harvest Scene in the Maze, Poncho House in Chinle Wash, Moon House Ruin on Cedar Mesa, the thousands of figures and dozens of dwellings in Grand Gulch—are remote and not easily reached.

For most, a visit requires backpacking—and that is a blessing. At midday its hard to communicate with the past. Evening is better, and night, under a full moon or at least with a flashlight, is best. Commune by moonlight with those heroic-size trapezoidal human figures with their staring, ghostlike eyes, and the gulf between you and the past narrows a little. Ponder by moonlight in the Maze that dark, horned figure with a tree growing from the middle finger of its outstretched hand, or

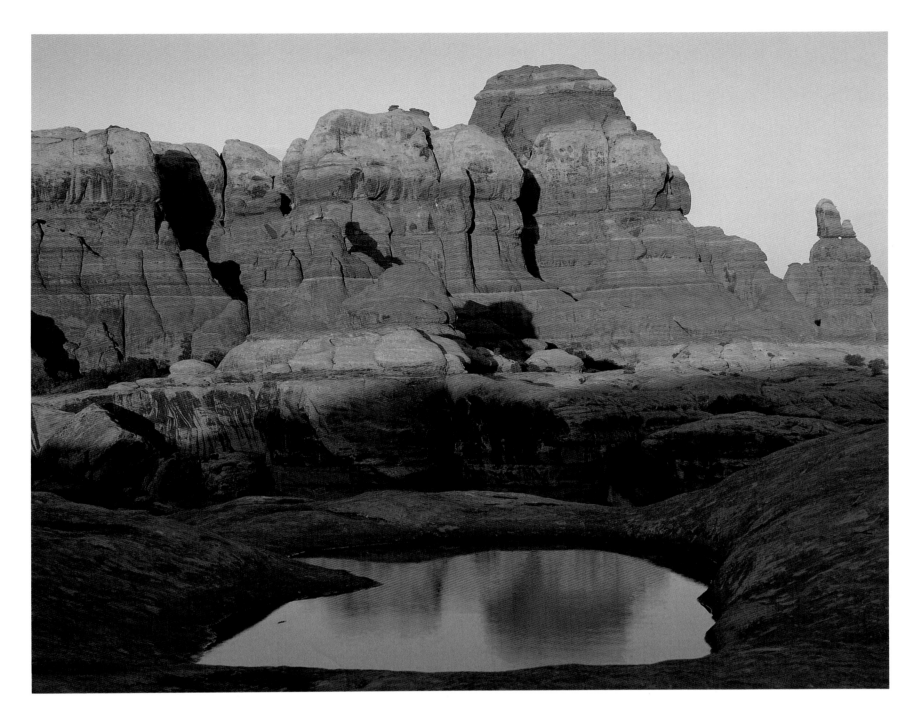

the flute player, Kokopelli, with his bag of seeds and outsized genitalia, or the spirals and mazes, the tracks running along what appear to be rivers of water, and imagination may—or may not—bring meaning a little closer.

Those whose historical connections to the area date less than 200 years find it difficult to comprehend just how long ancient peoples inhabited these mesas and canyons. For perhaps 10,000 years, until around the beginning of the Christian era, peoples of what we now call the Archaic culture wandered the region. These were hunters and gatherers—nomads—following the game and the seasons. Caves provided shelter, and

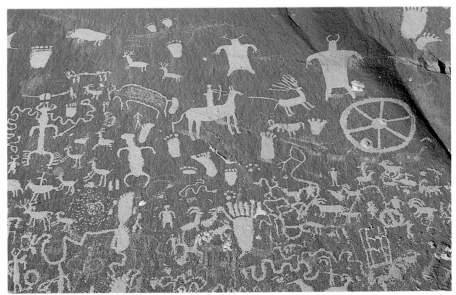

Above: Buttes reflected in pool, Canyonlands National Park
Right: Petroglyphs, Newspaper Rock State Park

mountain sheep, an occasional elk or deer, and many smaller animals as well as wild plants and seeds provided food. Hunting was done at first with spears, later improved by the atlatl, or throwing stick, as pictured frequently in rock art pecked on sun-blackened boulders. Chipped projectile points and scrapers, crude bone tools, cloth of woven strips of fur, woven sandals, twined and, later, coiled basketry hint at how these people lived. Cooking was done over open fires or by dropping hot stones into skin containers.

Beginning about the start of the Christian era, for the next 1,300 years or so the Anasazi culture slowly evolved across southern Utah. These were the area's first farmers, raising corn and squash. Farming meant semipermanent dwellings, either in caves or crude pit houses. It also meant development of the mano and metate for grinding corn. Slab-lined cists stored corn or housed blanket-wrapped, flexed-position burials. Jewelry of turquoise, seashells, bones, and seeds adorned lightly clothed bodies. Sandals were woven of yucca fiber, blankets from fur strips, nets and cordage from human and, sometimes, dog hair. Pottery was still unknown, but beautifully woven baskets gave the Early Basketmaker period (A.D. 1–750) its name.

In the Modified Basketmaker period (A.D. 450–750), living was easier. The bow and arrow replaced the atlatl. Pottery replaced the basket, and, now that there was something to cook them in, beans added protein to the diet. So did turkeys, which the Basketmakers domesticated. The true pithouse appeared, four feet deep and ten to fifteen feet in diameter, and these were clustered together as village life started to evolve.

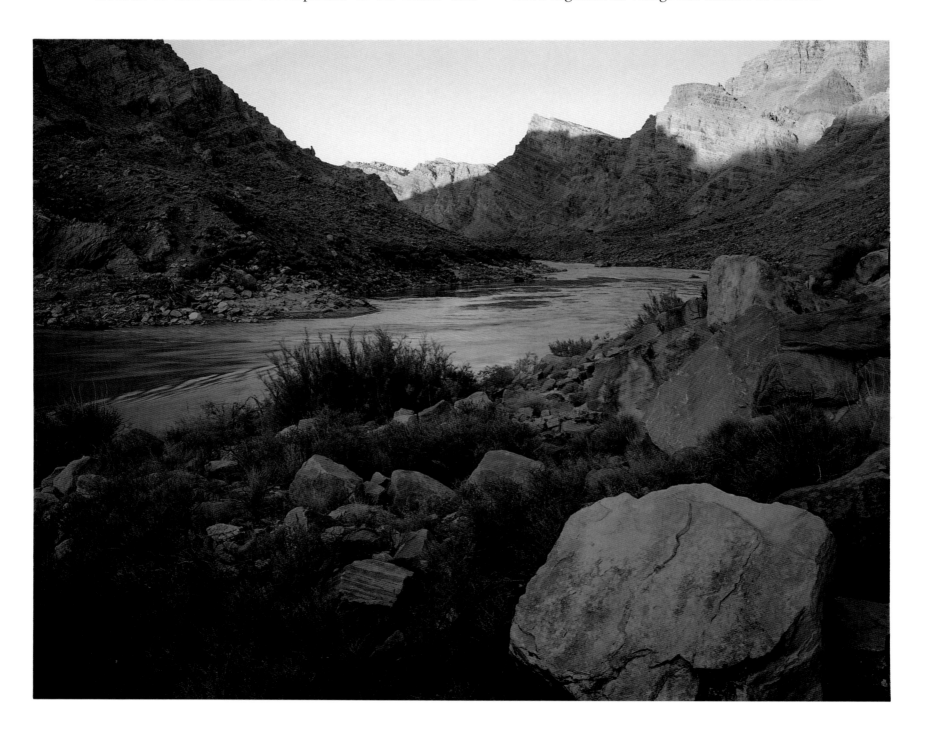

With better diet, population soared. Stone masonry appeared, and builders began to join rooms together horizontally and, later, vertically in the Developmental and Great Pueblo periods (750–1300). In front of each cluster of rooms was dug an underground, circular, ceremonial room, the kiva, its roof supported by cedar posts resting on stone pillars. Stone benches lined the walls, and a small circular hole, the sipapu, represented the entrance place of the spirit from the underworld. The corrugated and beautifully painted pottery shards you kick up in countless sites throughout canyon country come from this period.

Around the year 1300 something happened. It was probably drought, perhaps the pressures of strangers moving into the area, or possibly the spiritual need to move on because, according to Hopi legend, the people had not yet found their intended Place. For whatever reason, the Anasazis disappeared from canyon country, leaving it for the next 500 years to the more primitive Paiutes, the Utes who preyed on them, and the Navajos who occasionally raided from the south.

Opposite page: Colorado River at Spanish Bottom, Canyonlands National Park
Right: Burr Trail, Long Canyon, near Boulder, Utah
Below: Waterfall in Mill Creek Canyon near Moab

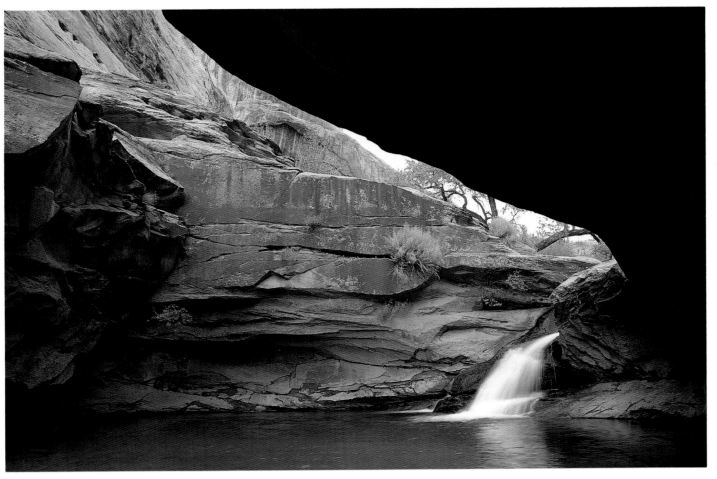

Which white man first entered southeastern Utah is lost to history. It could have been the conquistador Cardenas, who in 1540 reached the great canyons of the Colorado River and turned back, reporting that the country to the north was inaccessible. If so, he saw only a corner of Utah, on the edge of Glen Canyon; more likely, he was farther west and south. It could have been any of a number of unknown traders, miners, and slavers who in the seventeenth and eighteenth centuries were pushing their operations north from Santa Fe into Ute country. That might explain a 1642 inscription found in Glen Canyon before its flooding or the persistent rumors of lost Spanish gold mines.

Fathers Dominguez and Escalante barely missed getting into the region on their 1776 expedition to find a trail to California; they stayed east of the La Sal Mountains but they would have avoided much delay and hardship if they had swung to the west on what would become the Old Spanish Trail.

So it was the Spanish Trail itself that brought the first travelers of record into the area. For some twenty years during the 1830s and 1840s Santa Fe traders pushed pack trains loaded with New Mexican woolens along a 1,200-mile trail to the Pacific, returning with thousands of horses and mules bought—or stolen—in California, and selling, at each end of the trail, Paiute

Left: Island in the Sky, Canyonlands National Park
Above: Scenic overlook, Utah Highway 12 near Escalante
Below: Sunset, Peek-a-boo area, Canyonlands National Park

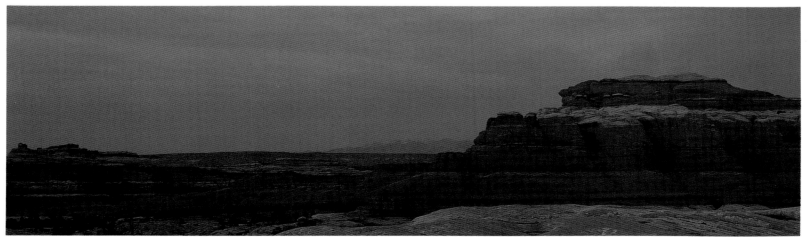

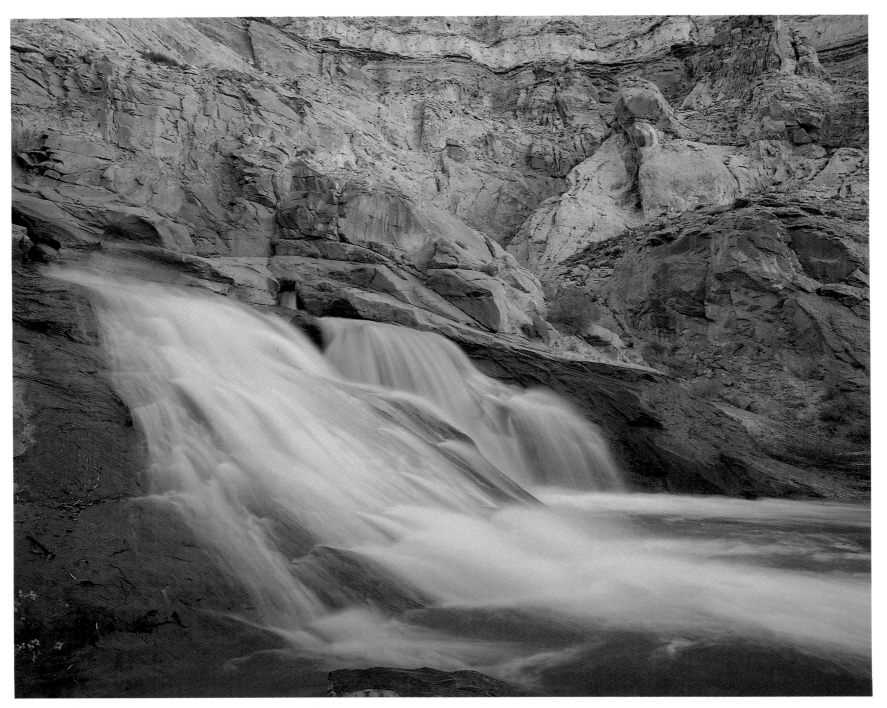

Waterfall, Fremont River, Capitol Reef National Park

children kidnapped or bought along the way. The trail entered Utah over the Sage Plain east of Monticello, dropped into Spanish Valley and crossed the Colorado River near Moab, skirted the red-rock wilderness that is Arches National Park, and swung northwest to cross the Green River near the town of that name.

"The mountains all about us are covered with snow," wrote Orville Pratt of his travels on this part of the trail in 1848. *"Through a cold & heavy rain we began descending the longest & steepest mountains yet passed over. But we got down it with safety. After reaching the bottom the scenery in the valley was the most rugged & sublime I ever beheld."* Escalante had

described the La Sal mountains from the Colorado side, but Pratt's, as far as we know, was the first written description of the majestic Navajo and Entrada formations in the Moab area.

Other descriptions did not soon follow. For years, official U.S. government surveys in search of a railroad route to the west failed to penetrate canyon country. Lieutenant John W. Gunnison skirted its northern edge in 1853 on his way to die with seven of his party at the hands of Indians in central Utah. Others explored possible railroad routes to the south. Finally, in 1859, Captain John N. Macomb, ordered to explore a central railroad route, set out to reach the confluence of the

Green and Colorado rivers. For reasons anyone who has wrestled a jeep over Elephant Hill will understand, he never reached it; but he and his men looked out over where they thought it was and at the country beyond. John Newberry, a geologist with the expedition, gave us the first description of the Needles district of Canyonlands National Park, quoted at the beginning of this chapter.

With more on his mind than scenery, Macomb expressed something less than the delight Newberry felt. Ruling out the possibility of a rail route through this country, he wrote: *"I cannot conceive of a more worthless and impracticable region than the one we now find ourselves in. . . . I doubt not that there are repetitions and varieties of it for hundreds of miles down the cañon of the Great Colorado."*

In 1879 the first relief map published of Utah, Clarence Dutton's *Atlas of the High Plateaus*, placed the rivers and major mountains of Utah's southeast quarter more or less accurately, thanks to Macomb's expedition and the more extensive expeditions of John Wesley Powell in 1869 and 1871–72. But except for those few lines the map is bare. There is no hint of the kind of country that lies beyond the rivers and behind the mountains. There is no hint of human settlement, and in this the mapmakers were almost correct. Nomadic bands of Ute Indians hunted and gathered pine nuts on its highlands, and an occasional outlaw hid out in its deep canyons. A Mormon outpost, the Elk Mountain Mission at Moab in 1855, had been abandoned after Indians killed three men. A half-dozen families had settled in Potato Valley (now Escalante)

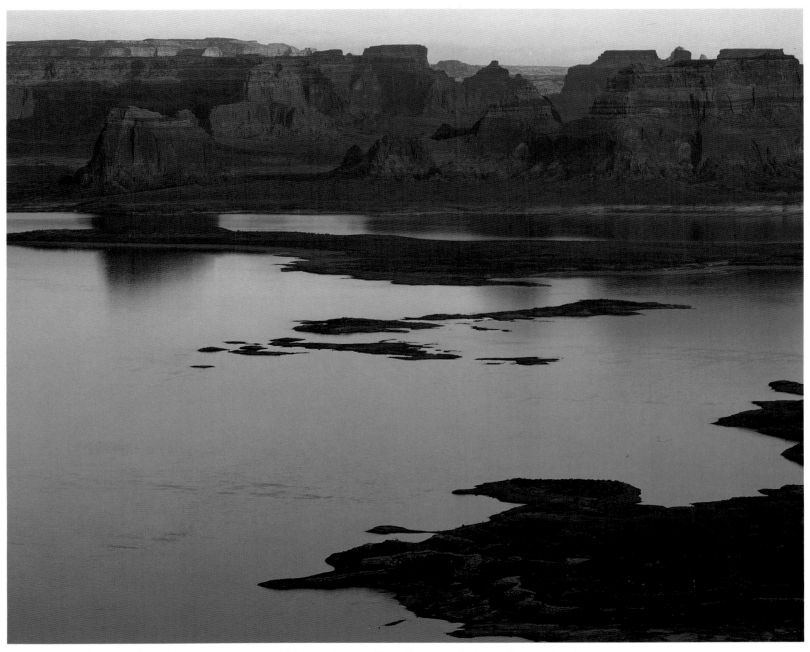

Padre Bay, Lake Powell, and Padre Butte from Ahlstrom Point, Glen Canyon National Recreation Area

on the western fringe of the region in 1875, and a couple of others had homesteaded in La Sal on the eastern fringe in 1877. But that was it. By 1870, Mormon settlements occupied every fertile valley north, south and west of Salt Lake City, but the canyon country was essentially empty.

Brigham Young decided to change that. His far-flung Mormon empire needed an anchor on its southeastern corner, he reasoned, to keep out the Colorado and New Mexico cattlemen who were starting to push their herds into the area. Besides, a Mormon outpost on the San Juan River would bring law and order into the region and help stop Indian raids across the Colorado against the settlements in southwestern Utah.

Brigham's death in 1877 delayed the project, but in the winter and spring of 1878–79 the call went out for missionaries to the San Juan area. An exploring party leaving Paragonah took six weeks to reach the proposed site on Montezuma Creek by way of northern Arizona, and another four weeks to return by way of the Spanish Trail. After a thousand-mile round-trip, they reported that the San Juan region was nice country to settle, but a shorter and better way had to be found to get there.

The way chosen, east across country from Escalante, was shorter all right—only 180 miles. But better? It took the pioneers six months of incredible labor to get their 82 wagons, 250 men, women, and children, and hundreds of head of livestock through the heart of canyon country, surely the most difficult place a wagon road has ever been built. The Hole-in-the-Rock expedition, named for the place they blasted and scraped a road down 2,000-foot cliffs to the Colorado River, is unmatched for stubborn determination. *"It's the roughest country you or anybody else ever seen,"* Elizabeth Decker wrote after the party had crossed the river, heading east through the slickrock wilderness. *"It's nothing in the world but rocks and holes, hills and hollows. The mountains are just one solid rock as smooth as an apple."*

Below: River runners at quiet stretch of Colorado River at Cataract Canyon, Canyonlands National Park
Opposite page: Warner Lake, La Sal Mountains

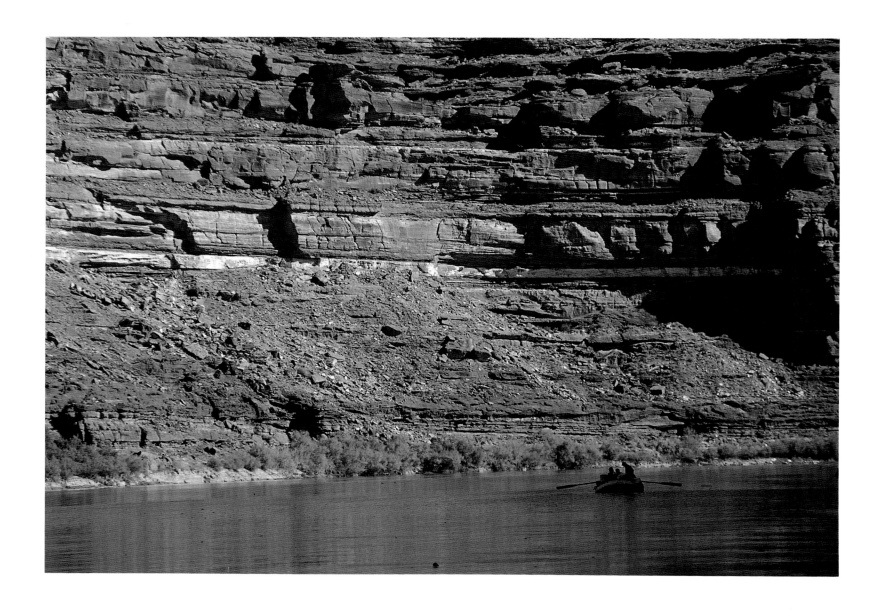

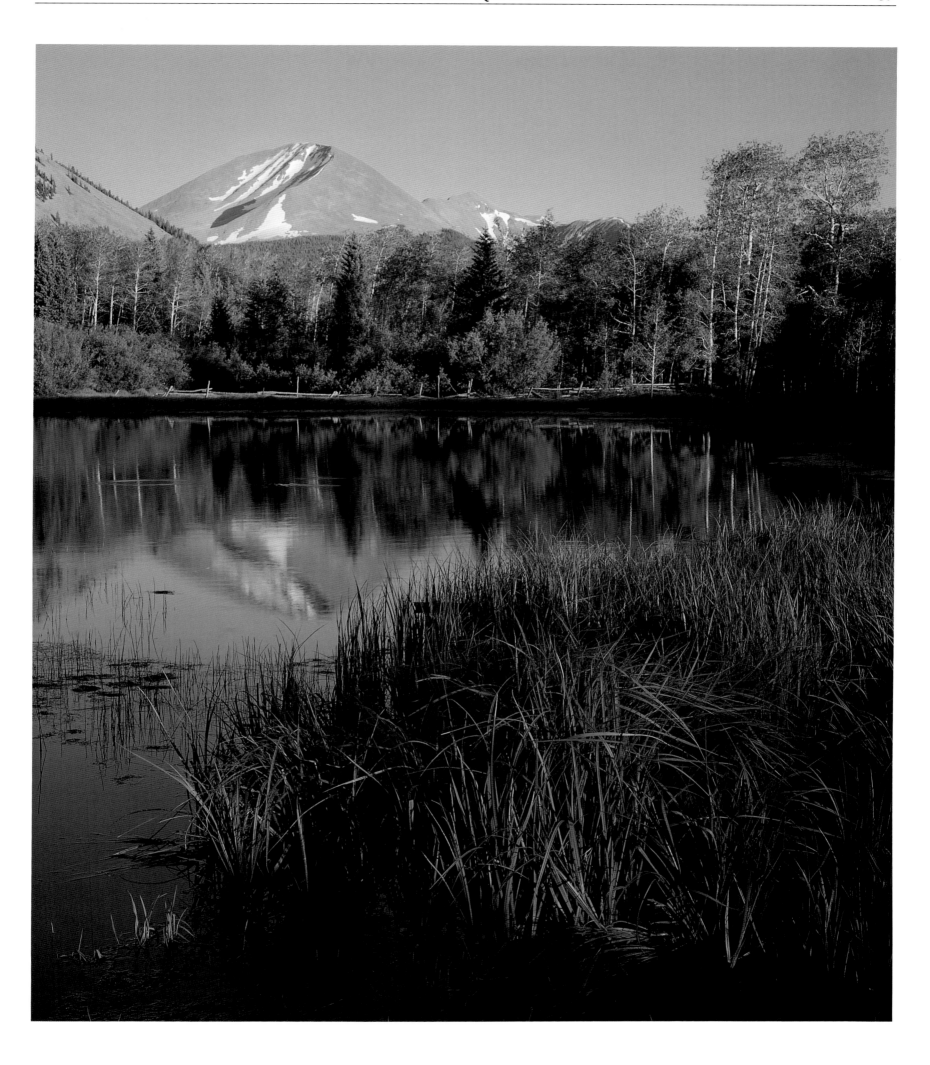

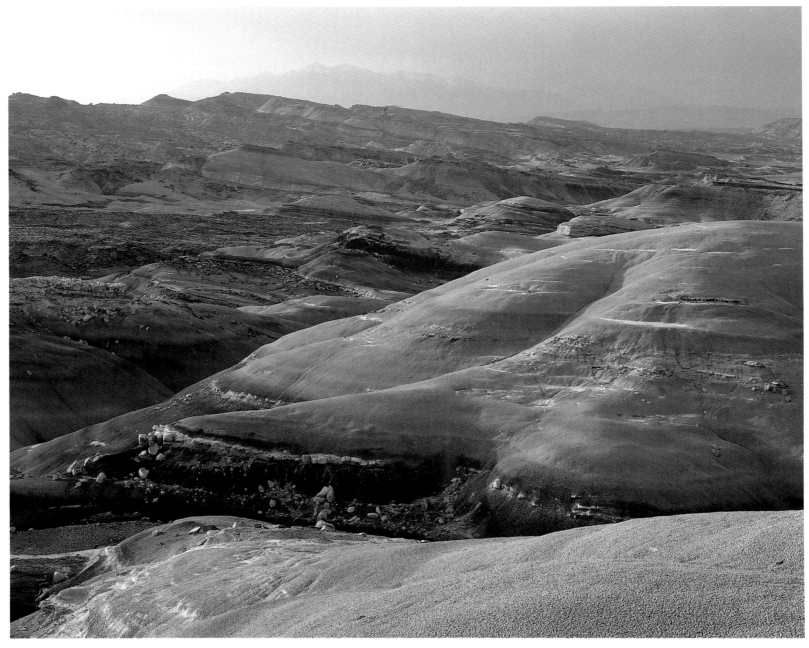

Bentonite Hills, Capitol Reef National Park, with Henry Mountains in distance

They never reached their destination. By the time they finally reached the San Juan, they and their horses were too worn to go further. So they stopped, eighteen miles short of Montezuma Creek, and put down their roots in what became Bluff. For a time they prospered there—once they turned to cattle ranching after learning that the soil was too thin and the San Juan too unreliable for irrigated farming. For a time, cattle gave Bluff what was said to be the highest per capita income in the country. But the range deteriorated and markets changed. Ranchers went broke and left for places like Blanding, Monticello, Moab, and elsewhere, leaving their fine, large, cut-sandstone houses to be restored years later by the artists, photographers, geologists, river guides, and lodge operators who keep Bluff alive today.

The San Juan Mission story is a microcosm of boom-and-bust life on the Colorado Plateau. Uranium. Oil and gas. Movie making. Even toxic and nuclear waste dumps. One after another, they brought dreams, if not of wealth, at least of a chance to make a living on the Plateau. But the dreams don't last. One after another, bust follows boom. Lumbering survives, but barely, in the face of environmental protests, Forest Service restrictions, and declining markets. Ranchers do somewhat better, but it's hard to find one who doesn't worry about being squeezed off public lands by higher grazing fees, permit reductions, or even the outright banning of cattle from areas designated as wilderness—a suspicion that persists even though proposed wilderness legislation promises continued grazing rights.

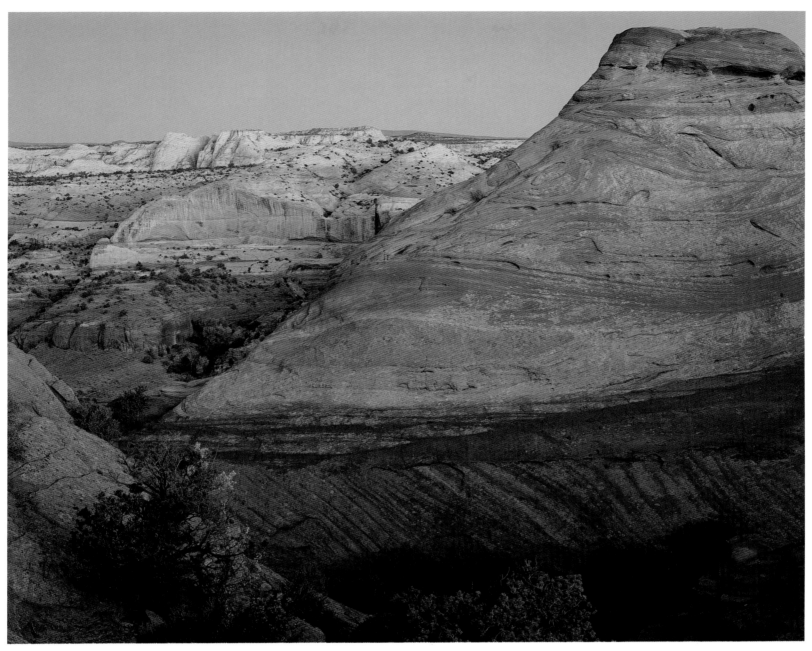

Sunrise, Box-Death Hollow Wilderness Area

The Plateau has a resource, however, that, with care, will last forever—the uniqueness and magnetism of the land itself. That uniqueness already draws hordes of people to spend their leisure and money in southeastern Utah. Try to find a weekend campsite in Arches, Capitol Reef, or Canyonlands national parks, or a motel room in Moab, an unrented houseboat on Lake Powell, a vacant seat on a river raft in Westwater or Cataract Canyon. Drive through Moab and you'll think that mountain bikers have taken over the world—or at least have come from all corners of it. On weekends, bikers wait up to forty-five minutes for their turn on certain sections of the famous Slickrock Trail. And the hordes will grow and spread out over more and more country as increasing numbers of people have more leisure time and money.

But it's big, this canyon country, and those willing to get away from paved roads and developed campgrounds can still find the resource that may be most precious of all—solitude. The closer civilization hems us in, the more we need the renewal of escape. The more technology softens, yet complicates our lives, the more we need places in nature for hard, simple testing of ourselves. When Thoreau wrote that "in wildness is the preservation of the world," he was thinking of the forests and lakes of New England. Those who know the deep, shadowed canyons, lonely mesas, and hundred-mile vistas of canyon country might put it more personally: in wildness is the renewal of the soul.

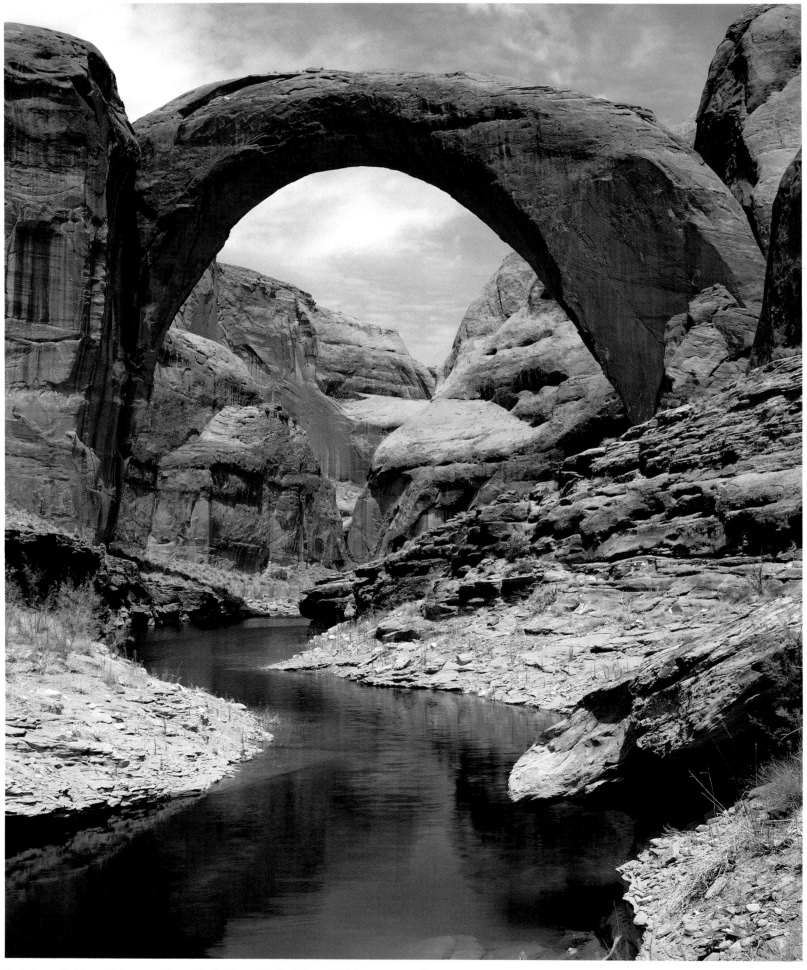

Rainbow Bridge with water from Lake Powell, Rainbow Bridge National Monument

My memories of canyon country are rich. Of the copper taste of fear while wrestling a jeep over Elephant Hill long before there was a Canyonlands National Park or protective boulders in places where, without them, you could slip off for a 1,000-foot fall into eternity. Of an expedition to Rainbow Bridge with then Secretary of the Interior Stewart Udall before they closed the gates at Glen Canyon Dam, studying ways to keep Lake Powell's waters away from the Bridge; of the magic of water running over slickrock as we splashed up Bridge Canyon; of the sadness we felt—Stewart, the Sierra Club's Dave Brower, and I—as we sat for an hour atop the Bridge waiting for others who never made it, and concluded there was no environmentally ac-

ceptable way to hold back the water or save the magic.

Those were days of 100-mile vistas—before there was a Navajo Power Plant or haze drifting up from Phoenix or Los Angeles. Days when we were foolhardy enough to wrestle an aging passenger car into Arches over a track barely fit for a jeep. Days before hordes of fee-paying backpackers crowded the trail through the Anasazi ruins and rock art of Grand Gulch; days when we swam the jump pools of Slickhorn Canyon buck naked in a sensuous ritual of washing away the river silt of the San Juan. Days when you could—and we did—manhandle a jeep down Halls Creek almost to the Colorado, when you crossed the river not over the three modern

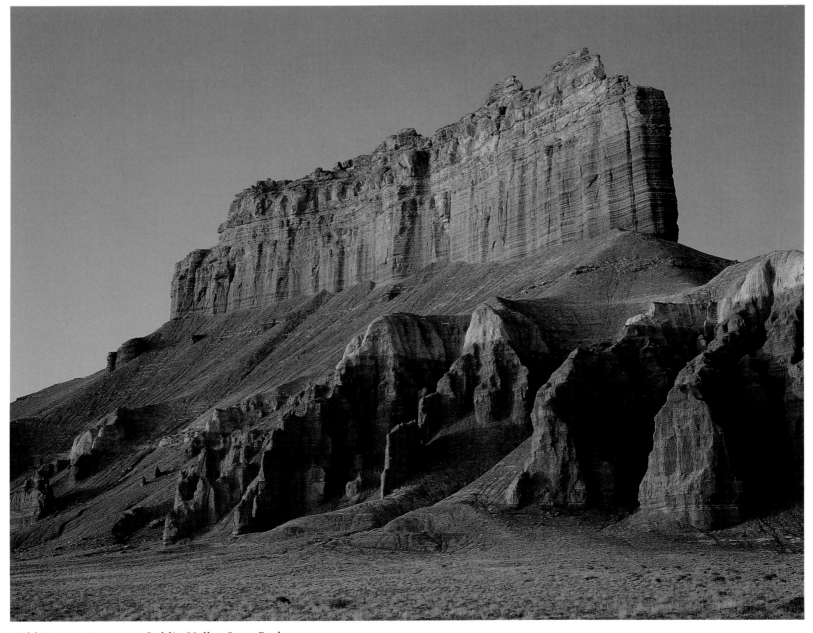

Wild Horse Mesa near Goblin Valley State Park

Stream, Stevens Canyon, Escalante area

bridges around Hite but on Art Chaffin's old cable-strung ferry, when from Blanding to Monument Valley was eighty miles of rock ledge, sand wash, blown tires, and boiling radiators. And when anyone who knew the region stayed out of those washes if there was a rain cloud anywhere upcountry.

Travel in canyon country was harsh in those days. And it was wonderful.

From my scrapbook, a *Deseret News* clipping about my first hike through the canyons of the Escalante twenty-five years ago:

The first day, 15 miles down Hurricane Wash to Coyote Gulch, was easy. [We've since found a better route—a compass course across the mesa top and a rope-assisted descent down the cliff above Jacob Hamblin Arch.] *It was also incredibly beautiful. The trail is Coyote Creek itself, clear and cool as it splashes over waterfalls, through tempting natural bathing pools, along the base of immense overhanging sandstone walls beribboned with desert varnish and festooned with hanging gardens, sweeps around majestic Jacob Hamblin Arch and directly through Coyote Natural Bridge, and finally loses itself in the sparkling waters of the Escalante.*

First-night camp was on a sandy bench half a mile down the Escalante. With a cool spring nearby, we found it a delightful spot. So had others, 600 and more years ago, as evidenced by petroglyphs of deer, antelope, elk, and mountain sheep chiseled into the cliff face. Had those ancient artists, we wondered, taken as much delight as we in the campfire smoke curling up the canyon walls? Had they been as stirred by the canyon wren's evening serenade, the murmur of the restless river?

The next day was much tougher—and still more beautiful. A mile upriver, where Stevens Arch soars in pure grandeur above the canyon, Stevens Canyon enters from the north. It's a wild place of grottos and narrows, towering cliffs and verdant glens, seldom seen above the place where the only way to keep moving up-canyon is by standing a log against the 15-foot overhanging rockface, the most agile man shinnying up and roping the others up one by one. There are no trails here except in a very few adventuresome minds, and there are plenty of opportunities for trouble—not to say disaster. Upper Stevens Canyon is no place for faint hearts or shaky knees or anyone without a competent guide. [More recently, without a competent guide, we discovered a different route involving an icy 50-yard swim through an arms'-width channel.]

The third day was sheer delight, crossing the Waterpocket Fold and exploring a way down its maze of gorges to the long-abandoned Baker Ranch on Hall's Creek. There after a night in the most beautiful campsite of all (may its location always remain secret), a boat from Bullfrog picks us up for the return to civilization. . . .

There's a magic about the Escalante country that touches the soul of anyone who pays the price to know it. Consider a passage from the National Park Service master plan and wilderness study. Some nameless author of this otherwise dust-dry document was touched by the magic, and wrote:

From the headwaters of the Escalante River high on Boulder Mountain, one can gaze over the expanse of sand, rock, and plateaus of one of the largest unbroken wilderness areas left in the United States. The core of this great wilderness is the Escalante River, which has carved this land, shaped its history, and whose heartbeat gives it life.

. . . Bending tortuously in great oxbows around sand banks, sliding past

sheer sandstone walls, winding under shady alcoves and past verdant glens, the river is one of the scenic wonders of North America.

It is. It really is. It simply must be kept that way.

* * * * *

But it wasn't. Where Coyote Creek enters the Escalante, the water no longer sparkles. To get there, you slog through a half-mile of stinking silt left by receding waters of Lake Powell. That first-night campsite with its spring and petroglyphs lies under yards and yards of the same silt. The Bureau of Reclamation didn't tell us about that. Its pre-dam maps showed that the high-water level of Lake Powell would never reach the confluence of Coyote Creek and the Escalante; actually, it extended half a mile or more beyond. To reach water's edge at Halls Creek, the last time we were there, was a nightmare of scratching our way through hundreds of yards of shoulder-high Russian thistle growing on silt where the high water once reached.

And so it goes. The insatiable highway builders have spun smooth, wide ribbons of asphalt over miles and miles of ledge and wash, rimrock and canyon floor—country where once, to get from here to there, we sweat and worried and swore, . . . and loved it. With the roads came people; and to serve the people came campgrounds with flush toilets and numbered campsites, guard rails and asphalted trails, naturalist lectures and park patrols. It's nicer and safer and more convenient these days. And infinitely less rewarding.

But it's big country out there. With a topo map and a beat-up jeep—or, better yet, a backpack—there's still solitude to be found, adventure with the smell of danger, and the wonder of a raw, unfinished, and awesomely beautiful world.

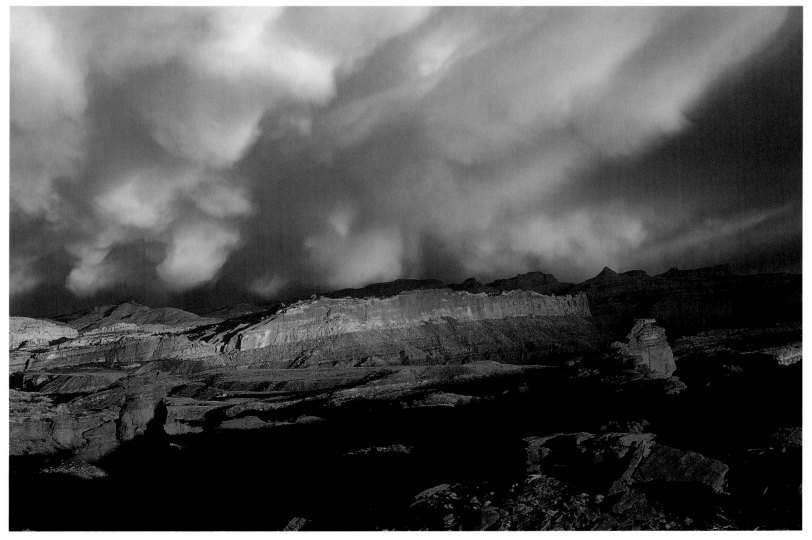

Mammato cumulus clouds at Panorama Point, Capitol Reef National Park

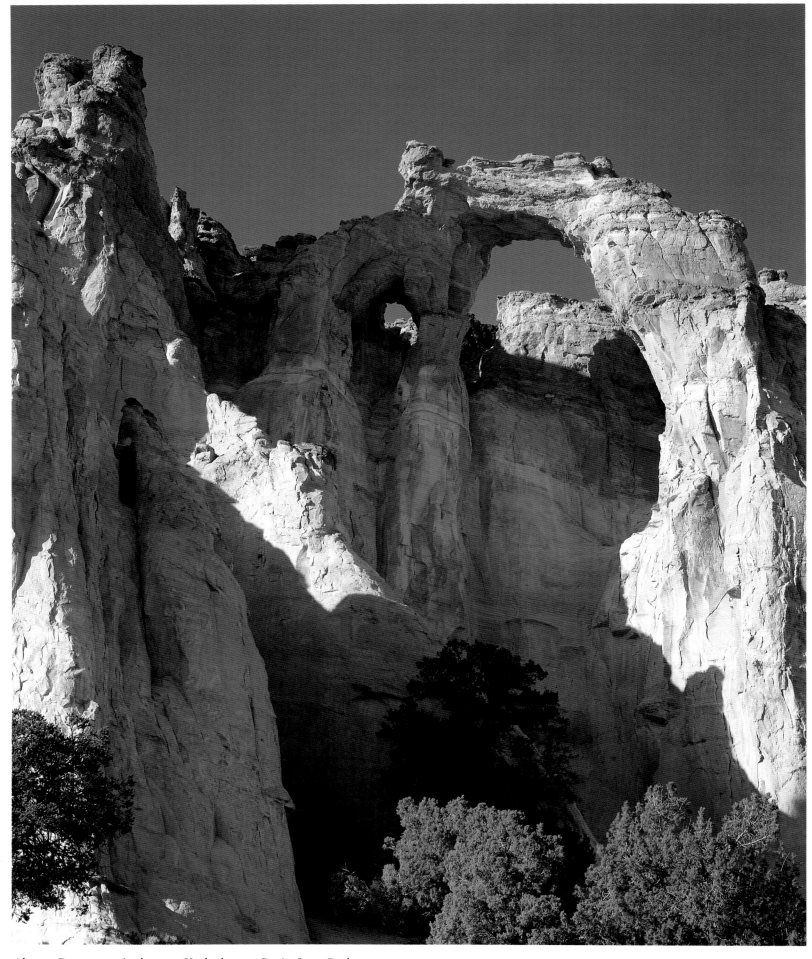

Above: Grosvenor Arch, near Kodachrome Basin State Park
Opposite page: Wall detail, Buckskin Gulch, Vermilion Cliffs

THE SOUTHWEST QUARTER

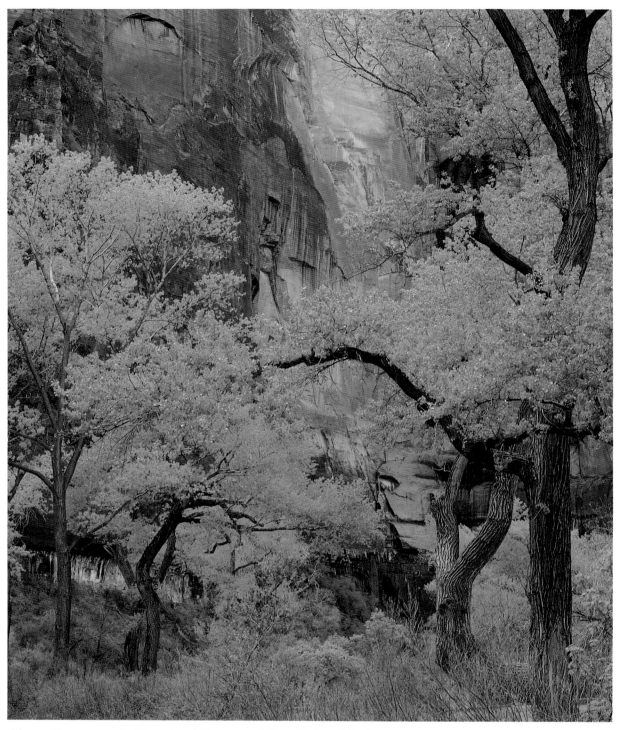

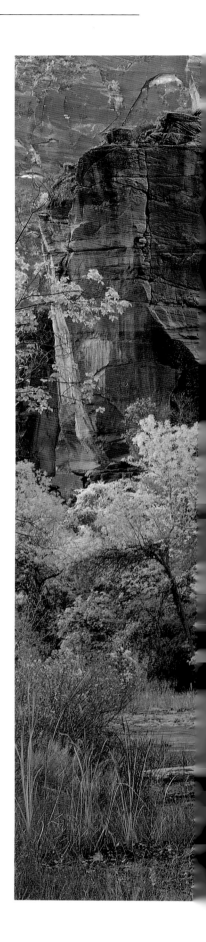

Above: Cottonwoods, Temple of Sinawava, Zion National Park
Right: The Pulpit, with cottonwoods and maples along Virgin River, Zion National Park

Oct. 13 . . . The Valley of Señor San Jose [Cedar Valley] through which we have just passed . . . from north to south is about twelve leagues long, and from east to west in some places is more than three, in others two, and still others, less. It has very abundant pasturage, large meadows, fair-sized marshes, and plenty of very good land for a settlement with seasonal crops, although there is not water in the two small rivers of Señor San Jose [Coal Creek] and Pilar [Ash Creek] to irrigate more than a few small areas. However, the great moisture of the land may supply this lack so that the irrigation will not be missed, because the moisture in all the valley is so great that not only the meadows and the flats, but even the high places at this season had green and fresh pasturage, like the most fertile meadows of rivers in the months of June and July.

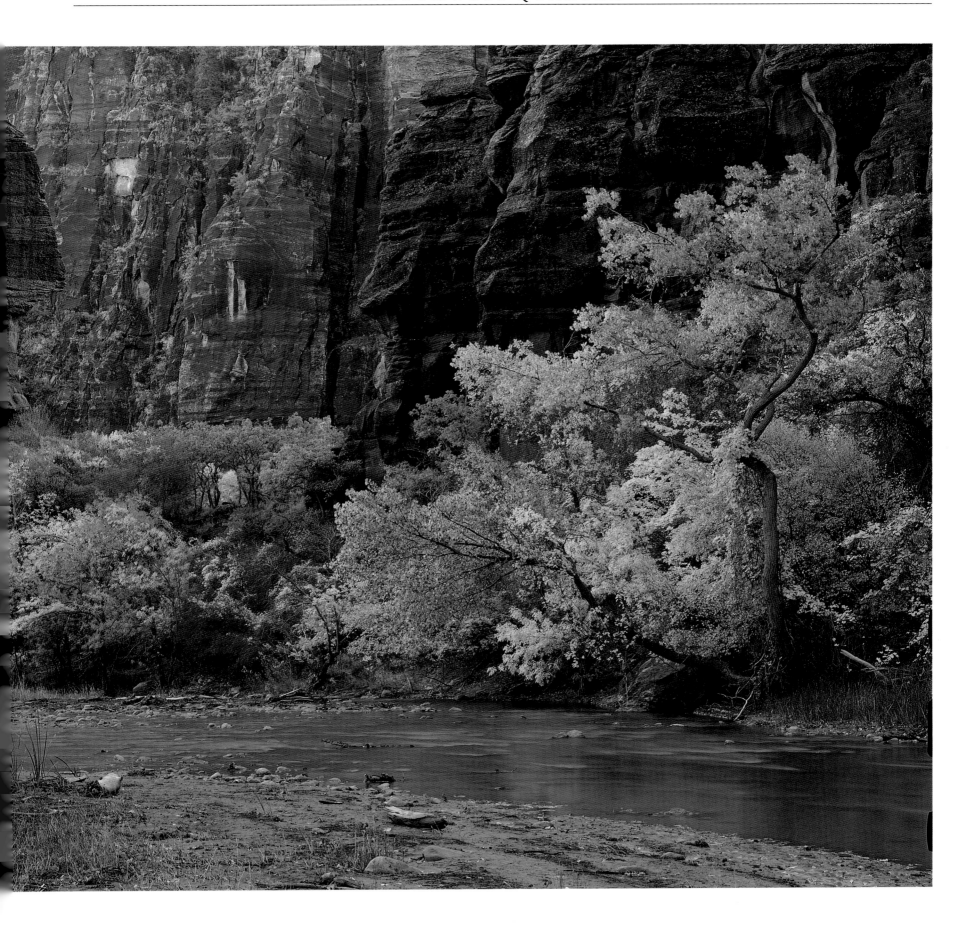

Round about the valley and very near at hand there is plentiful timber, firewood of spruce and piñon, and good sites for raising large and small stock. The Indians who live in the valley and in its vicinity . . . dress very poorly, and eat grass seeds, hares, piñon nuts in season, and dates. They do not plant maize, and judging from what we saw, they obtain very little of it. They are extremely cowardly. . . .

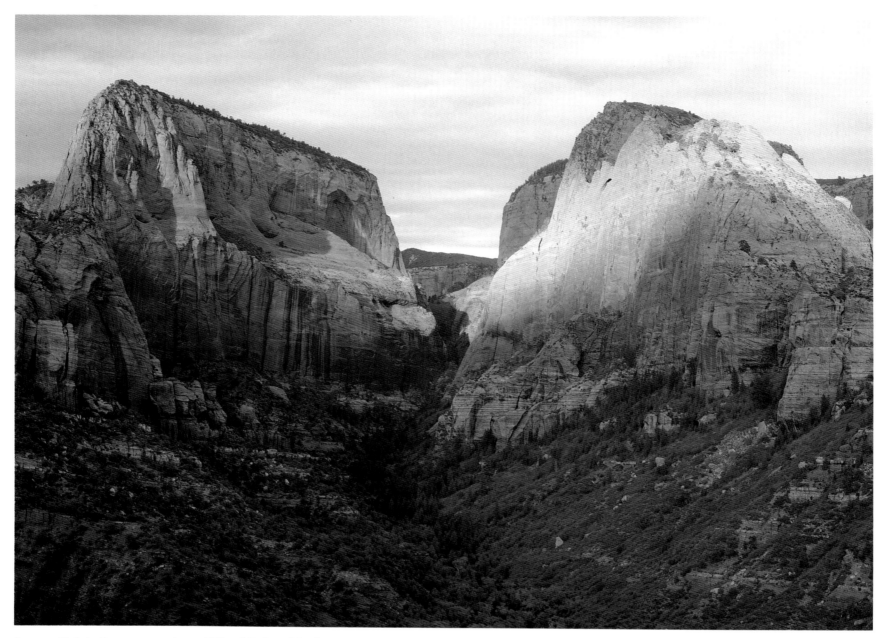

Sunset, Kolob Canyons section of Zion National Park

Oct. 14 . . . Here [near Toquerville] *the climate is very mild . . . and today the cottonwoods of the river were so green and leafy, the roses and flowers which grow here so flaming and undamaged that they showed that through here they had not yet been frozen nor frosted. We also saw mesquite trees, which do not grow in very cold lands. . . .*

Oct. 15 . . . Here [around LaVerkin] *we found a well made mat with a large supply of ears and husks of green corn which had been placed on it. Near it, in the small plain and on the bank of the river, there were three small corn patches with their very well made irrigation ditches. The stalks of maize which they had already harvested this year were still untouched. For this reason we felt especially pleased, partly because it gave us hope that we should be able to provide ourselves farther on with assured supplies, and principally, because it was evidence of the application of these people to the cultivation of the soil, and because of finding this preparation for reducing them to civilized life and to the Faith when the Most High may so will. . . .*

—Fray Silvestre Vélez de Escalante, 1776, describing his passage
from the Great Basin over the rim to Utah's "Dixie"

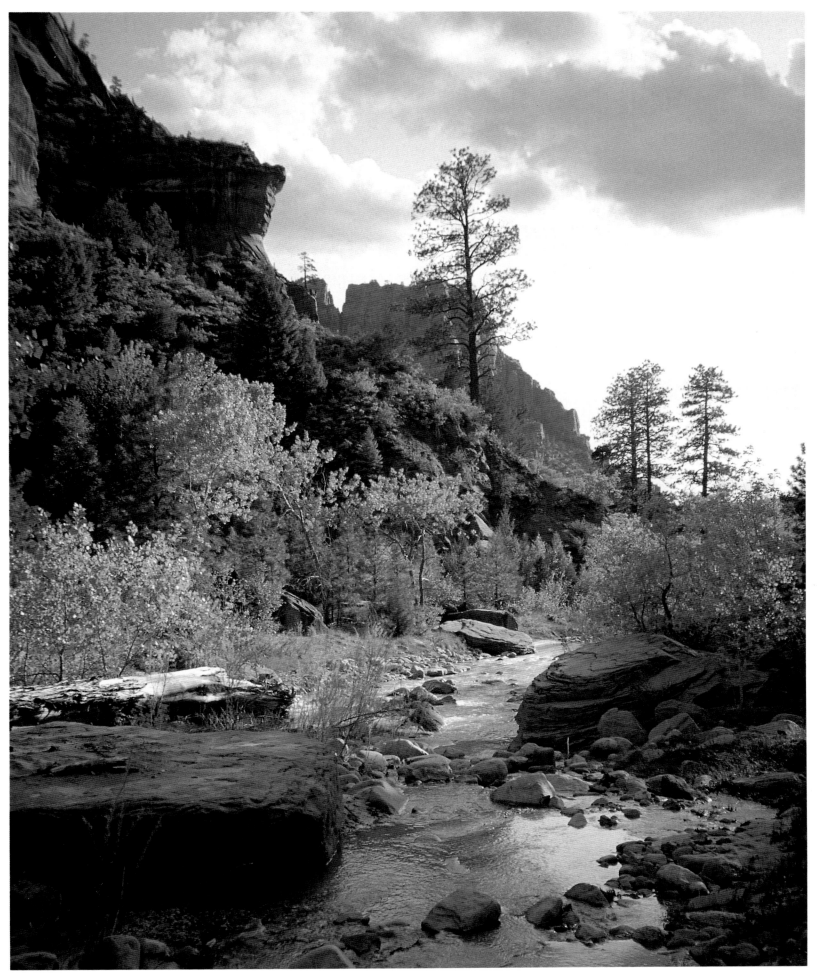

La Verkin Creek, Kolob Canyons section, Zion National Park

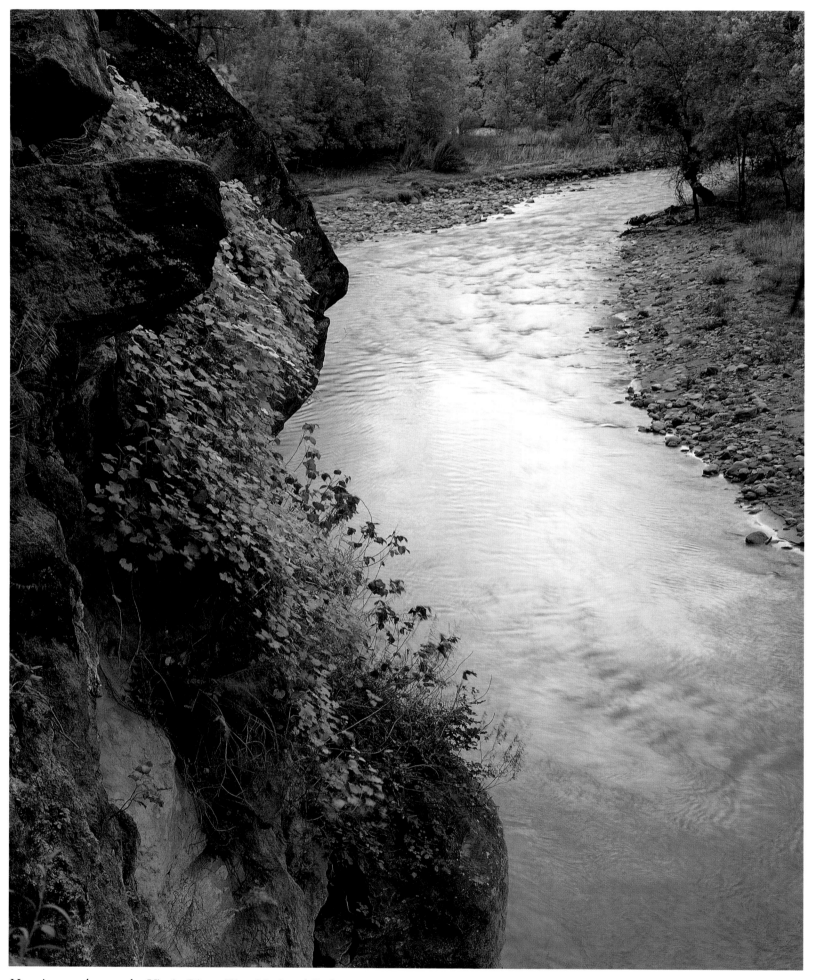

Hanging garden on the Virgin River, Zion National Park

Our trappers, with much toil, reached a strip of Table land, upon a lofty range of mountains [Markagunt Plateau], where they encountered the most terrible snowstorm they had ever experienced—During several days, no one ventured out of camp—There they lay embedded in snow, very deep, animals and men huddled thick as possible together, to husband and enjoy all possible animal warmth, having spread their thick and heavy blankets, & piled bark and brush wood around & over them. After the storm subsided and the weather had softened, Yount & Wolfskill ascended a lofty Peak of the mountains for observation—In the whole range of human view, in every direction, nothing could be discerned, in the least degree encouraging, but only mountains, piled on mountains, all capped with cheerless snow, in long and continuous succession.

. . . It was a cheerless prospect. . . .

. . . [W]ords [cannot] describe the feelings & emotions, which struggled in the breasts of the party, while there encamped, & when groping their way upon the glare ice, & frozen snow, down the steep declivities & into the vallies which lie beneath them—After a few days march, they knew not whither, & what to hope for, to their utter astonishment, they were ushered into another of those enchanting vallies [Parowan Valley?]—There the earth was bare of snow, & the evergreens waved in gentleness & calm serenity—the Elk, deer and antelope, driven from the mountains by the snow & piercing cold, were basking, with their frolicsome fawns, unaware & unintimidated by the sight of man. . . .

They bade farewell to this enchantment & resumed their journey—The soil is red sandstone & therefore the waters of the [Virgin] River are almost like blood. . . .

—George C. Yount, on the Old Spanish Trail, 1830–31

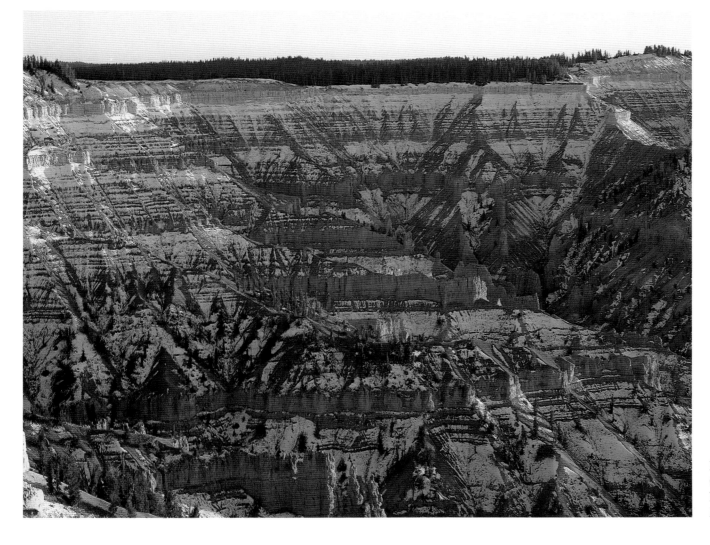

Point Supreme,
Cedar Breaks
National
Monument

May 9 . . . We left the Rio de los Angeles [Muddy River] and continued our way through the same desolate and revolting country, where lizards were the only animal, and the tracks of the lizard eaters the principal sign of human beings. After twenty miles' march through a road of hills and heavy sands, we reached the most dreary river I have ever seen. . . . The stream was running towards the southwest, and appeared to come from a snowy mountain [to] the north. It proved to be the Rio Virgen—a tributary to the Colorado.

May 10 . . . Our camp was in a basin below a deep cañon—a gap of two thousand feet deep in the mountain [the Virgin River Narrows, where I-15 now goes]—through which the Rio Virgen passes, and where no man or beast could follow it. [Jedediah Smith, with horses, had, in 1826.] The Spanish Trail, which we had lost in the sands of the basin, was on the opposite side of the river. We crossed over to it, and followed it northwardly towards a gap which was visible in the mountain. We approached it by a defile, rendered difficult for our barefooted animals by the rocks strewed along it; and here the country changed its character. From the time we entered the desert, the mountains had been bald and rocky; here they began to be wooded with cedar and pine, and clusters of trees gave shelter to birds—a new and welcome sight. . . . The changed appearance of the country infused among our people a more lively spirit, which was heightened by finding at evening a halting place of very good grass on the clear waters of the Santa Clara fork of the Rio Virgen.

May 11 . . . Our march today was very laborious, over very broken ground, along the Santa Clara river; but then the country is no longer so distressingly desolate. The stream is prettily wooded, with sweet cottonwood trees—some of them of large size; and on the hills, where the nut pine is often seen, a good and wholesome grass occurs frequently.

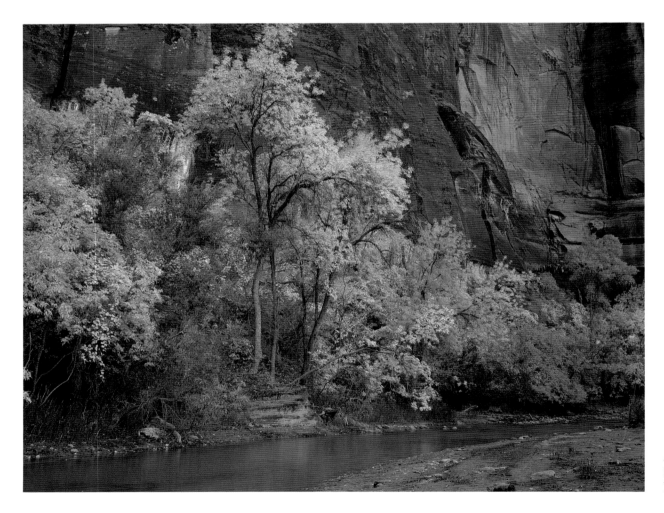

Autumn, Temple of Sinawava, Zion National Park

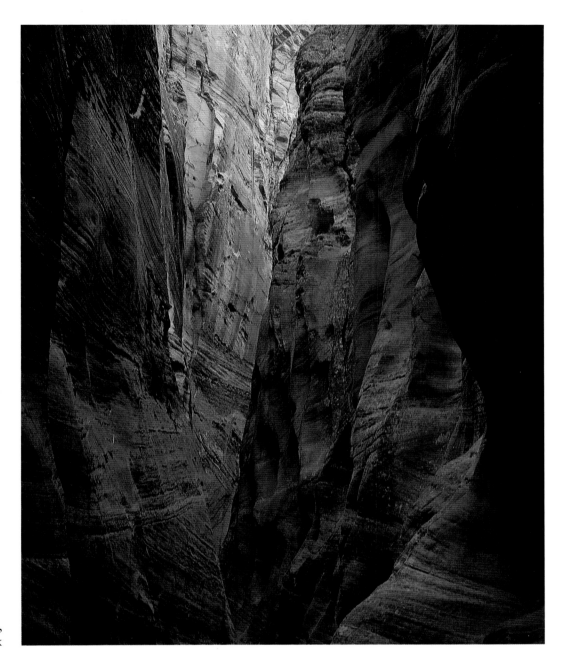

Slot canyon off of Echo Canyon,
Zion National Park

May 12—A little above our encampment, the river forked; and we continued up the right-hand fork [Magotsu Creek], gradually ascending towards the summit of the mountain. As we rose towards the head of the creek, the snowy mountain on our right [Pine Valley Mountains] showed out handsomely—high and rugged with precipices, and covered with snow for about two thousand feet from their summits down. Our animals were somewhat repaid for their hard marches by an excellent camping ground on the summit of the ridge, which forms here the dividing chain between the waters of the Rio Virgen, which goes south to the Colorado, and those of the Sevier river, flowing northwardly, and belonging to the Great Basin. We considered ourselves as crossing the rim of the basin; and, entering it at this point, we found here an extensive mountain meadow, rich in bunch grass, and fresh with numerous springs of clear water, all refreshing and delightful to look upon. It was, in fact, that las Vegas de Santa Clara [Mountain Meadows] which had so long been presented to us as the terminating point of the desert, and where the annual caravan from California to New Mexico halted and recruited for some weeks. It was a very suitable place to recover from the fatigue and exhaustion of a month's suffering in the hot and sterile desert. . . .

—John C. Frémont, 1844

I found a vast difference in all respects between these Indians and the miserable beings who we had hitherto seen. The Eutaws are perhaps the most powerful and war-like tribe now remaining upon this continent. They appear well provided with firearms, which they are said to use with the precision of veteran riflemen. I remember they expressed their surprise that the white men should use so much powder in firing at marks, while to them every load brought a piece of game or the scalp of an enemy.
—George D. Brewerton, at Little Salt Lake,
on the Spanish Trail with Kit Carson in 1848

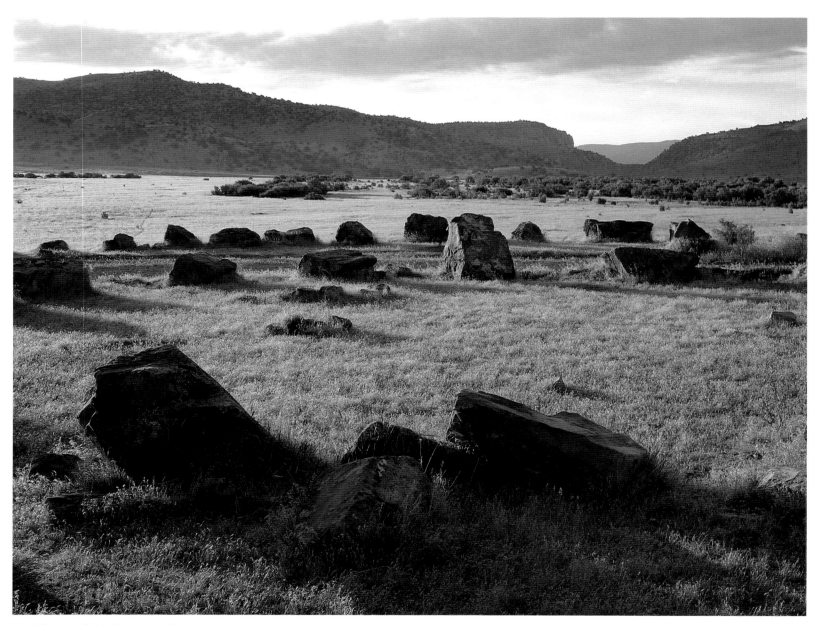

Boulders in field, Parowan Gap

Dec. 13—Traveled six miles today, had hard work breaking ice to cross the [Sevier] river. . . . I went out with Bro pratt to explore the mountains, rode hard all day and when we got back to camp I was so tired I cant stand nor sit down. I could not lift my leg up to step in the wagon. I walked as well as I could and blew the trumpet for prayer—slipped off to bed, rubbed my limbs trembling all the time with cold, my teeth chattering in my head. Truly I thought of home and a good comfortable bed.
—John Armstrong, with the Parley P. Pratt 1849 exploring expedition

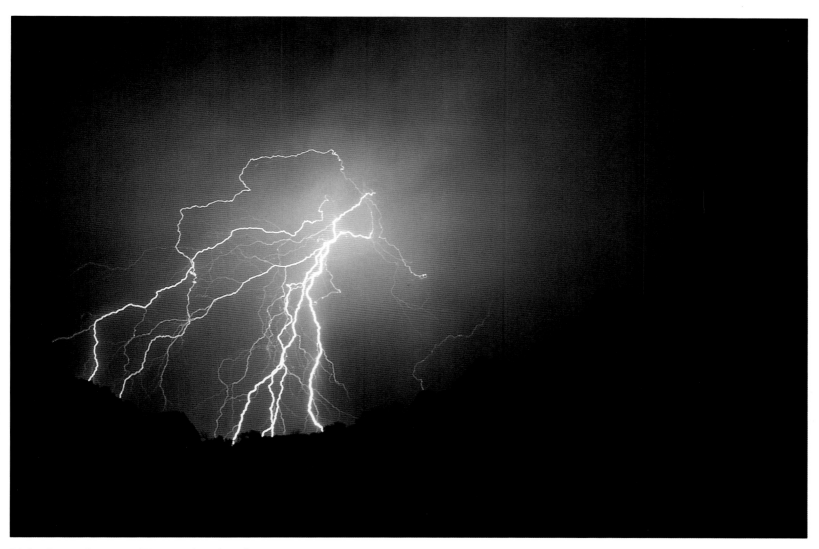

Lightning strikes over Zion National Park

[Three days later:] *We road all day and found a pass over which I thought we could go. It was a long way through the mountain and very difficult snow 1 1/2 to 2 feet deep . . . we did not know but we were to the end of our row when we reached this place. . . . It was a great undertaking and a very hazardous one to cross so large a mountain at this season of the year. there was danger of being snowed under.*
—John Brown, with Pratt, 1849

[At the same pass.] *Four days before we entered Little Salt Lake* [Parowan] *Valley we were surrounded by very deep snows; but as it was necessary to proceed, the whole party started, to penetrate through what appeared to be a pass, on the Warsatch Mountains. . . . The mountains were covered with snow four feet deep. The ascent bore an angle of forty-five degrees, and was at least one thousand feet from base to summit. Over this, Captain Wolff* [a Delaware Indian hunter] *said it was impossible to go. "That is not the point," replied Col. Fremont, "we must cross, the question is, which is most practicable—and how can we do it." . . .*

We commenced the ascent of this tremendous mountain, covered as it were, with an icy pall of death, Col. Fremont leading and breaking a path; the ascent was so steep and difficult, that it was impossible to keep on our animals; consequently, we had to lead them, and travel on foot—each man placed his foot in the tracks of the one that preceded him; the snow was up the bellies of the animals. In this manner, alternately

toiling and resting, we reached the summit. . . . When I surveyed the distance, I saw nothing but continued ranges of mountains of everlasting snow, and for the first time, my heart failed me. . . .

. . . At this spot [on a ridge dividing Fremont Wash and Parowan Valley] *our companion in joy and sorrow* [Oliver Hunter] *was left to sleep his last sleep on the snows. . . . His companions who were suffering dreadfully, though not to such an imminent degree,* [had] *voluntarily deprived themselves of a portion of their small rations of horse meat to increase his meal, as he seemed to require more sustenance than the rest of us. His death was deeply regretted. . . .*

. . . The nearer I approached the settlement, the less energy I had at my command; and I felt so totally incapable of continuing, that I told Col. Fremont, half an hour before we reached Parowan, that he would have to leave me there; when I was actually in the town, and surrounded with white men, women and children, paroxysms of tears followed each other, and I fell down on the snow perfectly overcome. . . .

. . . My hands were in a dreadful state; my fingers were frost-bitten and split at every joint; and suffering at the same time from diarrhea, and symptoms of scurvy . . . I was in a situation truly to be pitied, and I do not wonder that the sympathies of the Mormons were excited in our favor, for my personal appearance being but a reflection of the whole party, we were indeed legitimate subjects for the exercise of the finer feelings of nature. When I entered Mr. Heap's house I saw three beautiful children. I covered my eyes and wept for joy to think I might yet be restored to embrace my own. . . . Mr. Heap was the first Mormon I ever spoke to, and although I had heard and read of them, I never contemplated realizing the fact that I would have occasion to be indebted to Mormons for much kindness and attention, and be thrown entirely among them for months.

 —Solomon Nunes Carvalho, with Frémont's
fifth expedition, 1853

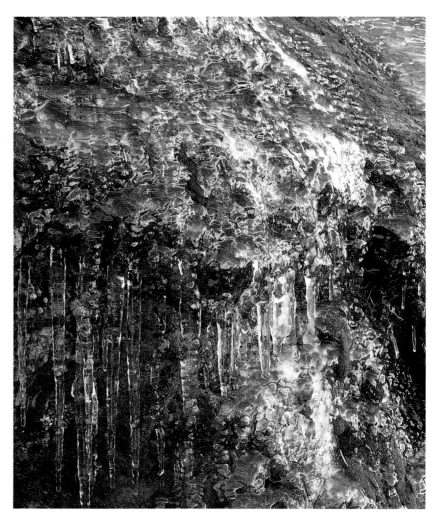

Ice on mossy ledge in Echo Canyon, Zion National Park

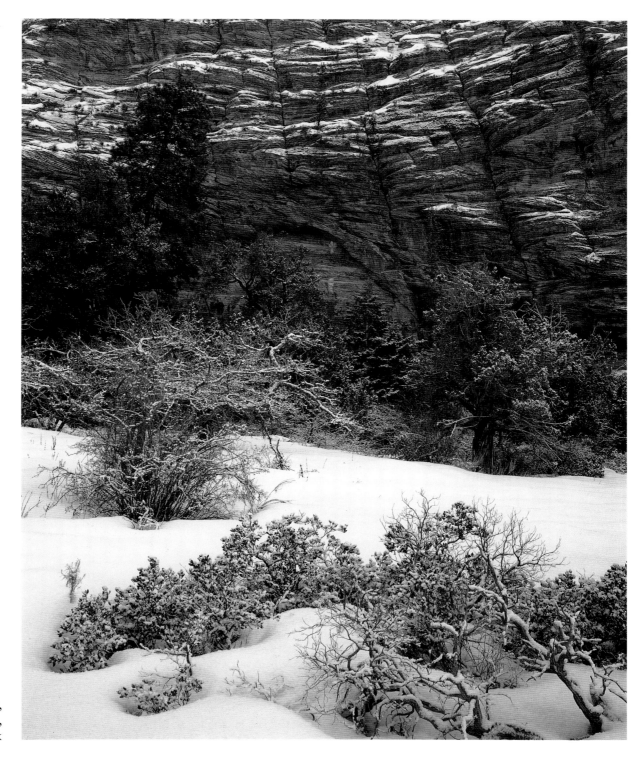

Snow-covered foliage,
Mount Carmel Road,
Zion National Park

On invitation I hitched my team to Brother [Erastus] Snow's carriage and went with
him to Cedar City to attend a sale of the property belonging to the Old Iron Works.
. . . We came home by way of Pinto settlement and Pine Valley. That was the first time
I had seen that place. I liked its appearance very much. Timber then grew all over the
upper end of the valley, and all around the face of the mountains. There was good grass
over the valley and hills with good black soil in the valley. There was a nice stream of
soft running water and many nice cold springs. The valley was high and cold. There
was one saw mill in Pine Valley. . . . Brother Snow was very anxious to have the lumber
business increased for all the new settlements needed lumber. He asked me if I would
like to come to Pine Valley and take charge of the business. I said to him, that I had
not come to do my own will, and would go any place I was sent.

—Robert Gardner, 1861

Swamp with golden
reflections, Gateway Trail,
Zion National Park

When I was there [exploring the Virgin River country] *in the forepart of February
and saw the trees putting forth their green foliage, and herbs almost in bloom, the rich
soil, and streams of pure water . . . where we can raise cotten* [sic]*, hemp, grapes, figs,
sweet potatoes, fruit of almost every kind . . . I scarcely could content myself to stay*
[away] *until another fall.*
—John D. Lee, to Brigham Young, 1852

The water was running through our little town [Santa Clara] *and had surrounded
the Fort where Jacob Hamblin and several others lived. . . . There was a large amount of
grain stored in the Fort, which it was thought advisable to remove, as fast as possible . . .
The men exerted themselves but before all the grain and molasses could be removed, the
Fort and its contents were carried off into the raging flood.* [One dwelling after another
followed the Fort until nearly all the houses of the settlement had disappeared.]

The following days, after the water had subsided, through our fields and where the grist-mill and our homes had stood was a gulch several rods wide and forty or fifty feet deep. . . . In this flood went down one town, a Fort, a grist-mill and much of the farming land on which stood many beautiful shade trees and fruit trees. The results of toil and privation passed away like a dream or night vision, down to the river Colorado and the sea. Soon after this sweeping misfortune we moved about two miles down the Santa Clara on to a large bottom. There a town site was located and surveyed. We moved what we had saved from the flood onto the lots and commenced again to make a home.
—Mary Dart Judd, after forty days of
continuous rain in December 1861 and January 1862

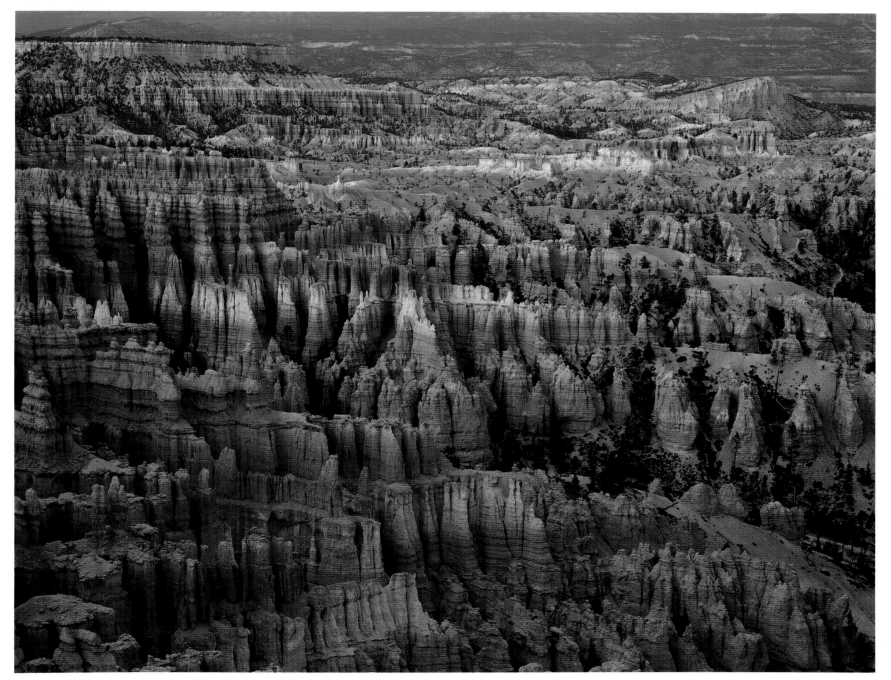

Inspiration Point, Bryce Canyon National Park

[On discovering Bryce Canyon:] *What a helluva place to lose a cow.*
—Ebeneezer Bryce, Mormon rancher (apocryphal statement)

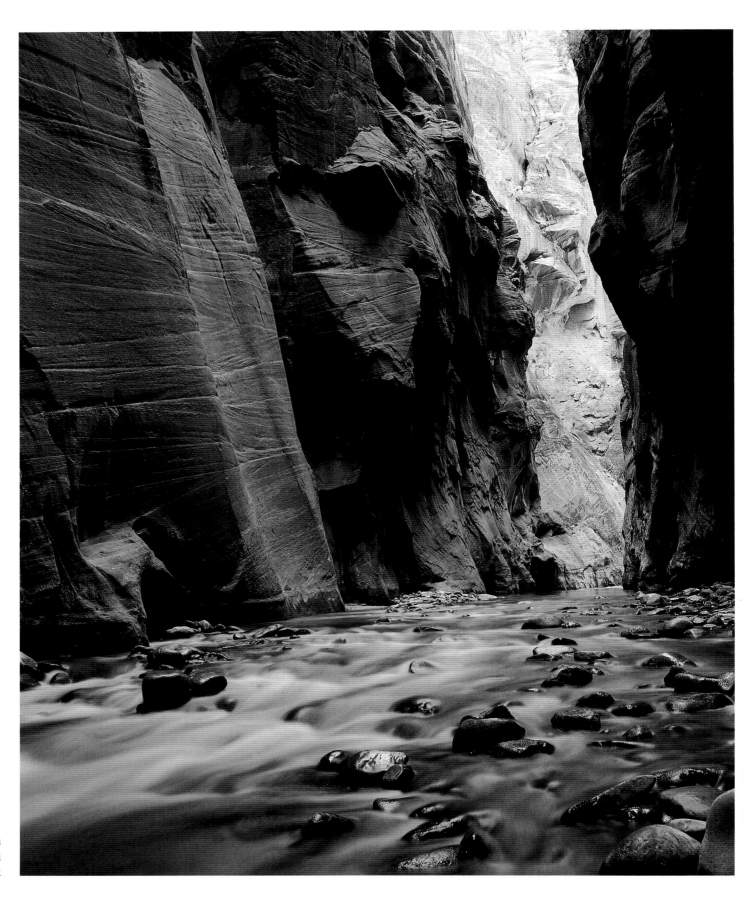

Virgin River at Zion
Narrows, Zion
National Park

*The height of the canyon walls gradually increases until it includes the entire mass
of sandstone. At the water's edge, the walls are perpendicular, but in the deeper parts,
they open out towards the top. As we entered [the Zion Narrows] and found our
outlook of sky contracted as we had never seen it between canyon cliffs, I measured the
aperture above and found it 35 degrees. We thought this a minimum, but soon*

discovered our error. Nearer and nearer the walls approached, and our strip of blue narrowed down to 20 degrees, then to 10 degrees, and at last was even intercepted by the overhanging rocks . . . many times our upward view was completely cut off by the interlocking of the walls, which remaining nearly parallel to each other, warped in and out, as they ascended. . . . For a number of miles, the bottom of the cleft averages 30 feet in width, contracting frequently to 20 feet, and in many places is entirely occupied by the stream, even at its low stage.

—Clarence Gilbert, with the Wheeler Survey,
making the first known hike through the Zion Narrows, 1873

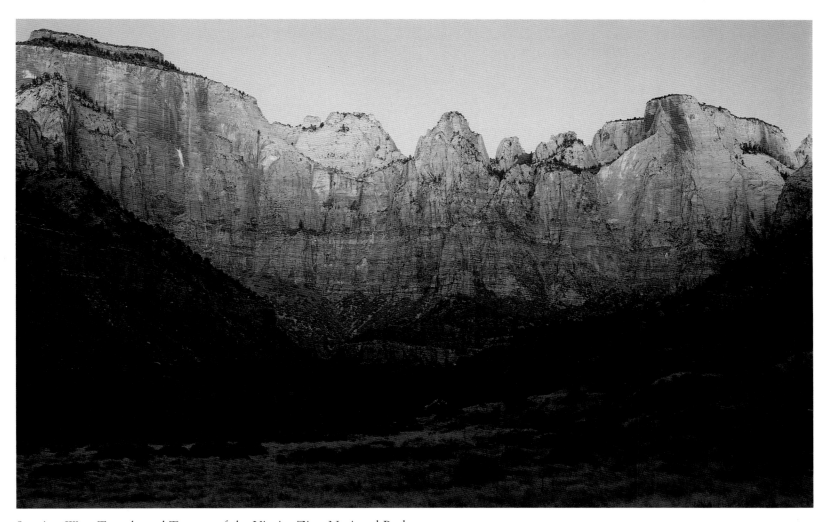

Sunrise, West Temple and Towers of the Virgin, Zion National Park

In an instance, there flashed before us a scene never to be forgotten. In coming time it will, I believe, take rank with a very small number of spectacles, each of which will, in its own way, be regarded as the most exquisite of its kind which the world discloses. The scene before us was the Towers of the Virgin. . . .
Nothing can exceed the wondrous beauty of Little Zion Valley [Zion Canyon] which separates the two Temples and their respective group of towers. Nor are these the only sublime structures which look down into its depth, for similar ones are seen on either hand. . . . In its proportion, it is about equal to Yo Semite, but in nobility and beauty of the sculptures there is no comparison. . . . No wonder the fierce Mormon zealot, who named it, was reminded of the Great Zion, on which his fervid thoughts were bent—"of houses not built with hands, eternal in the Heavens."

—Major Clarence Dutton, 1875

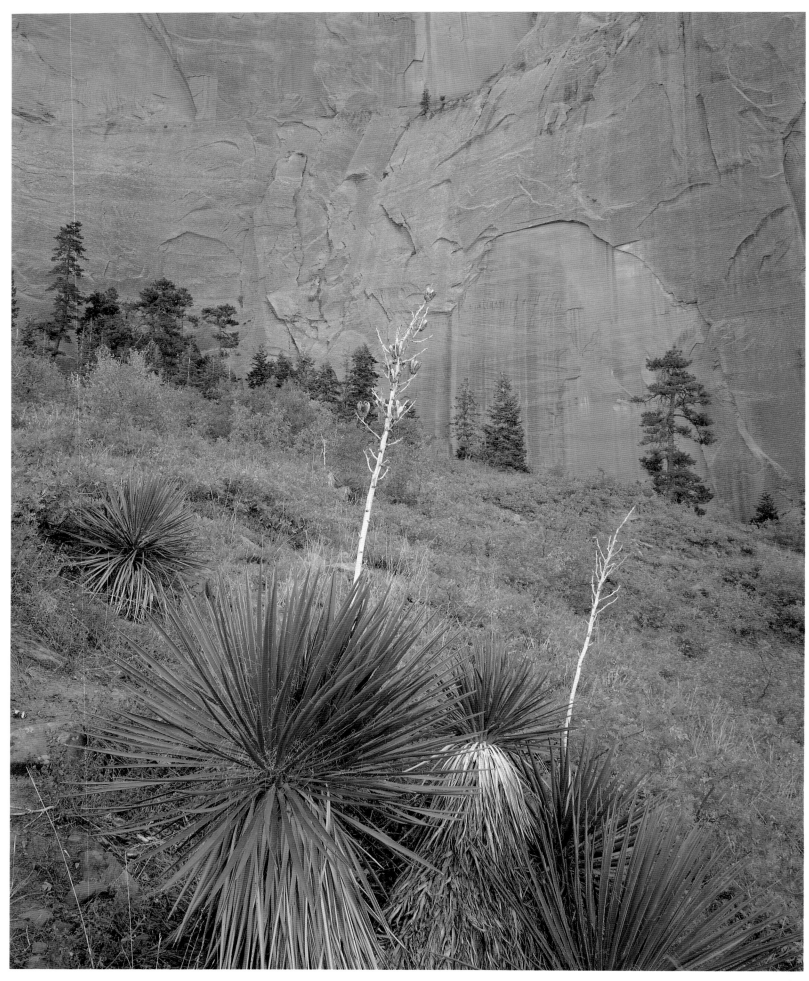

Yuccas on hillside, Kolob Canyons, Zion National Park

The Southwest Quarter

OUT IN THE DESERT beyond the alkali hard-pan that once was Little Salt Lake, a narrow gorge slices through the naked, deeply faulted Red Hills bordering Parowan Valley. Parowan Gap it is called, and chiseled into the desert varnish of its south-facing rocks is the record—perhaps 10,000 years of it—of human presence in this region.

You find petroglyphs and pictographs scattered through much of Utah; treasures so abundant that *National Geographic* some years ago called southern Utah the "Louvre of rock art." But nowhere do those strange symbols more alluringly stretch my imagination than at Parowan Gap. And nothing at the Gap tempts the imagination quite like a long line curving down from the upper left to a sort of bulb at the bottom, and then curving off to the upper right. Hatch-marks, perhaps a hundred of them, intersect the line all along its length. Just below is a rectangle with rows of evenly spaced dots—and what on earth is *that*? A game? a scoreboard? a calendar?

Anthropologists caution us that there is no way to know the meaning of rock art symbols. Agreed; but it's a dull mind that doesn't try. Alvah Matheson's is one that has. As a boy growing up in Cedar City, he listened to legends told by Indians who came to his father's gristmill, and he has spent much of his nearly ninety years searching out the mysteries in Utah's deserts. A legend told by an old Indian suggests to him the meaning of those unique figures.

Long ago, the old man said, a tribe of Indians, different from his own, came from the northwest. Because life was hard in the bitter cold of their home far to the north, those people had decided to travel south and toward the rising sun to find a better place. With its tall, waving grass and abundant fish and game, Cedar Valley was a pleasant place to rest while scouts explored the country to the south. Finding they couldn't cross the Colorado River, the scouts followed the western rims of its canyon to the northeast before returning to report so the tribe could move on. The Parowan Gap carving, Matheson believes, records that journey, the hatch-marks indicating the passage of days—or months or years, depending on how much of the journey the figure represents.

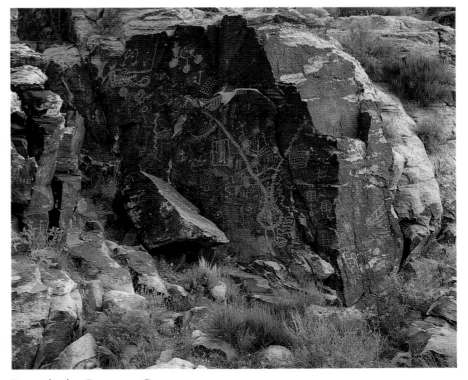

Petroglyphs, Parowan Gap

65

Well, maybe. If so, that figure can stand as a symbol of much of the recorded history of southwestern Utah—a place to hurry through on the way to someplace else.

If you discount the Parowan Gap and many other petroglyphs throughout the region that may or may not represent travel, the Spanish padres, Francisco Atanasio Domínguez and Silvestre Vélez de Escalante, were the first tourists to leave a written record. Seeking a trail to the newly established missions in Southern California, their ten-man party left Santa Fe in July 1776. Northern Arizona was too dry and too full of hostile Indians, they had found, so they took a longer way, swinging north through western Colorado, entering present-day Utah near Jensen, crossing the Uinta Basin and Wasatch Mountains to Utah Lake, then hurrying south.

Some days later, dreams of California died in the snow, mud, and icy winds of the Beaver River bottoms north of Milford. Scouts sent to explore a route to the west had returned with a disheartening report: *"saying that they had found no pass whatever by which to cross the sierra, that it was very rough and high in this direction, and that in front of it there was a wide plain without any pasturage or water whatsoever . . . we decided to continue south."* Anyone familiar with the naked peaks of the San Francisco Mountains and the glistening hardpan and utter desolation of Wah Wah Valley beyond can only conclude that the decision was a wise one.

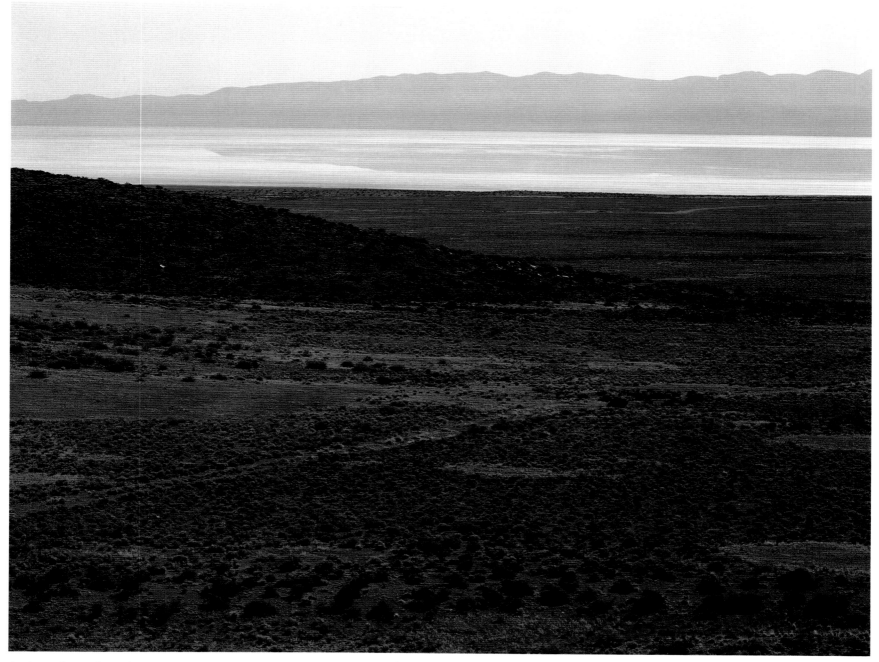

Sevier Lake and Cricket Mountains

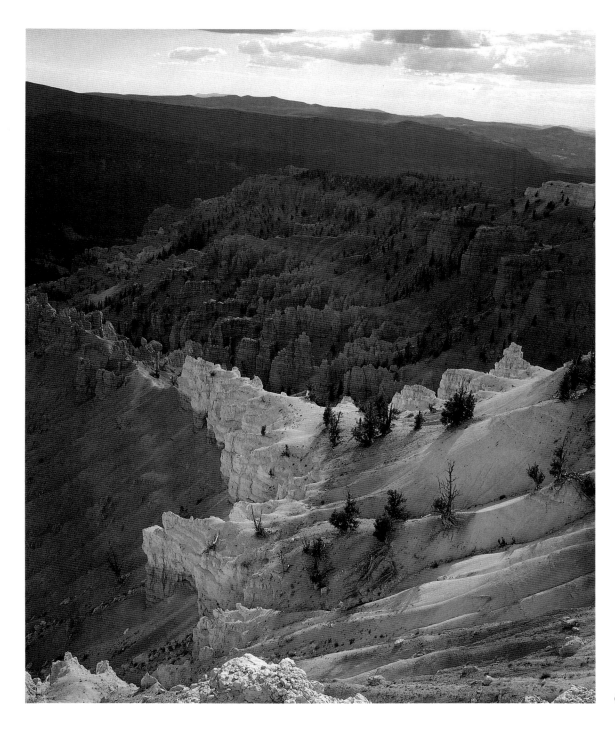

Cedar Breaks National Monument

Unseasonable wintry weather added to their misery. Though this was early October, Escalante wrote that *"on the preceding days a very cold wind from the south had blown fiercely and without ceasing, followed by a snowfall so heavy that not only the peaks of the sierra but likewise all the plains were covered with snow tonight."* For two days they couldn't travel, and when they finally got under way *"it was so soft and miry everywhere that many pack animals and saddle horses, and even the loose ones, either fell down or mired in the mud."* The grease-slick gumbo of the Escalante Desert hasn't changed that much, as any four-wheel driver caught off-road in a rainstorm can attest.

It was enough. The Monterey goal was abandoned, the decision confirmed by a casting of lots. They headed, instead, for home by way (they hoped) of the *Cosninas* [Havasupais] south of the Grand Canyon.

In Cedar Valley—a *"beautiful valley . . . very great abundance of pasturage,"* Escalante noted—they encountered Indian women gathering seeds. They wore only strips of buckskin hanging from their waists, which, he reported in the modesty of his priestly celibacy, *"hardly covered what can not be looked at without peril."* Safely past that danger, they hurried on over the rim of the Great Basin and down Ash Creek. Like every traveler that way since—including motorists who speed down I-15 today—they skirted the impassable gorge where Ash Creek cuts through the Black Ridge, and found themselves, as millions since have done and do, in the welcome warmth of Utah's Dixie.

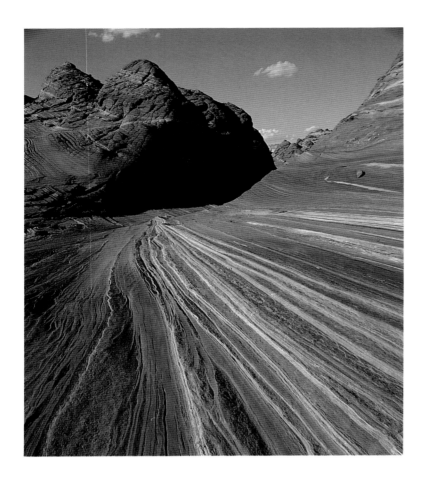

Crossing the Virgin River near present-day La Verkin, Escalante found that the river *"consists in great part of hot and sulphurous water"*; a pleasant hot springs resort welcomes tourists there today. Keeping the Hurricane Cliffs—*"a chain of very high mesas,"* Escalante called them—on their left, the party trudged on south toward the Colorado River. At the lovely pools where the Mormons would later build Fort Pierce in defense against Indians, the ancestors of those Indians soberly warned the padres not to continue south. *"They told us that in two days we would reach the Rio Grande* [the Colorado], *but would not be able to go the way we wanted to, because there was no watering place, nor would we be able to cross the river in this region because it ran through a great canyon and was very deep and had on both sides extremely high cliffs and rocks, and finally, that from here to the river the terrain was very bad."*

That's a pretty good working description of the Arizona Strip and the Grand Canyon beyond; but the suspicious padres ignored this sound advice. Starving and

Left: Sandstone patterns, Paria/Vermilion Cliffs area

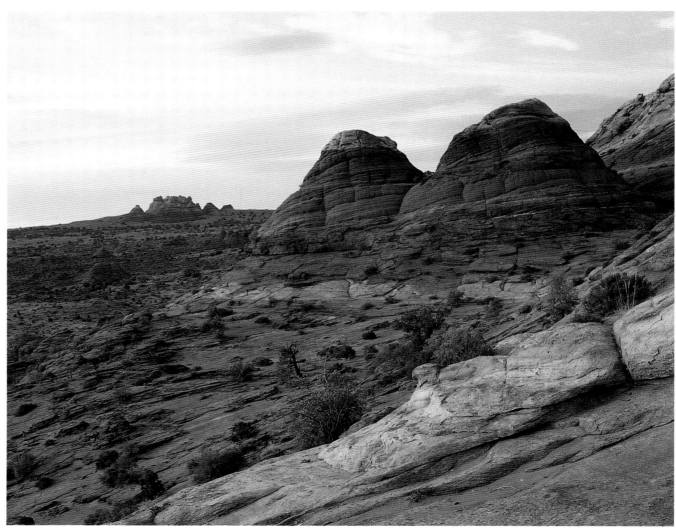

Sunrise, petrified sand dunes, Paria/Vermilion Cliffs area

desperate for water, they wandered through the Arizona Strip before concluding, like the scouts of the Indian legend, that this was indeed no way to go. They turned to the east and, after nearly perishing in and around Glen Canyon, finally found the Ute Crossing of the Colorado (later named the Crossing of the Fathers and now buried deep under Lake Powell).

That little detour cost three weeks of arduous travel, but Escalante, ever the optimistic Christian, put a positive spin on it. *"For lack of an experienced guide,"* he wrote, *"we went by such a circuitous route, spent so many days in so small an area, and endured such hunger and thirst. And now, after suffering all this, we learned of the best and most direct route, where there were waterholes adjusted to an ordinary day's travel. . . . But doubtless God disposed that we could not obtain a guide, perhaps as a benign punishment for our sins, or perhaps in order that we might acquire some knowledge of the people who live in these parts. May His holy will be done in all things and His holy name glorified."*

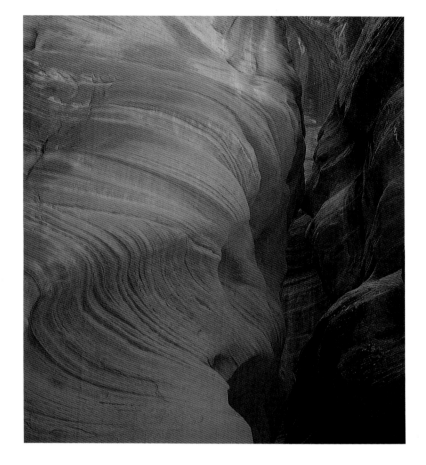

Right: Buckskin Gulch slot canyon, Paria/Vermilion Cliffs area

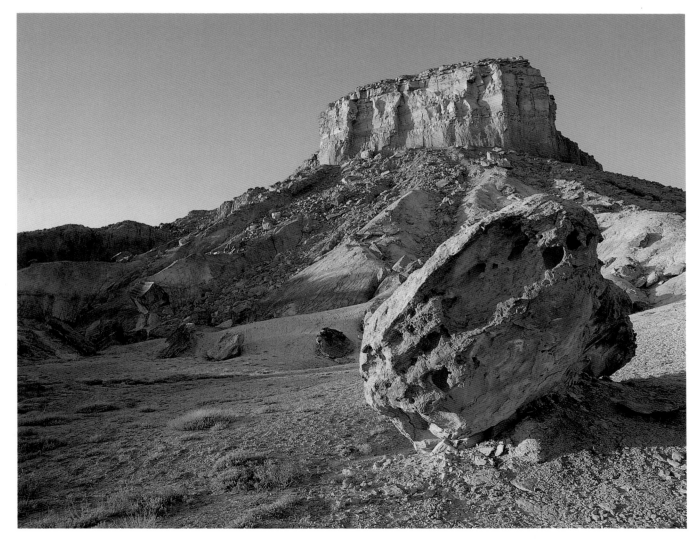

Boulders and butte, Big Water

Sunrise, Padre Bay, Lake Powell, Glen Canyon National Recreation Area

It was half a century before the next traveler of record hurried through Utah's southwest quarter. This was Jedediah Smith, the indefatigable twenty-six-year-old trapper who crossed the length of Utah north to south not once but twice within a year. In 1826 Smith and two fellow trappers bought out William Ashley's trapping company and Jedediah set out from the Bear River country to see what he could see.

"In taking charge of our S western Expedition," he wrote, *"I followed the bent on my strong inclination to visit this unexplored country and unfold those hidden resources of wealth and bring to light those wonders which I readily imagined a country so extensive might contain. . . . I wanted to be the first to view a country on which the eyes of a white man had never gazed and* *to follow the course of rivers that run through a new land."*

New land he found in abundance, though few rivers running through it—certainly not the fabled Buenaventura that supposedly drained the Great Salt Lake to the ocean. As for hidden resources of wealth . . .

In Castle Valley, Smith *"learned that the valley was verry [sic] barren and Rocky [so] I did not venture into it . . . after traveling in this direction 2 days [toward the San Rafael Swell] the country looked so unpromising that I determined to strike westward to a low place in the Mountain and cross over."*

In the vicinity of Beaver, after crossing the Wasatch Plateau and skirting the Tushar Mountains along the route of I-70, he learned something about the Great

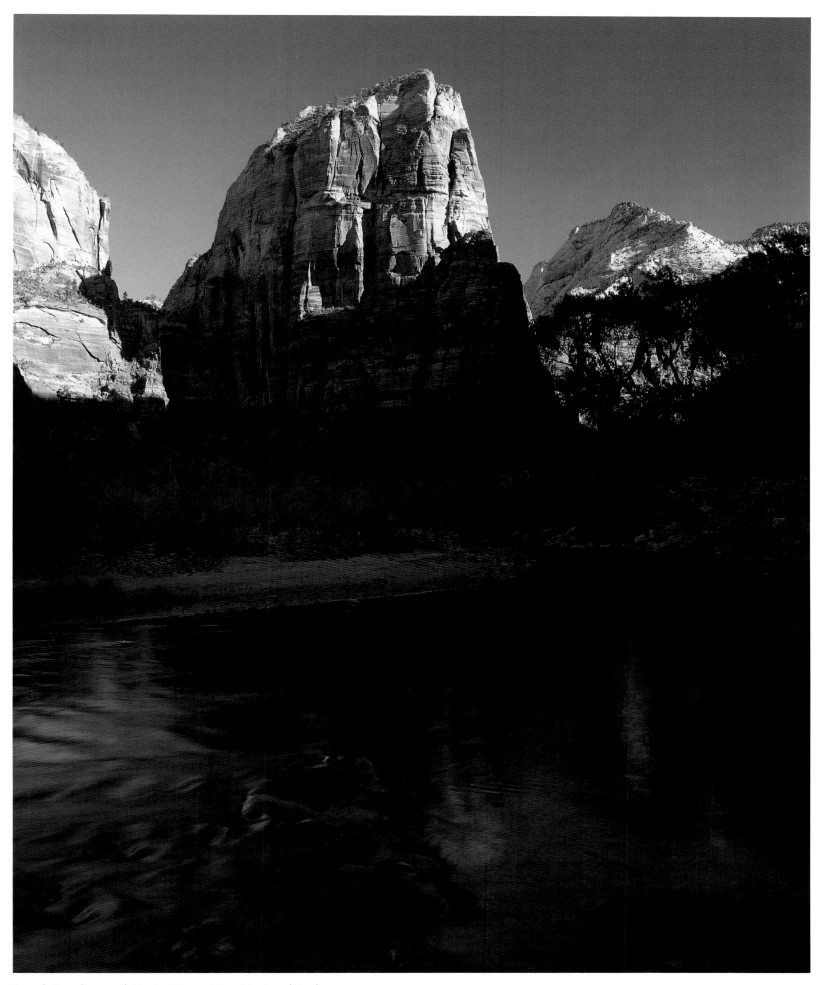

Angels Landing and Virgin River, Zion National Park

Basin—the rivers don't go anywhere: "*I started SW we moved in that direction about 20 miles and to my great Surprise instead of a River an immense sand plain was before me where the utmost view with my Glass could not embrace any appearance of water. The only exception to this interminable waste of sand was a few detached rocky hills that rose from the surrounding plain and the stunted sedge that was thinly scattered over its surface.*"

And after crossing the rim of the Great Basin and descending into Dixie, "*without game or beaver [so] we had nothing to eat,*" the best he could write about the country was that at the confluence of the Virgin and Santa Clara the party found "*a spot of ground where corn had been raised 3 or 4 years since. Some of my men could hardly believe it possible that corn had ever been planted in this lonely country.*"

His trip along much of the same route the following year, to recover the men he had left trapping the western slopes of the Sierra Nevada, was worse. But at least it wasn't in Utah that he suffered his major disasters: the Mojave Indian massacre of most of his men while crossing the Colorado River near Needles, California, and the later massacre of most of the California party in the coastal forests of southern Oregon.

So much, as far as Jedediah Smith was concerned, for the hidden resources of wealth in southwestern Utah.

Others were equally disappointed. For twenty years, during the 1830s and 1840s, mule trains carrying New Mexican woolens along the Old Spanish Trail snaked diagonally from Castle Valley to the southwestern corner of Utah, returning with thousands of California horses and mules, and picking up Paiute chil-

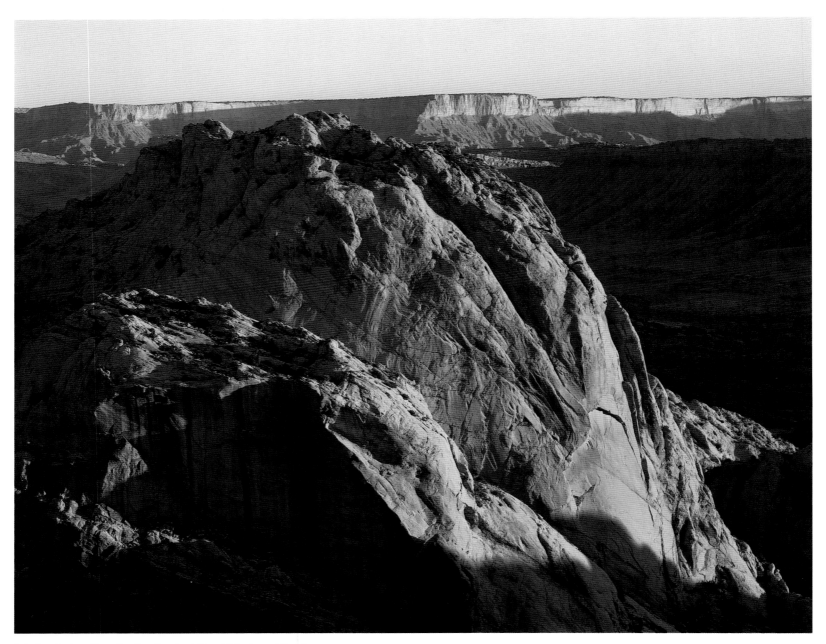

Muley Point Overlook, Capitol Reef National Park

dren to be sold as slaves at each end of the trail. Few travelers on the trail wrote about it, and those who did mostly complained about freezing in snow-choked passes or thirsting across long sandy wastes. Orville Pratt, traveling the trail in 1848, for example, described the country as *"sandy, hilly, and utterly barren. Water is also scarce, & if there is no mineral wealth in these mountains I can hardly conceive of what earthly use a large proportion of this country was designed for."*

In 1848 a few members of the Mormon Battalion, mustered out in San Diego, dragged the first wheeled vehicle over the trail and on to Salt Lake City, bringing seedlings from California to the new Zion. And in 1849 Jefferson Hunt, recently of the Battalion, guided 500 California-bound gold seekers in 100 wagons over the southern route. By the time they got into the Escalante Desert, near present-day Newcastle, most of them were so disgusted with the labor of road-building through that harsh country that they deserted Hunt and struck west on what they believed to be a shortcut to California. Crossing the Beaver Dam Mountains and Beaver Dam Wash was a major ordeal, and what they found to the west was worse; many of them left their bones bleaching in and beyond Death Valley.

So, hurrying through southwestern Utah to someplace else was no picnic. Putting roots down and surviving there was even harder, as Brigham Young's Mormons were about to learn.

Brigham was nothing if not expansionist. Barely two years after his arrival in Salt Lake Valley, he had pushed settlers north into Davis County and Ogden, south to Provo and Sanpete Valley, west to Tooele. But his vision saw much farther than that. In November 1849 he sent one of the apostles, Parley P. Pratt, with fifty men 300 miles south to the Virgin River, searching out places for settlement along the way.

Why such ventures had to be carried out in midwinter mystifies us today. Maybe it was simply that the crops were in and there was time to spare. Maybe it was out of ignorance of what winter could be like in the upper elevations of the Great Basin. Maybe it was to try the venturers' faith—which it surely did; some of them barely survived. But what they found and reported to the legislature set the pattern for much of Utah's settlement.

Peteetneet Creek (now Payson) would be a good place for a settlement, Pratt wrote, and so would the Yohab (Juab) Valley. He noted the "inexhaustible" pasturage and iron ore in and around Mountain Meadows, and reported that the present site of Beaver, with good soil and nearby timber, would be *"an excellent place for an extensive Settlement."* John Armstrong, one of the party, called Sevier Valley *"a very dreary place and very cold, I have two toes frozen . . . Ought to be*

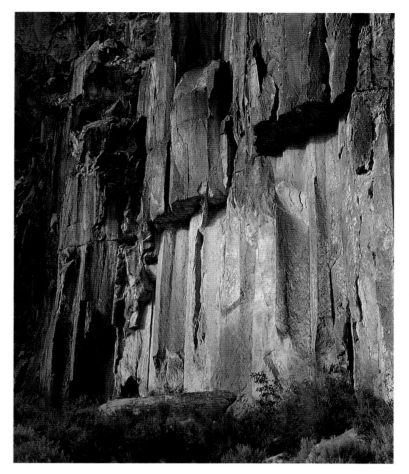

Columnar basalt, Fremont Indian State Park

Crossbedded sandstone, White Cliffs area, Zion National Park

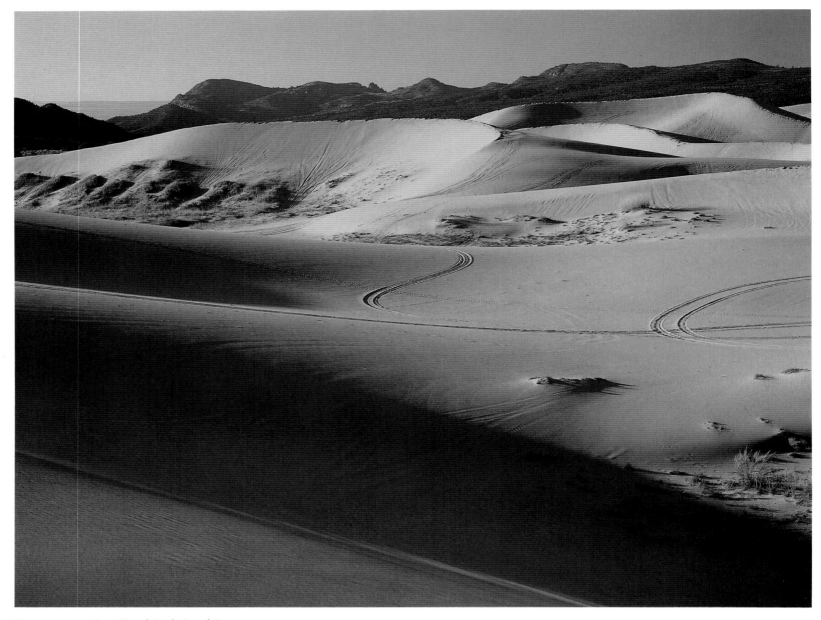

Dunes at sunrise, Coral Pink Sand Dunes

called 'Severe Valley' A large dreary wilderness, A complete Barren waste." Pratt's report generally agreed, though he did report outcroppings of coal near present-day Salina and some rich bottomlands where, in 1865, Richfield would be settled.

What really impressed Pratt, though, were Little Salt Lake and Cedar valleys. He told the legislature of "thousands of acres of rich soil convenient for water," of an "inexhaustible supply of shrub pine and cedar fuel" on the foothills, and of "lofty pine" in the mountains. In the southwestern part of Cedar Valley, he wrote, *"are thousands of acres of cedar contributing an almost inexhaustible supply of fuel which makes excellent coal. . . . In the centre of these forests rises a hill of the richest iron ore, specimens of which are herewith produced. Taken as a whole we were soon convinced this was the 'firstrate good place' we were sent to find as a location for our next Southern colony. . . . [It] con-* *stitutes a field of rich resources capable of sustaining and employing 30,000 inhabitants at present, and 100,000 eventually."*

That got Brigham's attention. Within a year, Apostle George A. Smith was on his way south with 119 men and 31 women to establish the Iron Mission in Parowan and Cedar City. They left in December, the leaders apparently unimpressed by the misery Pratt reported of winter travel through that country. *"I hope our ears will not be saluted with any profanity, swearing or blasphemous words, or taking the name of the Lord in vain,"* Smith warned the group. Those who have felt the numbing cold of a Cedar Valley blizzard have to wonder if the warning was always heeded.

For a number of reasons—labor shortages, technical difficulties, floods, hard winters, crop failures, and, finally, competition with iron brought in by the railroad—the Iron Mission failed. But the ore is certainly

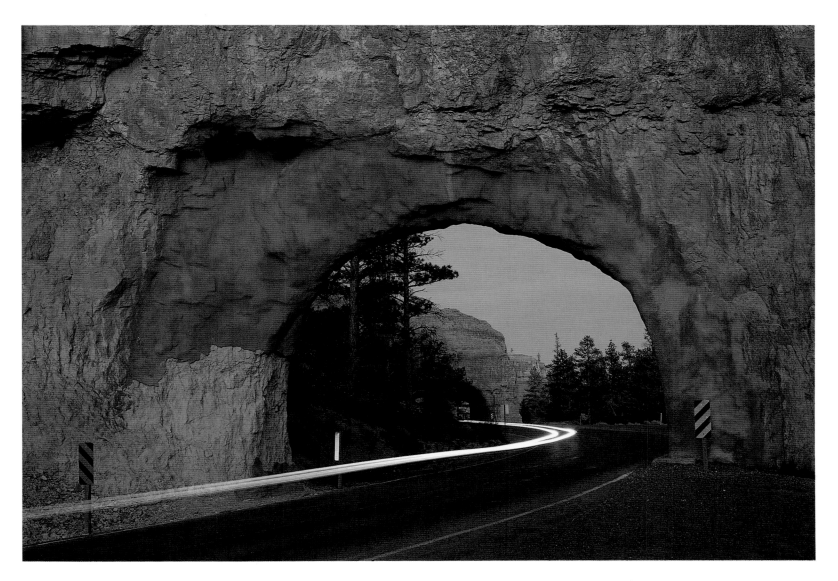

Above: Automobile light streak at tunnel, Red Canyon
Right: Golden columbine and small waterfall, Zion National Park

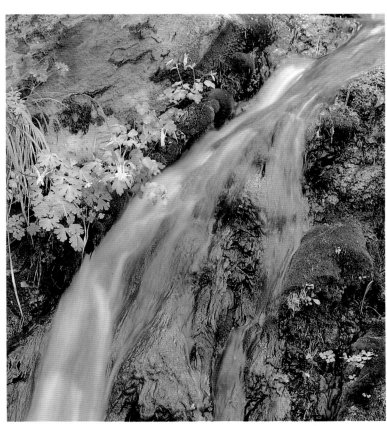

there—an estimated 100 million tons of it. Mining began again in the 1920s, accelerated during the World War II era, and reached production of four million tons in 1957. But, as so often happens in the West, the boom turned to bust.

Today, Little Salt Lake, once such a welcome stopping place, is an alkali playa, sucked dry by wells and irrigation. Much of the cedar and pinyon that so impressed Pratt is gone. The abandoned mines that once held such promise at Old Ironton, Iron Mountain, Iron Springs, and Granite Mountain are apparently permanent scars on the landscape—Utah has never troubled its mining developers with reclamation requirements. The 100,000 inhabitants Pratt envisioned never came.

But growth has come in other ways. Parowan quietly prospers as one gateway—Cedar City is the other—to Cedar Breaks National Monument and Brian Head resort on the 11,000-foot Markagunt

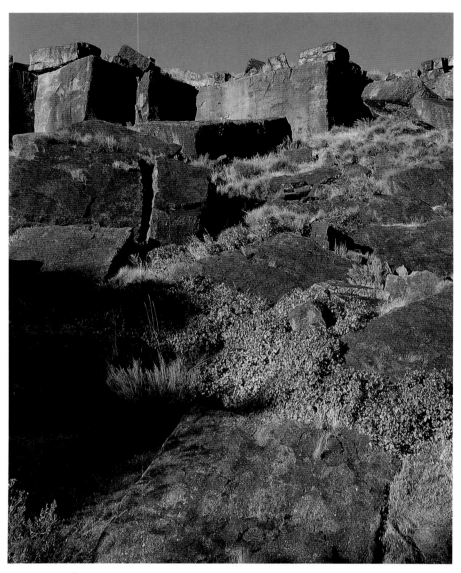

Boulders at Santa Clara River near Santa Clara

ous other elements lying in inconceivable confusion, in short a country in ruins, dissolved by the peltings of the storms of ages, or turned inside out, upside down by terrible convulsions in some former age." He recommended no settlement there.

But Brigham Young had other ideas, and Pratt's "cheerless, grassless, waterless plains" today hold lush golf courses and million-dollar homes in one of America's fastest-growing retirement/recreation communities.

That didn't come easily, though. Brigham sent pioneer settlers to Santa Clara on the Virgin in 1854, to Washington in 1857, to Virgin in 1858, and finally to St. George in 1861. Their job was to plant orchards and vineyards, grow cotton and sugarcane, and produce silk. All had a terrible time.

Getting there was hard enough, especially the wretched wagon road over the Black Ridge and down Ash Creek. Of the lava boulders on that road, one disgruntled pioneer wrote home that there was only one bump—but it was forty miles long.

Staying in Dixie was even harder. Floods of the Virgin and tributary streams washed out dams, silted up canals, and washed away whole fields. Torrential rains demolished adobe houses; John D. Lee lost two children when a twenty-eight-day rainstorm in 1862 melted the walls of his home in Fort Harmony. Malaria debilitated the settlements, its chills and fevers made even more intolerable by the blazing heat. And then there was the wind: According to an anonymous poet,

> *The wind like fury here does blow that when we plant or sow, sir,*
> *We place one foot upon the seed and hold it till it grows, sir.*

Plateau, whose miles of trails through open forests and high mountain meadows attract backpackers, hunters, fishermen, snowmobilers, and, increasingly, mountain bikers. And Cedar City shows what ingenuity and bootstrap determination can do for a community. In 1897 the tiny, struggling community pooled all its resources, sending crews into the mountains in midwinter for timber, to establish the little school that now flourishes as Southern Utah University. And in the early 1960s, when collapse of the iron industry left the area in deep depression, the same kind of community effort created the Utah Shakespearean Festival, which now attracts actors and audiences from across the country.

What of the country "over the rim"—the redrock country of Utah's Dixie? Parley Pratt thought little of it, reporting to the legislature that it was *"a wide expanse of chaotic matter huge hills, Sandy desert, cheerless, grassless, waterless plains, perpendicular rocks, loose, barren clay, dissolving beds of Sandstone & vari-*

J. Golden Kimball, the much-loved, frank-speaking Mormon general authority, spoke the mind of more than one Dixie pioneer when he told a St. George congregation: "If I had a house in St. George and a house in hell, I'd rent out the one in St. George and live in hell."

Moreover, with Salt Lake City 300 miles of rough wagon road away and Los Angeles even farther, there was little market for the fruits of their labor. Poverty was a way of life. That changed dramatically in 1874 when the Walker brothers, bankers in Salt Lake City, inspected a sample of horn silver sent up from the sandstone ledges of Cedar Ridge and sent an expert to investigate. The resulting stampede to Silver Reef brought saloons, brothels, and gambling dens to Mormon Dixie. But it also brought the production of more than nine million ounces of silver in the next twenty years. And it brought economic viability, even a measure of prosperity, to the struggling settlements along the Virgin.

Eventually, falling silver prices and declining ore quality ended the boom. Mining ended for good in the Great Depression of the 1930s. But before that collapse, St. George had become an important stopping place on the old Arrowhead Highway from Los Angeles to Salt Lake City, and its future was assured. Highway 91 replaced the Arrowhead, and I-15 followed in the 1960s, its section through the Virgin River gorge the most costly rural interstate project ever built. Increasing streams of motorists poured into and through the area, and suddenly the nation "discovered" Dixie, with its warm winter sunshine and its superb scenic setting.

Growth has been explosive. Washington County's population has doubled each decade—to 50,000 by 1990, with 100,000 expected by the turn of the century. But vision has lagged behind growth. With little restraint or planning, subdivisions have sprawled out, leaving gaping red gashes in the lava-faced mesas guarding St. George. Traffic congestion, crime, and other urban problems plague the area. And still the growth continues. So insatiable is the demand for water for more golf courses and condominiums that officials have pushed, unsuccessfully so far, for dams in some of America's most beautiful canyons, including one on the East Fork of the Virgin in a wilderness study area above magnificent Parunaweap Canyon and Zion National Park.

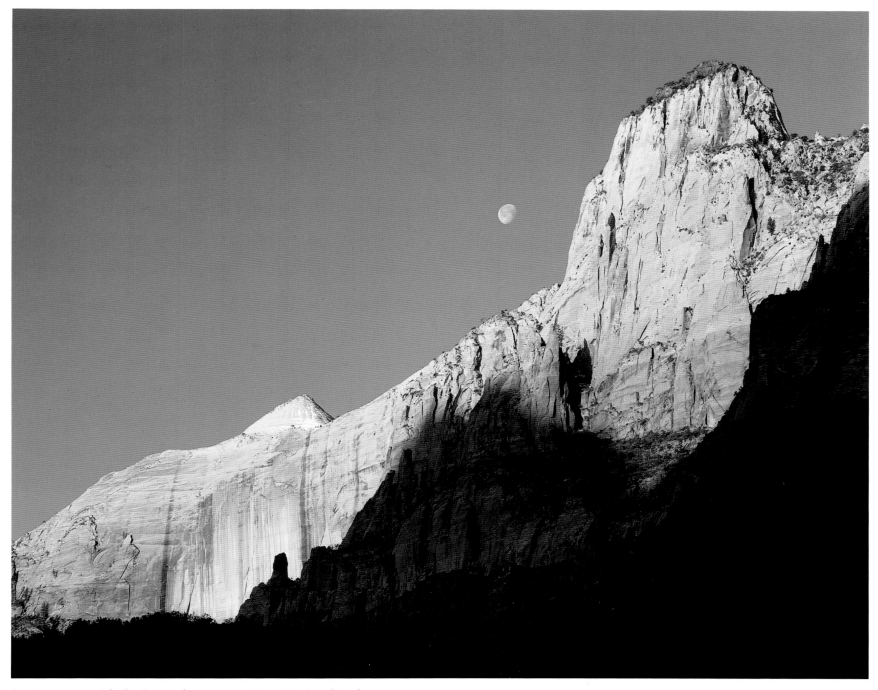

Setting moon with the Sentinel at sunrise, Zion National Park

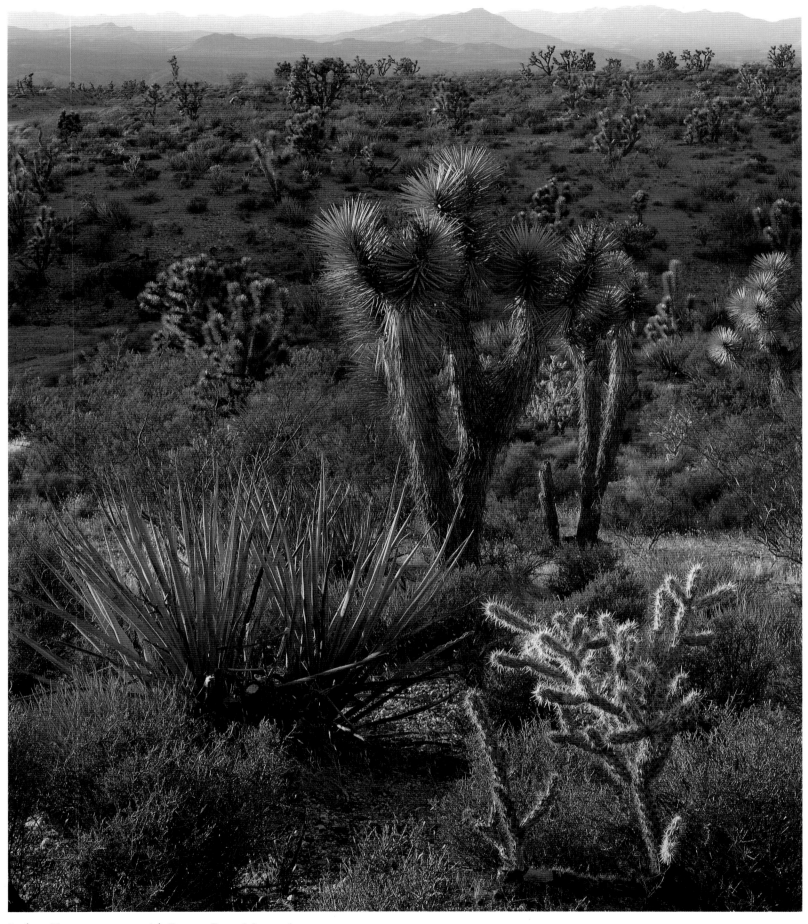

Joshua Trees at sunset with Beaver Dam Mountains

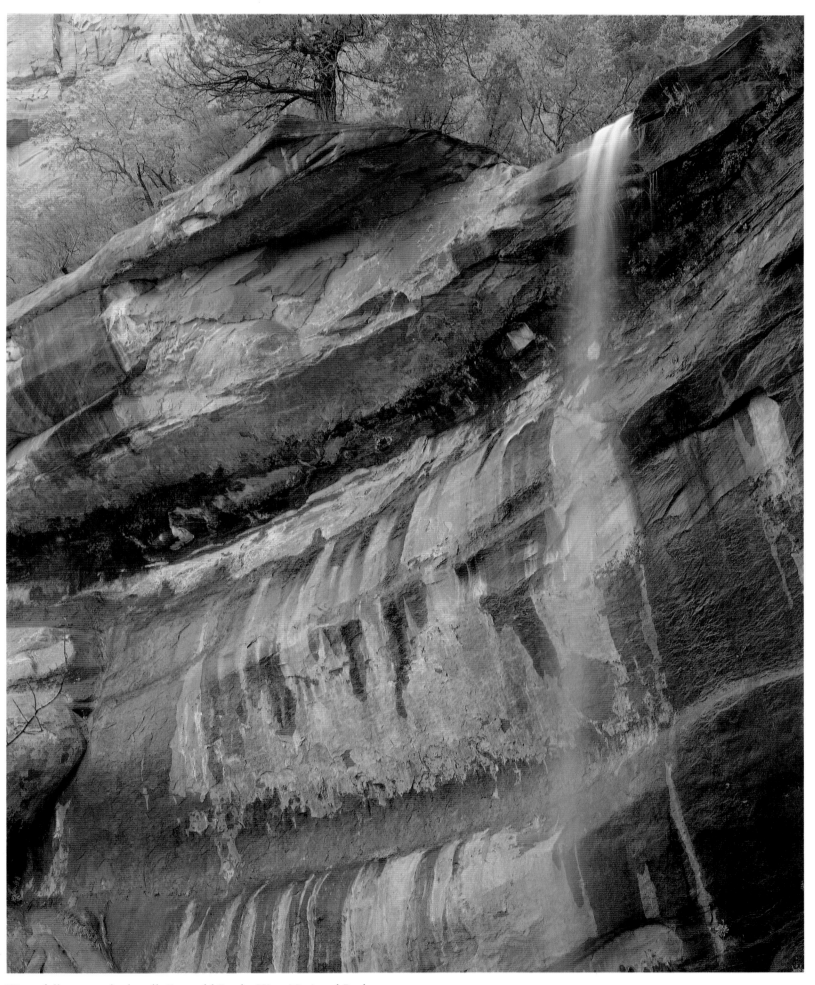

Waterfall on streaked wall, Emerald Pools, Zion National Park

It's astonishingly diverse country, this southwestern quarter of Utah. You can divide it, roughly, into sharply contrasting thirds.

On the west is the Basin and Range province of long, lonely valleys and twisted, naked mountains whose names—Needle, House, and Confusion ranges; Mineral, Black, and Wah Wah mountains; Silver, Crystal, Granite, and Sawtooth peaks—suggest their character. The Forest Service runs a desert experimental range out there, and the Pentagon once tried to sprawl its MX missile system across those lonely valleys. But sanity returned, and that effort failed. Except for a few winter-range sheep herds and increasing numbers of rock hounds and climbers, the area is pretty much left alone.

Across the southern third of the quarter stretches the northern edge of the Colorado Plateau. This is raw land, where for ten million years wind and water have

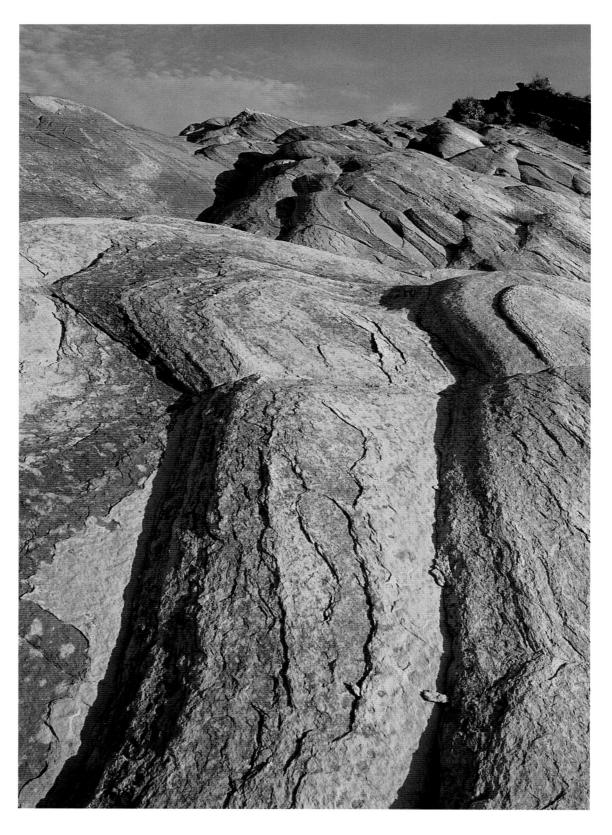

Sandstone patterns, Paria Canyon

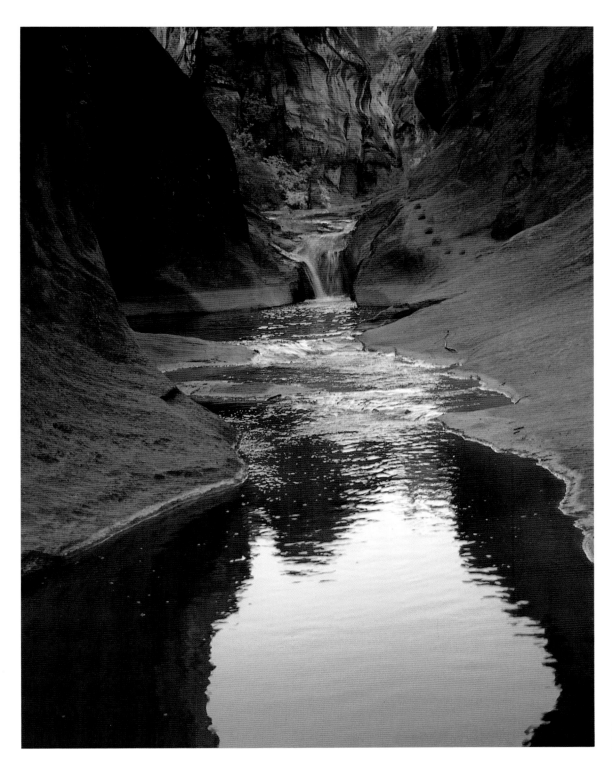

Stream and waterfall, Red Cliffs
Recreation Area

worked to strip bare the sheer cliffs and buttes and
mesas, the towers and monuments and hoodoos, the
deep, shadowed canyons and shifting sand dunes that
Hollywood has recorded in countless movies and that
now attract adventurers from many parts of the world.
Even within this third there is startling diversity. In the
southwestern corner, at Beaver Dam Wash—at less
than 2,000 feet the lowest area in the state—the life-
forms would generally be classified Sonoran. Two hun-
dred miles away, still in Utah's southwest quarter and
still on the Colorado Plateau, pinyon and juniper cover
the 7,000-foot uplands of Capitol Reef.

Between those points lies the Grand Staircase, that
remarkable region sweeping up from the Grand
Canyon to Utah's high plateau country. In four great
steps the land rises from around 4,500 feet elevation to
over 10,000 feet, forming in turn the Vermilion, White,
Grey, and Pink cliffs—and covering 200 million years
of geologic time.

Lowest and oldest of the four, the Vermilion Cliffs
were named by John Wesley Powell during his explo-
ration of the Colorado River and surrounding country
in 1869 and 1871. Drive Highway 59 from Hurricane
to Kanab, or Highway 89 east from Kanab toward

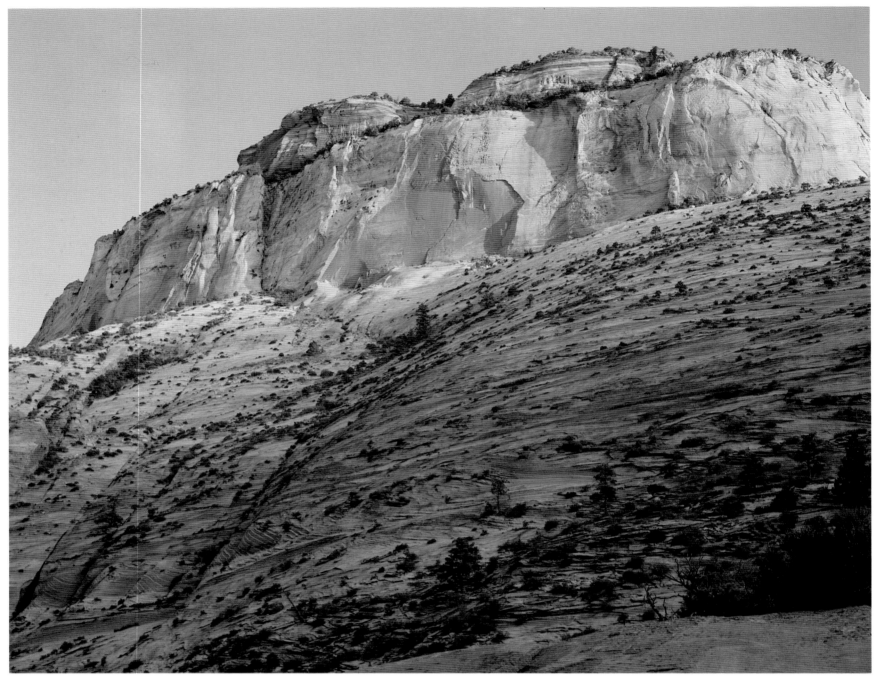

Sunrise, East Temple, Zion National Park

Lake Powell, especially after a rainstorm or when the cliffs glow in the light of the setting sun, and you'll know why no other name would fit. Wingate Sandstone, laid down during the Triassic era (245–208 million years ago) is the dominant cliff-forming rock here. Below it spread out the soft, eroded slopes of Chinle shales, rich in fossils and petrified wood. In outcroppings of the Moenave formation (230-200 million years ago), some of the oldest dinosaur tracks are found—such as those in Warner Valley, southeast of St. George, where the tracks of a couple of huge herbivores mingling with those of a pack of much smaller carnivores suggest that life in those days, as ever since, was uncertain and violent.

The White Cliffs are the next step on the Grand Staircase; they were laid down in the Jurassic period beginning about 204 million years ago and lasting 64 million years. Winds swept over the region for millions of years, blowing sand from a vast mountain range that once covered Nevada and western Utah (the Mesocordilleran High) and depositing it thousands of feet deep. From this great sand sheet came the Navajo sandstone that, more than any other formation, gives the canyon country its splendor. It is on Navajo Sandstone in Dixie State Park that children scramble up petrified dunes at angles and to heights that give parents the shakes. It is through 2,000-foot Navajo cliffs that hikers thread their way on one of the West's great

hikes, the Zion Narrows, or an equally great but lesser known hike, Parunaweap Canyon on the East Fork of the Virgin. The world's best-known monolith, the Great White Throne, is Navajo, and, in fact, it is Navajo Sandstone that forms most of Zion National Park, where the Virgin River slices through the White Cliffs. Capitol Reef National Park and, farther east, Canyonlands National Park, Dead Horse Point, the cliffs of Lake Powell, and Rainbow Bridge are all mostly Navajo, one of the world's great scene builders.

Above the Navajo Sandstone sprawl the Gray Cliffs, unmarked on most maps because they don't look much like cliffs. This is the land, primarily, of Mancos Shale, laid down during the latter part of the Cretaceous period (144–68 million years ago), when seas invading from both north and south covered most

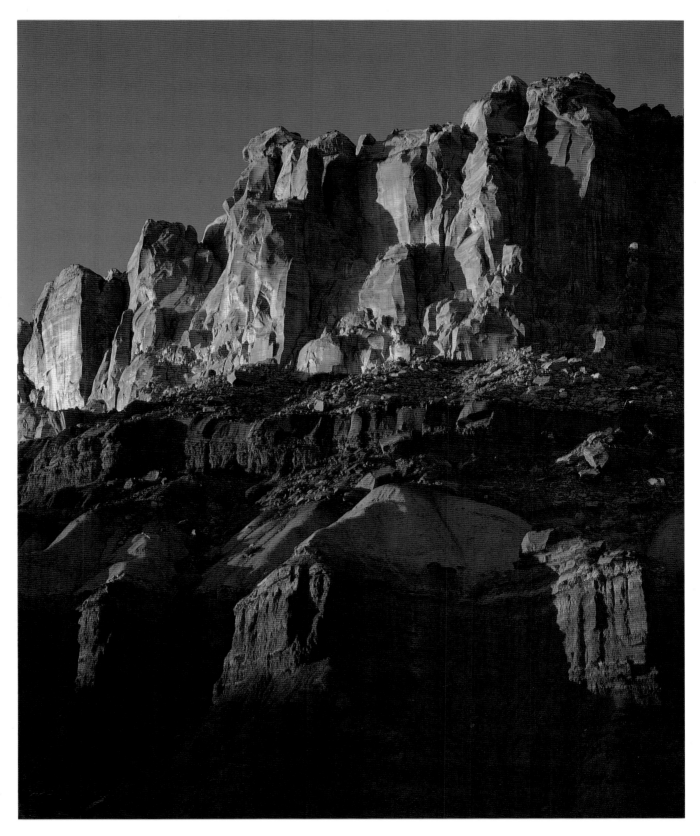

Sandstone formations, Scenic Drive, Capitol Reef National Park

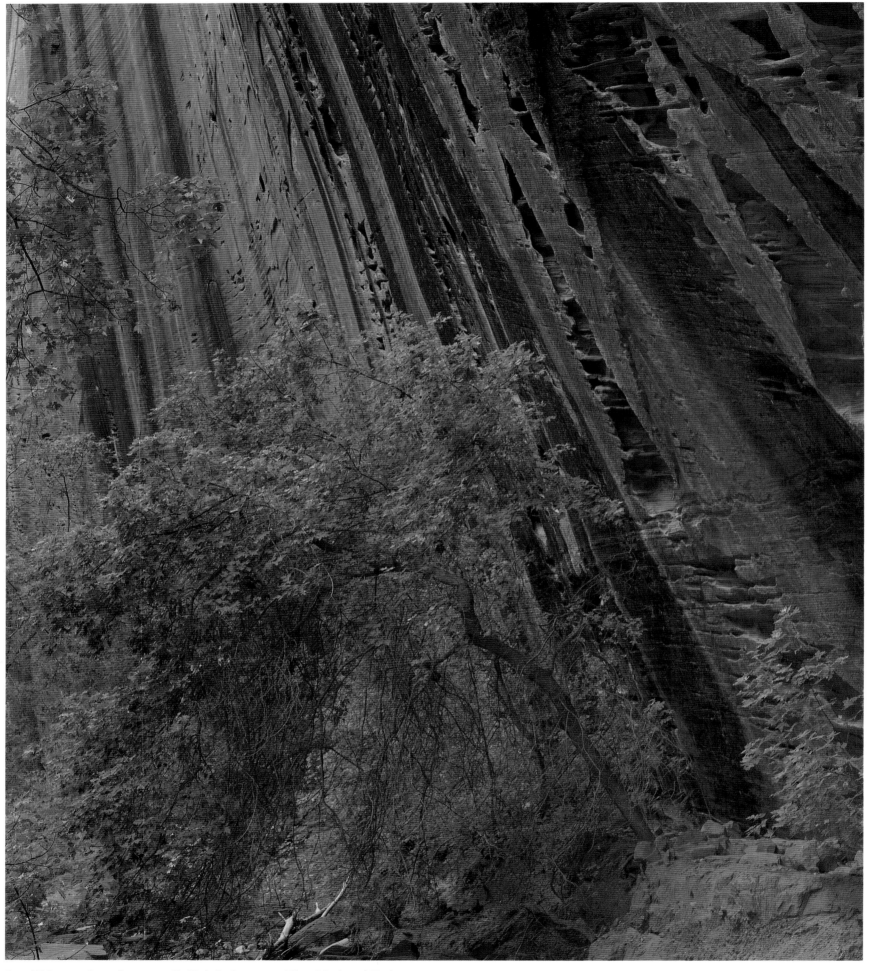

Box Elders and sandstone wall, Kolob Canyons, Zion National Park

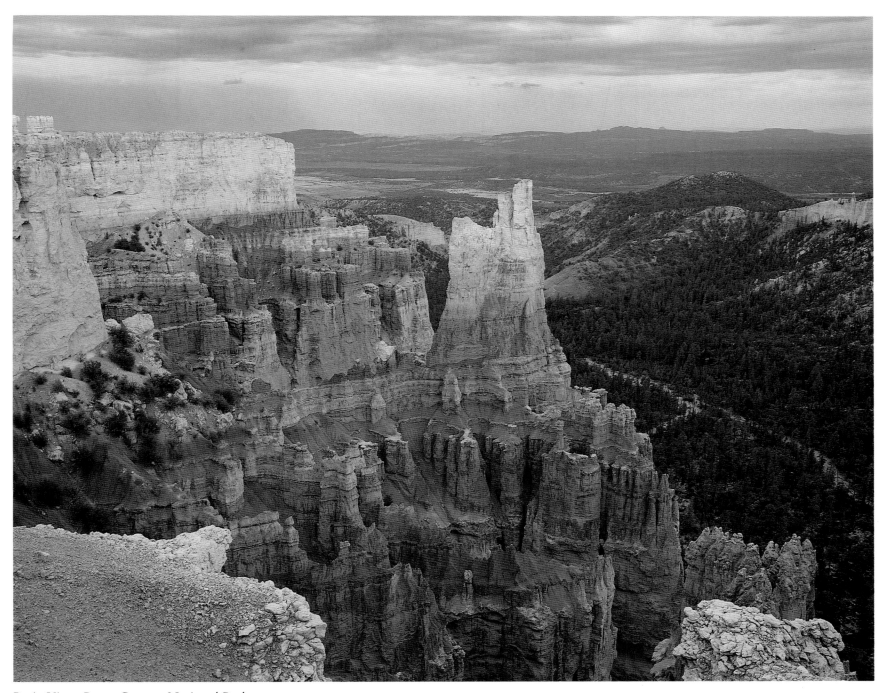

Paria View, Bryce Canyon National Park

of Utah. The shale is soft and mostly grey, and the dunes and gullies of Mancos are not particularly scenic as they fan out below overlying cliffs. But no other area is richer in marine fossils, including untold billions of sharks' teeth. And the oil, natural gas, and coal locked in such Cretaceous formations as the Kaiparowits Plateau are important—though controversial—Utah resources.

Towering atop the Grand Staircase, its final riser, are the Pink Cliffs. Bryce Canyon National Park and Cedar Breaks National Monument are world-famous parts of these cliffs, but step out to the edge of the plateau at almost any point on the great arc between them and you can find a similar though lesser array of

pinnacles and towers with their characteristic horizontal grooves and protrusions. How did they get that way? Lee Stokes explains in his *Geology of Utah* that these rocks, the Wasatch Formation, were laid down during a long period (56 to 35 million years ago) of shallow, fluctuating lakes. Some layers of sediments contained more lime than others, and formed rocks more resistant to erosion. These formed the caps left balancing atop many pinnacles as well as the grooves spaced horizontally below.

Bryce Canyon is not a canyon at all but a series of amphitheaters and naked cliffs where the edge of the Paunsaugunt Plateau has eroded into the headwater breaks of the Paria River. At the more appropriately

named Cedar Breaks the Markagunt Plateau falls off into the headwaters of Ashdown and Coal creeks. And the headwaters of the Virgin gather in the less known but almost as spectacular breaks of Strawberry Point and those below Navajo Lake. Around the edges of those two great plateaus the Pink Cliffs stretch in a glowing semicircle broken only by the Paunsaugunt Fault, where Highway 89 snakes through some of Utah's loveliest country.

If a single geologic event—or era—more than any other could be said to give southwestern Utah its special character and beauty, perhaps it would be the period of intense igneous activity that began some 30 million years ago. For 25 million years awesome sub-terranean forces sent molten magma to the surface. Some of it built the volcanoes and cinder cones of the Sevier, Black Rock, and Escalante deserts, showering tuff and volcanic ash over the land. Some poured out in the vast lava flows of southwestern Utah and the Arizona Strip. Some pushed up the overlying crust but never broke through, creating, among other laccoliths, the Pine Valley Mountains, which capture the moisture that gives life to St. George and nearby communities. Utah's hard-rock mining industry was built on the mineral deposits laid down during this period.

But the greatest endowment left by the age of magma is the caprock of granites and basalts it spread over what would become the great high plateaus that

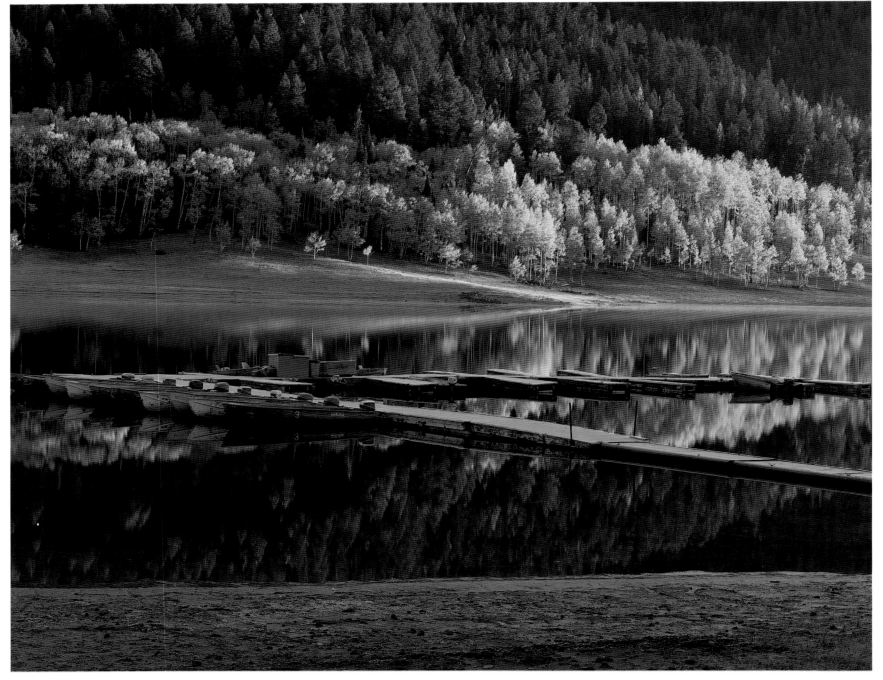

Boat dock at Navajo Lake with aspens on hillside at sunrise

Cyclone Lake, Aquarius Plateau

form Utah's spine. Without that caprock, Markagunt, Paunsaugunt, Aquarius with its beautiful Boulder Mountain, Fish Lake with its 12,000-foot Tushar Mountains, Sevier, Awapa, and Thousand Lakes plateaus and others would be long gone, melted away by aeons of erosion. Without them, life as we know it in the communities at their feet could not exist. Without them and the beauty, solitude, and adventure they afford campers, hikers, mountain bikers, hunters, fisher-

men, and just plain nature lovers, life in Utah would be immeasurably poorer. And without them and the washes and streams that flow from their heights, there would be no Zion National Park, no Bryce or Cedar Breaks, no Capitol Reef, little or none of the carving and sculpting that have made southwestern Utah one of America's great destinations for recreation and renewal.

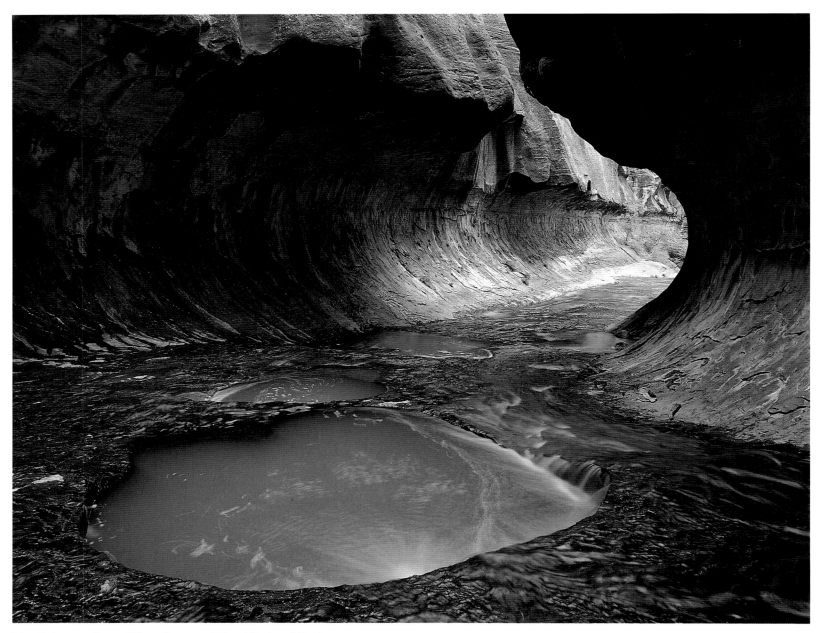

The Subway, Great West Canyon, Zion National Park

The Subway

Ask any of the hiking fanatics with whom southwestern Utah is afflicted what is the best single-day hike in this whole splendid area, and you'll get unhesitating answers. But they'll all be different.

Some will ask, Why hike at all? Real men and women do it on mountain bikes. Try, for example, as we did one bright June day, the trail that drops off the 10,000-foot shoulder of Boulder Mountain and meanders down Pleasant Creek, past deeply entrenched meanders and jump pools and over various sandstone ledges before arriving, 4,000 feet lower, in Capitol Reef National Park.

The hikers, though, will talk of the 3,000-foot climb from Pine Valley over the spine of the Pine Valley Mountains and then down the knee-pounding switchbacks of the incredibly steep east face. Or they will tell of Calf Creek or various other tributaries of the upper Escalante. Or Box-Death Hollow. Or Sevenmile Creek and 11,600-foot Mount Marvine above Fish Lake. Or . . . well, the list is endless.

But let me tell you about the Subway.

Many day-hikers and some overnight backpackers come in from the bottom to the Subway, explore as far as they can until the ledges and cliffs box them up, then retreat the way they came. But done right, it's a point-to-point hike; you come in from above, go through, and climb out below. It's an easy shuttle. You take

the Kolob Reservoir road from Virgin, climb up to the Lower Kolob Plateau, and spot one car at a parking area 8.5 miles from the turnoff. You drive another 5.5 miles, up steep switchbacks leading to the Upper Kolob Plateau, and park the second car at the Wildcat Canyon trailhead. That's where the trail starts.

A short distance in, the trail forks—Wildcat Canyon to the left, Northgate Peaks to the right. You take neither, but go straight ahead. From here on, there's no trail; that's an important part of the magic. You pick your way over gently sloping ripplerock, keeping a white checkerboard mesa on the right, and head toward the base of a steeper butte on the left. When, at the base of that butte, you see and are tempted to explore an arms'-width chasm, you know you're in the right place. You keep heading generally east, keeping the drainage on the right, watching for signs of travel, which you see intermittently among the slickrock.

This is lovely country, spotted with pinyon and juniper, ponderosa pine, desert holly, and sagebrush. The white and red buttes of Zion Park jut against the incredibly blue sky that characterizes southern Utah.

In about two hours, you should arrive at "The Tree"—and here the adventure begins. Some people loop ropes around The Tree for security on the scramble down the steep, rocky chute that begins here, but it's not really necessary. With judicious use of hands as well as feet, the descent is reasonably safe.

At the bottom, turn right down the left fork of North Creek and enter the magic of this deeply entrenched meander with its soaring red cliffs, tunnel-like overhangs (hence the name Subway), hanging gardens of fern, and the ineffable beauty of water running over slickrock.

At first, you'll hop from boulder to boulder, trying to keep your shoes (wear running shoes or sandals, not boots) dry. Give it up. You'll soon enough be wading waist deep. In fact, you'll soon enough be swimming through pools, pushing your clothes and daypack ahead of you in the securely tied garbage bag you had the foresight to bring along. You'll be squealing at the water's cold, and exulting in the privilege of being alive and being here.

You must swim two pools; they're short, just a few strokes across. And then, to avoid swimming a hundred yards or so through a shoulder-width chasm, you scramble up and along a ledge on the left side and lower yourself back down to the streambed. Here a 60-foot rope is

essential. You double it around a tree at the top, grab the double strands, and "walk" down the near-vertical face.

You'll be cold, but don't put on the sweats you brought just yet. There are still pools, not deep enough to require swimming, but certainly deep enough to thoroughly wet anything you're wearing. And there are a couple of pour-offs where you'll need the rope again, looped through slings the Park Service has thoughtfully bolted into the rock.

The Subway is two miles of magic, and then it's probably three miles of hiking through a more open canyon, still spending a lot of time in the water, boulder-hopping, and loving what you're doing. And finally, the steep climb out to where you parked that first car.

Figure on eight hours for the hike. It can be done more quickly, but why? Why would anyone want to leave such a place any sooner than hunger, or the fading light of day, or the threat of rain and a possible flash flood makes absolutely necessary?

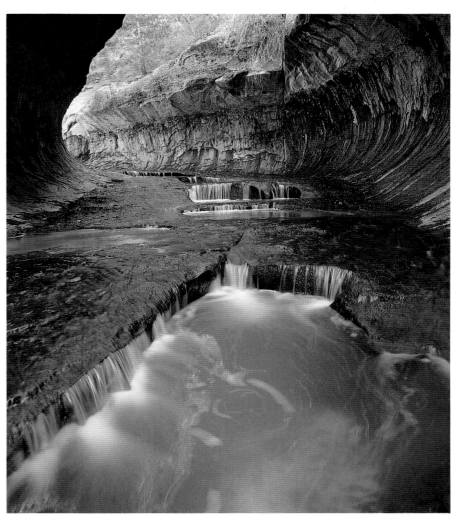

The Subway, Great West Canyon, Zion National Park

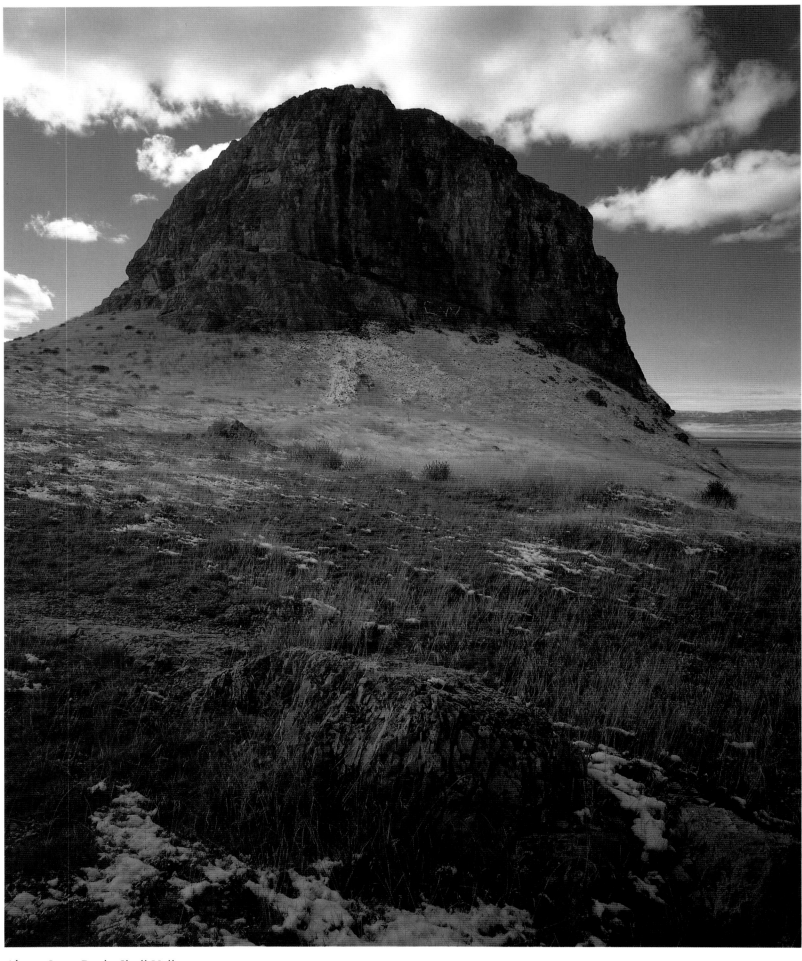

Above: Lone Rock, Skull Valley
Opposite page: Claret Cup Cactus

THE NORTHWEST QUARTER

Sept 30—Very early twenty Indians arrived at the camp [on the Sevier River, near the town of Mills] *. . . wrapped in blankets made of the skins of rabbits and hares. They remained conversing with us, very happily. . . . These people here have much heavier beards than the Lagunas* [the Utah Lake Indians]. *They have holes through the cartilage of their noses and they wear as an ornament a little polished bone of deer, fowl or some other animal thrust through the hole. . . .*

Oct. 2 . . . Shortly afterward the men who gone seeking water arrived, accompanied by some Indians. . . . These were some of the people with long beards and pierced noses who, in their language, are called Tirangapui. The five who first came with their chief had such long beards that they looked like Capuchin or Bethlemite fathers. The chief was an attractive man of mature years but not aged. . . .

. . . We preached the Gospel to them as well as the interpreter could explain it, telling them of the Unity of God, the punishment which he has in store for the bad and the reward ready for the good, the necessity of holy baptism, and of the knowledge and observance of the divine law. . . . We told them if they wished to obtain the proposed benefit we would return with more fathers so that all might be instructed. . . .

They all replied very joyfully that we must return with other fathers, that they would do whatever we might teach and command them. . . . We said goodby to them and all, especially the chief, took our hands with great fondness and affection. . . . They scarcely saw us depart when all of them, imitating their chief, who set the example, broke out weeping copious tears, so that even after we were a long distance away we still heard the tender laments of these miserable little lambs of Christ who had strayed only for lack of The Light. They so moved us that some of our companions could not restrain their tears.

—Fray Silvestre Vélez de Escalante, 1776

Above: Sunrise, Wah Wah Mountains, West Desert
Opposite page: Sevier River near Joseph, Utah

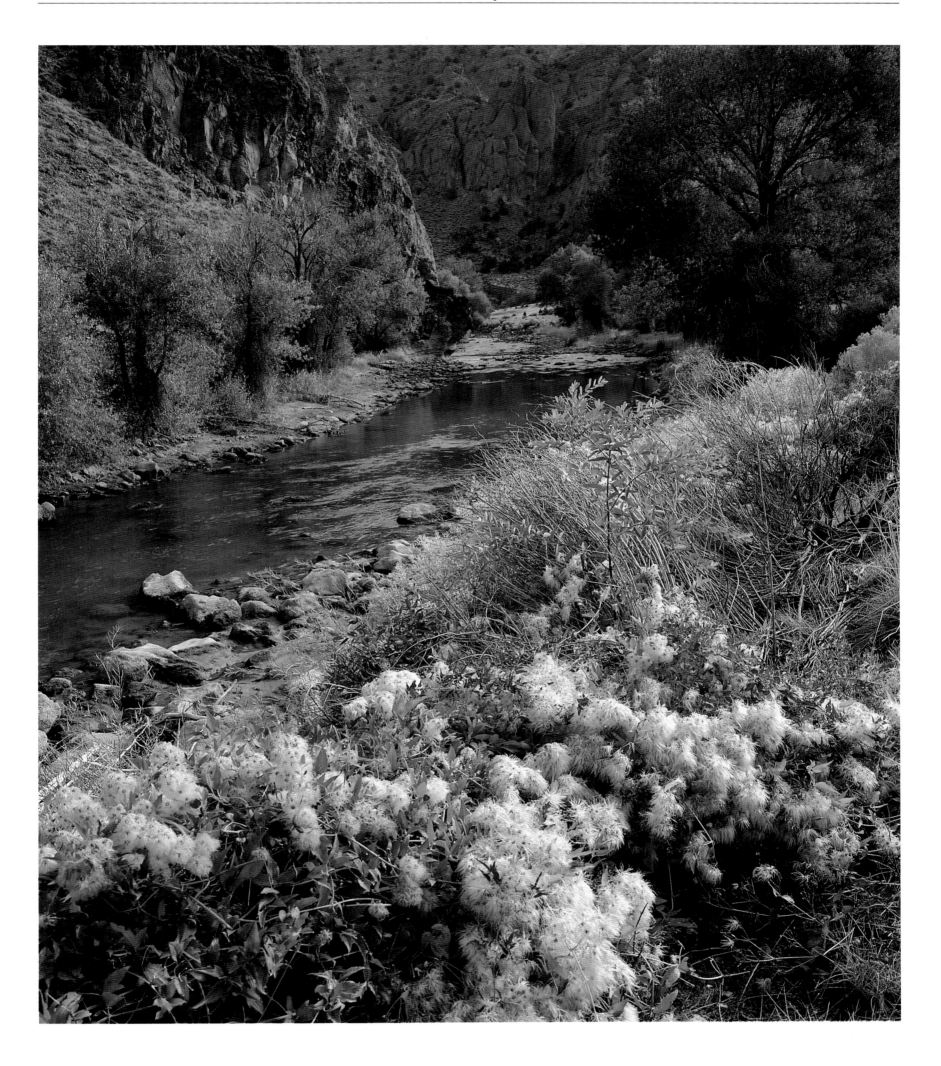

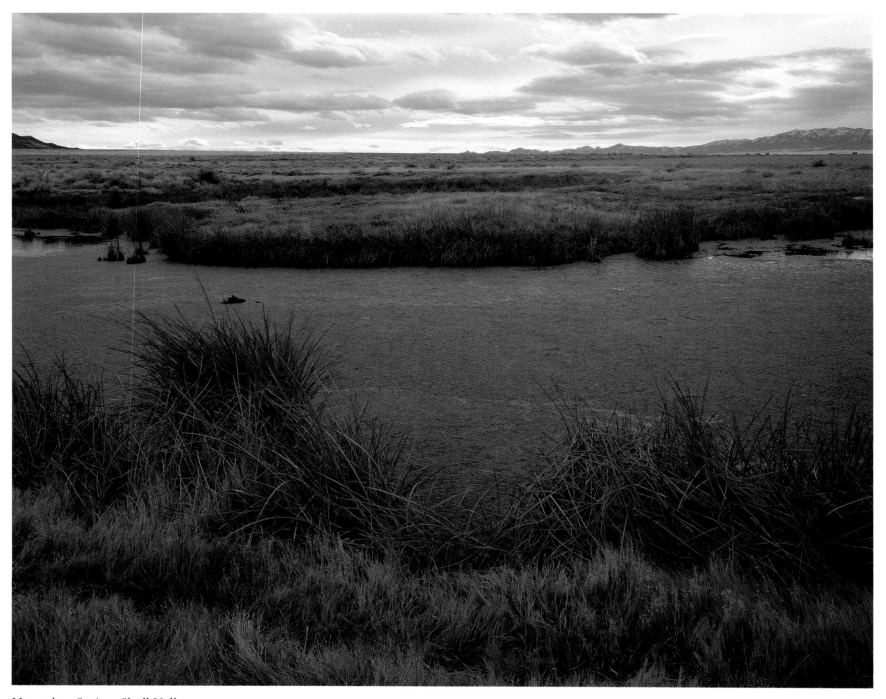

Horseshoe Spring, Skull Valley

This [Utah Valley] *is a most beautiful country. It is intersected by a number of transparent streams. The grass is at this time from six to twelve inches in height, and in full bloom. The snow that falls, seldom remains more than a week. It assists the grass in its growth, and appears adapted to the climate.*
The Utaw lake lies on the west side of a large snowy mountain [Wasatch Range] *which divides it from the Leichadu* [Green]. *From thence we proceded due south about thirty miles to a small river heading in said mountain and running from S.E to S.W.* [They are at the bend of the Sevier River, southwest of Nephi. Actually, the headwaters of the Sevier are far to the south.] *To this I have given the name of Rabbit river, on account of the great number of large black tail rabbits or hares found in its vicinity.*

We descended this river about fifty miles to where it discharges into a salt lake [Sevier Lake, now largely dry], *the size of which I was not able to ascertain, owing to the marshes which surround it, and which are impassable for man and beast. . . . The Indians informed us that the country lying southwest, was impassable for the horses owing to the earth being full of holes. As well as we could understand from their description, it is an ancient volcanic region. This river is inhabited by a numerous tribe of miserable Indians. Their clothing consists of a breech-cloth of goat or deer skin, and a robe of rabbit skins, cut in strips, sewed together after the manner of rag carpets, with the bark of milk weed twisted into twine for the chain. These wretched creatures go out barefoot in the coldest days of winter. Their diet consists of roots, grass seeds, and grass, so you may judge they are not gross in their habit. They call themselves Pie-Utaws.*
—Trapper Daniel T. Potts, 1827

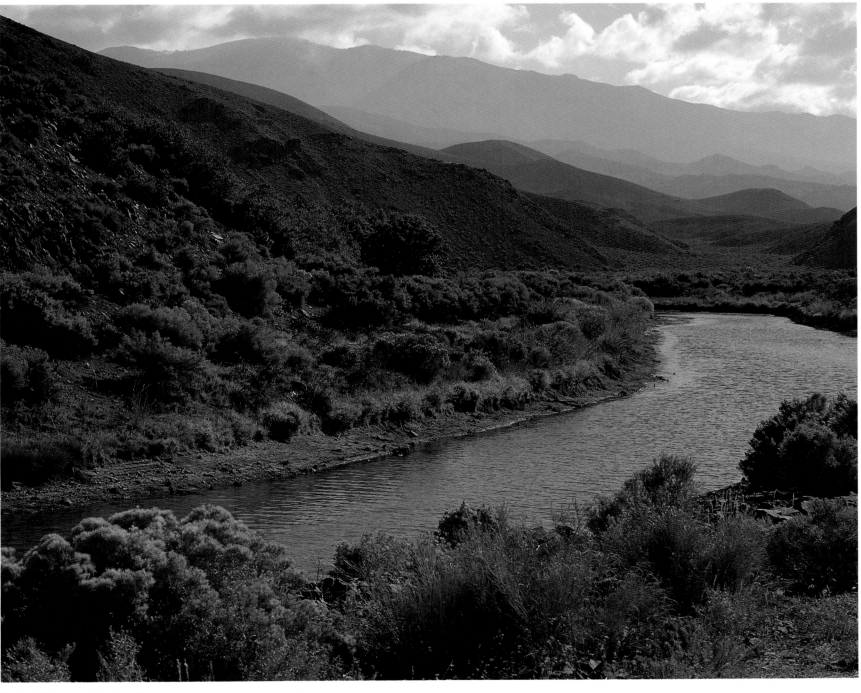

Sevier River and Sevier Plateau

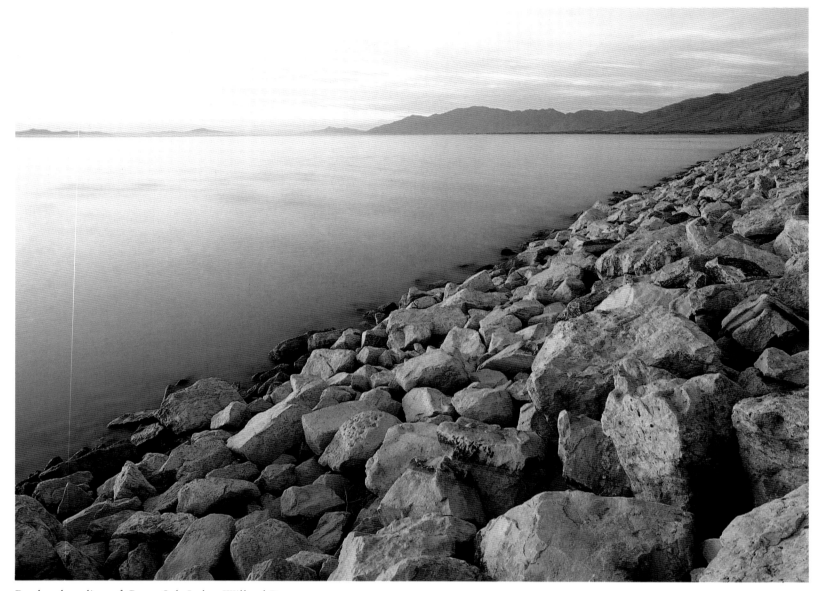

Rocky shoreline of Great Salt Lake, Willard Bay

Ascending to the summit [of a butte west of present Ogden], *immediately at our feet we beheld the object of our anxious search—the waters of the Inland Sea, stretching in still and solitary grandeur far beyond the limit of our vision. It was one of the great points of the exploration; and as we looked eagerly over the lake in the first emotions of excited pleasure, I am doubtful if the followers of Balboa felt more enthusiasm when, from the heights of the Andes, they saw for the first time the great Western ocean. It was certainly a magnificent object, and a noble terminus to this part of our expedition; and to travellers so long shut up among mountain ranges, a sudden view over the expanse of silent waters had in it something sublime. . . .*

*. . . With Mr. Preuss and myself, Carson, Bernier, and Basil Lajeunesse, had been se-*lected for the boat expedition—the first ever attempted on this interior sea. . . . [Not true; Jim Clyman and three others in a skin boat had circumnavigated the lake in 1826.]

Sept 8 . . . We did not steer for the mountainous islands [Antelope Island and Promontory Range] *but directed our course towards a lower one* [Fremont Island]. *. . . So long as we could touch the bottom with our paddles, we were very gay; but gradually, as the water deepened, we became more still in our frail batteau of gum cloth distended with air, and with pasted seams. Although the day was very calm, there was a considerable swell on the lake; and there were white patches of foam on the surface, which were slowly moving to the southward, indicating the set of a current in that*

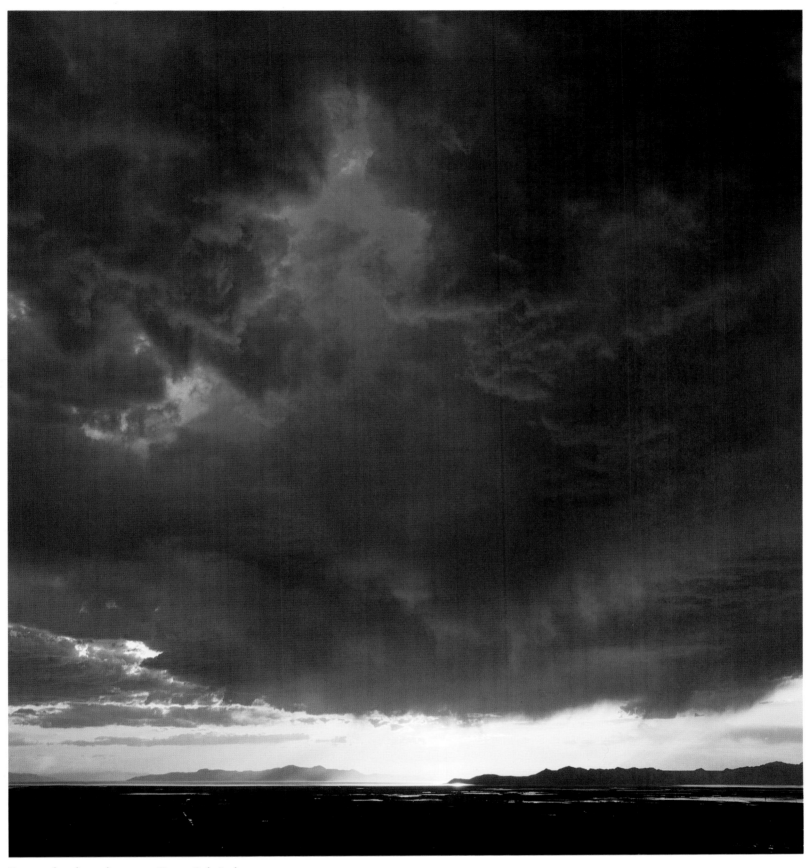

Storm clouds and sunset, Great Salt Lake

direction, and recalling the recollection of the whirlpool stories. The water continued to deepen as we advanced; the lake becoming almost transparently clear, of an extremely beautiful bright green color; and the spray, which was thrown into the boat and over our clothes, was directly converted into a crust of common salt, which covered also our hands and arms. . . .

. . . Among the successive banks of the beach, formed by the action of the waves, our attention, as we approached the island, had been attracted by one 10 or 12 feet in breadth, of a dark-brown color. Being more closely examined, this was found to be composed, to the depth of seven or eight and twelve inches, entirely of the larvae of insects [brine flies] about the size of a grain of oats, which had been washed up by the waters of the lake. . . .

. . . Carrying with us the barometer and other instruments, in the afternoon we ascended to the highest point of the island—a rocky peak, 800 feet above the lake. . . . As we looked over the vast expanse of water spread out beneath us, and strained our eyes along the silent shores over which hung so much doubt and uncertainty, and which were so full of interest to us, I could hardly repress the almost irresistible desire to continue our exploration; but the lengthening snow on the mountains was a plain indication of the advancing season, and our frail linen boat appeared so insecure that I was unwilling to trust our lives to the uncertainties of the lake. I therefore unwillingly resolved to terminate our survey here.

—John C. Frémont, 1843

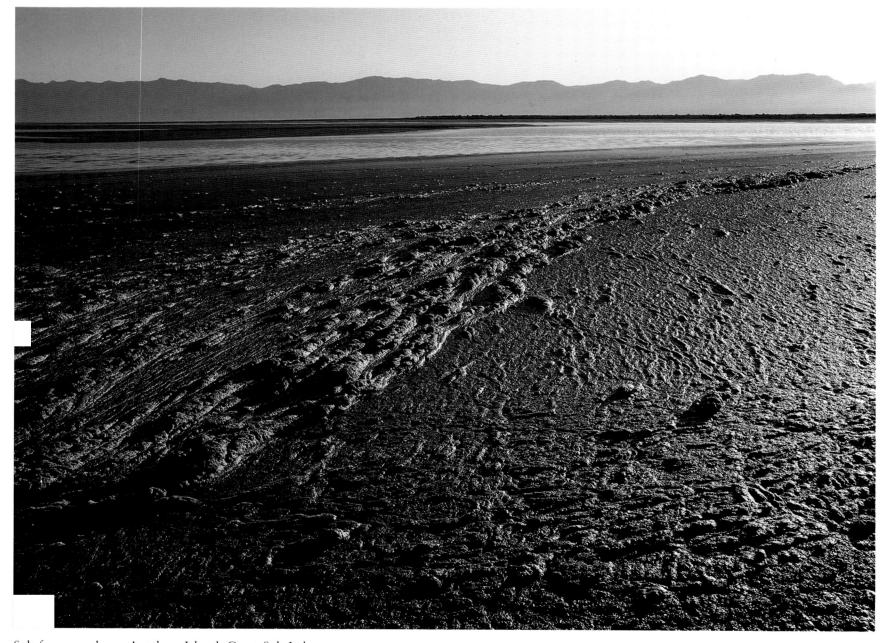

Salt foam on shore, Antelope Island, Great Salt Lake

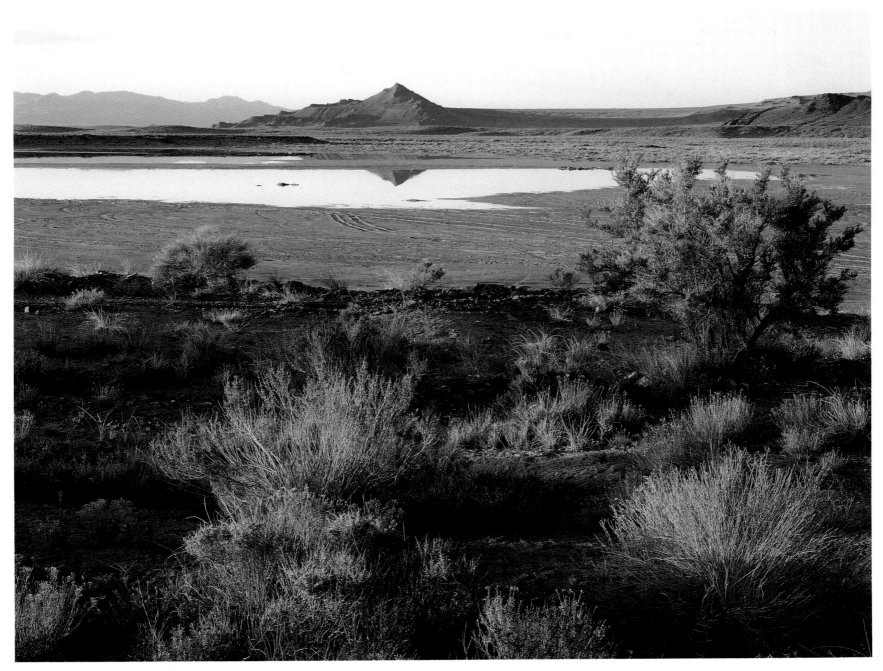

Small desert pool near Knolls, Utah

The contents of this Great Basin are yet to be examined. That it is peopled, we know; but miserably and sparsely. From all that I heard and saw, I should say that humanity here appeared in its lowest form, and in its most elementary state. Dispersed in single families; without fire arms; eating seeds and insects; digging roots, (and hence their name)—such is the condition of the greater part. Others are a degree higher, and live in communities upon some lake or river that supplies fish, and from which they repulse the miserable Digger. The rabbit is the largest animal known in this desert; its flesh affords a little meat; and their bag-like covering is made of its skins. The wild sage is their only wood, and here it is of extraordinary size—sometimes a foot in diameter, and six or eight feet high. It serves for fuel, for building material, for shelter to the rabbits, and for some sort of covering for the feet and legs in cold weather. Such are the accounts of the inhabitants and productions of the Great Basin; and which, though imperfect, must have some foundation, and excite our desire to know the whole.
—John C. Frémont, 1844

*As we proceeded, the plain gradually became softer, and our mules sometimes sunk
to their knees in the stiff composition of salt, sand, and clay. The traveling at length
became so difficult and fatiguing to our animals that several of the party dismounted.
. . . A cloud arose from the south, accompanied by several distant peals of thunder, and
a furious wind, rushed across the plain, filling the whole atmosphere around us with
the fine particles of salt and drifting it in heaps like newly fallen snow. Our eyes became
nearly blinded and our throats choked with the saline matter, and the very air we
breathed tasted of salt. . . .*

Lakes, dotted with islands and bordered by groves of gently waving timber, whose

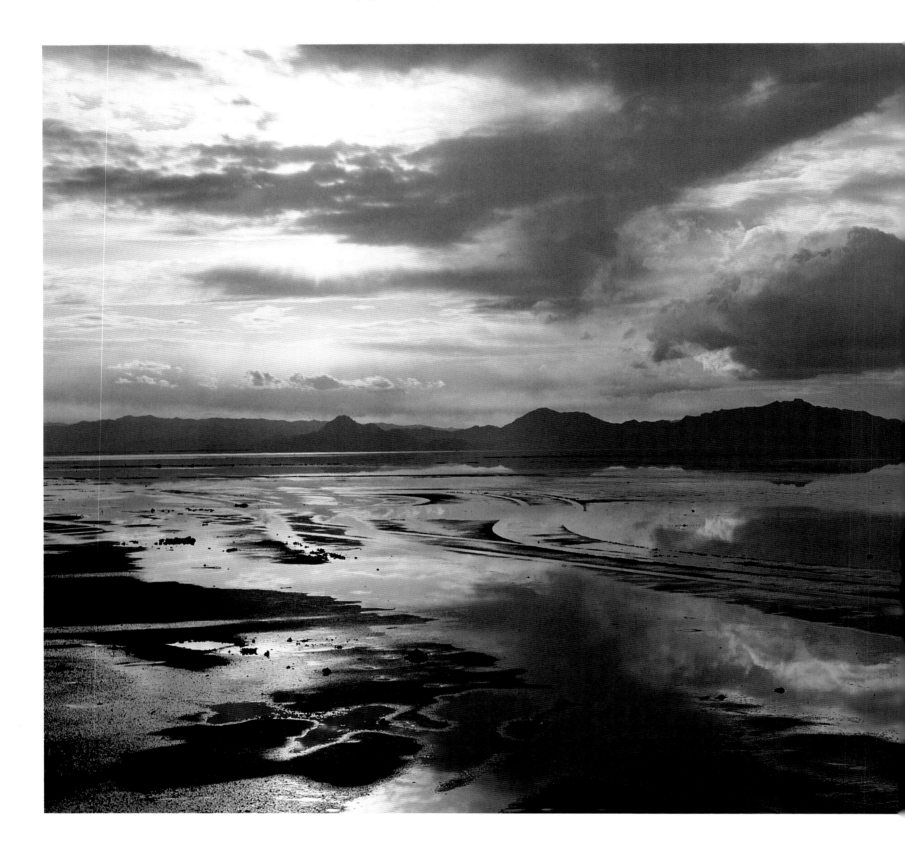

tranquil and limpid waves reflected their sloping banks and the shady islets in their bosoms, lay spread out before us, inviting us, by their illusory temptations, to stray from our path and enjoy their cooling shades and refreshing waters. These fading away as we advanced, beautiful villas, adorned with edifices, decorated with all the ornaments of suburban architecture, and surrounded by gardens, shaded walks, parks, and stately avenues, would succeed them. . . . These melting from our view as those before, in another place a vast city, with countless columned edifices of marble whiteness, and studded with domes, spires, and turreted towers, would rise upon the horizon of the plain, astonishing us with its stupendous grandeur and sublime magnificence.

—Edwin Bryant, on crossing the Salt Flats in 1846

Left: Sunset, Silver Island Mountains, Bonneville Salt Flats
Below: Dry alkali mud flats, Great Salt Lake Desert

It [Corinne] *was a gay community. Nineteen saloons paid license for three months. Two dance-houses amused the elegant leisure of the evening hours, and the supply of "sports" was fully equal to the requirements of a railroad town. At one time, the town contained eighty* nymphs du pave, *popularly known in Mountain-English as "soiled doves." Being the last railroad town it enjoyed "flush times" during the closing weeks of building the Pacific Railway. The junction of the Union and Central was then at Promontory, twenty-eight miles west, and Corinne was the retiring place for rest and recreation of all employees.*

—J. H. Beadle, Corinne citizen, 1870

Basalt boulders, Curlew Valley

I was compelled to remain there [in Corinne] *one night, and after inspection of the locality, and noting the number and variety of the faces of the men portion of the community, I deemed it best for the safety of my person and pocket to leave if possible. Looking eastward I happened to espy a neat looking town or village . . . about eight miles distant, and upon inquiry found that it was Brigham City, a thoroughly Mormon settlement but a place where one could stay with comparative comfort and safety. . . . I drew a long sigh of relief when Corinne was behind me.*

—Correspondent, New York *Herald,* 1869

Aspen trees, autumn, Monte Cristo Mountains

Deseret Peak and Skull Valley

The Northwest Quarter

STAND ATOP 11,031-foot Deseret Peak in the Stansbury Mountains after a lung-burning ascent of one of Utah's most beautiful mountains. On a clear day, you may not see forever, but you can see the entire northwestern quarter of Utah. And with that view comes a panorama of history.

Look south and a little west to the House Range west of Delta, and you look, in fact, far beyond history. This is the home of some of the earth's oldest animal fossils, crablike trilobites that 500 million years ago lived, bred, and died in the mud that aeons later hardened into the shales of these stark Cambrian-era mountains of the desert range.

Look north where, just beyond sight, is Red Rock Pass at the north end of Cache Valley. There, some 16,000 to 18,000 years ago, Lake Bonneville breached its northern rim and began what Frank DeCourten of the Utah Museum of Natural History has said might have been the greatest flood in the world's history. For weeks, 14 million or more cubic feet of water a second roared through the breach into the Snake and Columbia river drainages—roughly a third of the volume of all the world's rivers today. When it was over, the lake was 350 feet lower, to the level of today's Provo Bench. From its peak of 5,100 feet above sea level, Lake Bonneville intermittently shrank by a thousand feet in depth over the ensuing millennia to become the 30-foot-deep puddle we now know as the Great Salt Lake.

The rampart of the Wasatch, behind you, was the eastern shore of that 20,000-square-mile inland sea, and the western shore was the Deep Creek and Pilot Peak Mountains you see out there on the Nevada border. The mountain range on which you stand, the Stansbury, was an island. So were the others you see jutting out of the desert—the Fish Springs, Confusion, House, Thomas, and Dugway ranges; the Oquirrhs, Onaquis, and Sheeprocks, and, to the north, Stansbury, Antelope, and Fremont islands, as well as the Lakeside, Newfoundland, Silver Island, and Promontory mountains out there in the salt desert.

Look west to the Silver Island Range north of Wendover, where, in Danger Cave, University of Utah archaeologists in the 1950s dug through fifteen feet of accumulated sand and debris to discover the firepits and gnawed bones left by people who lived 10,000

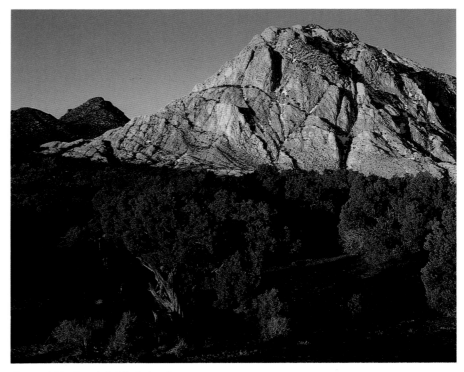

Crystal Peak with Utah junipers

105

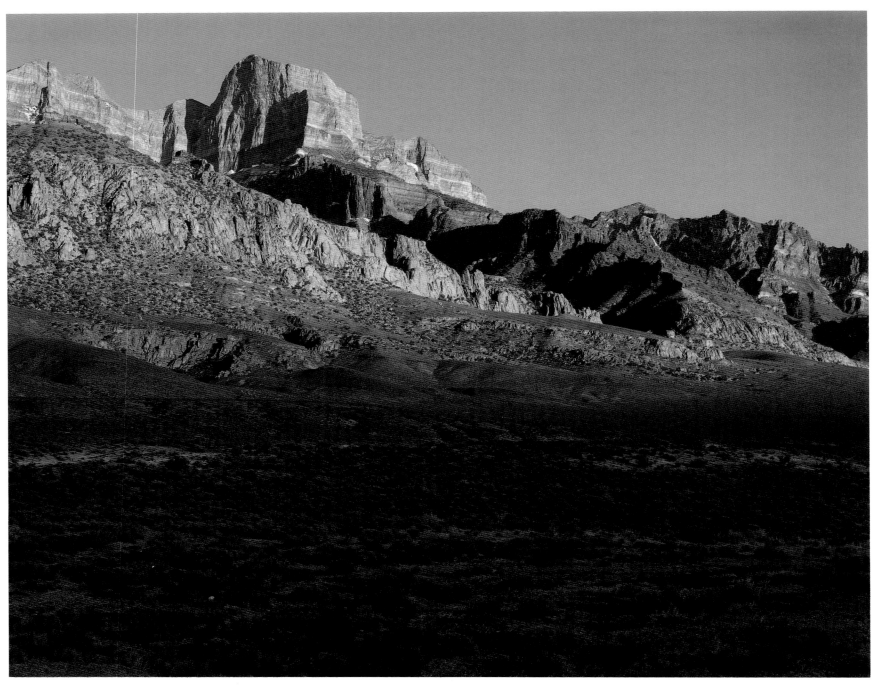

Notch Peak, House Range

years ago along the shores of Lake Bonneville. The National Register states: *"The thousands of artifacts of chipped and ground stone, bone, horn, antler, wood, leather, cordage, basketry, and shell* [found there] *were the basis for defining the Desert Archaic lifeway, a model of prehistory that has since influenced all scientific work done in the Western United States."*

The Travelers

Look down to the western base of the mountain on which you stand. There, in those patches of green, Jedediah Smith and two companions who in 1827 had survived a winter crossing of the Sierra and had become the first white men to cross the Great Basin, found lifegiving water after very nearly perishing in those shimmering wastes stretching out to the west. Understandably, Jedediah didn't speak fondly of the real estate he had just crossed, or of its naked Goshute inhabitants, who, he wrote, *"appeared the most miserable of the human race having nothing to subsist on except grass seed, grasshoppers, &c,"* and who, he concluded, *"form a connecting link between the animal and intellectual creation and quite in keeping with the country in which they are located."*

Look sixty-five miles out to the southwest, where, at the south end of the Salt Desert, lie the ponds of Fish

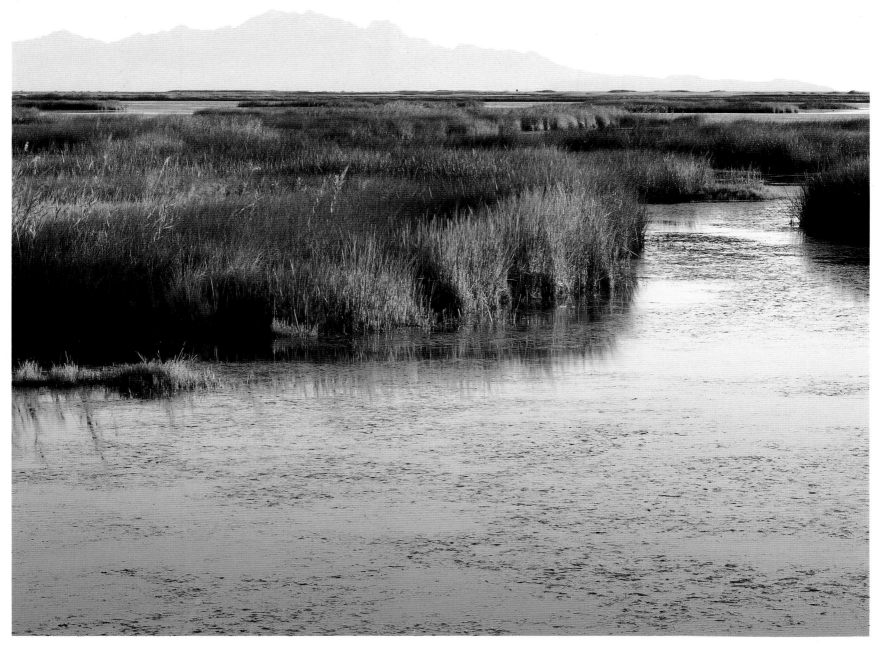

Fish Springs, with Deep Creek Mountains in background

Springs, now a national wildlife refuge. Jedediah and his companions got their last drinks of water there before pushing out into the desert on a route that missed the cold, sweet water of Simpson Springs. After a day of traveling and a waterless camp, he wrote that, *"I started very early in hopes of soon finding water. But ascending a high point of a hill* [in the Dugway Range] *I could discover nothing but sandy plains or dry rocky hills with the exception of a snowy mountain* [Deseret Peak] *off to the NE at a distance of 50 or 60 miles. When I came down I durst not tell my men of the desolate prospect ahead."*

This was in midsummer, and Jedediah wrote of the ordeal that followed: *"To us worn down with hunger and fatigue and burning with thirst increased by the blazing sand it was almost insupportable."* To Robert Evans, one of the three, it *was* insupportable; on the third day without water, he lay down to die. But Deseret Peak was close now. Three more miles and *"to our inexpressible joy we found water. Goble plunged into it at once and I could hardly wait to bath my burning forehead before I was pouring it down regardless of consequence."* Rushing back with water, they reached Evans in time to save his life.

What a difference a little water makes! After reaching the south shore of Great Salt Lake a day later, Jedediah wrote: *"Those who may chance to read this at a distance from the scene may perhaps be surprised that*

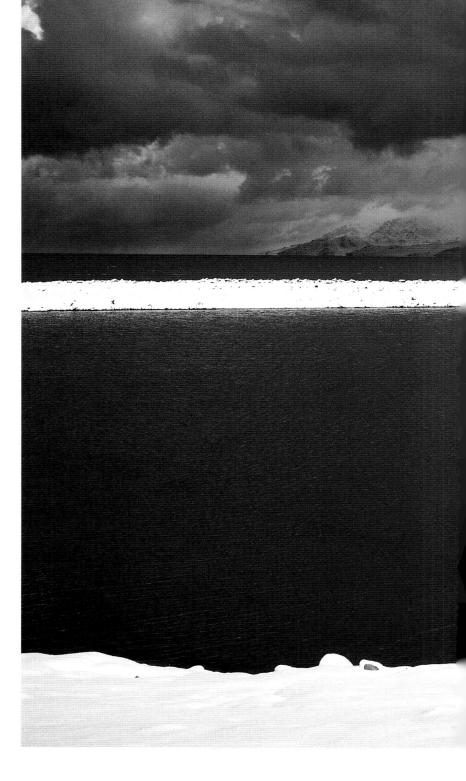

Right: Storm clouds and snow at Great Salt Lake
Below: Boulders and road on Antelope Island, Great Salt Lake

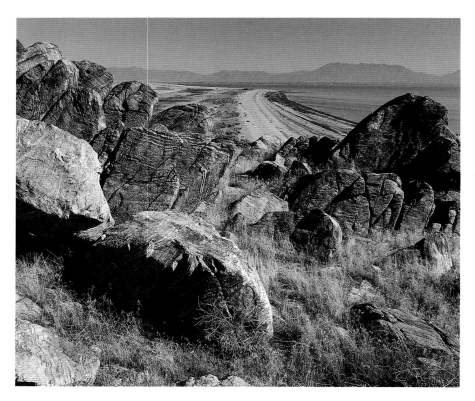

the sight of this lake surrounded by a wilderness of more than 2000 miles diameter excited in me those feelings known to the traveler who after long and perilous journeying comes again in view of his home. But so it was with me for I had traveled so much in the vicinity of the Salt Lake that it had become my home of the wilderness."

Look a bit north of west, now, to the vast white expanse of nothingness the maps call the Great Salt Lake Desert but locals call simply the Salt Flats. Flat they

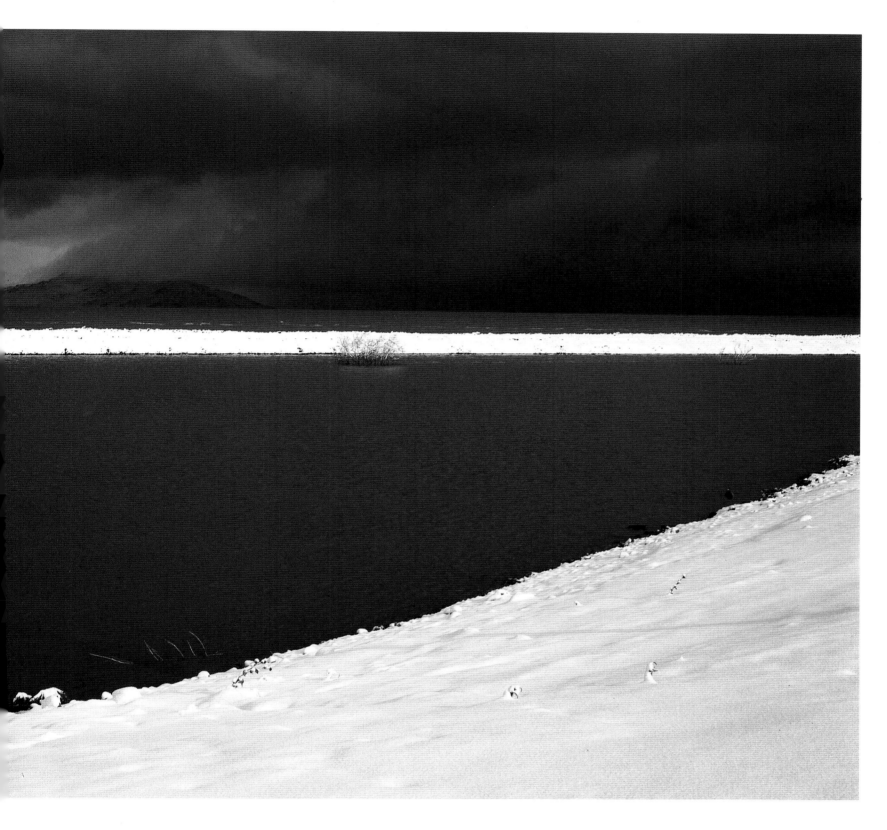

are—so flat that, watching a distant truck approaching on the freeway, you can actually see the curvature of the earth. And lifeless—for much of its 4,000 square miles, nothing grows in this mud-and-salt bed of a long-vanished lake.

A level, straight-line-shortest-distance-between-two-points route ought to make the Salt Flats a highway to the West. It didn't, at least not for many years; some who attempted it found it a deadly trap. There were few who tried. Jedediah Smith had skirted the southern edge in 1827. Joe Walker, leading a detachment of Captain Benjamin L. E. Bonneville's expedition to California, had circled the northern edge in 1833. So had the California-bound Bartleson-Bidwell party in 1841, the first to bring wagons into the Great Basin. It remained for John C. Frémont, the first and unarguably the greatest scientific explorer of the West, to make the first recorded tracks through the heart of the Salt Flats.

In 1845, following his 1842 expedition to the

Rockies and his much longer 1843–44 expedition to Oregon and California, Frémont published the report and map that Brigham Young would follow, two years later, to Salt Lake Valley. Beautifully drawn by his surveyor/cartographer, George Preuss, the map describes the country Frémont saw on the Oregon Trail, down the interior valleys of Oregon and California, and along the Old Spanish Trail from Los Angeles to the Wasatch. In a long line of type curving on the map from the Blue Mountains of Oregon to the Mojave Desert of southern California, he noted: *"THE GREAT BASIN: diameter 11° of latitude, 10° of longitude: elevation above the sea between 4 and 5000 feet: surrounded by lofty mountains: contents almost unknown, but believed to be filled with rivers and lakes which have no communication with the sea, deserts and oases which have never been explored, and savage tribes, which no traveler has seen or described."* This was not quite accurate, however; in 1776 the Spanish friar Escalante had done an excellent job of describing the Indians he and Dominguez found along the shores of Utah Lake as well as the bearded Utes to whom they preached in the Black Rock Desert. Travelers on the Old Spanish Trail also had described Indians they encountered in southern Utah.

On that 1845 map, the first to name the Great Basin, the vast region from the Sierra Nevada to the Wasatch is completely empty. Frémont's next map, published just three years later, filled in much of that blank. The Oquirrhs, the Stansburys, Silver Island, the Deep Creeks, and the Pilot Peak area were fairly accurately shown, and this time, instead of showing Utah Lake as an arm of Great Salt Lake, he got it right, with the Utah [Jordan] River connecting them. Guided by Kit Carson and Joe Walker, Frémont had gained that knowledge in his 1845 third expedition through much of the Great Basin, including the first crossing of the Salt Flats and the naming of Pilot Peak.

Frémont spent two weeks exploring the vicinity of Great Salt Lake, and published the first descriptions of this strange place:

The shores of the lake, especially on the south side, are whitened with incrustation of fine white salt. The shallow arms of the lake, under a slight covering of briny water, present beds of salt extending for miles. Plants and bushes blown by the winds upon these fields are entirely incrusted with crystallized salt. . . . We could find in it no fish, or animal life of any

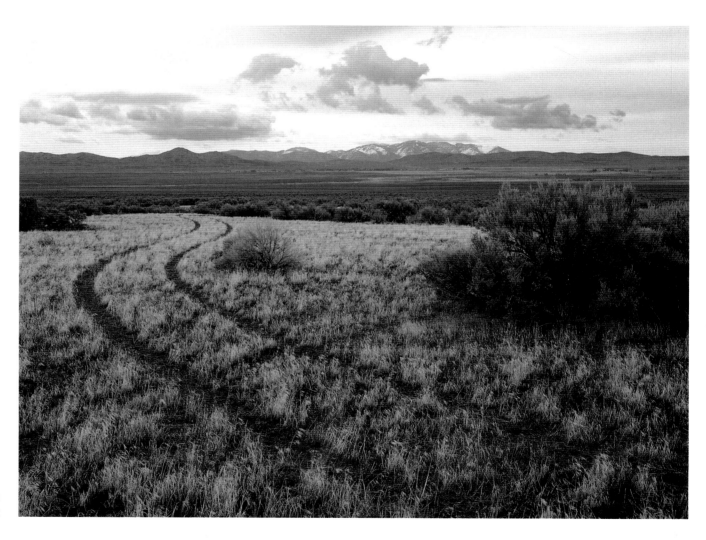

Vehicle tracks in grass, West Desert

Sunset, Great Salt Lake at Willard Bay

kind, the larvae which were accumulated in beds on the shore being found to belong to winged insects [brine flies]. On the contrary, the upper lake—the Timpanogos [Utah]—which discharges into this by a stream about thirty-five miles long, is fresh water, and affords large trout and other fish in great numbers. These constitute the food of the Indians during the fishing season.

Frémont does not seem to have been adventuresome enough to take a dip in the Great Salt Lake, as the exuberant young California-bound traveler, Heinrich Lienhard, did the following year, leaving this account: *"For learning to swim, no water in the whole world is so well adapted as the Salt Lake; here, at the mouth of an inflowing fresh water stream where one*

could choose gradually lighter water, one could safely learn how to be a perfect swimmer. . . . Only a single feature had the swimming in this lake that was not conducive to pleasure; this consisted in the fact that when one got a little water in one's eye, it occasioned a severe burning pain; and after we reached the shore and dressed ourselves without first washing in unsalted water, being desirous of hastening on, we soon experienced an almost unbearable smarting or itching over the whole body where the salt water had filled up all the crevices of the skin with an all-enveloping deposit of salt."

But, with Kit Carson, Frémont did splash through the shallows to the lake's largest island. *"The floor of the lake was a sheet of salt resembling softening ice, into which the horses' feet sunk to the fetlocks. On the island we found grass and water and several bands of*

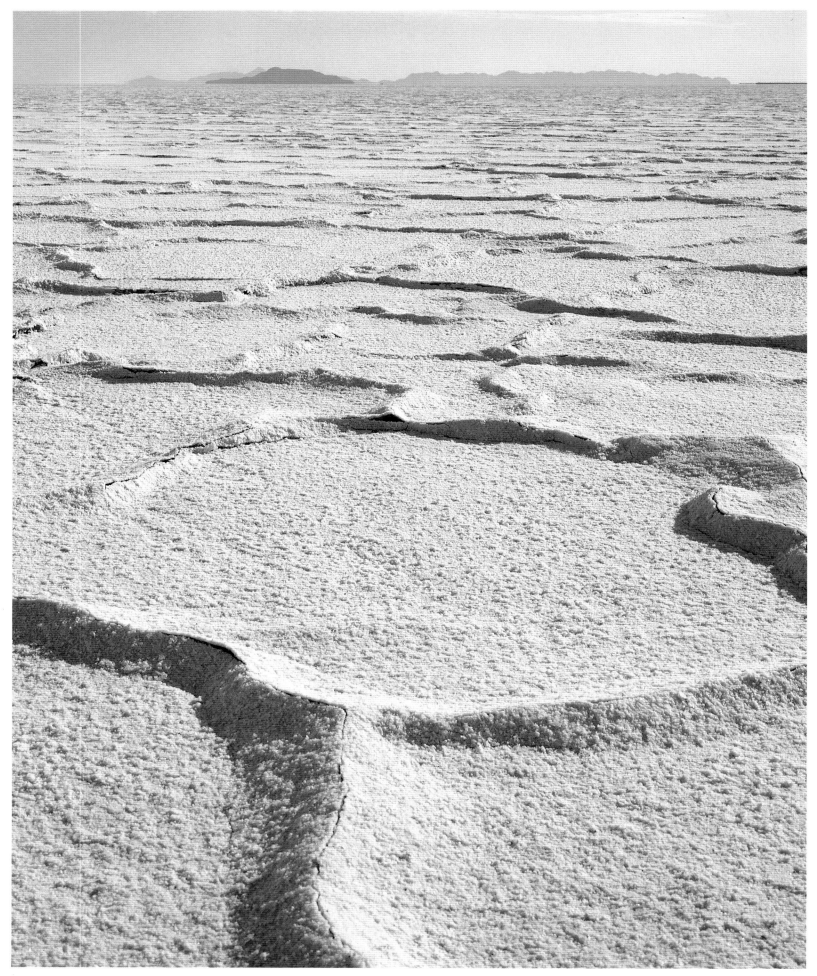

Rippled salt formations, Bonneville Salt Flats

Pilot Peak at sunrise from desert near Knolls

antelope. Some of these were killed, and, in memory of the grateful supply of food they furnished, I gave their name to the island."

Frémont now faced, with apprehension, the ordeal of crossing the Salt Flats. His Indian guide *"declared to us that no one had ever been known to cross the plain, which was desert; so far as any of them had ventured no water had been found. It was probably for this reason Father Escalante had turned back."* (In this he was mistaken; Escalante came no closer than seventy miles to this place. He turned back near the present site of Milford, far south of the Salt Flats.) But Frémont was hopeful. Eighty miles across the Flats, he saw *"a peak-shaped mountain. This looked to me to be fertile, and*

it seemed safe to make an attempt to reach it." But he was also cautious, sending Kit Carson and two other men to cross the Flats by night and light a signal fire if they found water. They did, and Frémont followed, finding the surface *"absolutely bare and smooth as if water had been standing upon it"*—which, in fact, it had. *"To the friendly mountain I gave the name of Pilot Peak. . . . Some time afterward, when our crossing of the desert became known, an emigrant caravan was taken by this route, which then became known as the Hastings Cutoff."*

The next year, James Hudspeth guided one of those caravans, the nine-man, mule-mounted Bryant-Russell party, to this place. He had ridden eastward over the

Flats earlier that season with Lansford Hastings, the optimistic, if irresponsible, promoter who later lured several California-bound caravans to his cutoff. So Hudspeth knew the Flats well. As he left the party at the edge of the salt to do some exploring of his own, his instructions were succinct and clear: "Now, boys, put spurs to your mules and ride like hell!"

They did, and crossed those deadly miles in seventeen hours. Despite his haste, Edwin Bryant's articulate journal records the remarkable description quoted at the beginning of this chapter.

There was none of that kind of eloquence in the largest party to cross during that fateful year of 1846. By the time they reached the Flats, the Donner-Reed party was late, discouraged, worn out by their crossing of the Wasatch, and riven by dissension. They spent four days slogging through the salt, and another seven

resting at Pilot Springs, rounding up oxen, and retrieving wagons from the salt. But some thirty-six oxen were never found, and four wagons remained in the Salt Flats. Two of them were abandoned by James Reed, who had entered the desert with eighteen oxen and left it with one ox and a cow. Far worse was to come. Long delayed, the eighty-seven men, women, and children were caught in early Sierra snows. Barely half survived the horror of cold, starvation, and cannibalism that followed.

For 140 years, long, parallel lines under a glaze of salt marked where the party's wagons had churned up the mud. As we found in a University of Utah-sponsored expedition across the Salt Flats in 1962, low mounds holding ox bones, rotted or corroding wagon parts, or pitiful bits of personal and household goods testified of the tragedy. No more. In the early 1980s

Russian thistle in plowed field near Cedar Fort with Wasatch Mountains in background

Simpson Springs, West Desert

several especially wet years had raised the lake to a level that was threatening the railroad, highways, and lakeside industries. Among several proposals to solve the problem—including doing nothing except wait for the dry years that history said would surely follow— the state chose to create a second lake to the west, to increase evaporation. In 1987 giant pumps began flooding the Flats—just as the predicted dry spell began. The lake went down anyway, miles of dikes stand dry and ugly, the historical traces are gone, the pumps are locked in storage from which no one knows if they can ever be retrieved, and the taxpayers are $70 million poorer.

From a boat on the lake, an ATV on the Salt Flats, or afoot slogging through the mud of the east shore marshes, the world seems awfully big, the traveler awfully small. To the east, the familiar rampart of the Wasatch gives a comforting sense of place and safety.

But to the west or south or north, depending on just where you are, desert islands or desert ranges shimmer in the distance beyond the earth's curvature, and what you sense is space—a great deal of space.

Atop Deseret Peak you can look out to where, in different ways and with remarkably different results, men strove to deal with space. Off to the north, a thin, black line cuts arrow-straight across the middle of the Great Salt Lake from Little Mountain on the east shore to Lakeside on the west, by way of Promontory Point. This is the Lucin Cutoff, and what you mostly see is the Southern Pacific Railroad causeway, the third generation of a century-long effort to shorten the space of Great Salt Lake country by rail. The company completed the causeway across the deepest part of the lake in 1956, destroying fair-sized mountains for the rock fill needed to build a solid bed 13 miles long, 60 to 70 feet deep, 400 feet wide at the bottom, and 40 feet

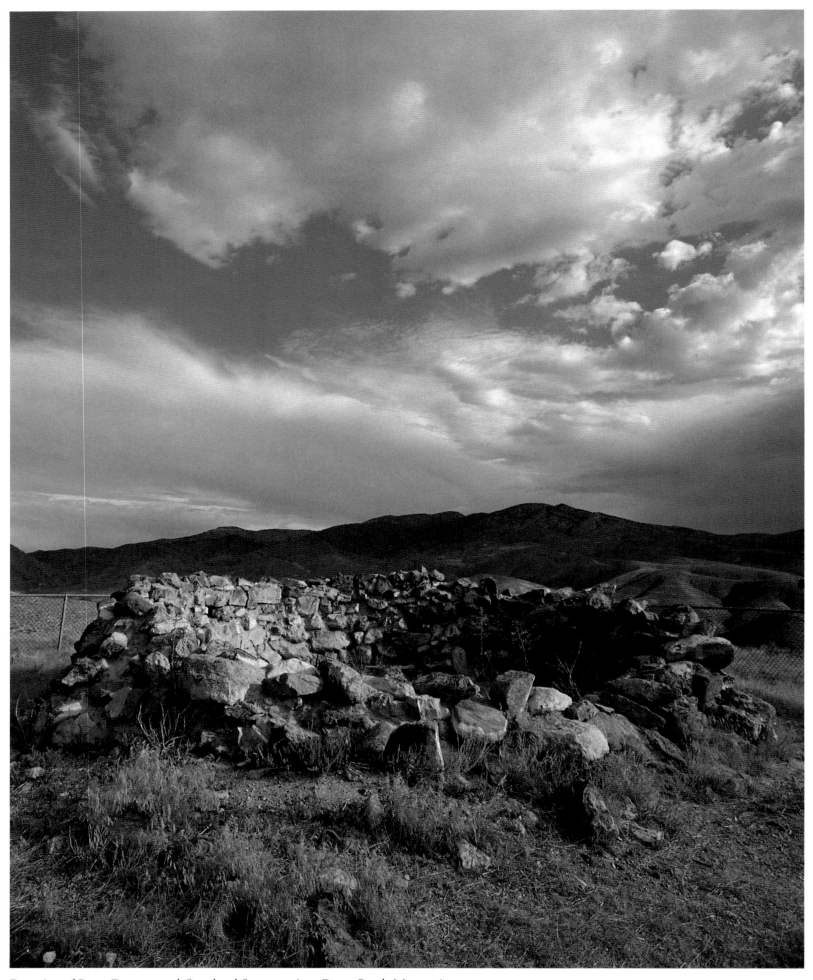

Remains of Pony Express and Overland Stage station, Deep Creek Mountains

wide at the top. That mammoth effort replaced the old wooden trestle of the first 102-mile Lucin Cutoff, built in 1902–03 at a cost of eight million dollars and 38,000 trees. With the new causeway, no longer would trains have to creep across the trestle at trotting-horse speed, and no longer would crews have to worry about fire (which destroyed part of the trestle in 1951) or ice. Ice? In the Great Salt Lake? Yes. In extremely cold weather, fresh water flows over the heavier brine, freezes, and can build into battering-ram ice floes twenty feet high or more.

And the original Cutoff: it cut forty miles of the rail distance to California and eliminated the tortuous climb to Promontory Summit. As the tourist brochures proclaimed at the time, it gave passengers the unique experience of "going to sea by rail." But it also bypassed the site of what historians agree is one of the five most significant events in America's history—the joining of the nation by rail.

The building of the transcontinental railroad is a story well known. How the Union Pacific built west from Omaha with track crews largely Irish, and the Central Pacific built east from Sacramento with crews largely Chinese. How enormous government subsidies and shady financial dealings made the railroad's financiers some of America's wealthiest men. How the grant of twenty sections of land for each mile of completed rails turned the enterprise into a frantic race that completed 1,776 miles of track in less than four years, a record unequaled anywhere. How greed reached the point that the crews passed each other and built 225 miles of parallel grade, side by side, until sanity returned and Congress decreed that the rails would be joined at Promontory Summit.

Ranch, Ibapah Valley, with Deep Creek Mountains in background

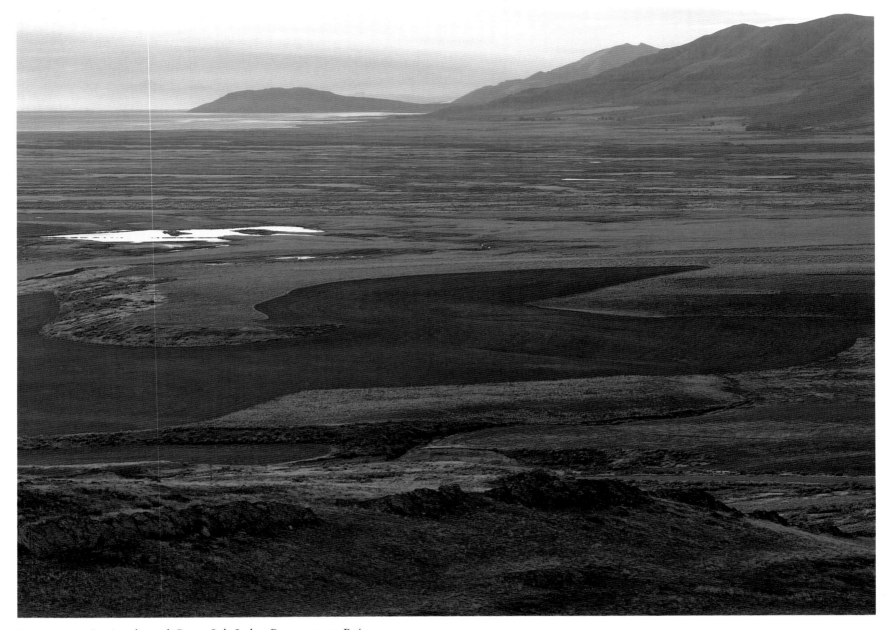

Promontory Peninsula and Great Salt Lake, Promontory Point

There, at the Golden Spike National Historical Site, the story is told, complete with a reenactment of the moment when the two locomotives, Jupiter and No. 119, nosed together after the final spike was driven. But to get a real feel for the heroic—and wasteful—effort that brought the rails together, take the three-quarter-mile walk along the deep cut the crews blasted through the solid limestone of the summit ridge. There, near the top, the two companies built the last, and biggest, of the fills and trestles needed to climb Promontory Mountain. The Central Pacific built solidly, using 10,000 yards of rock for its "Big Fill," 170 feet deep and 500 feet long. In its haste, the Union

Pacific built nearby a shaky log trestle of equal size, intending to replace it later with a fill.

If you have plenty of time and patience and your car a good set of shock absorbers, drive sixty miles or so west from Promontory on the old railroad grade—choosing the Central Pacific, which is far more substantial than the Union Pacific grade a few feet away. The route takes you past the ponds of Locomotive Springs, astonishingly big and deep for such a desolate place next to the saltiest part of Great Salt Lake. And it takes you directly to Kelton, one of the ghostliest of Utah's ghost towns. Stagecoaches and freight wagons met the railroad here for the long haul to Boise and the

Oregon country beyond. Crumbling loading platforms and a weed-choked cemetery remain from the days when the past met the future and the West was being forever changed.

Another reminder of changing times is the dim line seen from Deseret Peak snaking through the desert from Johnson Pass through the restricted Dugway Proving Grounds and U.S. Air Force Test and Training Range, past Granite Peak, to join the old Pony Express route east of Callao. This was to be the western Utah section of the transcontinental Lincoln Highway. The story of how that never happened is a little-remembered one of broken trust and national scandal.

In 1913, with obvious self-interest, the nation's auto and tire companies set out to get America out of the mud. Their most ambitious goal was a transcontinental highway, to accomplish which they formed the Lincoln Highway Association and contracted with states along the route to construct, at Association expense, their sections of the highway. Utah's section, after coming down Echo Canyon and to Salt Lake City, was to go across the southern end of the Great Salt Lake Desert and connect with the Nevada section at Ibapah. Ely was to be the junction of the Lincoln Highway running on to San Francisco with another highway swinging south to Los Angeles.

Clouds over Deep Creek Mountains

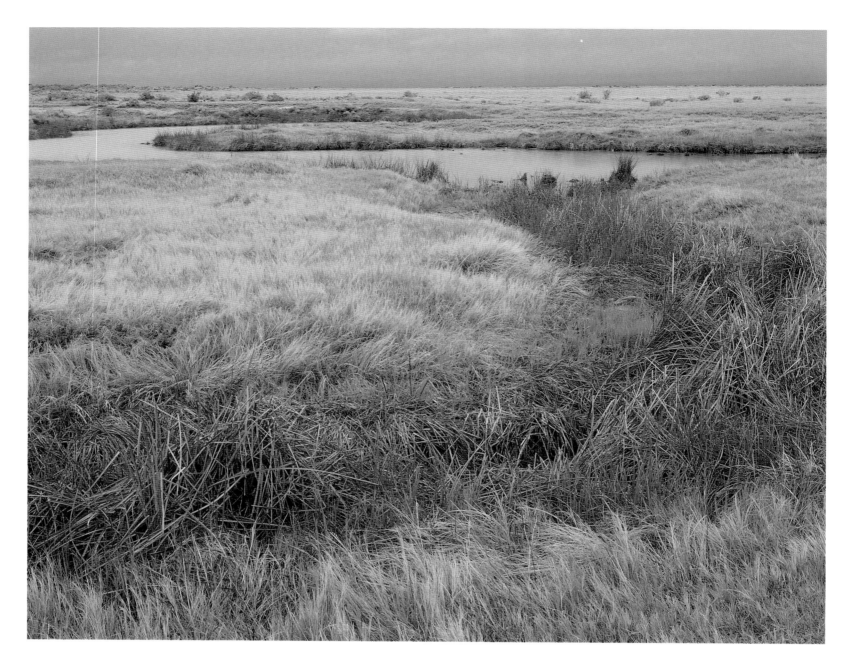

Above left: Horseshoe Spring, Skull Valley
Above right: Lone Rock, Skull Valley
Right: Sunset, Silver Island Mountains and flooded Bonneville Salt Flats

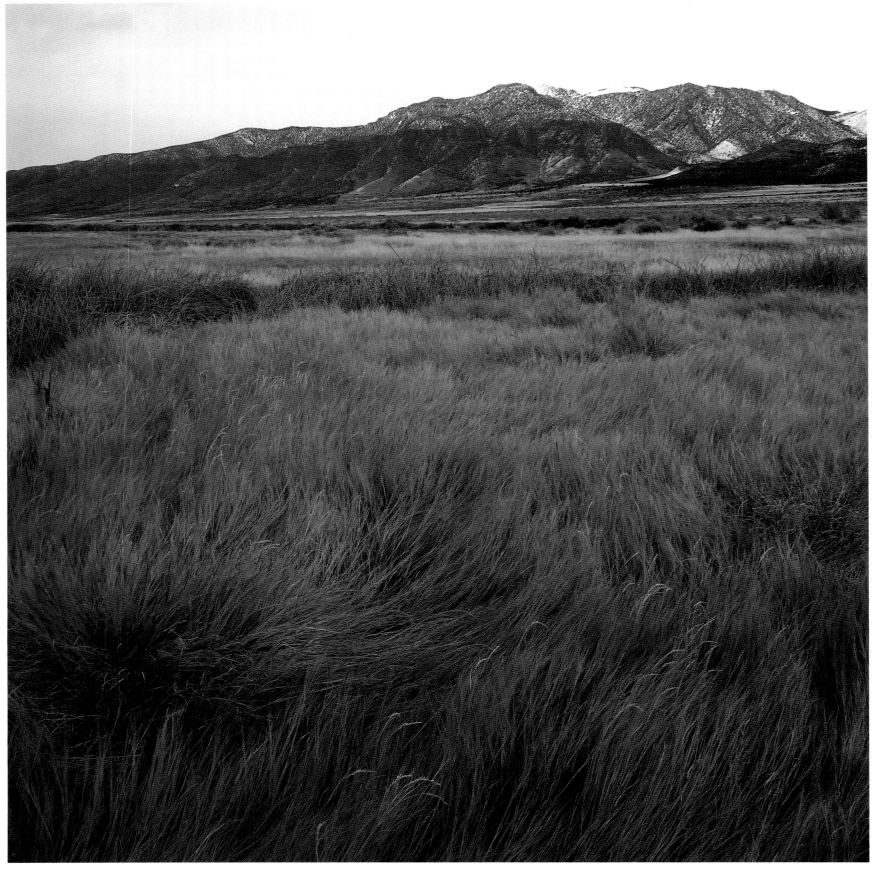

Cedar Mountains with windblown bunchgrass

Utah's section of highway was to be completed by 1919. That's the way the contract was signed, and a considerable amount of money changed hands. But Utah's decision-makers saw it differently. Salt Lake City, not Ely, should be the junction city, they felt. Though Nevada dutifully finished its section from Ely to the border, Utah never did. Instead, in 1925, it opened Highway 40 across the Salt Flats to Wendover

and formally removed the Lincoln Highway section from the state road system. The Association was outraged; its *Fifth Biennial Report* for the years 1917–18 called Utah's failure to complete its work "rank repudiation of contract which could fairly be stigmatized as dishonorable." But the strategy worked. The route—now I-80—is forty miles shorter, although its wisdom came into question in the mid-1980s when the lake's rising waters lapped over the asphalt. Ely remained a backwater mining town.

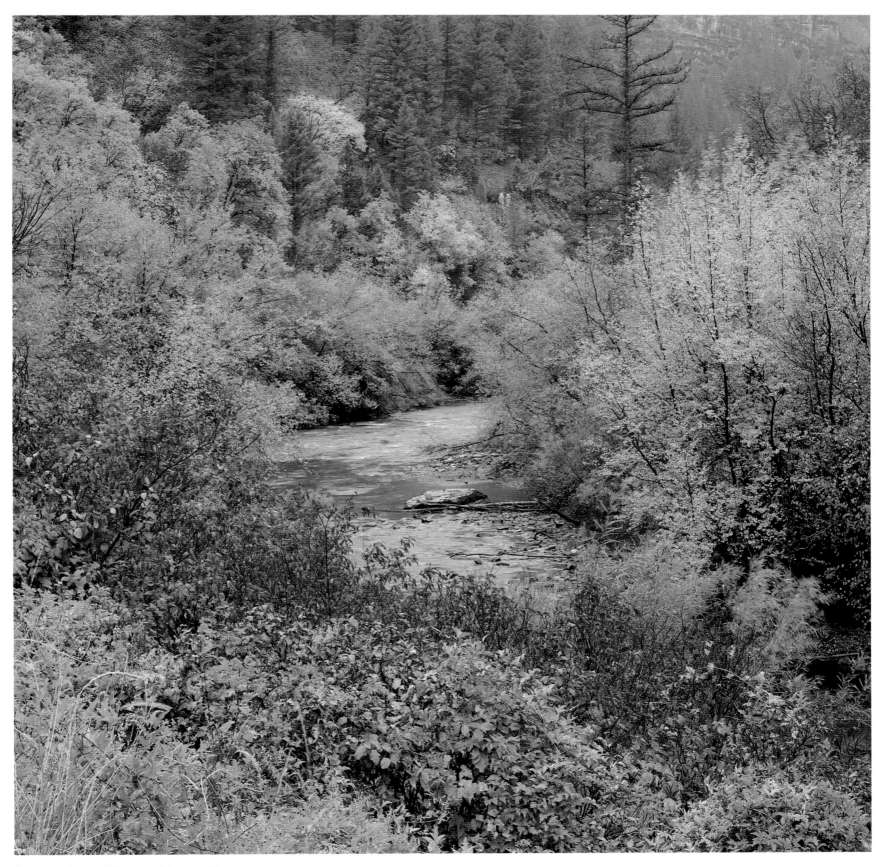

Autumn, Logan River and Logan Canyon

Red weeds in swampy ravine, Honeyville

Out on the Flats adjacent to I-80 men tried to conquer space in a different way. There, in 1925, Ab Jenkins, later to become Salt Lake City mayor, astonished the motoring world by driving for twenty-four hours at an average speed of 112.9 miles an hour. The Salt Flats, left brick-hard and perfectly smooth by evaporating water, quickly attracted others. Britain's John Cobb and George E. T. Eyston joined Jenkins in competition that in 1939 pushed the twenty-four-hour average to 161 miles an hour—with Jenkins still the winner. Meanwhile, in 1935, Sir Malcolm Campbell's *Bluebird* roared through a measured mile at 301 miles an hour. Cobb and Eyston jumped into that competi-

tion, too, and year by year the record rose until, in 1939, Cobb reached what seemed to be the limit for piston-driven engines—368.9 mph.

In more recent years, jet engines have pushed the land speed record much higher—to 622 mph, in fact, in 1972. But to those of us who have trembled with excitement as a tiny object appeared from beyond the earth's curvature and grew with incredible speed into a long, sleek racer that arrived only seconds after the roar of its sixteen-cylinder engine, rocket-car speed records are irrelevant. They belong to a high-tech age that somehow doesn't quite seem to fit into the ambience and traditions of these desert wastes.

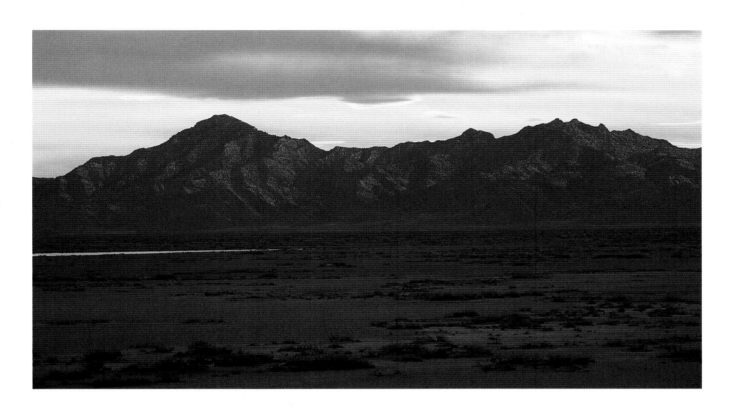

Above: Newfoundland
Mountains
Right: Granite formation in
Granite Canyon, Deep Creek
Mountains

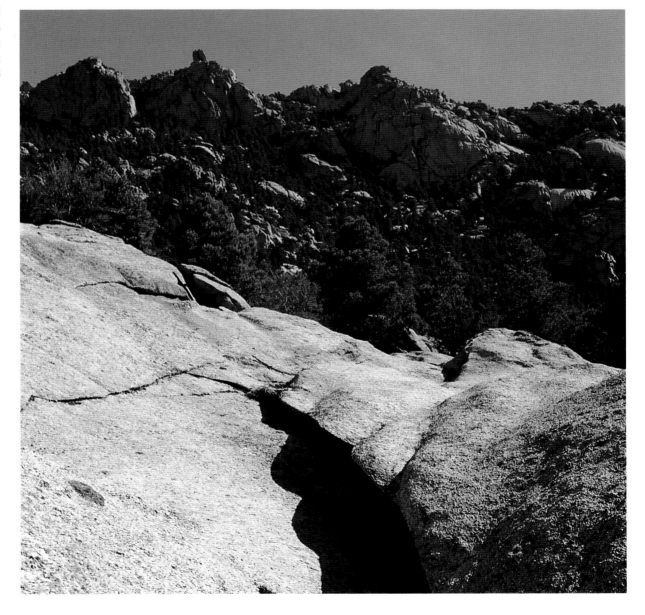

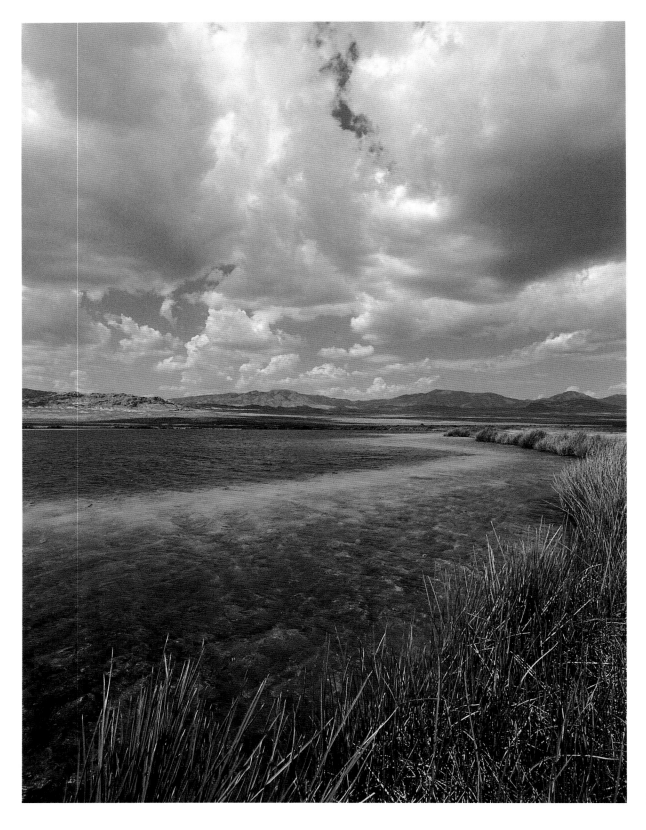

Blue Lake near Wendover

It's empty in the west desert. Except for Delta and its surrounding towns, the Goshutes on their Deep Creek reservation, and the Utah part of Wendover, you'd be hard-pressed to find a thousand residents in all that vast area of the state north of Highway 6 and west of the Stansbury Mountains. Whether it is the isolation, the strangeness of the land, or its harshness, the people you find out there are apt to be . . . well, different.

Men such as Cecil Garland. How likely are you to find in a place like Callao, at the foot of the Deep Creek Mountains—no pavement, no stores, no telephone lines, a boarded-up, one-room school—a rancher who would fight to a standstill the Pentagon's insane plan to build the

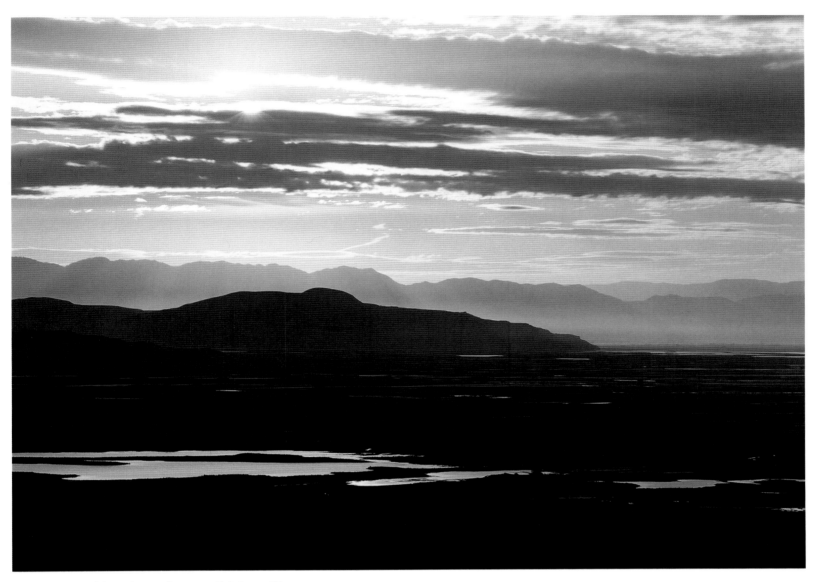

Sunrise, Box Elder Mountains near Brigham City

"racetrack" MX missile system in Utah's desert? Or who would lead a peace delegation to Moscow? Or who, surrounded by Sagebrush Rebellion-type ranchers, would declare himself a Sierra Club environmentalist?

Or women like Nancy Holt. How but "different" can you describe a woman who spent two years of her life and $60,000 putting what appear to be four sewer pipes—real big ones; eighteen feet long, nine feet in diameter—out in the remotest part of the desert? The X-shape in which they are laid appears to be random—unless you are there at the times of the solstices. Then, in the summer, the rising or setting sun shines directly through one pair of tunnels, in the winter the other. The effect is stunning. And there is not only that; but holes are bored in painstakingly located spots on the tunnels so that . . . but let Ms. Holt describe it. As she wrote in the *Deseret News*:

There are times when the sun is directly over a hole and a perfect circle is cast. Day is turned into night, and an inversion of the sky takes place: stars are cast down to Earth, spots of warmth in cool tunnels. . . .

At night, the moon can cast a pattern of light. The moonlight shines through the holes in different positions and with a different intensity than the sunlight does. In the moonlight the tunnels seem to glow from within their own substance, the rims of the tunnels forming crescents in the night. As you move through the tunnels, the moon and stars and planets can be lined up and framed through each hole. Looking up through the holes on a bright night is like seeing the circles of light during the day, only inverted.

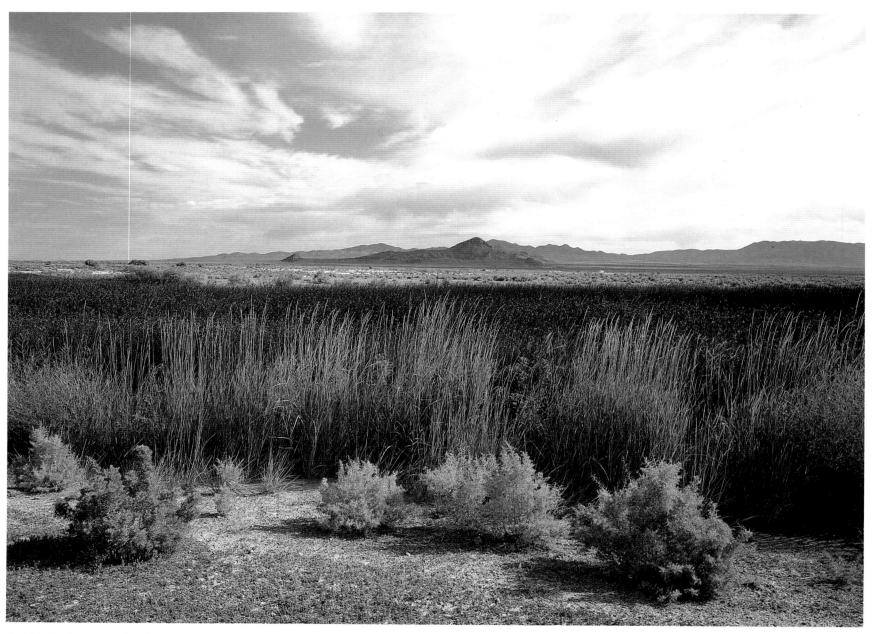

Rabbit Springs near Lucin

It was while looking for the Sun Tunnels that I met two other memorable desert characters: Harold Jewel and his buddy Jake.

"Welcome to Lucin Village," the sign read. "Altitude 4496. Population 18." But the sign was outdated. It should have read: "Population 3. And 17 dogs. One of which can talk. And do square roots. And quote Shakespeare. And read minds."

Lucin squats out in the northwestern corner of Utah between the Pilot Peak Range and the northern arm of the Salt Flats. It's where the old Central Pacific Railroad line over Promontory joined its replacement, the Lucin Cutoff across the lake. For nearly a century it was an important stop for filling boilers with water piped down from the mountains.

Diesel ended all that, as it ended much of the romance of railroading. The empty water towers bake in the desert sun. The houses are mostly gone. Antelope wander through town. The rails still stretch east and west, but nothing stops. There's no longer even a horn sounded as the trains rumble by.

But maybe someone there could tell me how to find the Sun Tunnels. Harold Jewel turned out to be the someone. Hair past his shoulders, a Santa Claus beard, thick horn-rim glasses held together by gobs of glue, sockless, wearing a greasy cap and a shirt that might once have been plaid, he looked the prototypical desert rat. But no. He had come to this desert ghost town nine months earlier, after a career as a marine engineer, scuba-diving instructor, porpoise trainer,

collector of exotic shells, and underwater rescue expert in Hawaii.

Why Lucin?

"I had hiked every trail in Hawaii, caught every kind of fish, swam with wild porpoises in the open ocean, collected some of the world's rarest seashells. My life was getting repetitive. I wanted something as different as possible." He looked out over the shimmering desert. "I guess I found it."

What Jewel was doing out here, besides making jewelry and prowling the desert for gemstones and fossils, was breeding dogs. Not just any dogs, but Weimaraners, a breed of silver-grey hunting dogs known for intelligence.

"Would you like to meet Jake? He talks."

I would. Jake is whistled out of the uproar of seventeen dogs housed in an old trailer. We sit under 100-year-old cottonwoods, and the conversation goes like this:

"I love you, Jake. Do you love me?"

Jake says yes, and kisses Jewel.

"What's your name?"

Jake utters something between a bark and a whine. Let's call it a moan. It's the closest a dog's vocal chord can come to speech, Jewel explains.

"What's two plus one?" Three moans.

"What's four take away two?" Two moans.

"What's the square root of 16?" Four moans.

"What's the cube root of 729?" Nine moans.

"Okay, Jake, let's sing 'Yankee Doodle Dandy.' " They do; sort of. This is followed by a rendition of Chaucer's Prologue to the *Canterbury Tales*.

"Now," says Jewel, "This will really blow your mind. Whisper to me a quotation from literature. I'll think it and Jake will repeat it."

"Okay, let's try Polonius' advice to Laertes: To thine own self be true, etcetera."

Nose to nose, eye to eye, Jewel exhorts: "Concentrate now, Jake. What am I thinking?"

A considerable pause while Jake concentrates. Then a whole series of moans of varying pitches and volume.

"See, what did I tell you? Did you ever see anything like that?"

To be honest, I couldn't really understand what Jake was saying. But then neither can I understand what my two-year-old granddaughter says. Her older brother can, though, and so can her mother, sometimes. Jewel says he understands Jake, and who am I to disbelieve?

If you don't believe, drive out and see. It's only sixty miles of dirt road north of Wendover, and both Harold and Jake—if they're still there—will be glad to chat with you.

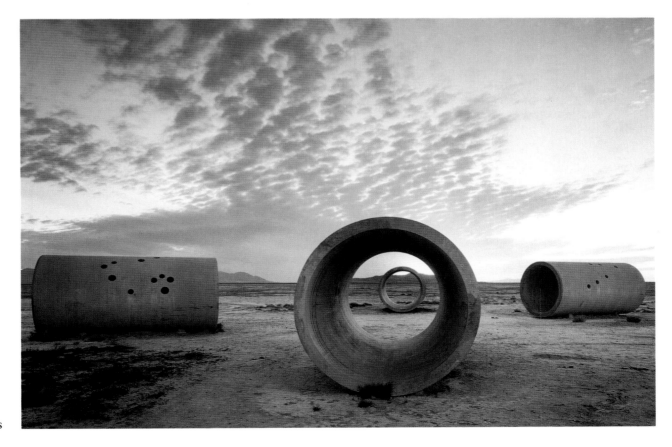

Sun tunnels

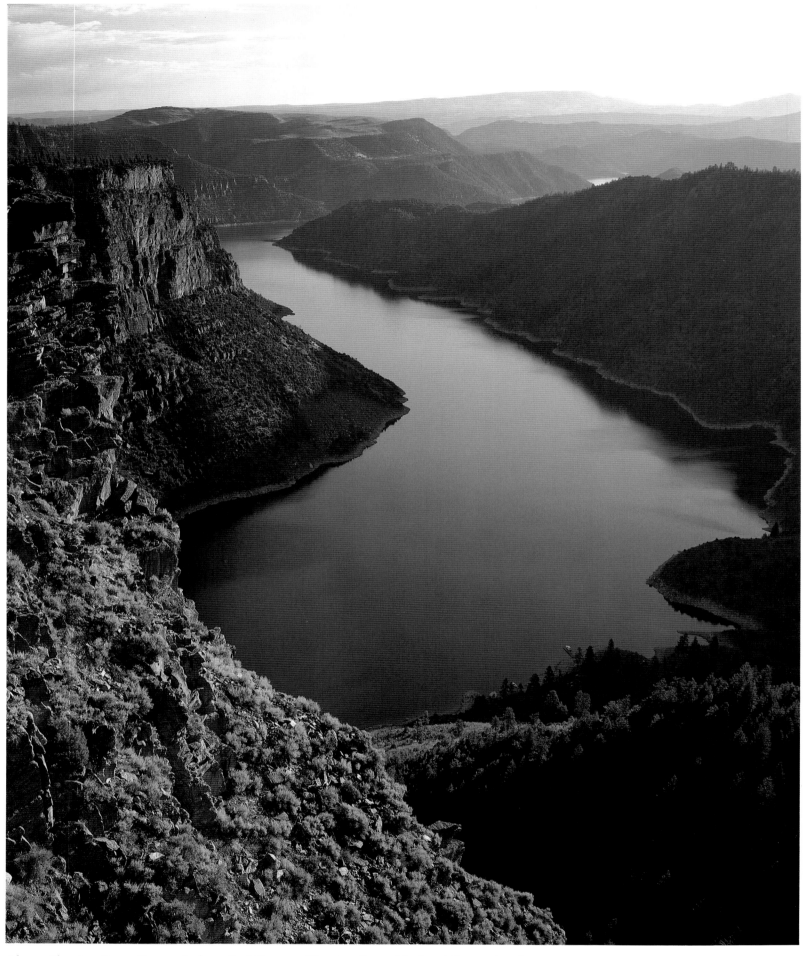

Above: Flaming Gorge Reservoir from Red Canyon, Flaming Gorge National Recreation Area
Opposite page: Hoarfrost on brush near Deer Creek Reservoir

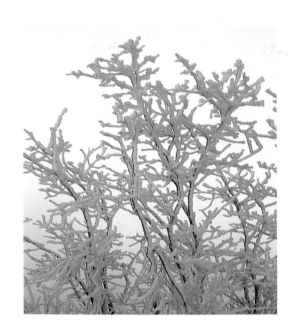

THE NORTHEAST QUARTER

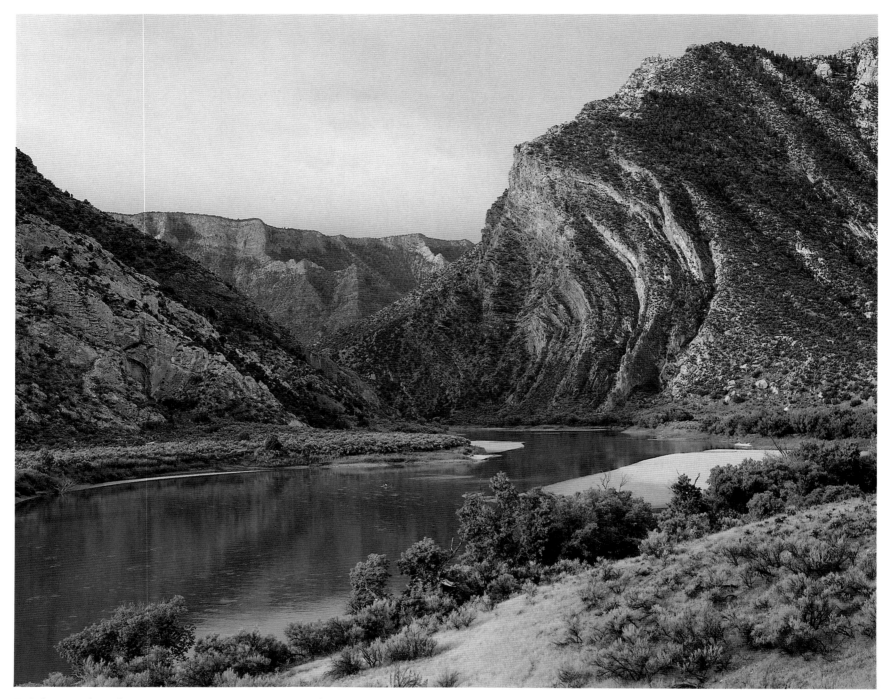

Rainbow Park and Green River at Dinosaur National Monument

Sept. 13 . . . This Rio de San Buenaventura [Green River] *is the largest river we have crossed. . . . Here it has meadows abounding in pasturage and good land for raising crops, with facilities for irrigation. . . . The river enters this meadow between two high cliffs* [Split Mountain, near Dinosaur National Monument] *which, after forming a sort of corral, come so close together that one can hardly see the opening through which the river comes. . . .*

Sept. 18 . . . Along these three rivers we have crossed today [the Duchesne, Lake Fork, and Antelope Creek] *there is plenty of good land for crops to support three good settlements, with opportunities for irrigation, beautiful cottonwood groves, good pastures, with timber and firewood nearby.* [Myton, Bridgeland, and Duchesne are in this area today.] *. . .* [A] *very long high sierra* [runs] *from northeast to southwest . . . for more than seventy leagues . . . at this season its highest hills and peaks are covered with snow, for which reason we named it Sierra Blanca de los Lagunas* [the Uinta Mountains]. *. . .*

Sept. 20 . . . We swung southwest for about two leagues through a very pleasant and pretty valley with very abundant pasturage [Strawberry Valley]. *We camped at the end of the valley at a small marsh with plentiful pasturage in the middle of which was a good spring of water. . . . Tonight it was so cold that even the water which was near the fire all night was frozen in the morning. . . .*
—Fray Silvestre Vélez de Escalante, 1776

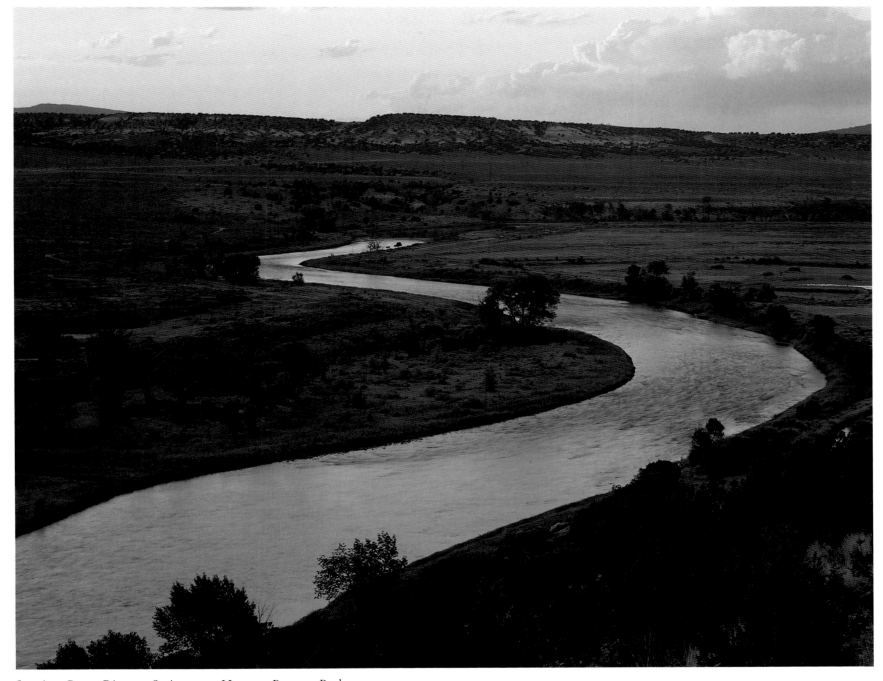

Sunrise, Green River at Stairway to Heaven, Browns Park

Pine sapling near dead tree trunk, Island Lake, Uinta Mountains

[Early July] . . . *Next day* [two days out of Fort Bridger] *we traveled through brush, and pine saplings, and logs, so that we could scarcely get along with our pack-horses. We went through piles of snow two feet deep, and camped on the side of the mountain* [north slope of the Uintas]. *It both rained and snowed a little.*

Next day we traveled through brush and logs and rocks till 12 o'clock, and only gained half a mile. Then we began to ascend the mountain. . . . When we got to the top of the mountain, it was raining and snowing and thundering, and I was shivering with cold. There are elk and sheep on this mountain. There were snow piles on the mountain; and yet there was green grass, and flowers, and it looked like the spring of the year. . . .

Next morning we continued our way through logs and brush again, and got to the brow of the mountain, on its southern declivity, but saw no way down. We went back and forth seeking a place to get down, and about an hour before sunset, we commenced the descent. . . . We are now on the head of the Wintey [Uintah] *River, down which we pursued our journey toward Rubedeau's Fort* [near present Whiterocks]. . . .

We had to wait there for Mr. Rubedeau about eighteen days, till he and his company and horse-drivers were ready to start with us to the United States. This delay was very disagreeable to me, on account of the wickedness of the people, and the drunkenness and swearing, and the debauchery of the men among the Indian women. They would buy and sell them to one another. . . . I tried several times to preach to them; but with little effect.

. . . Mr. Rubedeau had collected several of the [Digger] *Indian squaws and young Indians to take to New Mexico, and kept some of them for his own use! The Spaniards would buy them for wives. This place is equal to any I ever saw for wickedness and idleness.*

—Joseph Williams, Methodist preacher, 1842

Wildflowers near log at
Mount Watson, High
Uinta Mountains

June 1 . . . We left today the Duchesne fork [Duchesne River], and, after traversing a broken country for about sixteen miles, arrived at noon at another considerable branch, a river of great velocity, to which the trappers have improperly given the name of Lake Fork [it was, indeed, today's Lake Fork]. The name applied to it by the Indians signifies great swiftness, and is the same which they use to express the speed of a race horse. . . . At this season of the year, there is an uninterrupted noise from the large rocks which are rolled along the bed. After infinite difficulty, and the delay of a day, we succeeded in getting the stream bridged, and got over with the loss of one of our animals. Continuing our route across a broken country, of which the higher parts were rocky and timbered with cedar, and the lower parts covered with good grass, we reached on the afternoon of the 3d, the Uintah fort, a trading post belonging to Mr. A. Roubideau, on the principal fork [the Whiterocks River] of the Uintah river. . . . It has a motley garrison of Canadian and Spanish engages and hunters, with the usual number of Indian women. . . . [The fort, Frémont later notes, was "attacked and taken by a band of the Utah Indians since we passed it; and the men of the garrison killed, the women carried off. Mr. Roubideau, a trader of St. Louis, was absent, and so escaped the fate of the rest."]

On the 7th we had a pleasant but long day's journey, through beautiful little valleys and a high mountain country, arriving about evening at the verge of a steep and rocky ravine, by which we descended to "Brown's Hole." This is a place well known to trappers in the country, where the canyons through which the Colorado [Green] runs expand into a narrow but pretty valley [Browns Park], about sixteen miles in length. [At its lower end] the river enters between lofty precipices of red rock [the Gates of Lodore canyon], and the country below is said to assume a very rugged character; the river and its affluents passing through cañons which forbid all access to the water. This sheltered little valley was formerly a favorite wintering ground for the trappers [and, later, cattlemen and outlaws], as it afforded them sufficient pasturage for their animals, and the surrounding mountains are well stocked with game.

—John C. Frémont, 1844

Left: Green River at Browns Park
Opposite page: Uinta Mountain Formation at Crouse Canyon, Browns Park

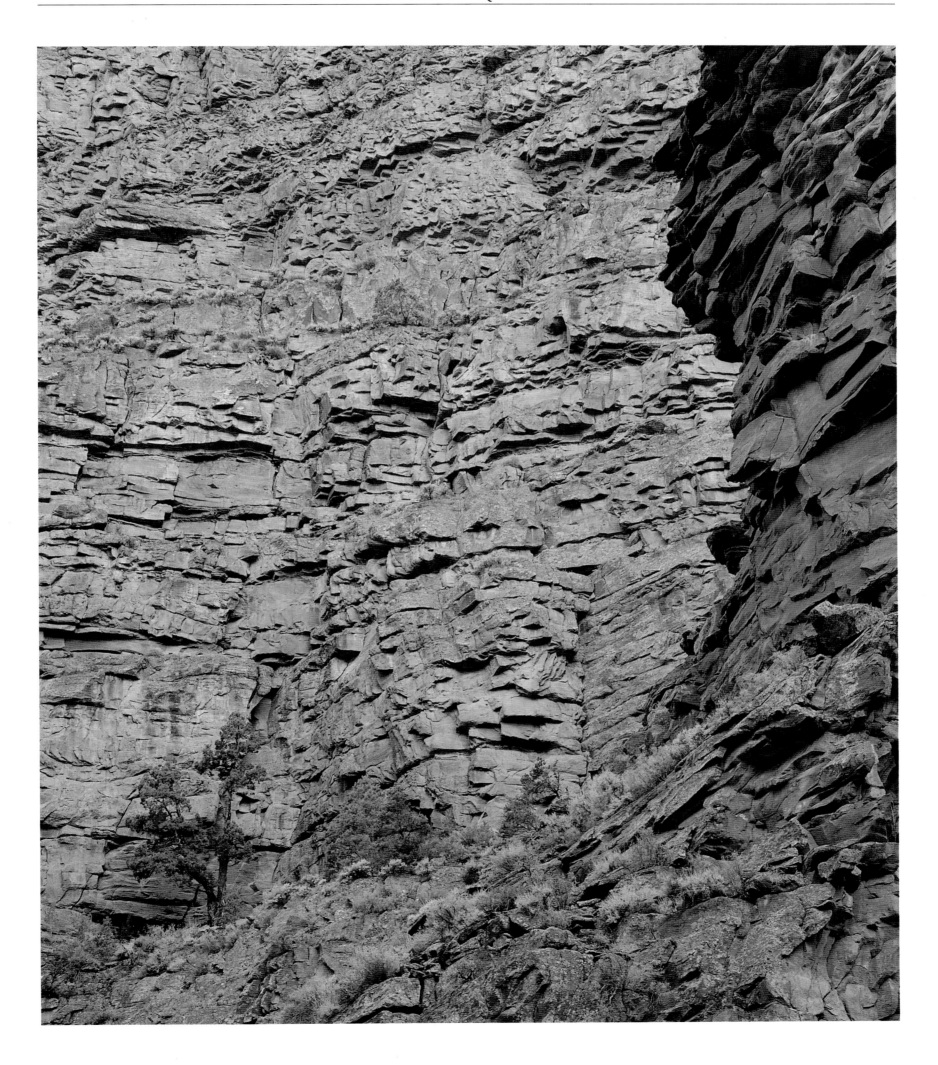

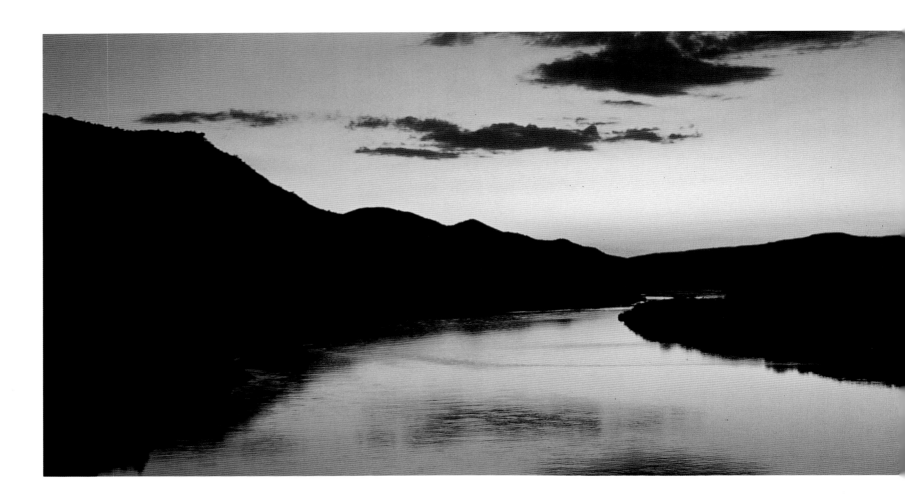

We were floating directly toward a perpendicular cliff, and I could not see any hole anywhere, nor any other place where it could go. Just as we were within a stone's throw of the cliff the river turned sharply to the right and went behind a high point of the mountain that seemed to stand squarely on edge. This was an immense crack or crevice [Flaming Gorge], *certainly 2000 feet deep and perhaps much more, and seemed much wider at the bottom than it did at the top. . . . Each wall seemed to lean in toward the water as it rose. . . . The mountains seemed to get higher and higher on both sides as we advanced. . . . We passed many deep, dark canyons coming into the main stream, and at one place, where the rock hung a little over the river and had a smooth wall, I climbed up above the high water mark which we could clearly see, and with a mixture of gunpowder and grease for paint, and a bit of cloth tied to a stick for a brush, I painted in fair sized letters on the rock, CAPT. W. L. MANLEY, U.S.A. . . .*

I don't think the sun ever shone down to the bottom of the canon [Red Canyon], *for the sides were literally sky-high, and a very small portion of that was all we could see. . . .*

While I was looking up toward the mountain top, and along down the rocky wall, I saw a smooth place about fifty feet above where the great rocks had broken out, and there, painted in large black letters, were the words, "ASHLEY, 1824." [General William Henry Ashley. The date actually was 1825. Both signatures are now under the waters of Flaming Gorge Reservoir.] *This was the first real evidence we had of the presence of a white man in this wild place. . . .*

. . . We found that another big rock blocked the channel 300 yards below, and the water rushed around it with a terrible swirl [Ashley Falls] *. . . the current was so strong that when the boat struck the rock we could not stop it, and the gunwale next to us rose, and the other went down, so that in a second the boat stood edgewise in the water and the bottom tight against the big rock, and the strong current pinned it there so tight that we could no more move it than we could move the rock itself.*

This seemed a very sudden ending to our voyage and there were some very rapid thoughts as to whether we would not [be] safer among the Mormons than out in this wild country, afoot and alone. . . . I saw two pine trees, about two feet through, growing on a level place just below, and I said to them that we must decide between going afoot and making some canoes out of these pine trees. Canoes were decided on, and we never let the axes rest, night or day till we had them completed.
—William Lewis Manley, California-bound, 1849

Opposite page: Sunset, Green River at Browns Park
Below: Green River at River Bend, Browns Park

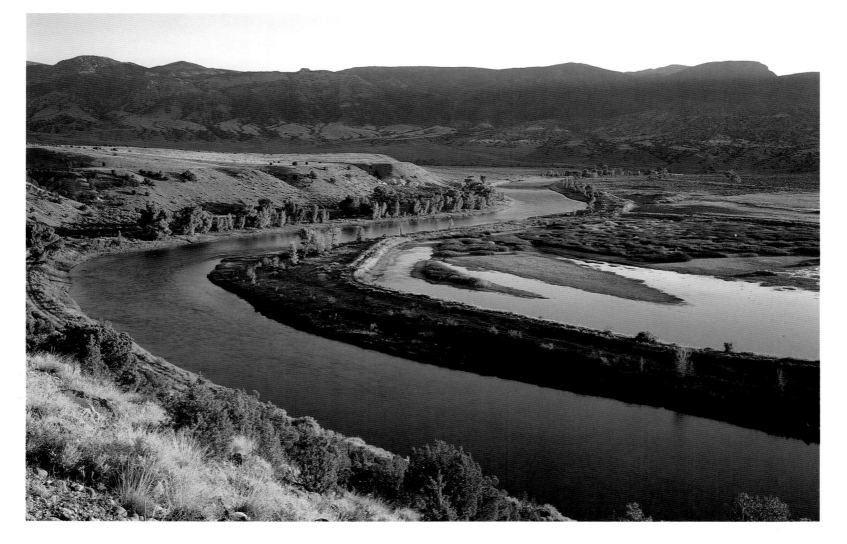

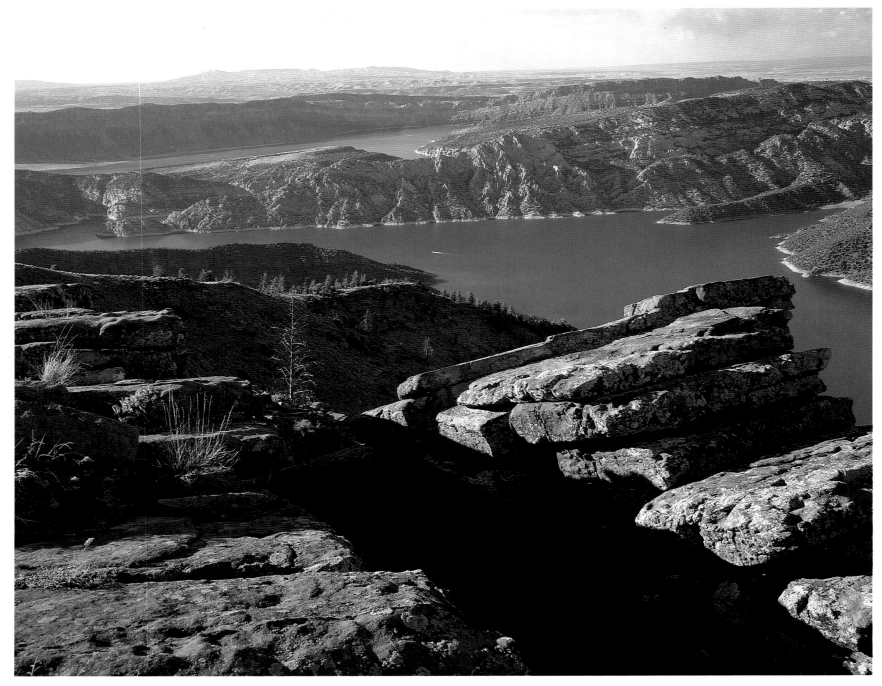

Flaming Gorge Reservoir from Dowd Mountain

The Yampa enters the Green from the east. At a point opposite its mouth the Green runs to the south, at the foot of a rock about 700 feet high and a mile long, and then turns sharply around the rock to the right and runs back in a northerly course parallel to its former direction for nearly another mile. . . . On the east side of the river, opposite the rock and below the Yampa, there is a little park, just large enough for a farm [Echo Park]. . . . Great hollow domes are seen in the eastern side of the rock, against which the Green sweeps. . . . Standing opposite the rock, our words are repeated with startling clearness, but in a soft, mellow tone, that transforms them into magical music. . . .

June 22 . . . What a headlong ride it is! shooting past rocks and islands. . . . One, two, three, four miles we go, rearing and plunging with the waves, until we wheel to the right into a beautiful park and land on an island. . . . The broad, deep river meanders through the park, interrupted by many wooded islands; so I name it Island Park, and decide to call the canyon above, Whirlpool Canyon.

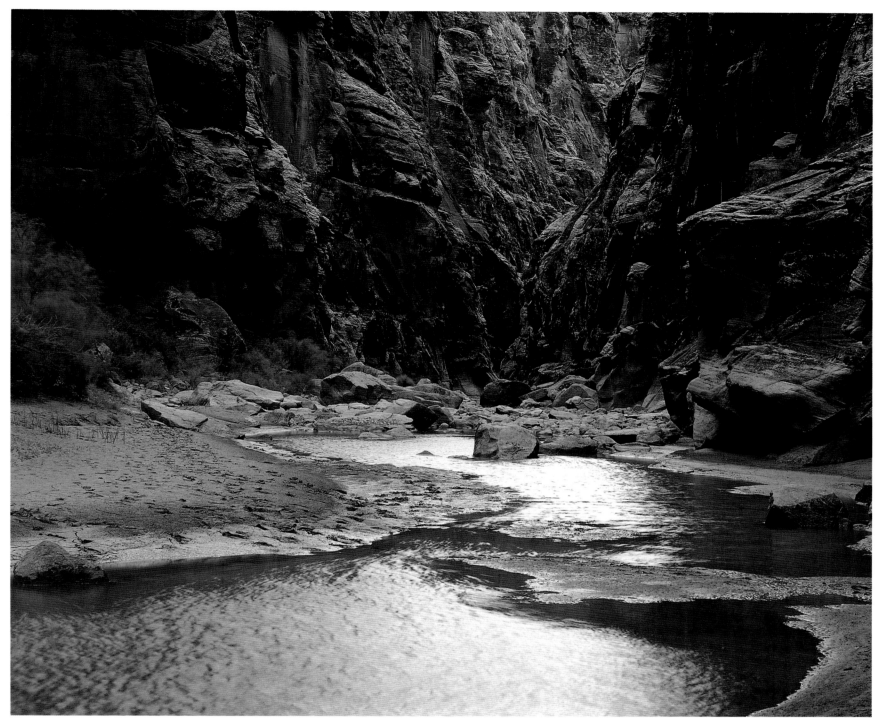

San Rafael River, Black Box, San Rafael Swell

June 24.—Bradley and I start early to climb the mountain ridge to the east, and find its summit to be nearly 3,000 feet above camp. . . . The park is below us, its island groves reflected by the deep, quiet waters. Rich meadows stretch out on either hand to the verge of a sloping plain that comes down from the distant mountains. These plains are of almost naked rock, in strange contrast to the meadows—blue and lilac colored rocks, buff and pink, vermilion and brown, and all these colors clear and bright. A dozen little creeks, dry the greater part of the year, run down through the half circle of exposed formations. . . . Each creek has its system of side streams and each side stream has its system of laterals, and again these are divided; so that this outstretched slope of rock is elaborately embossed. . . . [He is looking at the breaks coming off Diamond Mountain, part of which is Red Fleet State Park.]

June 29 . . . The region [east portion of the Uinta Basin] *is one of great desolation: arid, almost treeless, with bluffs, hills, ledges of rock, and drifting sands. Along the course of the Green, however, from the foot of Split Mountain Canyon to a point some distance below the mouth of the Uinta* [Duchesne]*, there are many groves of cotton- wood, natural meadows, and rich lands. This arable belt extends some distance up the White River on the east and the Uinta on the west, and the time must soon come when settlers will penetrate this country and make homes. . . .*

Left: Whirlpool Canyon, Green River, Dinosaur National Monument
Opposite page: Grasses on sand dunes, Green River at Desolation Canyon

July 8 . . . We pass through a region of the wildest desolation. The canyon is very tortuous, the river very rapid, and many lateral canyons enter on either side. These usually have their branches, so that the region is cut into a wilderness of grey and brown cliffs. In several places these lateral canyons are separated from one another only by narrow walls, often hundreds of feet high, so narrow in places that where softer rocks are found below they have crumbled away and left holes in the wall, forming passages from one canyon to another. . . . Piles of broken rock lie against these walls; crags and tower-shaped peaks are seen everywhere, and away above them, long lines of broken cliffs [the Book Cliffs]; *and above and beyond the cliffs are pine forests, of which we obtain occasional glimpses as we look up through a vista of rocks. The walls are almost without vegetation; a few dwarf bushes are seen here and there clinging to the rocks, and cedars grow from the crevices—not like the cedars of a land refreshed with rains, great cones bedecked with spray, but ugly clumps, like war clubs beset with spines. We are minded to call this the Canyon of Desolation.*

—John Wesley Powell, 1869–72

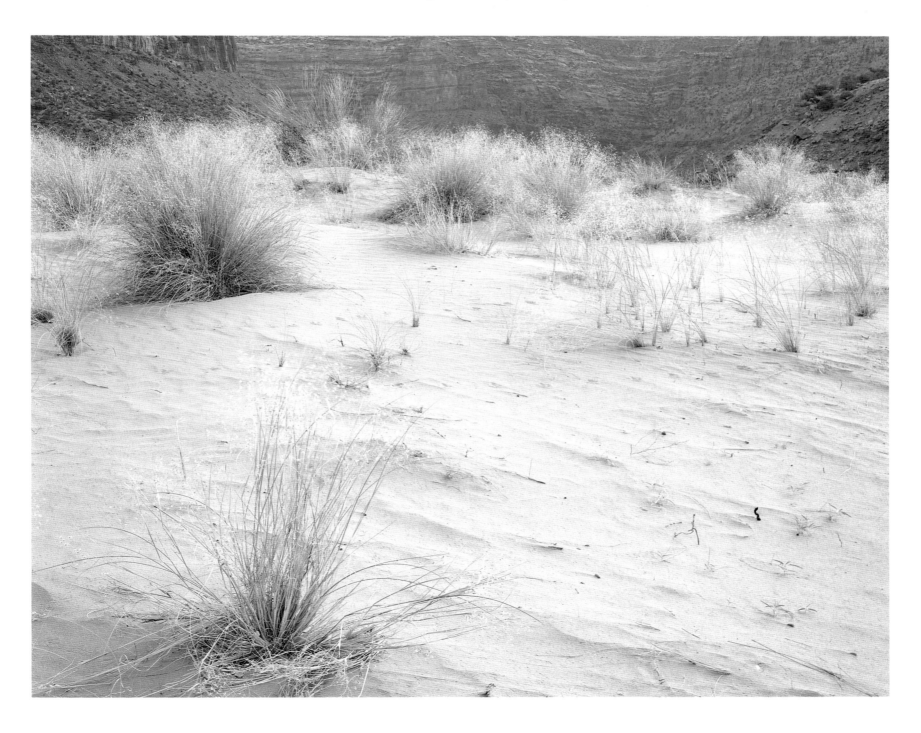

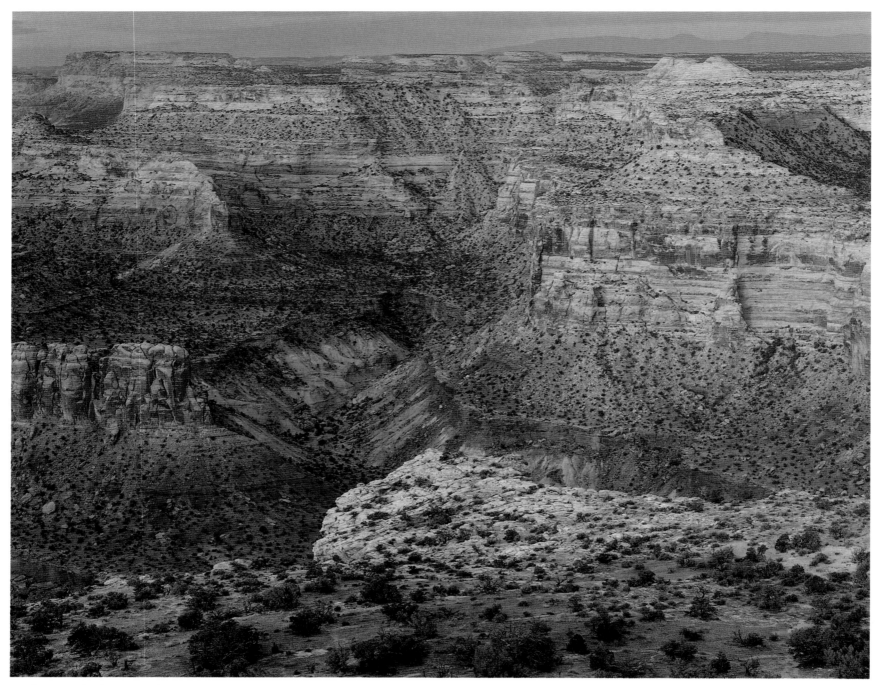

Wedge Overlook, San Rafael Swell

The Book Cliffs . . . provide an unobstructed view on either side of hundreds of miles. There are no other nearby mountains to shut off the view, as on other mountain railroads. Rising steadily up the face of this great range, there is never a moment when the eye of the passenger may not rest with perfect delight and wonderment upon a gorgeous panorama of slopes below, of valleys and deserts beyond, and of snow-clad mountain ranges in the far-off horizon. To the eastward, the great Continental Divide and the Grand Mesa; to the southeast, the precipitous San Juan mountains of Colorado, one hundred and fifty miles away; to the south, the Sierra La Sal in southern Utah, one hundred and sixty-five miles distant, rising in indescribable grandeur on the hither side of the valleys that lead to the Grand Canyon of the Colorado. These views from the train windows are best appreciated when the summit is reached at Baxter Pass. Here, simultaneously, another panorama is unfolded on the north, as from the narrow summit the traveller sees the valley of Evacuation Creek

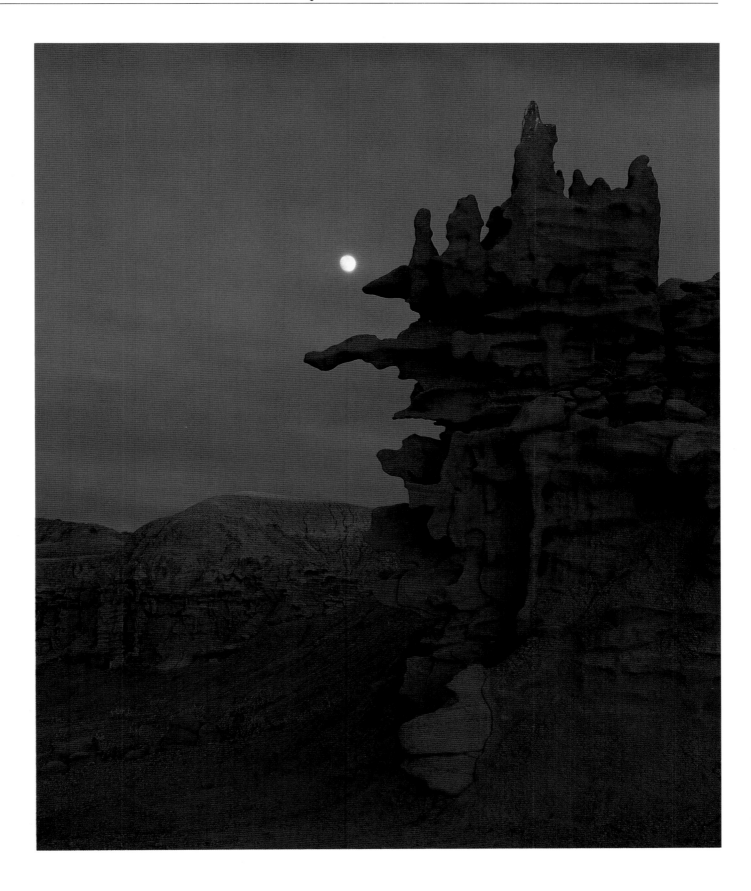

Moonrise and rock formations at Fantasy Canyon, Uintah County

stretching out to the Grand Canyon of White River . . . over the Uintah Reservation and beyond to the Uintah mountains in the northwest, one hundred and fifty miles; the breezes flinging through the pines and aspens on the neighboring summits, the blue vault above and eternal peace in all the atmosphere. Everywhere there is grandeur, accentuated lights and shadows, marvellous combinations of color. It is soul-stirring, poetic, stimulating, satisfying and a never-ending appeal to the artistic sense.
—Tourist brochure of the Uintah Railway, about 1904

Few places on the earth could have looked less promising for settlement than Castle Valley in 1877. Except for the cottonwoods along the creeks, the valley was treeless from the steep escarpment of the plateau to the distant buttes of the San Rafael Swell. The mancos shale soil ("blue clay," it is called locally) supported a thin growth of shadscale and prickly pear, the sparse vegetation that could survive on seven inches of rainfall. The Indians called it "Blow Valley" because of the continual dry winds, and they avoided the place, claiming that the water made their women's necks grow large. (Goiter trouble afflicted the settlers as well. . . .)

—Edward A. Geary, 1985

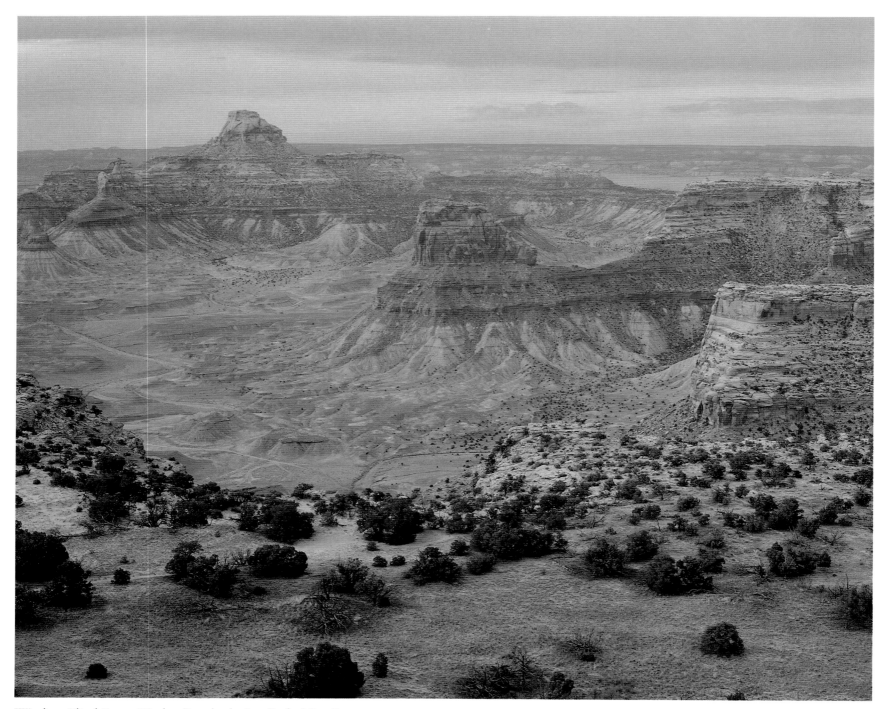

Window Blind Butte, Wedge Overlook, San Rafael Swell

Above: Winter sunrise, Richardson Flat near Keetley
Right: The Hunting Panel, petroglyphs at Nine Mile Canyon

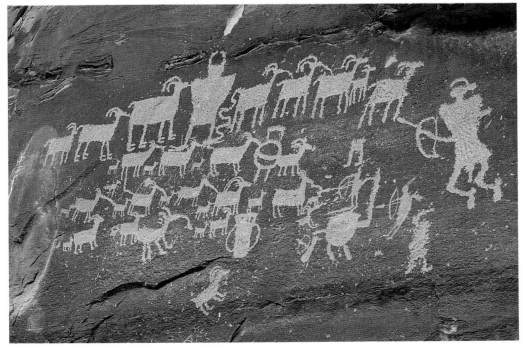

Castle Peak, near Kamas

The Northeast Quarter

WHOEVER WROTE the tourist brochures describing Utah as a land of contrasts may have sweltered in the naked desolation of the Green River Desert one day and shivered hip-deep in High Uintas wildflowers the next. Or maybe not; Utah has lots of desert–mountain contrasts, though few as stark as that. Maybe the writer knew how Bear Lake lies slate grey under leaden skies one day, cobalt blue in sunshine the next. Or how thirsty you can get tramping through labyrinths of the San Rafael Swell one day, how waterlogged rafting Split Mountain or Desolation Canyon whitewater the next.

Or perhaps the writer was thinking not of physical contrasts like these in the northwest quarter of the state, but of human ones. Of the polyglot mixture of races and nationalities who toiled in the coal mines and filled the taverns of Carbon County, while down the road Mormon ranchers branded cows and raised kids in quiet and sober Castle Valley. Or, to push contrast to the edge, of the Butch Cassidy Wild Bunch types who rustled and robbed and killed and then hid out in Browns Park while, just over the mountain, pioneer leader William H. Smart—my grandfather—was breaking his heart trying to build a Mormon empire of order and rectitude in the Uinta Basin.

Three great mountain systems dominate the landscape of northeastern Utah. The Uintas, 150 miles long and 30 to 45 miles wide, tower across the northern part. With the state's highest peak, Kings, soaring to 13,528 feet and nearly a dozen more over 13,000, this is aptly called the "roof" of Utah. On the west is the Wasatch Plateau, part of the 10,000- to 11,000-foot "spine" that runs the length of Utah north to south, dividing the state in two. Sprawling in a great semicircle across the center of the region lies the Tavaputs Plateau, known chiefly for the 200 miles of Book Cliffs where the Plateau breaks off 2,000 feet and more into the desolation of the Green River Desert.

Slicing through the east end of the Uintas and the heart of the Tavaputs, the Green River rushes toward its union with the Colorado. And out of the heights of the Uintas and Wasatch Plateau flow the streams, some of them tiny, that sustain life in the towns scattered in valleys of dubious fertility below the mountains.

Trees in snow at Indian Canyon, Duchesne County

149

Dandelions in meadow, Mormon Trail near Henefer

It took restless movements of the earth's crust for more than half a billion years to set the scene. Over aeons, the land rose, subsided, rose again, subsided. Each era left its legacy. In Precambrian times immense layers of sand, mud, and gravel washed down from adjacent mountains. Over time, these changed under pressure into the sandstones, shales, and quartzites that form the great cliffs of the Uintas. For the next 400 million years, the region rose and fell, with depositions alternating between sediments left by marshes and shallow seas and those washed from eroding mountains. In the Mississippian period, 360–320 million years ago, the oceans were deep enough that seashells were deposited thousands of feet thick, and they later hardened into limestone beds like those seen in the cliffs of Lodore Canyon.

The nearly 200 million years of the Mesozoic era (245–65 million years ago) gave northeastern Utah much of its uniqueness. Dinosaurs—5,000 or more species of them—roamed the earth for some 120 million years, reaching a climax during the Jurassic period (208–144 million years ago). Shallow lakes, marshes, and sluggish rivers covered the area. Huge herbivores like the brontosaurus, seventy feet or more long, fed on the rank foliage and were in turn eaten by smaller, more agile carnivores. Hunters and hunted alike bogged down in the marshes in such numbers that this region today boasts two of the world's most famous dinosaur graveyards—Dinosaur National Monument, just below Split Mountain where the Green River breaks out of the Uintas, and the Cleveland-Lloyd Quarry out in the Mancos Shale desolation east of Castle Valley. More dinosaur bones have been shipped from these two sites to universities and museums throughout the country and abroad than from any other place on earth.

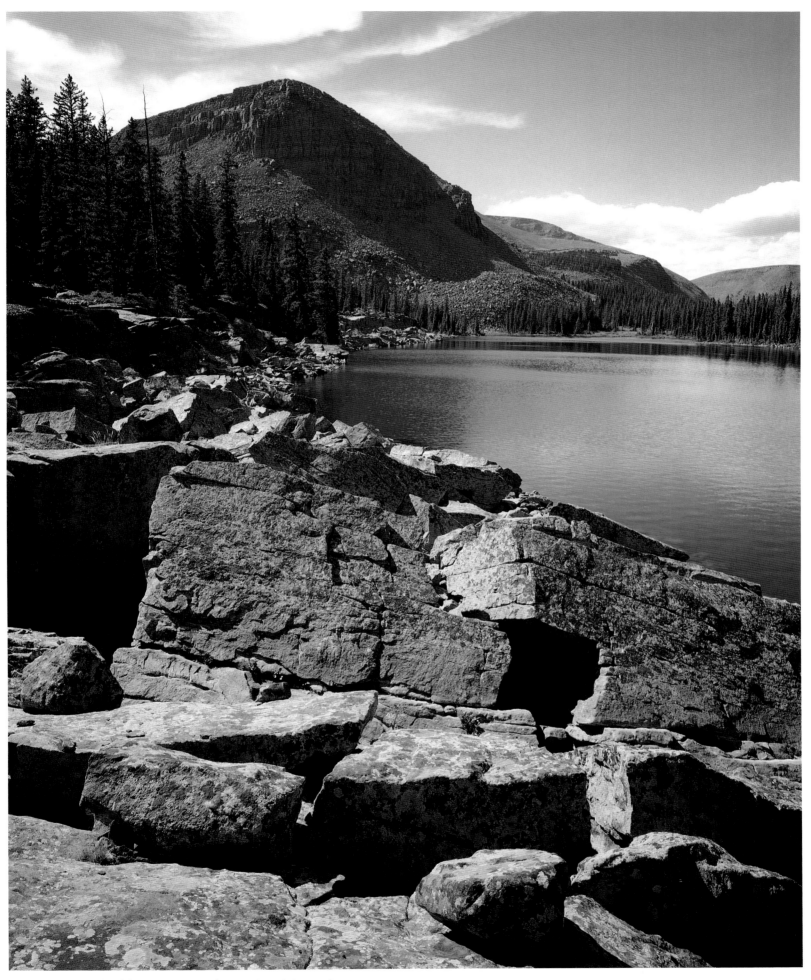

Lichen-covered boulders at Point Lake in Uinta Mountains

Clouds over Wanship area

In the Cretaceous period (144–64 million years ago), aeons of deposition laid down a 5,000-foot-thick mass of silt that became the soft, drab grey Mancos Shale that forms the badlands of Carbon and Emery counties. Sharks teeth and fossilized fish scales testify of the shallow seas in which the deposition took place. As the seas deepened, great beds of marine sand deposits accumulated, later to become the spectacular sandstone Book Cliffs. And then, as the land rose again and the seas retreated, a long period of subtropical climatic conditions produced luxuriant plant growth that heat and pressure later turned into the coal, gilsonite, oil shale, oil, and natural gas underlying so much of the area.

<p style="text-align:center">* * * * *</p>

If the character of the land doesn't wholly dictate the character of the people, it at least determines who comes and, more importantly, who stays. For example, the lush grasslands and clear streams of the north slope of the Uintas attracted cattlemen early. The vast lands stretching off to the north meant cattle outfits could grow large; the proximity of the Union Pacific Railroad meant they could grow rich. Among the largest and richest was that of William Carter, who came west in 1857 as a civilian merchant with Johnston's Army in the Utah War. Locating at Fort Bridger, he remained to become the area's first cattle baron, its dominant business and political figure, and a man as responsible as any except Brigham Young for the final shape of Utah's boundaries. Because of his anti-Mormon lobbying of Washington connections, Wyoming came into the union as a rectangular state—at the expense of a 70-by-105-mile bite out of northeastern Utah.

Grass grows lush in Browns Park as well, and, with the Green River running through the middle, fed by half a dozen creeks, water is no problem. But it's a small valley, 35 miles long and six miles at its widest. So a different kind of cattleman settled there—small ranchers who built their herds with the help of a running iron on the flanks of cows belonging to others.

Moreover, tucked in among the mountains and straddling the Utah-Colorado border, with Wyoming just over the hill, the valley well suited the needs of bank- and train-robbing types, whose life expectancy depended on staying one jump ahead of the law.

For such an isolated valley, Browns Park saw a surprising amount of early human activity, including what was probably Utah's first white settlement. With surrounding mountains sheltering the valley from blizzards raging on the high plains, deer and elk wintered there. So did Ute and Shoshone Indians for centuries, prospering on the game, the waterfowl that flocked to marshes flooded by the Green River, and the fish from

the river itself. The beginning of the end of that idyllic scene came about the year 1827 when, as tradition has it, a French-Canadian trapper named Baptiste Brown tired of the wandering life of the mountain man, built a cabin in Browns Park, and settled down.

If Brown didn't build Utah's first Anglo-Saxon habitation—the record is far from clear—that honor belongs to a band of trappers that included, from time to time, Kit Carson, Joe Walker, and Joe Meek. As early as 1832 they were operating a trading post of sorts in Browns Park, and by 1836—ten years before Miles Goodyear built his Fort Buenaventura in the Ogden area—they had erected a rude structure. In

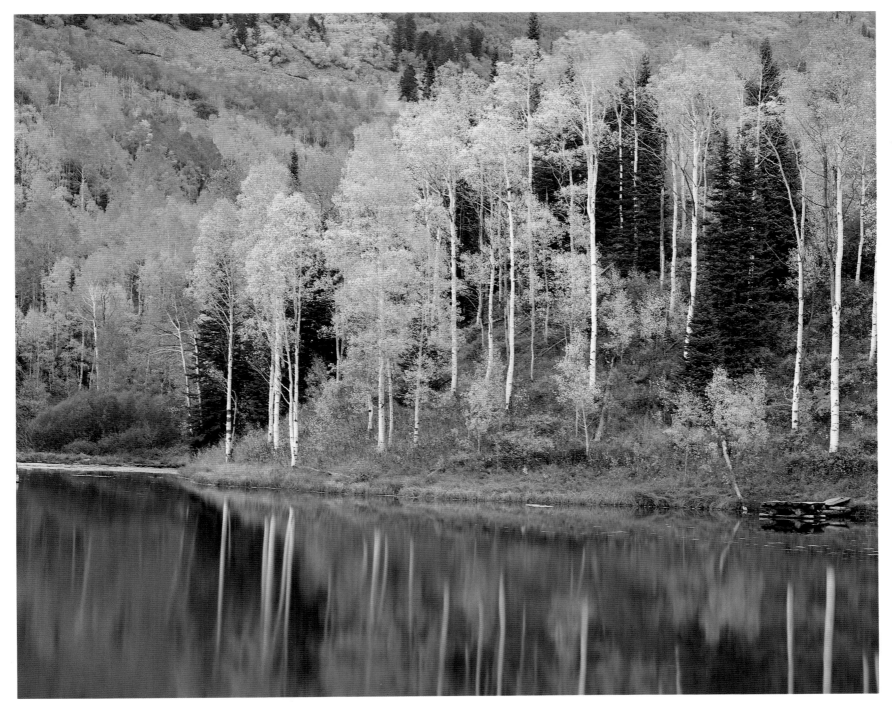

Aspens at small lake in Uinta Mountains near Kamas

1839 Thomas Jefferson Farnham, en route from Illinois to Oregon, dropped in and described the place and what went on there:

> The Fort is a hollow square of one story log cabins, with roofs and floors of mud. . . . Around these we found the conical skin lodges of the squaws of the white trappers, who were away on their 'fall hunt,' and also the lodges of a few Snake Indians. . . . Here also were the lodges of Mr. ["Uncle Jack"] Robinson, a trader.

> . . . And indeed, when all the 'independent trappers' are driven by approaching winter into this delightful retreat, and the whole Snake village, two or three thousand strong, impelled by the same necessity, pitch their lodges around the Fort, and the dances and merry makings of a long winter are thoroughly commenced, there is no want for customers.

Fort Davy Crockett they called it, but trappers who wandered through the region had a more descriptive

Two graves at John Jarvie Historic Farm, Browns Park

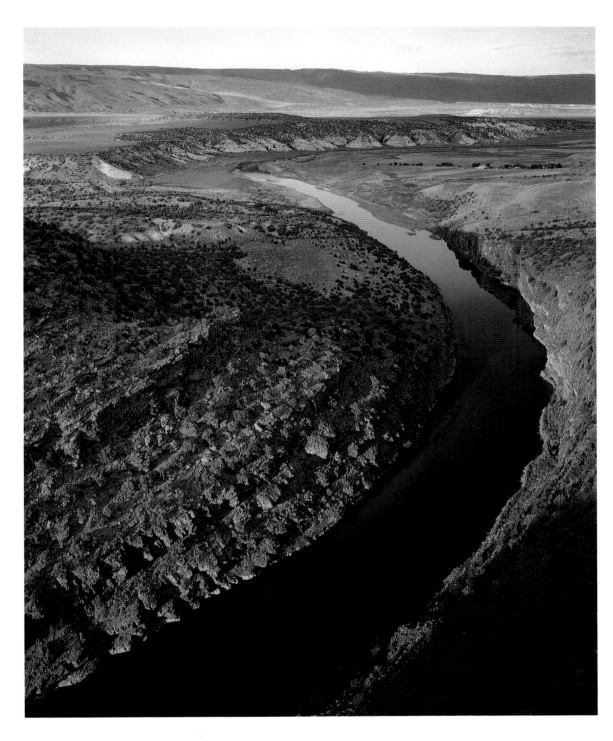

Green River at Swallow Canyon

term—Fort Misery. For a few years the trappers alternated horse-stealing forays with the Indians, with at least one deadly encounter. But the mountain-man era was winding down, and in 1840 Fort Misery was abandoned. The Indians gathered for a couple more rendezvous in 1842, but the fort was crumbling. John C. Frémont saw a few remains when he passed through the area in 1846. Lewis Manley and six companions floated down the Green River in 1849, hoping they could reach the California goldfields that way without having to winter among the Mormons. Preoccupied with their own survival, as evidenced by the quotation at the head of this chapter, they made no mention if they noticed that a settlement had ever been there. All traces had vanished so completely by the time the first settlers drifted into the area that today no one even knows where the fort was built; the best guess seems to be at the mouth of Vermilion Creek.

But Browns Park would not stay empty; Texas cattlemen driving their herds to California found Browns Park ideal for wintering over. So did a few opportunists who saw no reason why any man with a long rope and a hot iron shouldn't share in the wealth. José Herrera and Asbury B. Conway were among the early rustlers, in the early 1870s. Conway moved to higher things, including a stint as chief justice of the Wyoming Supreme Court, and could look with tolerance on the rustling that became a mainstay of the Browns Park economy.

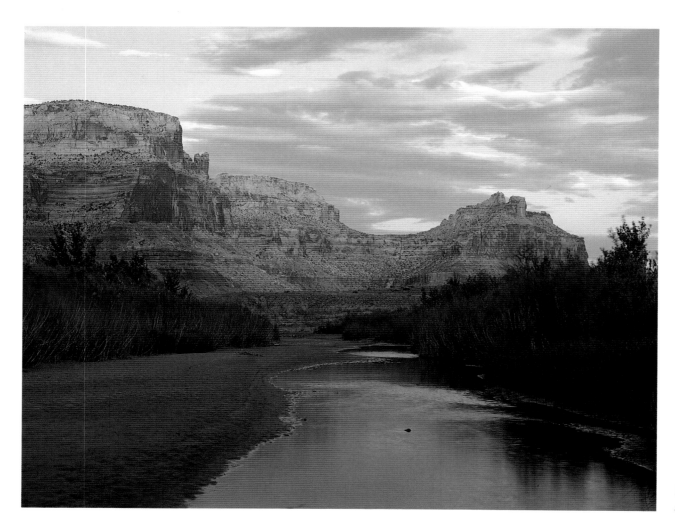

San Rafael River
at San Rafael Swell

Others weren't as tolerant. A cowboy posse shot up the Tip Gault gang, killing all but an ex-slave, Ned Huddleston, who escaped by playing dead. Wounded, Huddleston fled the Park but returned after some years as Isom Dart, only to die along with Matt Rash in 1900 at the hands of hired killer Tom Horn. Another who found tolerance has its limits was Jack Bennett; it wasn't any one thing but rather a series of annoyances that left him dangling at the end of a rope tied to a gate crossbar at the Bassett ranch.

As much as anyone, the Bassetts typified ranching in Browns Park. Herbert Bassett arrived in 1877 with his wife Elizabeth and their two small children, Josie and Sam. A year later, Ann joined the family, the first white child born in the Park. Though both parents were cultured and well educated, they soon found that surviving, much less prospering, in that wild country demanded different talents. The "Bassett Gang," including Rash and Dart, soon built a rustling reputation that eventually brought Tom Horn into the Park, almost certainly on the payroll of one or more of the big cattle outfits tired of losing their cows there. Ann grew up to become known as the "Queen of the Cattle Rustlers." Among other activities that earned her the title was her vendetta to avenge the deaths of Dart and her fiance, Rash, by hazing cows owned by the big cattle companies over the cliffs into the Green River. As for Josie, there were some who claimed that at least one of her five husbands departed life with the aid of a little of her strychnine.

Not even the much-respected John Jarvie escaped the violence that characterized life in Browns Park. A native of Scotland, he came into the Park in 1880 and built a general store/trading post as well as outhouses and corrals, using ties he snagged out of the river as they floated down from the railroad construction upstream. He became the local postmaster, and from 1881 until his death in 1909 he operated a ferry across the river. His place became the social center of the Park, partly because of his skill on the concertina, partly because of his library of the classics, partly because he was so much loved, especially by the children. But that didn't matter on the July day in 1909 when two drifters bent on robbery killed Jarvie, dragged his body to a boat at the river's edge, and pushed it out into the current. The boat snagged on bushes downstream, and Jarvie is buried there, a couple of miles above where the river plunges into the Gates of Lodore. His killers were never caught.

Paradoxically, the most violent of the men—and women—history recorded at Browns Park were among the most peaceable while they were there. This was the

Pines in snow at Beaver Creek
near Kamas

notorious Wild Bunch—Butch Cassidy, Harry Longa-
baugh (the Sundance Kid), Elza Lay, Harvey Logan,
and others. With its surrounding mountains where any
lookout could spot lawmen coming over the passes,
and with easy escape routes across state lines, the Park
became one of the gang's three major hideouts, roughly
halfway between Hole-in-the-Wall in Wyoming and
Robbers Roost above the Dirty Devil River in Wayne
County. There is no record that any of the Wild Bunch
got into trouble in Browns Park; they weren't looking
for trouble, and they certainly weren't the kind of men
with whom one picks a fight. They visited freely at the
Jarvie and Bassett homes and relied on local ranchers
to pass them the word if lawmen were seen coming
into the valley.

"We were pretty good at tending to our own af-
fairs," Ann Bassett recalled many years later. "The
young people of each group mingled and liked each
other. And let me say they had some cute boys with

their outfit. It was a thrill to see [the Sundance Kid],
tall, blond & handsome."

For lovers of dirt roads, solitude, and a sense of
how it used to be, Browns Park is as fine a destination
as any in Utah. Getting there from Vernal involves a
drive over Diamond Mountain through lovely pinyon
and juniper country, with rugged cliffs breaking off to
the Green River on the right and red rock ledges shin-
ing through the green cover. Deer and elk watch as you
pass. More miles over rough, rocky road, then around
a curve, and Browns Park is spread out below, the sun
glinting off the river. Cross a rude bridge and there,
gleaming golden in the autumn sun, are the great old
cottonwoods sheltering Jarvie's rock ranch house and
store. The place was purchased by the Nature
Conservancy in 1978 and is maintained as a historic
site by the Bureau of Land Management. A small mu-
seum shows the trading post as it must have been. The
corrals of hand-hewn railroad ties are still there as are

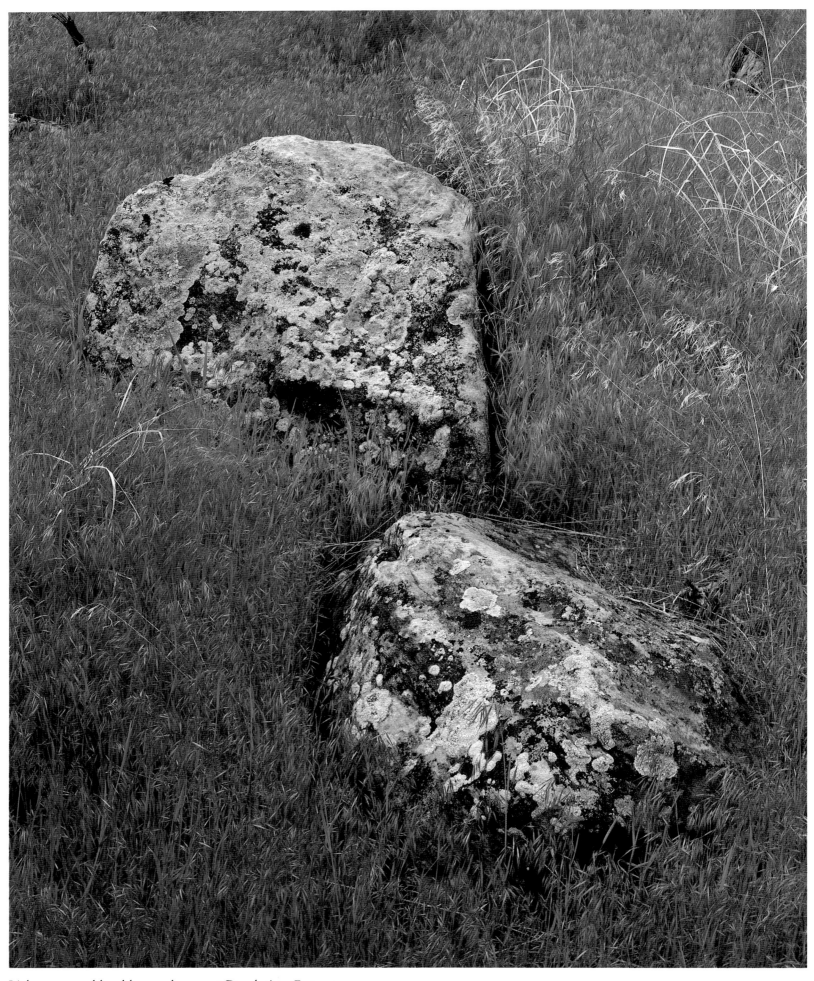

Lichen-covered boulders and grass at Desolation Canyon

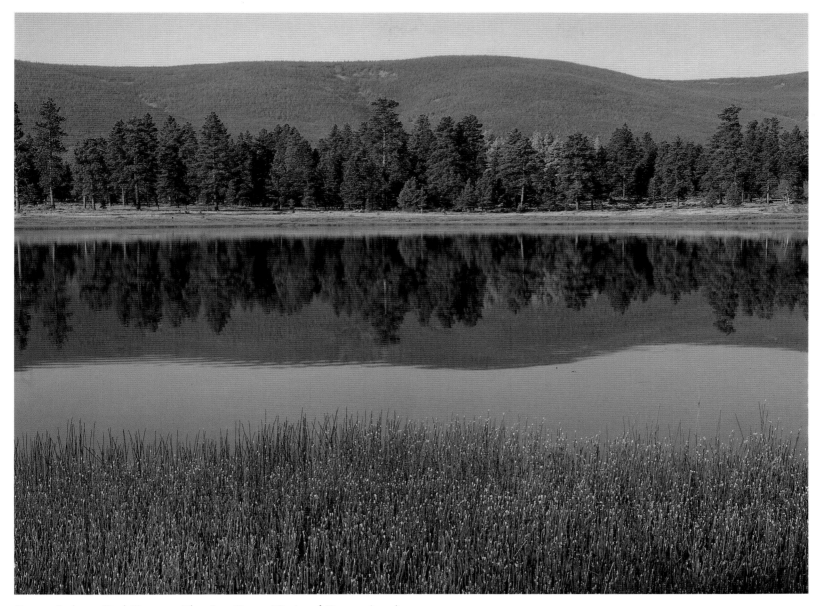

Greens Lake at Red Canyon, Flaming Gorge National Recreation Area

the remains of a sixteen-foot waterwheel with which Jarvie scooped water from the river for his garden and fields. So too is the hillside dugout where Jarvie and his wife lived until their house could be built and where the Wild Bunch held secret meetings. The gate crossbar from which the luckless Bennett swung is on display. And on the barren hillside is the grave of a young fellow named Robinson; he staked a claim too close to that of Jesse Ewing and died at the point of Ewing's knife out on the Green River ice. Next to it lies Ewing himself, ambushed by a rival for the affections of a Madame Forrestal, a whore from Green River.

Life is quieter in Browns Park now. Dust clouds trail behind the occasional car bringing visitors to Jarvie's ranch. A few rafts float by, their occupants intent on Green River's world-class trout fishing. Canada geese honk at the Browns Park National Wildlife Refuge. Just before the road climbs out of the Park, a sign points up a dirt road where, out of sight, sprawls

the Browns Park Store with gas pumps in front and a trailer house out back. Ed and Joy Blevins invite me to drive through their corral to visit Ann Bassett's cabin and the rock-walled, overgrown Bassett cemetery, where lie Ann and Josie, their mother, and two brothers—folks Ed's parents knew well.

To my comment that theirs is a strange place for a store, Joy admits that, yes, it's a bit out of the way, but when winter drives off the fishermen, and the deer and elk seasons are over, bear, lion, and bobcat hunters still come in for a cup of coffee. "Besides," she allows. "We're fifty miles from the nearest facility, so we don't get much competition out here."

* * * * *

One hundred fifty miles away, across the Uintas, the Uinta Basin, and the Book Cliffs, another kind of cattleman settled another kind of valley. Sprawling between the cliffs of the Wasatch Plateau on the west and the Green River badlands and San Rafael Swell on the

east and south, Castle Valley had no lush grass to attract big cattle outfits. It had no nearby state lines for
the convenience of bandits escaping the law, and it certainly had no banks or payrolls to lure them there in
the first place. To settle that land would require a people
under a certain amount of benign compulsion who had
learned not to expect much.

Jedediah Smith, the archetypal trapper/explorer,
was the first to describe Castle Valley. Looking for
beaver on his 1825 exploration to California, he complained that *"the valley was verry barren and Rocky
. . . after traveling in this direction* [toward the San
Rafael Swell] *2 days the country looked so unpromising that I determined to strike westward to a low place
in the Mountain* [the Wasatch Plateau] *and cross over."*
During the next quarter of a century, thousands of
horses and mules driven over the Old Spanish Trail left

a trail still faintly visible on hills just east of the valley.
Much more visible are cuts and fills and exquisite stone
bridgework built by Chinese railroad work-gangs in
1882. The Denver & Rio Grande Western Railroad
punched a roadbed fifty miles across the deeply eroded
country west of Green River before giving it up and
routing through Price instead. Tracks were never laid.

Mormon ranchers started pushing their cattle into
this unlikely country in 1875 because, as one of them
put it, their range west of the Wasatch "was all et out,
and we had to move our cattle to Castle Valley." Relying on the memories of Israel Bennion, his father,
Glynn Bennion described in the *Utah Historical Quarterly* "that gashed, reefed, upside-down nightmare of
sandstone" surrounding the valley, and what life was
like there. Getting to the valley, he wrote, meant trailing the cattle *"at right angles across the innumerable,*

Trees in snow, Roan Cliffs, Duchesne County

very deep, narrow, and practically impassable sand-stone canyons infesting the area. . . . A rider passing over the rolling surface of some parts of the Castle Valley range might suddenly and without warning find himself on the edge of a yawning chasm whose vertical sandstone walls dropped dizzily down to a dry, boulder-strewn wash hundreds of feet below."

Bennion described the men—one of them, at least—who matched the country: *"One of these riders was a black-bearded giant named Sam Gilson, who later achieved fame as the discoverer of an asphalt now called Gilsonite [more on that later]. . . . The man scorned hardship and traveled without food or bedroll. At night he pulled his saddle blanket over his shoulders and slept on the ground. If the night was cold and the ground wet, he woke next morning with his hair usually frozen in the mud. When he got hungry he shot a good-looking calf, cut off a sizable part of its anatomy, threw it on a brush fire burned down to coals and ashes, scorched the meat briefly on one side, then the other, and ate it (ashes, etc.) with blood dripping down both sides of his magnificent beard."*

This is the country to which Brigham Young called settlers in 1877. It was, noted Edward Geary, who was born and raised there, Brigham's last colonizing call; a week later he was dead. *"There used to be a saying,"* Geary wrote, *"that as soon as Brother Brigham called people to Castle Valley the Lord took him. This was said in such a way as to leave it uncertain whether he was taken because his mission had now been completed or because he had finally gone too far."*

So the Mormons came, struggling over the 11,000-foot Wasatch Plateau and into Castle Valley. Family history has it that when Orange Seely pulled up his

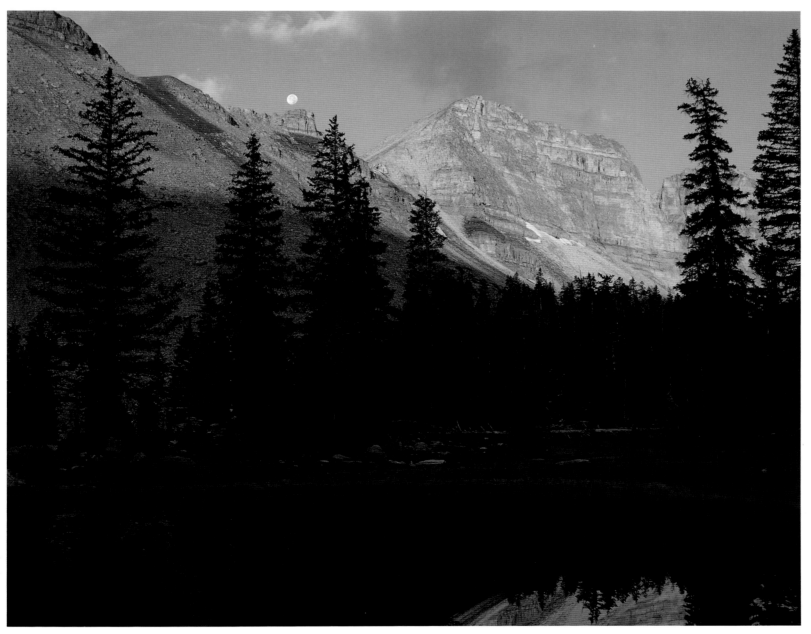

Mountain lake with moon, High Uintas Wilderness Area

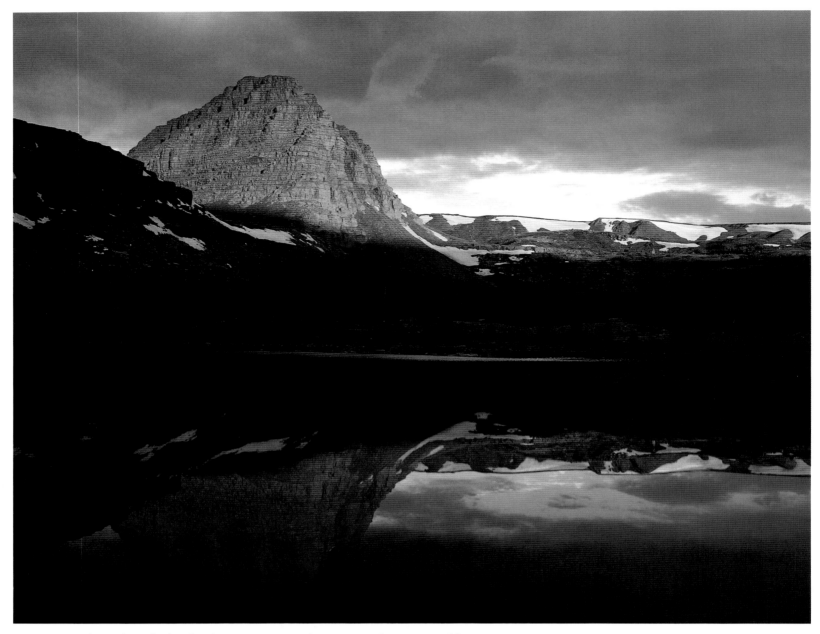

Sunrise, Castle Peak and Island Lake in Henrys Fork Basin, High Uintas Wilderness Area

team for the first night's camp in the valley, his wife exploded, "Damn the man who would bring a woman to such a God-forsaken country." In his annual pageant celebrating the settling of Castle Valley, Montell Seely, a descendant, has Orange taking his wife out of earshot of the children and warning her to change her attitude or get on her horse and "kick rocks" back to Sanpete. Leaving her fuming there, he goes back to start supper, and the children ask, "Where's Momma?" "Oh," he says, "she's out there falling in love with Castle Valley."

Whether she did or not, she stayed. So did others, digging the ditches and planting the poplars that marked every Mormon town. They never prospered. Some thought they would when, in 1970, Utah Power & Light Company began building the state's biggest coal-fired power plant at the northern end of the val-

ley—a project that turned out to be a mixed blessing. But while none got rich, the folks in Castle Valley generally have lived quiet, satisfying lives. And something about the place—the water, the fresh air, the down-home cooking, a ranch kid's daily toil, the genes, or all of the above—was enough to produce one of the state's phenomenons, a 7′6″ basketball franchise named Shawn Bradley.

＊＊＊＊＊

I have a theory about the land. Let's call it the Law of Compensation. Simply stated, and acknowledging many exceptions, it goes like this: The more worthless and unlovely a piece of real estate appears, the more likely it's underlain by hidden wealth. No place better illustrates the theory than huge chunks of Utah's northeastern quarter. Beneath the surface desolation of the Uinta Basin lies one of the continent's largest and deep-

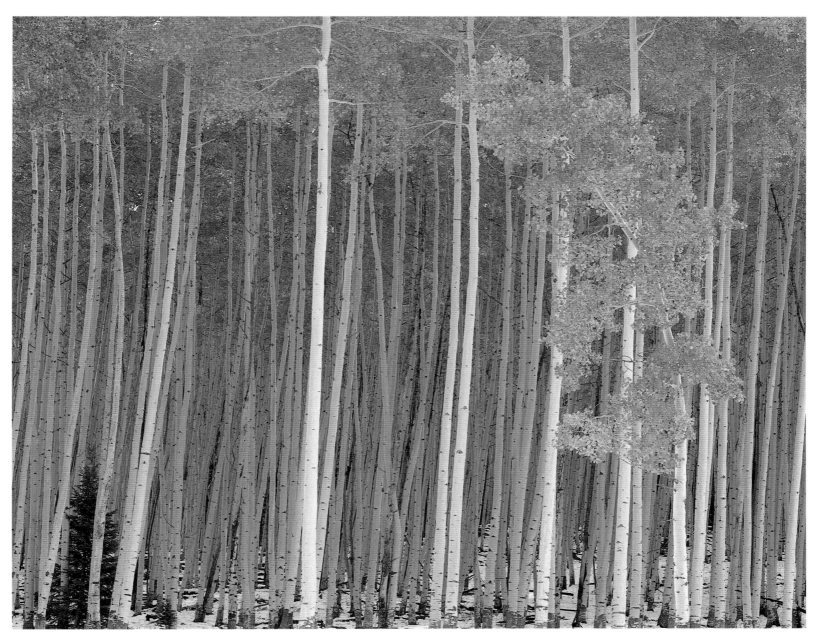

Aspens, Uinta Mountains

est coal reserves—too deep to recover profitably in today's economy with today's technology. But where the naked southern flanks of the Book Cliffs jut up from the dreary grey wastes of Mancos Shale covering much of Carbon and Emery counties, coal is there for the taking. For more than a century of boom and bust, taking it has been the chief occupation and chief economic base of the area.

Price started life as a quiet town of Mormons farming the limited lands along the Price River. That lasted only until 1883 when the Denver & Rio Grande Western Railroad punched its main line from Green River through Price, over Soldier Summit and on to Salt Lake City. Hardrock miners started flocking to the area to dig coal from the seams outcropping throughout the area, and Carbon County quickly earned its name.

The digging has continued for a century in upwards of a hundred mines throughout the area, taking more than 400 million tons of coal worth one dollar a ton at the minehead at the beginning, thirty dollars a ton today. But at what cost! On May 1, 1900, an explosion in the Winter Quarters Mine near Scofield killed 200 men and boys. One Finnish couple lost six sons and three grandsons in what was at the time the nation's deadliest mine disaster.

There was more to come. Castle Gate Mine Number Two was considered one of the country's safest, but on March 8, 1924, three successive blasts killed every one of the 172 men who entered its tunnels that morning. Twenty-three men died at Standardville in 1930, nine at the Carbon Fuel Mine in 1963, many others by ones and twos in rockfalls and other accidents. For a time, from 1914 to 1925, Utah's coal-mine fatality rate was almost twice the national average.

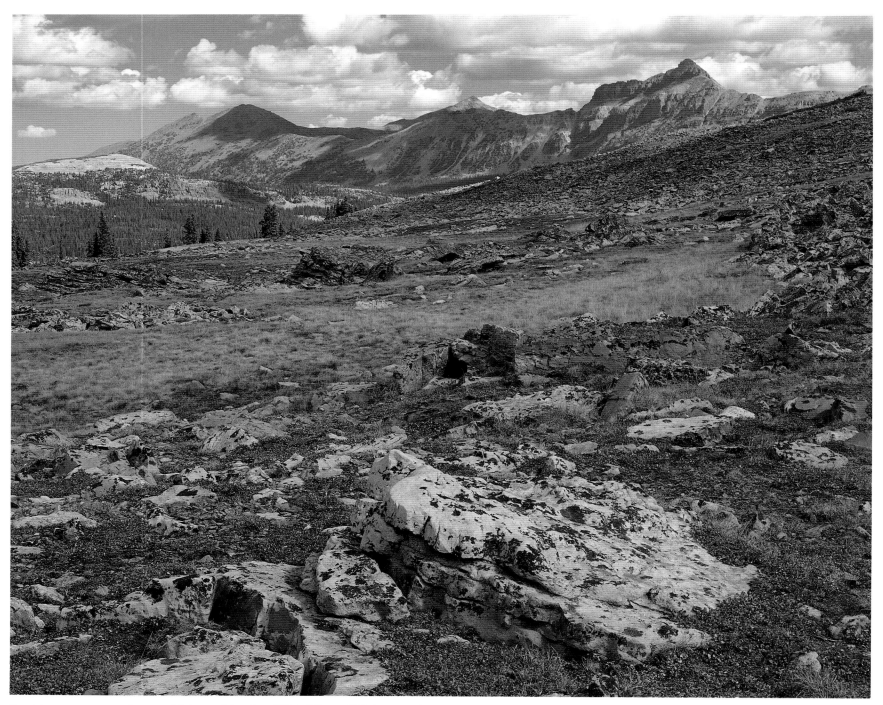

Boulder-strewn meadow and Mount Hayden, High Uintas Wilderness Area

Those who died were mostly foreign born. Chinese workers came early, and were quickly run off by whites. Then came the Finns, sixty-two of whom died at Scofield. Italians followed, then Greeks, and then Serbs, Croats, and Slovenes—the Southern Slavs. These were the major groups, but there also were Germans, Mexicans, Basques, Swedes, Japanese, Armenians, Lebanese, Syrians. The cultural differences have largely disappeared now; but, for the better part of a century, Carbon County was a colorful multinational enclave in white, Anglo-Saxon, Mormon Utah.

The mixture was also explosive. Off and on for half a century, the coalfields saw some of Utah's bitterest labor battles, with major strikes in 1901, 1902–03, 1922, and 1933. With companies importing strike-breakers, miners wielding axe handles, National Guardsmen mounting Gatling guns, and Communist agitators stirring up the whole brew, it's a mercy the area avoided major bloodshed. Yet it did and has settled into quiet normalcy. Giant machines rip off in a day the coal a large crew of miners would have struggled to dig in a week. So jobs have disappeared, and with them much of the color of this era of Utah history, but also the grinding toil, danger, and black-lung disease that made widows of so many of Utah's newer citizens.

How different are the people of the Uinta Basin and the lives they led there. Despite its vast carboniferous reserves, mining never prospered in the Basin. The coal lies too deep, and no one ever figured out how to make a profit mining the oil shale and tar sands. Gilsonite, found in commercial quantities nowhere else on earth, provided the raw material to paint Henry Ford's Model T's ("any color so long as it's black") and the surreys that preceded them. But that boom soon passed, and abandoned turn-of-the-century gilsonite diggings pockmark the harsh, gullied northern flanks of the Tavaputs Plateau. Oil and natural gas brought another boom in the 1970s, but the drillers are long gone and many of the wells are capped. So, in the main, the people of the Basin wrested their living from soil that too often turned alkaline, in a climate that was too wet or too dry, too hot or too cold.

Loreen Pack Wahlquist described what it was like. She and her young husband Fred bought a farm near Randlett in 1928 and moved into a one-room log cabin. Eighteen years, seven sons, and many blasted dreams later, she could assess the results. In a letter to her sister, later published in the *Utah Historical Quarterly,* she described her life when Fred, called as a Mormon bishop within months of arriving at Randlett, spent winter weeks in the mountains cutting timber to build a chapel. *"I milked nine cows, had twice that many to feed, and had to drive them half a mile to water and chop holes in the ice. The twins were three years old and Bryan was one, so they weren't much help."*

And then, this portrait of misery:

We bought this place for $2,800 and within a few years we couldn't have sold it for a tenth of that. . . . We bought that bunch of cows from the folks for a high price just before the depression. The first year our cows did fine and we had high hopes for the future. Then prices started a steady decline. The drought hit us exceptionally hard and we were unable to raise enough hay and grain for our stock. Some years our grain burned completely and there was no harvest. During the year 1931 we had a chance to sell our five best cows for $70 each. The spring before we had lost five cows from eating grasshopper poison and to part with five more of the best cows would leave us with scarcely any cream check but still with a debt of over $3,500, so we turned it down. It was a big mistake, as prices dropped so low we got practically no returns from the cows and we couldn't sell them at any price. . . .

Our biggest problem has always been water— I mean the lack of it. We have had to pay high assessments and much of the time our ditches have been dry. We have had so few people that it has been a real struggle to maintain our long canals. The summer of 1935 the Indian Department stopped furnishing us garden water so Fred and Frank Jarman leased a piece of Indian land three miles away. For the next two summers we raised our gardens there, traveling back and forth in a rickety old iron-tired wagon. We would take our barrels along and haul water home to help some of our trees and shrubs to live.

No wonder my father, who was raised out there, used to tell of the Uinta Basin farmer who sold a quarter section of land to an outsider.

"How much did you sell him?" someone asked.

"Well, the deed was for 160 acres. But" (in a behind-the-hand whisper) "I slipped in an extra ten."

This was the land Escalante first described when, in 1776, the Domínguez-Escalante party crossed its 130 miles of pinyon and juniper, sage and meadow, rocky

Lichen on rock in Henrys Fork Basin, High Uintas Wilderness Area

ridges and gullied valley floor on that aborted exploration to find a route to California. They may not have been the first white men here. George Thompson and others point to evidence that Spaniards had been working mines in the Uinta Mountains long before. But the evidence is shadowy and the mines—if they existed—are long lost.

Half a century after Escalante, William Ashley and his partner, looking for more beaver country, somehow negotiated buffalo-hide boats through the awesome Green River rapids to reach the Uinta Basin in 1825. But Etienne Provost was already there with a band of New Mexico trappers, and Ashley could only make his way back across the Uinta Mountains. Others came: Kit Carson in 1833, Miles Goodyear in 1842, John C. Frémont in 1844, various government explorers and scientists, including John Wesley Powell, in succeeding years. But the Basin remained essentially a backwater

in the tide of western migration. Brigham Young, ever the expansionist, sent exploring parties there in 1852 and again in 1861; each reported that this was no place for Mormons to settle.

But others came. In 1868 Parson Dodds established an Indian agency at Whiterocks. The following year, someone discovered nearby a lustrous black asphalt-like substance that looked like anthracite coal but didn't act like it. Cowboys trying to burn it in their campfires found that it melted like rubber instead. Not for years would it become an ingredient of paints and varnishes, insulation, asphalt floor tiles, battery boxes, brake linings, drilling muds, inks, fingerprint powders, road asphalt, chewing gum, and even rot-proofing for the pilings under the original Saltair Resort.

Sam Gilson was the first to suspect that the stuff had commercial value. As early as 1878 he had been scratching out a living rounding up wild horses in Juab

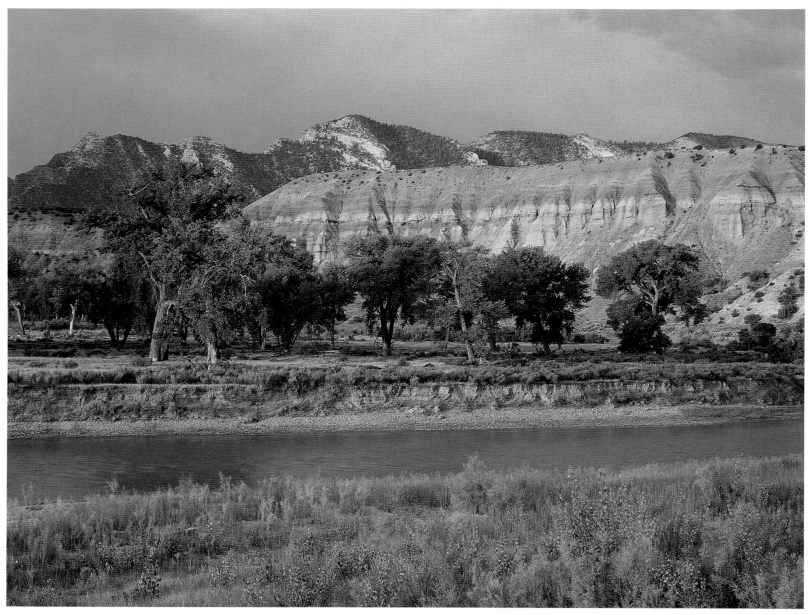

Island Park, Green River, Dinosaur National Monument

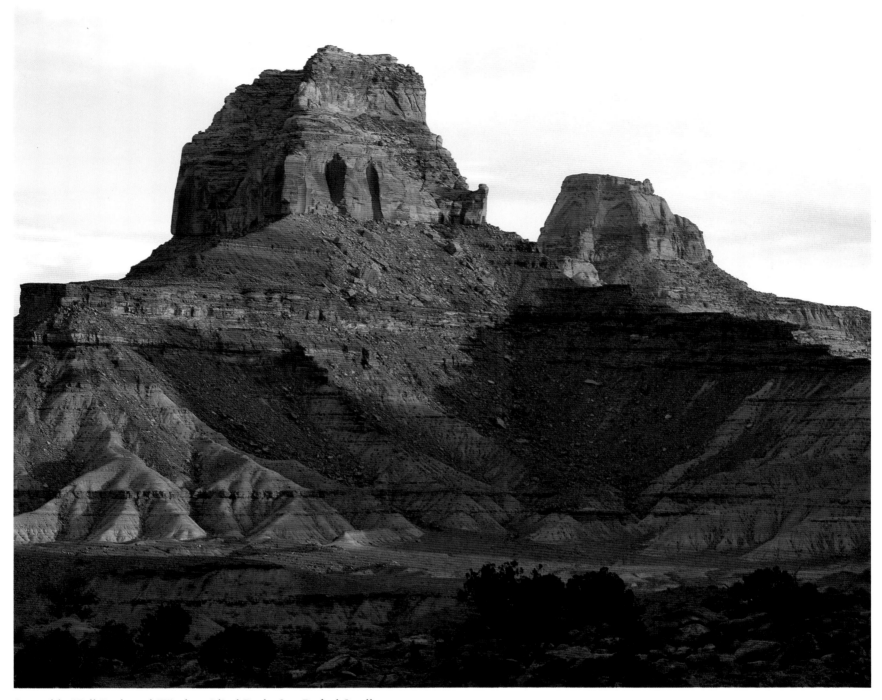

Assembly Hall Peak and Window Blind Peak, San Rafael Swell

County and trailing them across the Wasatch Plateau, Book Cliffs, and Uinta Mountains to the railroad at Green River. Noticing the vein outcroppings stretching for arrow-straight miles across the east end of the Uinta Basin, he began experimenting with and then mining what came to be called gilsonite. Others followed, hauling the ore 100 miles over the roughest kind of wagon road through Nine Mile Canyon to the railroad at Price. That haul ended in 1904 when the Uinta Railroad Company punched the nation's last narrow-gauge line over the Book Cliffs—fifty miles of track over the steepest grades and around the sharpest curves known to railroading anywhere. The railroad lasted until 1939, by which time the gilsonite towns of Dragon, Watson, and Rainbow were on the way to becoming ghost towns. But American Gilsonite still operates, sending its output in a slurry pipeline to Grand Junction.

The Basin's first settlement, Vernal, had a decidedly non-Mormon flavor. The first business, Dale Morgan reported in the 1941 WPA-sponsored Utah guidebook, was a saloon consisting of a plank laid over two barrels. The first drinks were on the house, Morgan wrote, and after that the customers took turns serving free drinks. All the proprietor had to show for his first night's business was an epic hangover.

Snowfall at Provo River near Francis, Utah

The whites were there despite an 1865 treaty designating the entire Basin as a home for several Ute tribes forced from better lands elsewhere. But Indian treaties have seldom held up against white land-hunger. When the Utes grew surly about the mining activities, the government rushed in troops in 1886 to establish Fort Duchesne and chopped off a strip of gilsonite-rich land from the eastern end of the reservation. By the turn of the century, cattlemen and settlers as well as miners were eyeing the Basin. So, naturally, there came another betrayal—100 million acres of the reservation were opened to white settlement in 1905, pushing the Indians back to the least promising lands.

This time the Mormons were ready for the land rush that followed. By instruction of the church's First Presidency, Wasatch Stake President William H. Smart

had spent two years traveling from his home in Heber to explore the Basin, identifying the best land, the most readily available water, the likeliest townsites. The letter he wrote to other stake presidents, offering the assistance of his land company to any Mormon who wanted to relocate, outraged non-Mormons. But it worked; the Uinta Basin quickly became Mormon country.

Smart wore out his life trying to keep it that way. As the ranking local LDS Church leader for sixteen years, he worried about spiritual matters; but most of his efforts went into building the water systems, the banks, the newspapers, the schools, and the churches needed to realize his dream of an orderly, prosperous center of Mormon culture and commerce.

It never quite happened. Except for the short-lived

narrow-gauge over the Book Cliffs, the long-hoped-for railroad never came. The Basin remained remote, its-freight rates so high that it proved cheaper to build the Bank of Vernal with bricks *mailed* by parcel post. The dream of "black gold" wealth remains largely that—a dream. Irrigation with sprinkler systems, government subsidized to minimize salinization of the Colorado River, has reduced the problem of soil turning alkaline. But drought and crickets and early frost still continue to plague the farmer stubborn enough to try to make a living there.

Basin dwellers increasingly look for their livelihood by servicing seekers after the area's scenic and recreational resources—the lakes and wilderness trails of the High Uintas, the fishing in Strawberry, Starvation, and other reservoirs or in the streams tumbling out of the mountains, the dinosaur remains at the national monument near Split Mountain, the whitewater rafting on the Green River. And the Book Cliffs. Travelers on Highway 6 and on I-70 look up at those stark, forbidding cliffs to the north and wonder what is behind them. What is behind them is some of the wildest, most remote country in the lower 48 states, and perhaps the most ambitious wildlife project ever attempted there.

For generations, a handful of ranchers have run cattle along the windswept ridges and in the deep canyons of Book Cliff country. There are natural gas wells in there too; they are fairly inconspicuous, as are the collector lines sending the gas to market. The state's largest elk herd is there, mule deer beyond counting, black bears, and mountain lions. Add, of course, hunters. And there are county commissioners both north and south of the area who want to carve a highway through the middle of it. In the Book Cliffs festers the classic Western confrontation between the values of traditional ranching and resource exploitation, and the values of those who want to preserve as much of America's wild country and wildlife as is still salvageable.

Intelligent cooperation enabled the two sides to reach solutions that ought to be a model for other areas of conflict, in Utah and elsewhere. The Nature Conservancy and the Rocky Mountain Elk Foundation bought up ranches from willing sellers and turned them over to the Bureau of Land Management and the Utah State Division of Wildlife Resources. Together with other state and federal lands, that created a block of nearly 500,000 acres where cattle are greatly reduced or eliminated; oil and gas development allowed under strict environmental and reclamation requirements; bighorn sheep, moose, buffalo, and wild turkeys introduced; and the entire ecosystem allowed to develop as naturally as possible in this mechanized and homogenized Western world. That's quite a gift for a state as it enters its second century.

Holy Spirit Episcopal Church, established in 1896, Randlett, Utah

Stream and Rabbitbrush near Randlett

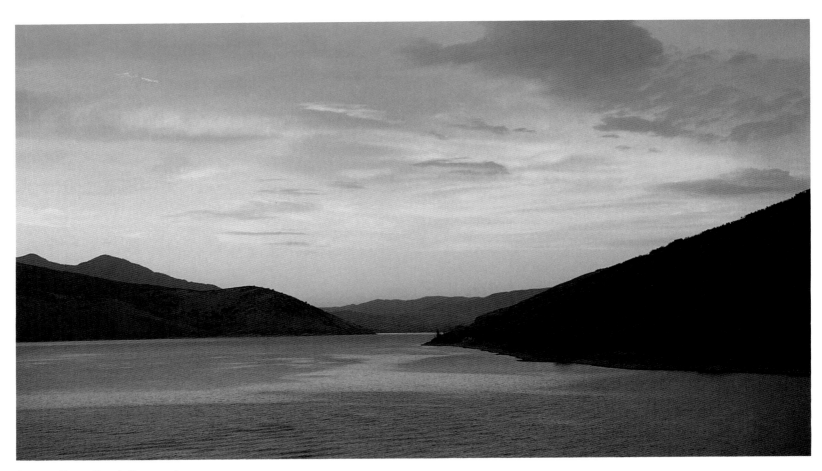

Sunset, Deer Creek Reservoir

Fetuses, we are told by those who claim to know, receive in-the-womb impressions that shape lifelong attitudes. If that is true, some of my ambivalent feelings toward the Uinta Basin may be traced to the exhausting trips my often-pregnant mother used to suffer to visit in-laws there.

Or maybe not; my own personal impressions were probably sufficient. They were never happy, those trips. Six kids and two parents jammed into our old Essex touring car made those dusty miles over what later became Highway 40 unendurably long. And scary. The dugways were raw and narrow. If we dared look down past wheels skidding to the edge, Death seemed to stare back. And the wind. How it whistled through the isinglass windows! I never remember arriving without an earache, chapped cheeks, and a sleeve stiff from wiping tears and a runny nose.

Arrival was only marginally better. Grandpa, tired out from a sixteen-year struggle as presiding Mormon official in the Uinta Basin, paid little attention to kids. Neither did Grandma, and to a kid there's nothing more boring than listening to grown-ups talk. Out at Randlett, where my uncle tried to scratch a living from a hardscrabble farm,

what I mostly remember is rocks and thistles and deer flies. And dirt. Lots of dirt. There was a washing machine with a hand crank on which even little kids like me had to take our turn. My cousins were bigger and tougher, and they bullied me. The chief recreation I remember was watching them put grasshoppers, legs broken off at the joints, into red-ant beds and bet which one would last longest.

So I had no regrets when the last relative gave up and fled to Salt Lake City. For years I did not return to the Basin—not until my own kids were about that age and I could bore them with tales of the great days out there. And not until my grandfather's fine two-story house in Vernal, the first in the Basin with indoor plumbing, crumbled under the wrecking ball did I sense how deep my family roots reached into that inhospitable soil.

Those roots stirred to life when some friends and I bought a quarter section of sage-and-aspen land on upper Red Creek in the 1960s. Thinking big, we designed and built a stone lodge and fenced the entire 160 acres to keep our horses. A hundred yards from that lodge, one snowy October day, I shot a buck that barely missed

making the Boone and Crockett record book. But things changed. One of the friends died, another moved away, another divorced and disappeared from our lives, others got involved in other interests. We sold out, and once more our family abandoned the Basin.

Most of my memories of that part of the country involve events that were not in the Basin but around it. There was, for example, the Yampa–Green River float trip in 1956 celebrating congressional approval of the Colorado River Storage Project Act. I was aboard because of my energetic support of that legislation, God forgive me, as editor of the *Deseret News* editorial page. Politicians, advertising executives, and this editor whooped through the whitewater and fought water battles through the quiet stretches like a bunch of kids, in mindless unconcern about the desecration dynamite and concrete in Glen Canyon would shortly wreak on one of the earth's unique and irreplaceable treasures.

There were other Green River trips. On one of them, sand waves swamped our canoe below Flaming Gorge Dam, putting two subteen children and me in water so cold it took an effort of will to swim the canoe ashore. Waiting below, my wife saw cushions from the canoe floating by and believed she must be a widow. She well might have been; the next day a canoeist drowned in the same stretch of river.

Then there are the Uintas. Uncounted are my backpack or horsepack trips; uncountable the miles I've slogged over rutted, muddy trails or rocky passes to reach those high wilderness lakes. Details fade, but not the feel of a good horse between the legs or of cold air burning my lungs at the top of an 11,000-foot pass. Nor the smell of a meadow after the common afternoon shower, or of steam rising off a horse's back in the sunshine that follows. Nor the dimples and splashes that say the fish are rising again.

Strange, though, that the trip that most sticks in memory was one into Duck Lake with Jim Barker and our respective sons. We made camp in the rain, cooked dinner in the rain, listened to rain through the night. For most of the next morning, water streaming off hat brims, eyes smarting from the smoke, we hunched in our ponchos around a fire that barely stayed alive under its soaked wood. Finally, mercifully, someone said to hell with it and we packed sopping tents on sopping horses and fled, fishless, for lower country.

Memory is like that. Good times blend into a pleasant glow. It's the hard times that give sharpness and savor. Maybe it's because there is an atavistic need in all of us to test ourselves against the harshness of nature. One thing about this Uinta country; there's plenty of that.

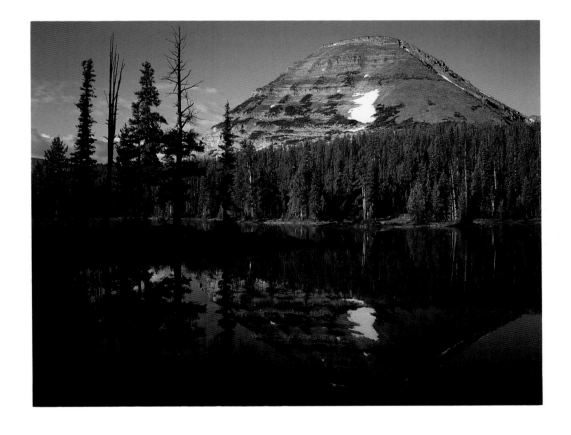

Bald Mountain at Pass Lake, High Uintas Wilderness Area

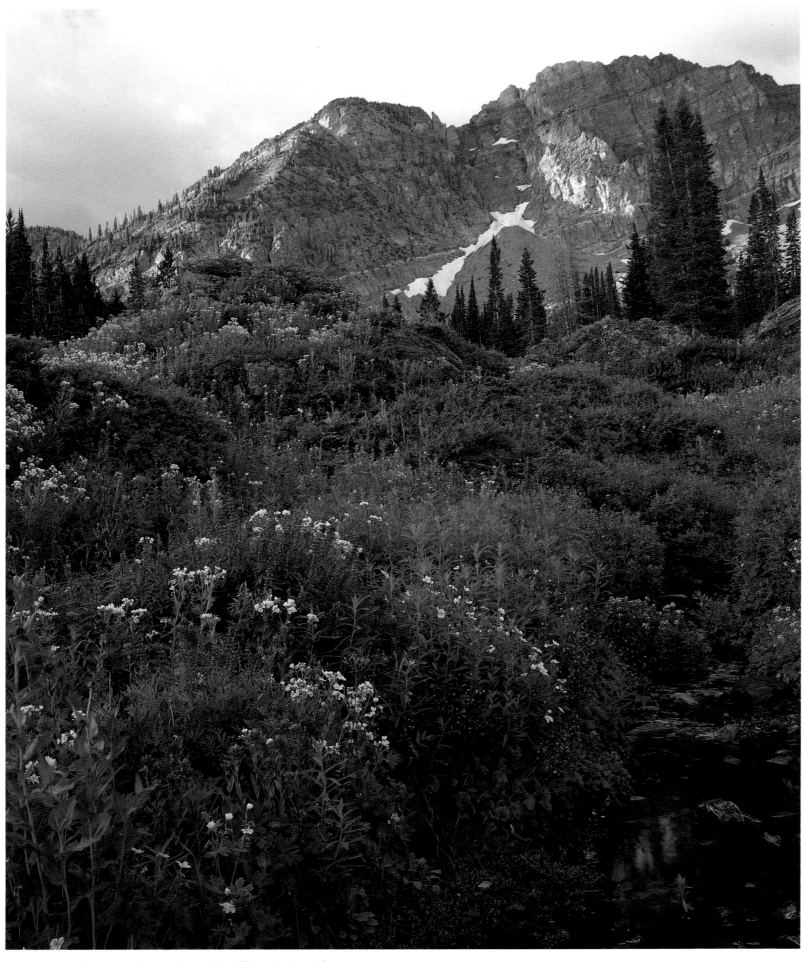

Above: Wildflowers and Devils Castle, Albion Basin, Alta
Opposite page: Wildflowers at Emigration Canyon

THE WASATCH FRONT

*The plain of the valley must be from southeast to northwest, sixteen Spanish leagues
[forty miles] long, and from northeast to southwest, ten or twelve leagues. It is all clear
and, with the exception of the marshes on the shores of the lake, the land is of good
quality, and suitable for all kinds of crops. . . . [O]n the south and in other directions,
there are very spacious areas of good land. On all of it there are good and very abundant
pastures, and in some places it produces flax and hemp in such quantities that it looks
as though they had planted it on purpose. . . . Besides these most splendid advantages,
in the nearby sierras which surround the valley there are plentiful firewood and timber,
sheltered places, water and pasturage for raising cattle and horses. . . .*

This lake of the Timpanogotzis [Utah Lake] abounds in several kinds of good fish,

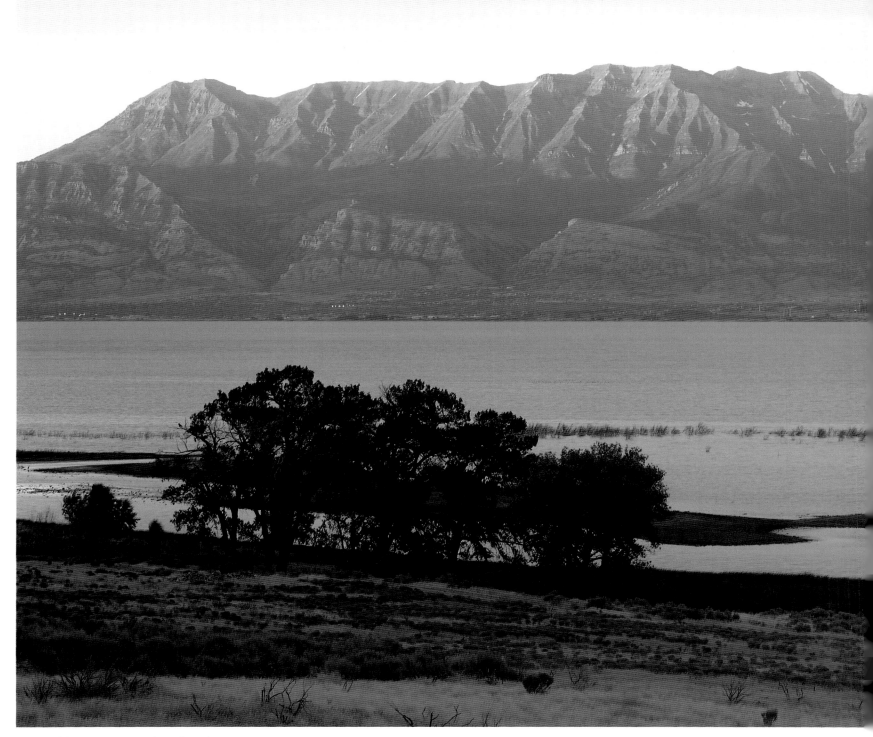

Mount Timpanogos and Utah Lake

geese, beaver, and other amphibious animals which we did not have an opportunity to see. Round about it live these Indians who subsist on the abundant fish of the lake, for which reason the Yutas Sabuaganas call them Come Pescados [Fish Eaters]. Besides this, they gather grass seeds in the plain from which they make atole, supplementing this by hunting hares, rabbits and fowls, of which there is a great abundance here. . . .

The other lake with which this one communicates, according to what they told us, covers many leagues and its waters are noxious and extremely salty, for the Timpanois assure us that a person who moistens any part of his body with the water of the lake immediately feels much itching.
　　　　　—Fray Silvestre Vélez de Escalante, describing Utah Valley, 1776

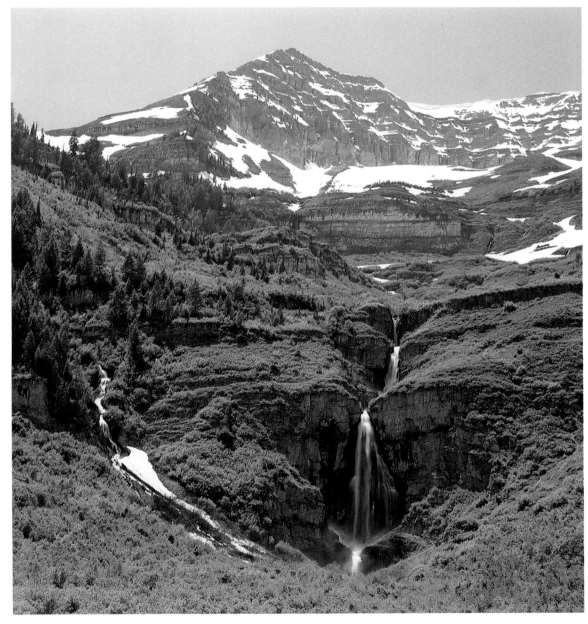

Stewart Falls, Mount Timpanogos

This is the most pleasing, beautiful, and fertile site in all New Spain. It alone is capable of maintaining a settlement with as many people as Mexico City, and of affording its inhabitants many conveniences, for it has everything necessary for the support of human life.
　　　　　—Don Bernardo Miera y Pacheco, mapmaker with
　　　　　Domínguez and Escalante, 1776

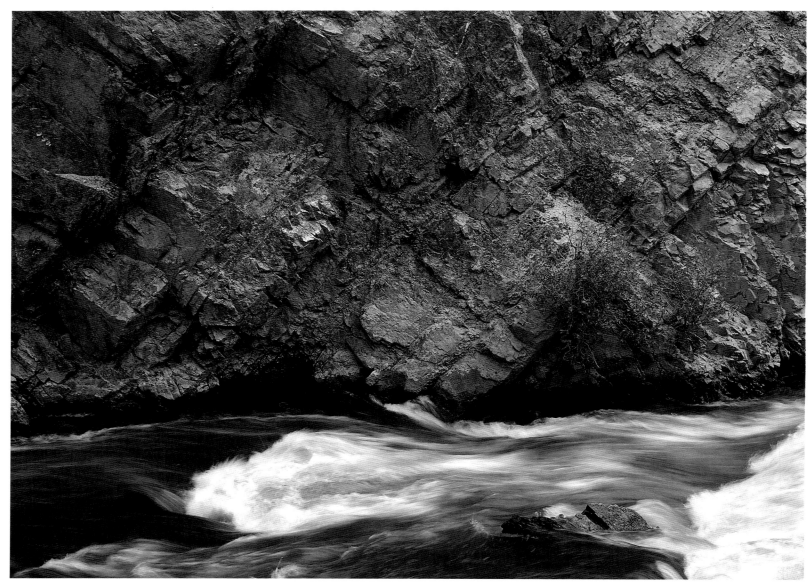

Quartz wall and Weber River in Weber Canyon

*On August 6 we ventured upon this furious passage, up to this point decidedly the
wildest we had encountered, if not the most dangerous. We devoted the entire forenoon
and until fully one o'clock in the afternoon to the task of getting our four wagons
through. In places we unhitched from the wagon all the oxen except the wheel-yoke,
then we strained at both hind wheels, one drove, and the rest steadied the wagon; we
then slid rapidly down into the foaming water, hitched the loose oxen again to the
wagon and took it directly down the foaming riverbed, full of great boulders, on
account of which the wagon quickly lurched from one side to the other; now we had to
turn the wheels by the spokes, then again hold back with all the strength we had, lest it
sweep upon a low lying rock and smash itself to pieces. In going back for each wagon
we had to be very careful lest we lose our footing on the slippery rocks under the water
and ourselves be swept down the rapid, foaming torrent. . . .*

*On the 7th we reached the flat shore of the magnificent Salt Lake, the waters of
which were clear as crystal, but as salty as the strongest salt brine. It is an immense
expanse of water and presents to the eye in a northeasterly [sic, northwesterly] direc-
tion nothing but sky and water. In it there are a few barren islands which have the
appearance of having been wholly burnt over. The land extends from the mountains
down to the lake in a splendid inclined plane broken only by the fresh water running
down from ever-flowing springs above. The soil is a rich, deep black sand composition*

doubtless capable of producing good crops. The clear, sky-blue surface of the lake, the warm sunny air, the nearby high mountains, with the beautiful country at their foot, through which we on a fine road were passing, made on my spirits an extraordinarily charming impression. The whole day long I felt like singing and whistling; had there been a single family of white men to be found living here, I believe that I would have remained. Oh how unfortunate that this beautiful country was uninhabited!
—California-bound Heinrich Lienhard, describing the descent
of the Weber River and the Great Salt Lake Valley, 1846

This is an important day in the history of my life and in the history of the Latter-day Saints. After traveling from our encampment through the deep ravine, ending with the canyon, we came in full view of the valley of the Great Salt Lake, the land of promise, held in reserve by the hand of God as a resting place for the Saints, upon which a portion of the Zion of our God will be built. We gazed with wonder and admiration upon the vast fertile valley spread out before us, for about 25 miles in length and 16 miles in width, clothed with a heavy garment of vegetation, in the midst of which glistened the waters of Great Salt Lake, with mountains all around, towering toward the skies, and streams, rivulets and creeks of pure water running through the beautiful valley.
—Mormon Apostle Wilford Woodruff, July 24, 1847

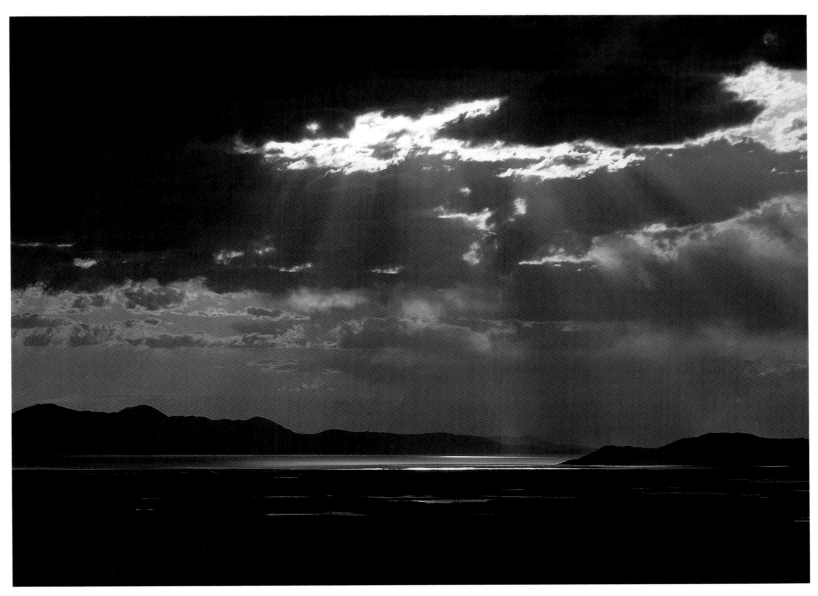

Sunset, Great Salt Lake

We had to struggle against great difficulties in trying to mature a first crop. We had not only the difficulties and inexperience incidental to an unknown and untried climate, but also swarms of insects equal to the locusts of Egypt, and also a terrible drought, while we were entirely inexperienced in the art of irrigation; still we struggled on, trusting in God.

During this spring and summer my family and myself, in common with many of the camp, suffered much for want of food. This was the more severe on me and my family because we had lost nearly all our cows, and the few which were spared to us were dry, and, therefore, we had no milk to help out our provisions. I had ploughed and subdued land to the amount of near forty acres, and had cultivated the same in grain and vegetables. In this labor every woman and child in my family, so far as they were of sufficient age and strength, had joined to help me, and had toiled incessantly in the field suffering every hardship which human nature could well endure. Myself and some of them were compelled to go with bare feet for several months, reserving our Indian moccasins for extra occasions. We toiled hard and lived on a few greens and on thistle and other roots. . . . In this way we lived and raised our first crop in these valleys. And how great was our joy in partaking of the first fruits of our industry.

—Parley P. Pratt, 1848

This is the Place Monument at sunset, Salt Lake City

Salt Lake Valley at sunset from Mount Olympus

*In their dealings with the crowds of emigrants that passed through their city, the
Mormons were ever fair and upright, taking no advantage of the necessitous condition
of many, if not most of them. . . . In the whole of our intercourse with them, which
lasted rather more than a year, I cannot refer to a single instance of fraud or extortion
to which any of the party was subjected. . . . In short, these people presented the
appearance of a quiet, orderly, industrious, and well-organized society. . . .
. . . [T]hat polygamy does actually exist among them cannot be concealed. . . . The
union thus formed is considered a perfectly virtuous and honourable one, and the lady
maintains, without blemish, the same position in society to which she would be entitled
were she the sole wife of her husband. . . . All idea of sensuality, as the motive of such
unions, is most indignantly repudiated; the avowed object being to raise up, as rapidly
as possible, "a holy generation to the Lord." . . . [A]nd they do not hesitate to declare,
that when they shall obtain the uncontrolled power of making their own civil laws
(which will be when they are admitted as one of the States of the Union), they will
punish the departure from chastity in the severest manner, even by death. . . .*
—Captain Howard Stansbury, 1850

*I shall leave for the States on the 1st of October, and most gladly will I go, for I am
sick and tired of this place—of the fanaticism of the people, followed by their violence of
feeling towards the "Gentiles," as they style all persons not belonging to their Church....
I hope I shall get off safely. God only knows. I am in the power of a desperate and
murderous set. I however feel no great fear. So much for defending my country.*
 —Judge Perry E. Brocchus to President Millard Fillmore, 1851

*[A] more joyous, happy, free-from-care, and
good-hearted people I never sojourned among.*
 —Solomon Nunes Carvalho, 1854

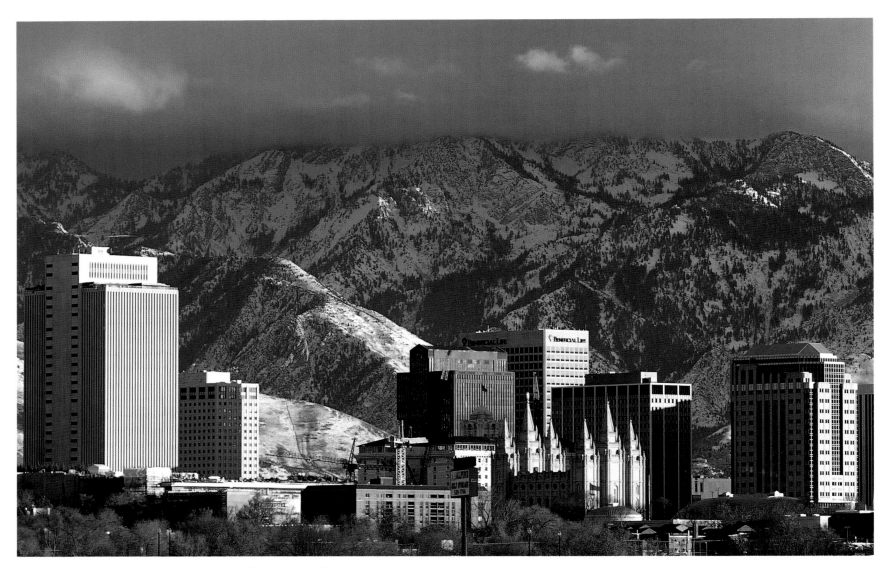

Salt Lake City and Wasatch Mountains, looking southeast

*Opening out from the last rough gorge, we entered upon a broad plateau, or bench,
and Salt Lake City lay at our feet. We are surprised and refreshed with its general
appearance of neatness and order. The buildings were almost entirely of adobe, giving
them the appearance of grey cut stone. They were set well apart, nearly each by itself,
and within the enclosures about them one saw that which one so longs to see from long
familiarity with these deserts—perfectly bright green and luxuriant trees and shrubbery.
The streets, as we viewed them from our height, are straight and wide, crossing each
other generally at right angles. Beyond the city the Jordan River, running north and
south. Beyond this the gray of the eternal desert, hemmed remotely by picturesque
peaks and mountains. But soon colors flying again the regiment falls in, and with the*

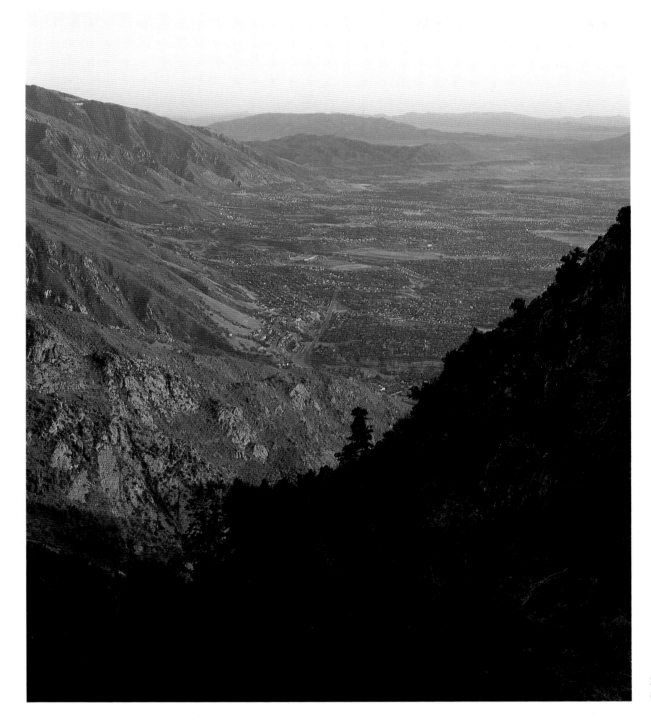

Salt Lake Valley from Mount
Olympus Wilderness Area

*Band at front and the whole in column of Companies, we enter, after a short descent,
the City of the Saints of our Latter Day. And now came a spectacle not common. With
the exception of a picked few of his "destroyers" of decidedly rough and sinister
aspect, left as a police, and with orders to fire the city in case we offered to occupy it,
every man, woman, and child, had, at the direction of the prophet, departed—fled! . . .
It was substantially a city of the dead. . . . The buildings of Brigham appear constituted
mainly of a series of gables within the enclosure of a wall of adobe, having a wide
gateway and a beehive above it. There are also images of lions, grim of aspect, at the
right and left. Why so many gables should appear, is explained upon the ground of the
abundance of wives of our modern Turk of the Valley, together with their reputed
steadily increasing families.*

—Captain Albert Tracy, entering Salt Lake City
during the Utah War, 1858

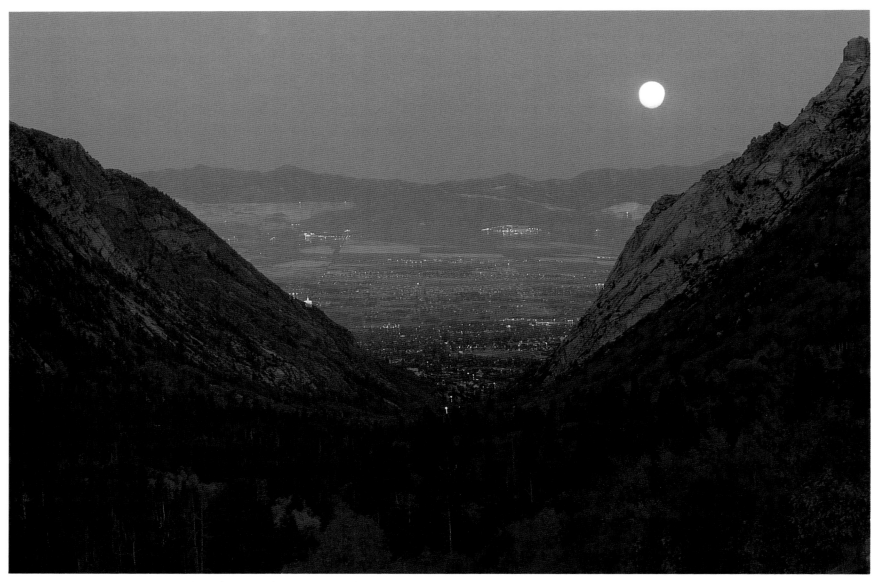

Setting moon over Salt Lake Valley, from Little Cottonwood Canyon

The city revealed itself as we approached. . . . At a little distance the aspect was somewhat Oriental, and in some points it reminded me of modern Athens—without the Acropolis. None of the buildings, except the Prophet's house, were whitewashed. The material—the thick, sundried adobe, common to all parts of the Eastern world—was of a dull leaden blue, deepened by the atmosphere to a grey, like the shingles of the roofs. The number of gardens and compounds—each tenement within the walls originally received 1.50 square acre, and those outside from five to ten acres, according to their distance—the dark clumps and lines of bitter cottonwood, locust or acacia, poplars and fruit trees, apples, peaches, and vines—how lovely they appeared, after the baldness of the prairies!—and, finally, the fields of long-eared maize and sweet sorghum strengthened the similarity to an Asiatic rather than to an American settlement. . . . The suburbs are thinly settled; the mass of habitations lie around and south of Temple Block. The streets of the suburbs are mere roads, cut by deep ups and downs, and by gutters on both sides, which, though full of pure water, have no bridge save a plank at the threaders. In summer the thoroughfares are dusty—in wet weather deep with viscid mud. The houses are almost all of one pattern—a barn shape, with wings and lean-to, generally facing, sometimes turned endways to, the street, which gives a suburban look to the settlement; and the diminutive casements show that window-glass is not yet made in the valley. In the best abodes the adobe rests upon a few courses of sandstone,

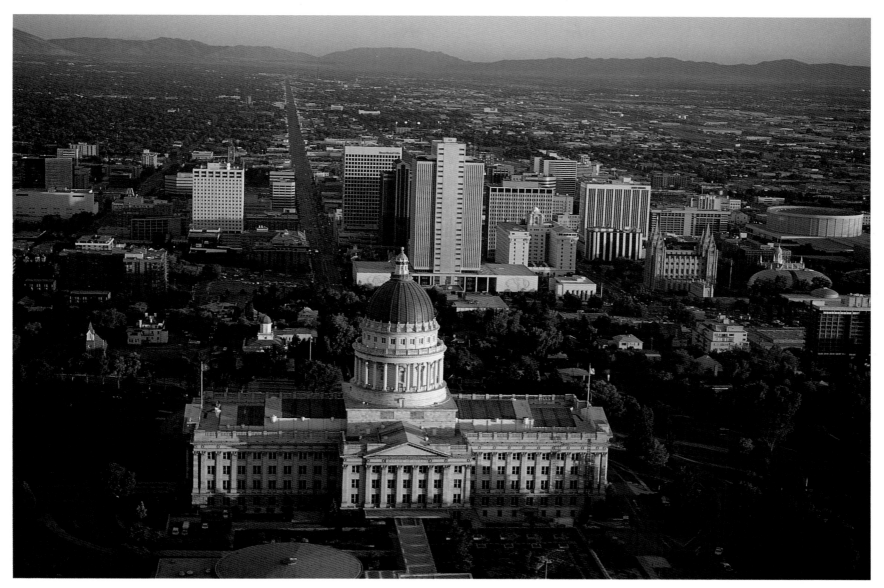

Salt Lake Valley, looking south

which prevent undermining by water or ground-damp, and it must always be protected
by a coping from the rain and snow. The poorer are small, low, and hut-like; others are
long single-storied buildings, somewhat like stables. . . . I looked in vain for the
outhouse-harems, in which certain romancers concerning things Mormon had informed
me that wives are kept, like any other stock. I presently found this but one of a multitude
of delusions. Upon the whole, the Mormon settlement was a vast improvement upon its
contemporaries in the valleys of the Mississippi and the Missouri. . . .

Walking in a northward direction up Main, otherwise called Whiskey Street, we
could not but observe the "magnificent distances" of the settlement which, containing
9000-12,000 souls, covers an area of three miles. This broadway is 132 feet wide,
including the side walks, which are each twenty, and like the rest of the principal
avenues, is planted with locust and other trees. . . .

[Of Brigham Young:] His manner is at once affable and impressive, simple and
courteous. . . . He shows no sign of dogmatism, bigotry, or fanaticism, and never once
entered—with me at least—upon the subject of religion. . . . His temper is even and
placid, his manner is cold, in fact, like his face, somewhat bloodless, but he is neither
morose nor methodistic, and where occasion requires he can use all the weapons of
ridicule to direful effect, and "speak a bit of his mind" in a style which no one forgets.
. . . He has been called hypocrite, swindler, forger, murderer.—No one looks it less. . . .

Box Elders in Millcreek Canyon, Wasatch Mountains

He is the St. Paul of the New Dispensation: true and sincere, he gave point, and energy, and consistency to the somewhat disjointed, turbulent, and unforeseeing fanaticism of Mr. Joseph Smith; and if he has not been able to create, he has shown himself great in controlling, circumstances. Finally, there is a total absence of pretension in his manner, and he has been so long used to power that he cares nothing for its display. The arts by which he rules the heterogeneous mass of conflicting elements are indomitable will, profound secrecy, and uncommon astuteness. . . .

[Of polygamy] The first wife, as among polygamists generally, is the wife, and assumes the husband's name and title. Her "plurality-" partners are called sisters—such as sister Anne or sister Blanche—and are the aunts of her children. . . . Girls rarely remain single past sixteen—in England the average marrying age is thirty—and they would be the pity of the community, if they were doomed to a waste of youth so unnatural. Divorce is rarely obtained by the man who is ashamed to own that he cannot keep his house in order; some, such as the President, would grant it only in case of adultery; wives, however, are allowed to claim it for cruelty, desertion or neglect. . . .

The "chaste and plural marriage" being once legalised, finds a multitude of supporters. The anti-Mormons declare that it is at once fornication and adultery—a sin which absorbs all others. The Mormons point triumphantly to the austere morals of their community, their superior freedom from maladive influences, the absence of that uncleanness and licentiousness which distinguish the cities of the civilized world. They boast that if it be an evil they have at least chosen the lesser evil, that they practise openly as a virtue what others do secretly as a sin.
—Richard F. Burton, 1860

Spring snowstorm at fruit orchard in Orem

I work on the Tabernacle; my wages are 5 dollars so that in 2 days I can earn all we need in a whole week and in 14 days I can provide for the whole winter. But the good times which we enjoy here have brought not a few Gentiles into the valley who would enrich themselves at the expense of the people.
—Danish LDS convert Christoffer J. Kempe, 1865

Twin Peaks above Sandy, Utah

I have been astonished, on a couple of recent trips through Salt Lake City, to find a conviction growing in me that I am not as homeless as I had thought. At worst, I had thought myself an Ishmael; at best, a half-stranger in the city where I had lived the longest, a Gentile in the New Jerusalem. But a dozen years of absence from Zion, broken only by two or three short revisitings, have taught me different. I am as rich in a hometown as anyone, though I adopted my home as an adolescent and abandoned it as a young man.

A Gentile in the New Jerusalem; certainly I was. Salt Lake City is a divided concept, a complex idea. To the devout it is more than a place; it is a way of life, a corner of the materially-realizable heaven; its soil is held together by the roots of the family and the cornerstones of the temple. In this sense Salt Lake City is forever foreign to me, as to any non-Mormon. But in spite of being a Gentile, I discover that much of my youth is there and a surprising lot of my heart. Having blown tumbleweed-fashion around the continent so that I am forced to select a hometown, I find myself selecting the City of the Saints, and for what seems to me cause.

It has such a comfortable, old-clothes feel that it is a shock to see again how beautiful this town really is, quite as beautiful as the Chamber of Commerce says it is; how it lies under a bright clarity of light and how its outlines are clean and spacious, how it is dignified with monuments and steeped in sun, tempered with shade, and how it lies protected behind its rampart mountains, insulated from the stormy physical and intellectual weather of both coasts. Serenely concerned with itself, it is probably open to criticism as an ostrich city; its serenity may be possible only in a fool's paradise of isolationism and provincialism and smugness. But what is a hometown if it is not a place you feel secure in? I feel secure in Salt Lake City.
—Wallace Stegner, *A Sense of Place*, 1989

Trees in snow at sunrise, Mountain Dell Golf Course, Parleys Canyon

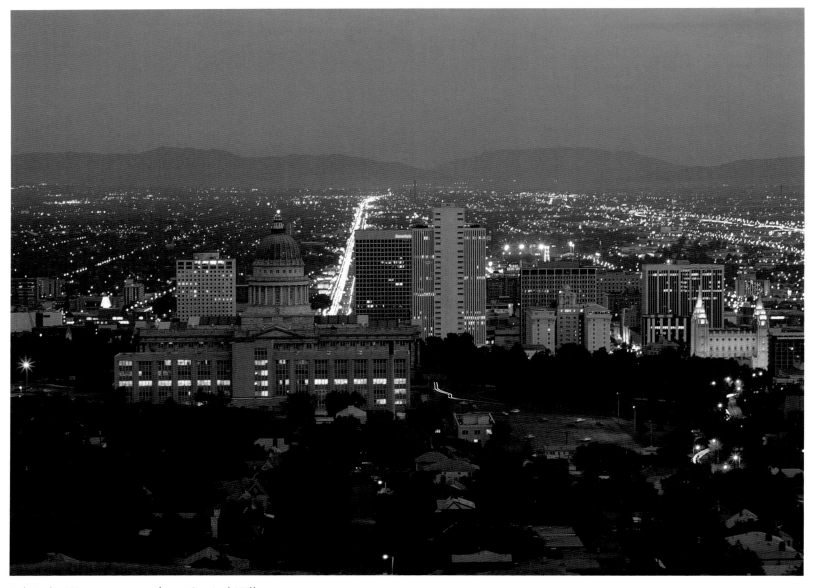

Salt Lake City at evening from Capitol Hill

When I was fourteen I sold hot dogs and hamburgers at Saltair, the resort built on pilings in the lake's south end. It was the old Saltair—since burned down and rebuilt. In those years the water was six feet higher than at present, and swimmers who now must chase the receding waters in little cars could step from their bathing houses into breast-deep brine.

In daytime the lake air was hot, rich with popcorn and spun candy and the smoke of frying. The whole pavilion, even the potted palms, glittered with an air-borne deposit of salt; salt gritted underfoot; the pilings, pink below the water line, were crusted white above. At night, because the water cooled more slowly than the land, the air stirred with a land breeze that strengthened as darkness came on, bringing hints of the mountains to the east, and more than a hint of the salt flats along the water's edge. Everything was louder and brighter at night; the roar of the roller coaster and squeals of girls, the glitter of thousands of lights, the barbaric noises of what we proudly called the Coney Island of the West.

Sometimes we slipped away from the stand for an after-dark swim, moving quietly among the reflected green and blue and lemon yellow lights on the water's metallic surface. Cradled in water warm as milk, we felt the sting of brine in every cut, and over us washed the secret, half-tainted shore breeze with its smell of the flats. To me it was an enchanted place. . . .

Saltair at flood with rock dike, Great Salt Lake

Everything about Great Salt Lake is bizarre and contradictory. Remnant though it is, it is still the biggest lake west of the Mississippi. In a land where water is more precious than diamonds, this lake seventy-five miles long and fifty wide provides not a single oasis; it offers little recreation or refreshment, and though it has been on the map as long as America has been a nation, it remains almost unknown.

—Wallace Stegner, 1957

Red maple, Big Cottonwood Canyon

The Wasatch Front

ON A BRIGHT DAY IN NOVEMBER a green young newspaper reporter set out to demonstrate why Utah is "the place." In slanting early sunlight he shot a limit of mallards on the Salt Lake marshes and was home by mid-morning. He dashed up to Alta for a half-day of skiing, returned to finish a round of golf at Forest Dale just before dark, and then attended a Utah Symphony concert in the Tabernacle—dozing a little, for some reason, during the third movement of Beethoven's Fifth Symphony.

Forty-five years later, on an April morning, now retired and recuperating from back surgery, he set out on a therapeutic walk in the hills above his home. Climbing to the ridgeline north of Red Butte Canyon, he sat looking at his valley and reflecting on how it had changed. Towering buildings punched the sky where the Salt Lake Temple, Hotel Utah, and Walker Bank with its weather sign once dominated the skyline. Rush-hour traffic flowed into the city on triple-lane freeways. Homes and condominiums filled the valley and climbed the hills. Just below where he sat sprawled the greatly expanded University of Utah campus and the buildings of Research Park, where go on all sorts of unimagined activities. For entertainment that night he could choose among the Utah Symphony in its gold-leafed, acoustically ideal concert hall, the NBA title-contending Utah Jazz in their 22,000-seat Delta Center, Ballet West at the Capitol Theater, a Broadway-caliber play at Pioneer Memorial Theater, or . . . well, the list is long.

Our city has grown up, he mused, become Big Time. And yet . . . turning around, he counted seventy-six deer in the basin just below and on the hillside beyond. And if he still had the energy and still hunted ducks there would be no reason he couldn't repeat that memorable day of forty-five years ago.

Those two days, and so many, many others between, help explain my love affair with Salt Lake Valley. Where else—except anywhere along the Wasatch Front—can you find nature and wildlife and adventure so close at your back door and the finest educational and cultural resources at the front?

Boulders in dry streambed, Little Cottonwood Canyon

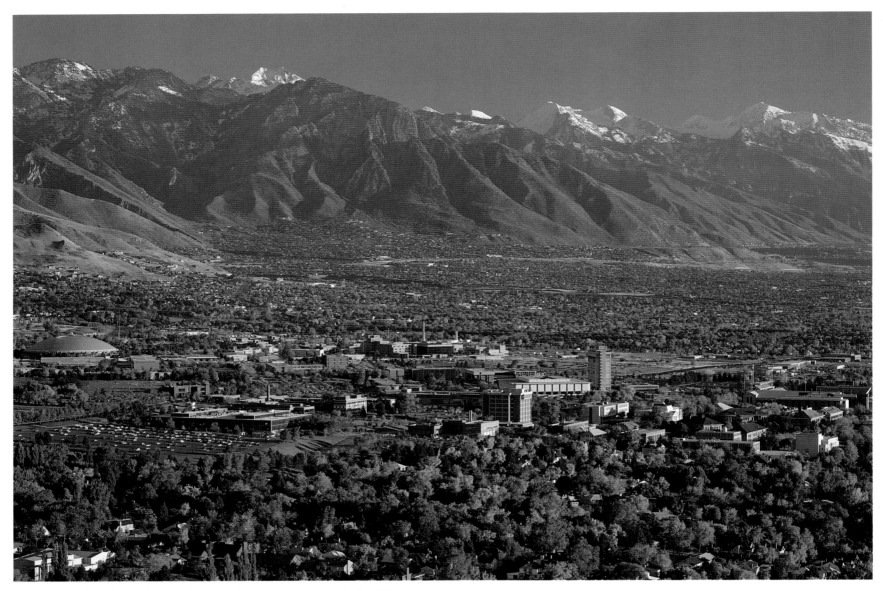

University of Utah campus and Wasatch Mountains, Salt Lake City

About that education: among the country's universities, the University of Utah has been ranked the tenth "best buy"—the quality of education it provides in relation to tuition and costs. Its honors program, judged one of the four best in the country, "offers a top education for a rock bottom price," according to the 1993 *Fiske Guide to Education.* Before the rankings stopped including religion-affiliated schools, Brigham Young University was judged the country's fourth "best buy." Utah State University at Logan and Weber State University at Ogden also offer excellent educational opportunities.

Four universities and two superior community colleges—to say nothing of a dozen theater companies, three dance companies, the symphony, the opera, the Mormon Tabernacle Choir—all in the 120-mile strip of the Wasatch Front may seem like overkill. But 80 percent of Utah's population, some two million people, live along that strip, and the rest of the state does most of its marketing there. This concentration makes Utah,

surprisingly considering its vast open spaces, the sixth most urban state in the country.

Why such concentration? The reasons tell us much about the nature of Utah.

First was the vision of Brigham Young and the energy of the religious movement he headed. From the reports of John C. Frémont and others, Brigham knew something about the Great Basin, and he knew that was where he wanted to relocate his persecuted church. Driven from New York to Ohio to Missouri to Illinois to Winter Quarters on the banks of the Missouri, the Latter-day Saints had suffered enough mobbings and burnings and killings. They sought an empty place where, with no neighbors to trouble or be troubled by, they could create their own society. The Great Basin seemed the emptiest place available.

But just where in the Basin? The pioneer company of Mormons got differing advice on that subject. At South Pass they met Moses Harris, who had trapped the area for twenty-five years. He had little good to say

Boulders at Storm Mountain, Big Cottonwood Canyon

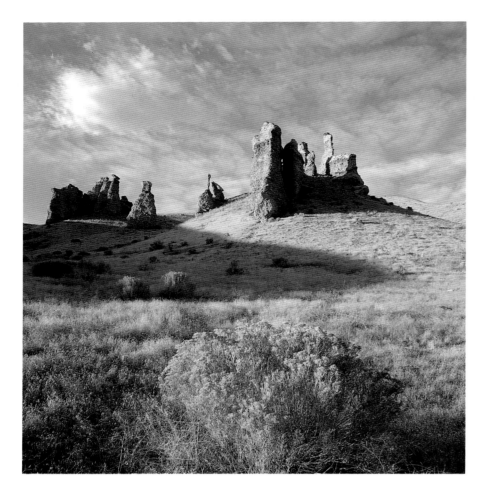

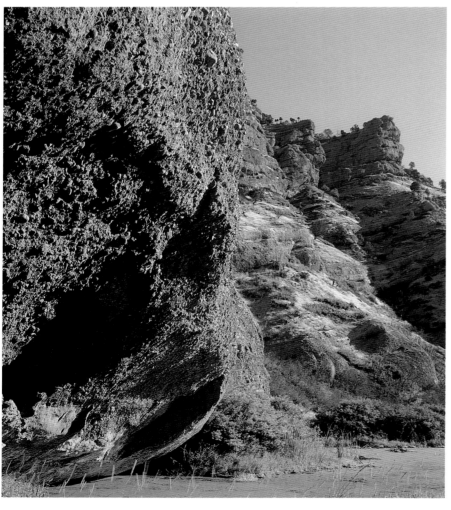

about any of it. *"From his description, we have little chance to hope for even a moderately good country anywhere in those regions,"* William Clayton wrote in his pioneer journal. *"He speaks of the whole region as being destitute of timber and vegetation, except the wild sage."* On the Big Sandy in Wyoming, Jim Bridger was not much more encouraging. Cold nights would make it difficult to grow corn, he told them, but if they were determined to settle in the area, Utah Valley would be the best place. Miles Goodyear thought differently. Meeting the pioneers near present-day Evanston, he urged them to settle near the cabin he had built in the Ogden area. He failed. *"We have an idea he is anxious to have us make a road to his place through selfish motives,"* wrote the skeptical Clayton. Regarding all the advice, Clayton recorded, *"We shall know more about things and have a better understanding when we have seen the country ourselves."*

And so they came, down Echo Canyon to the present site of Henefer, up Main Canyon and over Hogsback ridge, up East Canyon Creek, over Big Mountain, down Mountain Dell, over Little Mountain, and down Emigration Canyon. Atop a steep hill jutting up from the mouth of that canyon, luxurious condominiums today look over the valley. Not many Utahns know, or care, that what happened at this hill—Donner Hill—dramatized the difference between pioneering success and failure.

Mormon wagons weren't the first at that place. A year earlier, in 1846, the Donner-Reed party had pioneered a promised shortcut to California. For sixteen days since leaving the Weber River they had hacked and shoveled and cursed their way through the Wasatch, making only thirty-six miles on a trail that climbed over two mountains and required forty-four crossings of the three streams it followed through horrendous thickets of willow, chokecherry, and alder. The work was killing; shirking, bickering, and hard feelings made it worse. And here, only a gunshot from the open valley, Emigration Canyon narrowed into a boulder-strewn, brush-choked gorge that seemed impassable to the weary travelers.

Sick of hacking brush and manhandling boulders, they didn't attempt it. *"We reached the end of the canyon where it looked as though our wagons would have to be abandoned,"* Virginia Reed later recalled. *"It seemed impossible for the oxen to pull them up the steep hill and the bluffs beyond, but we doubled teams and the work was, at last, accomplished, almost every yoke in the train [of 23 wagons] being required to pull up each wagon."*

Above left: Witches Rocks, Weber Canyon
Left: Pond and rock outcrop in Echo Canyon

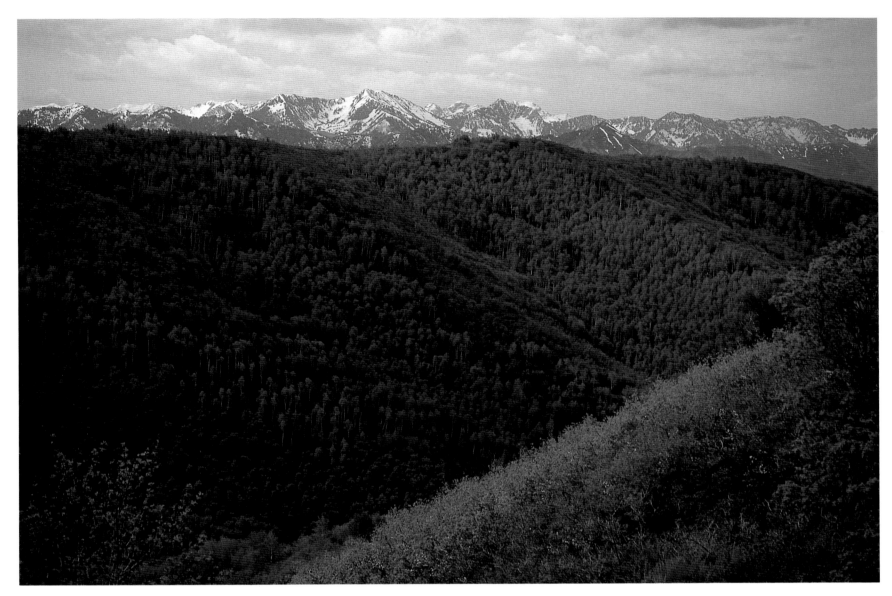

Wasatch Mountains from Big Mountain

Jaded and with no time to rest, the oxen later broke down in the Salt Desert, more time was lost, and the party staggered on to the horror of snow-bound starvation and cannibalism in the Sierra Nevada.

A year later, on July 22, the Mormon pioneer company followed the Donner track to that spot and saw where the teams had struggled to pull the wagons up Donner Hill. William Clayton recorded: *"We found the road crossing the creek again to the south side and then ascending up a very steep, high hill. It is so very steep as to be almost impossible for heavy wagons to ascend and so narrow that the least accident might precipitate a wagon down a bank three or four hundred feet—in which case it would certainly be dashed to pieces. Colonel Markham and another man went over the hill and returned up the canyon to see if a road cannot be cut through and avoid this hill. . . . Brother Markham says a good road can soon be made through the bushes some ten or fifteen rods. A number of men went to work immediately to make the road. . . . After spending about four hours' labor, the brethren succeeded in cutting a pretty good road along the creek and the wagons proceeded on."*

Enough foresight to scout out the way ahead. Four hours of willing, cooperative labor—while the oxen rested. Would that have averted the Donner disaster?

For the Mormon pioneer company, there was no question about cutting through that last obstacle. The road they were building was for thousands to follow. And follow they did—2,000 of them in the Big Company arriving in September that same year. Ninety-six hundred wagons, 650 handcarts, and 68,000 Mormons, about half of them European converts, reached the valley before the joining of the rails at Promontory in 1869 ended the pioneer period. With Brigham Young's genius for colonization, they quickly spread out along the Wasatch Front: to Bountiful in the year of arrival, to Provo in 1848, Manti in 1849, Lehi and Ogden in 1850, Brigham City in 1851, Wellsville in 1856, Logan in 1859.

So Brigham's vision and Mormon zeal in gathering the faithful to Zion was a first important reason cities grew along the Wasatch Front. Another was the Pony Express. In the 1850s communication with and settlement of the West was one focus of North-South tensions building toward the Civil War. Southern sympathizers in Congress wanted a transcontinental mail route they could control, along a southern route from St. Louis through El Paso, Albuquerque, and Tucson to California. They argued that any route north of that would be unreliable if not impossible because of heavy snows in the Rockies and Sierra Nevada.

The Pony Express proved them wrong. By maintaining, almost without fail, summer and winter, a ten-day schedule from St. Joseph to Sacramento, it established the central route through Salt Lake City, followed shortly by the telegraph, the railroad, and finally the transcontinental Lincoln Highway. The Pony Express was a colossal financial failure that bankrupted its owners, but it made the Salt Lake City–Ogden area the most important transportation and communication center between the Mississippi River and the West Coast.

But all of that wouldn't have mattered without the resources of the land itself. Nowhere else in the Great Basin are such wide expanses of fertile ground so generously watered by such streams as those flowing out of the Uinta and Wasatch mountains. How little most

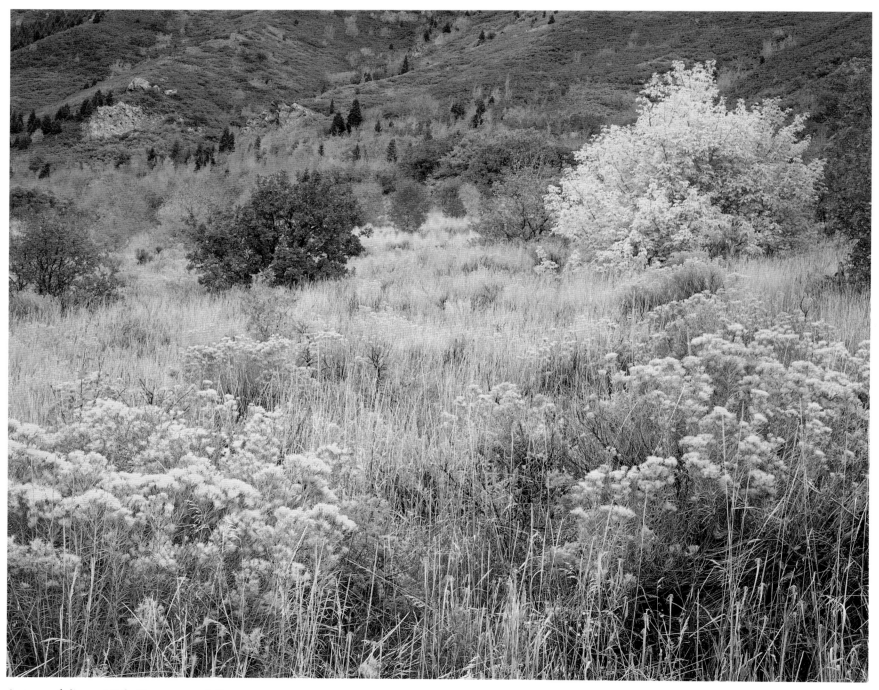

Autumn foliage, Little Cottonwood Canyon

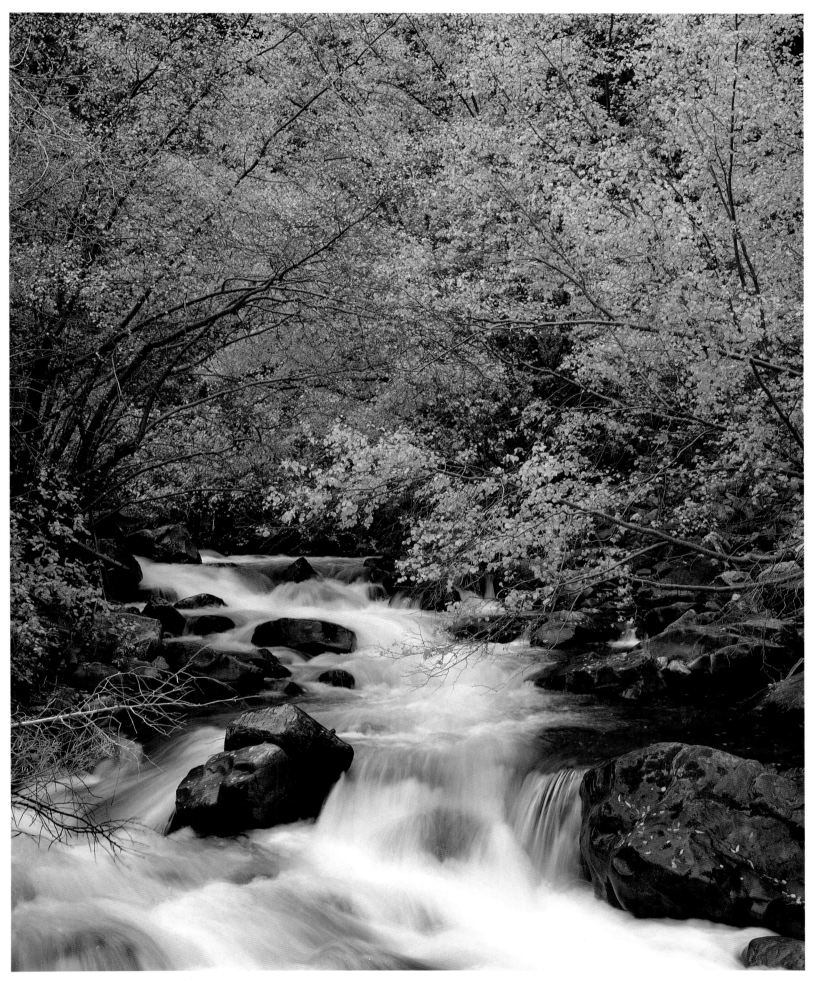

Box Elder trees at autumn with stream, Big Cottonwood Canyon

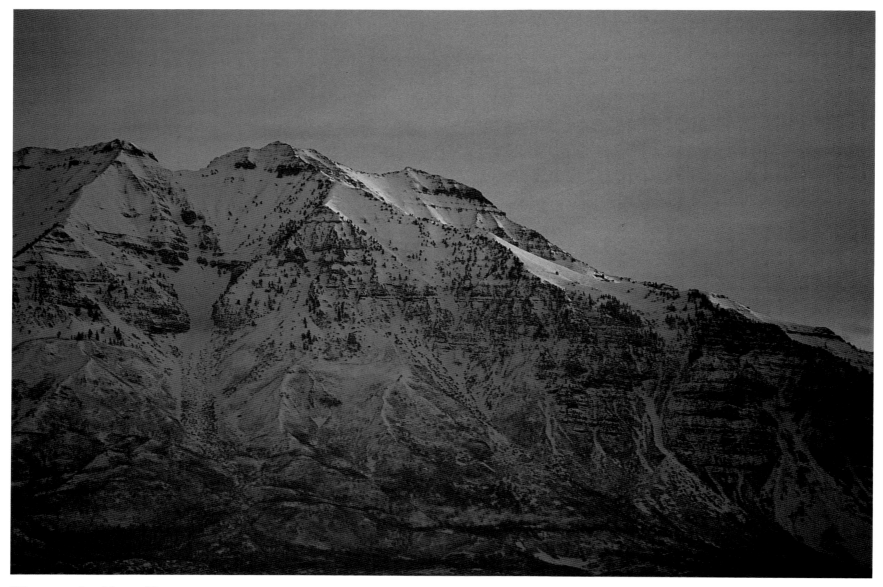

Winter sunrise, Mount Timpanogos

of us realize what those mountains mean to life on the Wasatch Front!

The Mountains

One day in the mid-1950s, a flash flood poured off Willard Peak, ripping through fields and orchards and a few houses in the peaceful little town of Willard. We rode horseback up the back side of the mountain with a Forest Service team trying to determine why contouring and reseeding by the CCC in the 1930s had not held back the flood. While we lunched on the peak, looking at verdant fields below and the Great Salt Lake shimmering beyond, Reed Bailey, the intermountain region's range expert, put aside his sandwich and rose to his feet. "I feel a sermon coming on. I take my text from Psalm 121: *'I will lift up mine eyes unto the hills, from whence cometh my help.'* All the beauty you see before you, the farms, the orchards, the towns, the lake

you see out there—all this comes from these mountains. Help from the hills? Better had the scripture said life itself."

As he talked on about the inseparable connection between moisture collected in the mountains and life in the valleys below and the need to protect these priceless watersheds, he awakened a new awareness in the mind of at least one man who had loved these mountains mainly as a great place to hike, to hunt, and, especially, to ski.

They are that, certainly. From Beaver Mountain in Logan Canyon on the north to Sundance in Provo Canyon on the south, no fewer than twelve ski resorts share powder snow whose lightness and depth are fabled wherever skiers gather. For more than a century, since the early Alta miners strapped boards to their feet for recreation or to get where they needed to go, skiing has been part of the Wasatch. But not until the late 1930s, when Alf Engen and others hiked over Catherine Pass from Brighton into the ruins of the abandoned

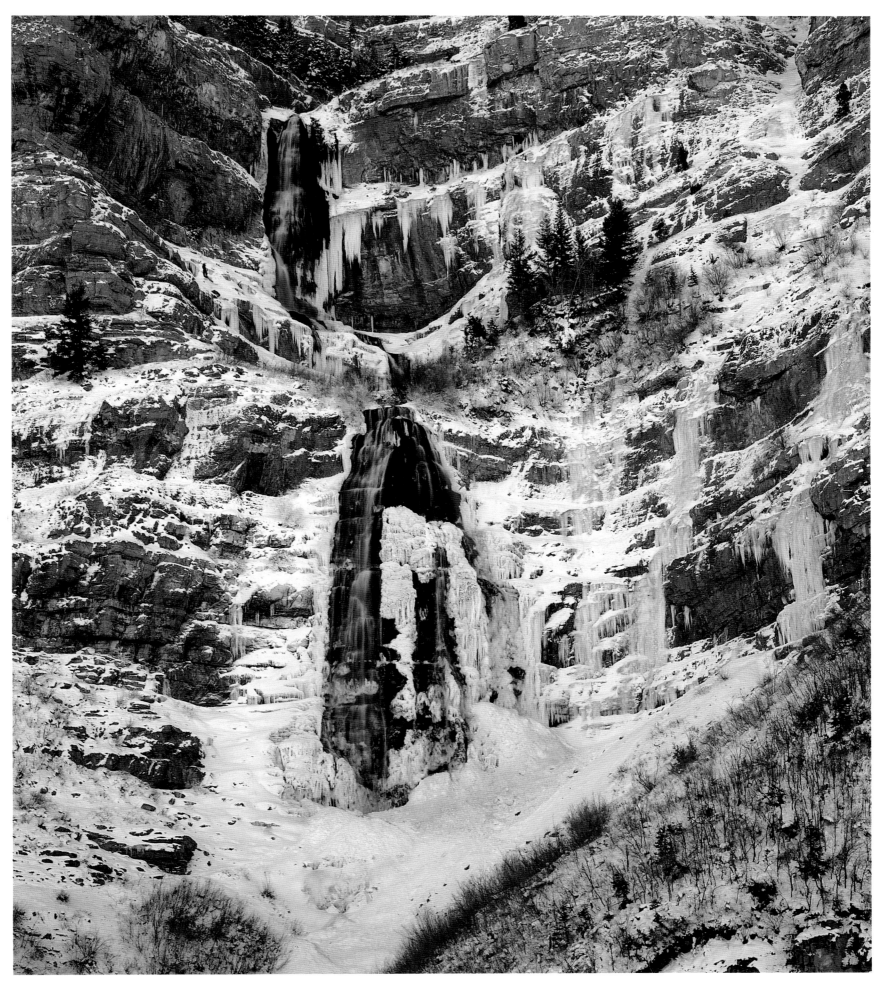

Bridal Veil Falls in winter, Provo Canyon

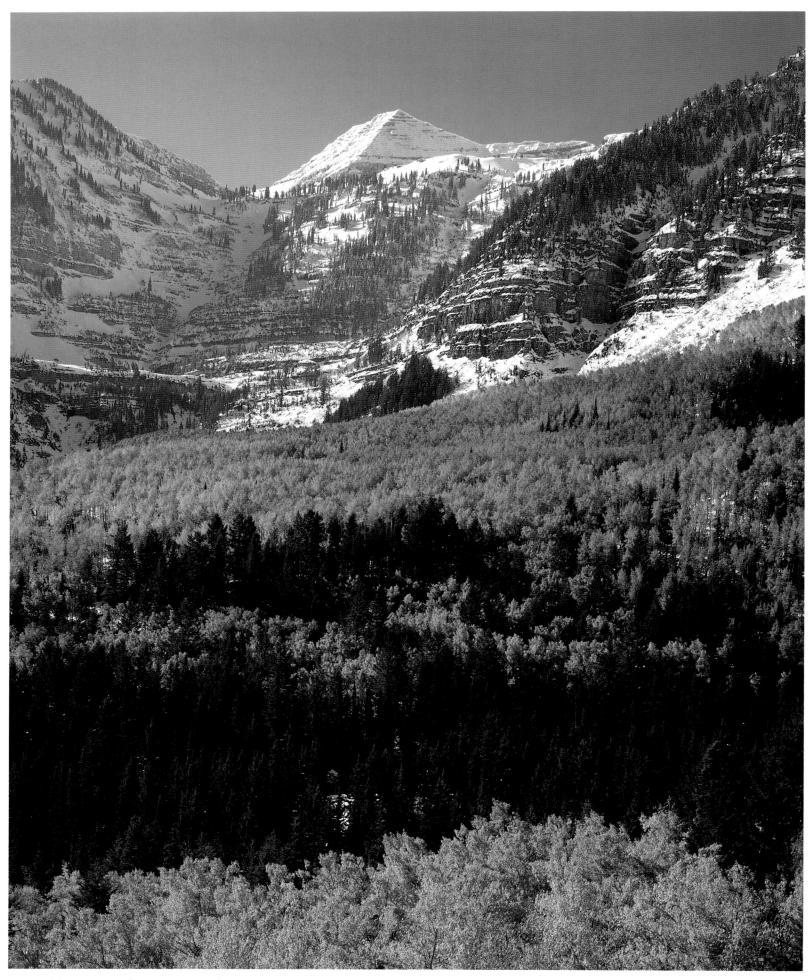

Mount Timpanogos from Timpooneke campground

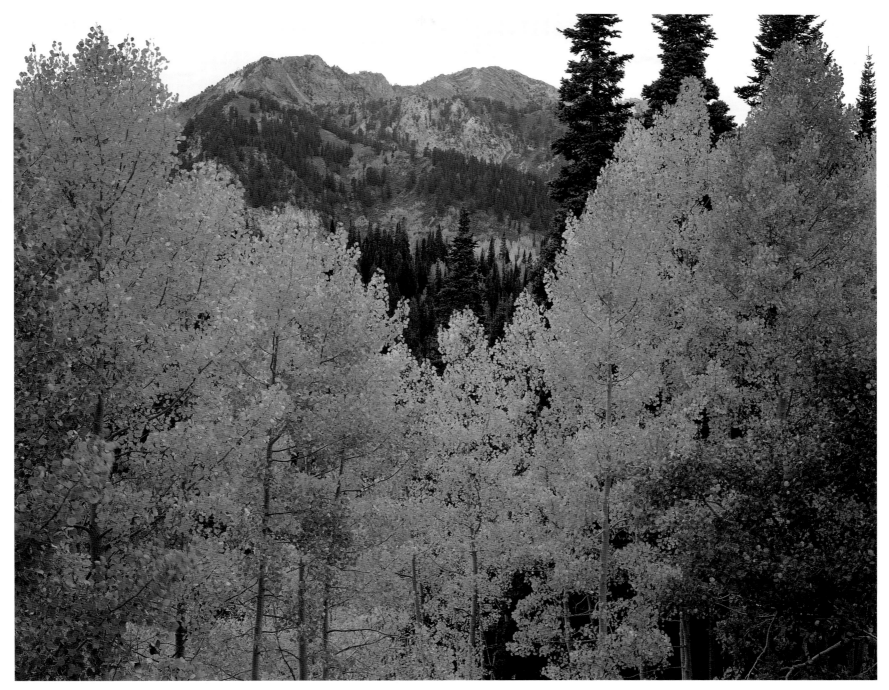

Mount Millicent, Big Cottonwood Canyon, Wasatch Mountains

mining area above Alta was the area's potential for commercial skiing recognized. In 1939, a single-chair lift, after Sun Valley the nation's first, began hauling skiers up Collins Gulch. At Snow Basin, up Ogden Canyon, enthusiasts installed a rope tow powered by an old truck engine, and at Beaver Mountain, in Logan Canyon, they powered the tow with the truck itself, the rope looped around a jacked-up rear wheel. It went on from there, until by the early 1990s there were in the Wasatch seventy-five chairlifts, many of them triple and quad, plus a gondola and a 100-passenger tram—and more on the way. The world has discovered Utah skiing; out-of-state skiers pump some $500 million a year into the Utah economy. No longer is it likely that

the "single" with whom you share a chairlift ride will turn out to be a local. Chances are your chairmate will speak English with an accent . . . if he or she speaks English at all.

There are days after a new snowfall in the Wasatch when you sink into the powder to begin your turns and the snow streams over your head like goose down, leaving you gasping for just enough breath to whoop with the joy of being alive, and being there. "Snorkel skiing" they call it, and nowhere else is there anything quite like it.

What makes the snow like that? It's the mountains, and the lake whose water they provide. Weather fronts sweeping in from the Pacific add to their normal load

water vapor soaked up from the Great Salt Lake—a phenomenon called the lake effect. Hitting the Wasatch, the winds rise and cool, the moisture condenses, and down comes the snow. Anyone who has skied much at Alta or Brighton or Snowbird knows how the summit peaks above Big and Little Cottonwood canyons trap the clouds, swirling them around and around to dump great loads of light, dry snow—an average of 500 inches a year at Alta.

It has long been like this—only more so. Ten thousand and more years ago, the world—this part of it, anyway—was wetter. Prehistoric Lake Bonneville covered twenty times the area of its remnant, today's

Great Salt Lake. With the lake effect correspondingly greater, the snow dumps were prodigious. A glacier formed in the Albion Basin at that time and flowed all the way to the water's edge of Lake Bonneville, carving Little Cottonwood Canyon into its typically glacial U-shape.

On any summer weekend hundreds of campers and picnickers stream into Albion Basin. Most of them make the short climb through fields of wildflowers to Cecret (sic) Lake. But leave the crowds at the lake behind and climb the ridge to the east. There, in the solitude below the crags of Devils Castle, lie long slopes of rust-red quartzite polished smooth by glacial action.

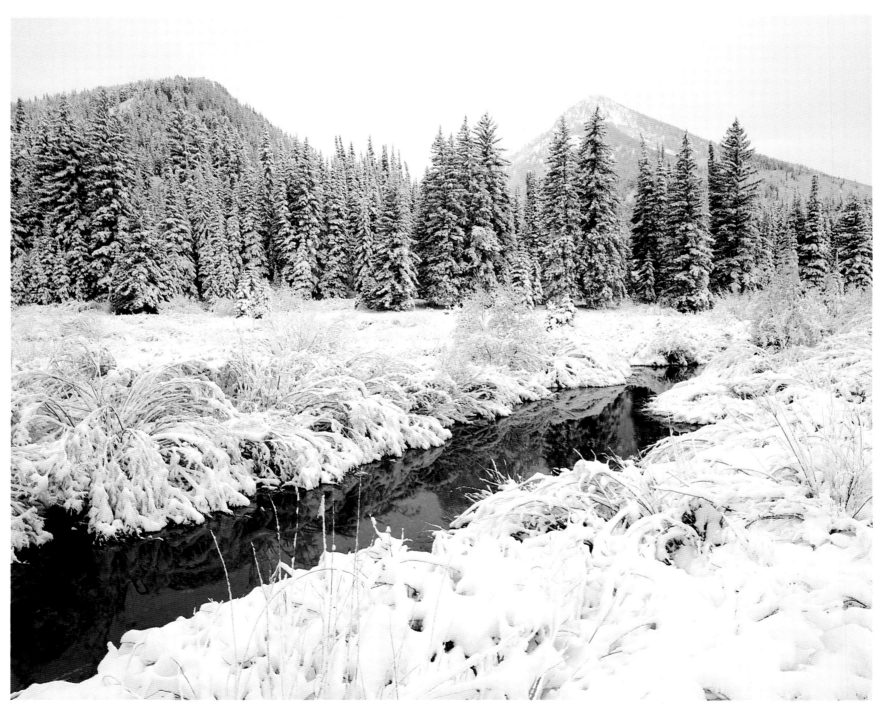

Mount Argenta with stream in winter, Big Cottonwood Canyon

Countless parallel scratches in the stone show which direction the glacier flowed.

In the thousands of years since the glaciers melted away, avalanches and stream erosion—as well as frequent minor earthquakes—have continued to shape the canyons of the Wasatch. But that represents an eye-blink in the geologic history of these mountains. The Precambrian gneisses and schists that form the steep mountains north of Salt Lake City—visible most dramatically on Willard Peak—are 2.5 billion years old.

The quartzite into which the Little Cottonwood glacier scratched the evidence of its passage metamorphosed from sandstone a billion years ago. The famous Little Cottonwood Canyon granite—from which the Mormons cut and shaped blocks to build their temple, into which they carved vast vaults to store their genealogical and other precious records, and upon which generations of daring souls have honed their rock-climbing skills—came from igneous intrusions 1.6 to 1.8 billion years ago.

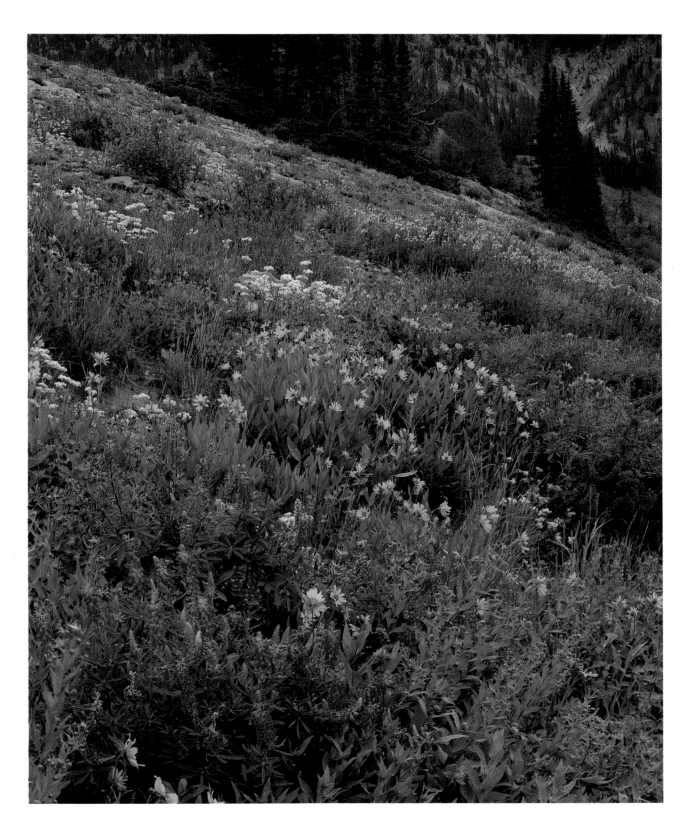

Wildflowers at Albion Basin, Alta, Little Cottonwood Canyon

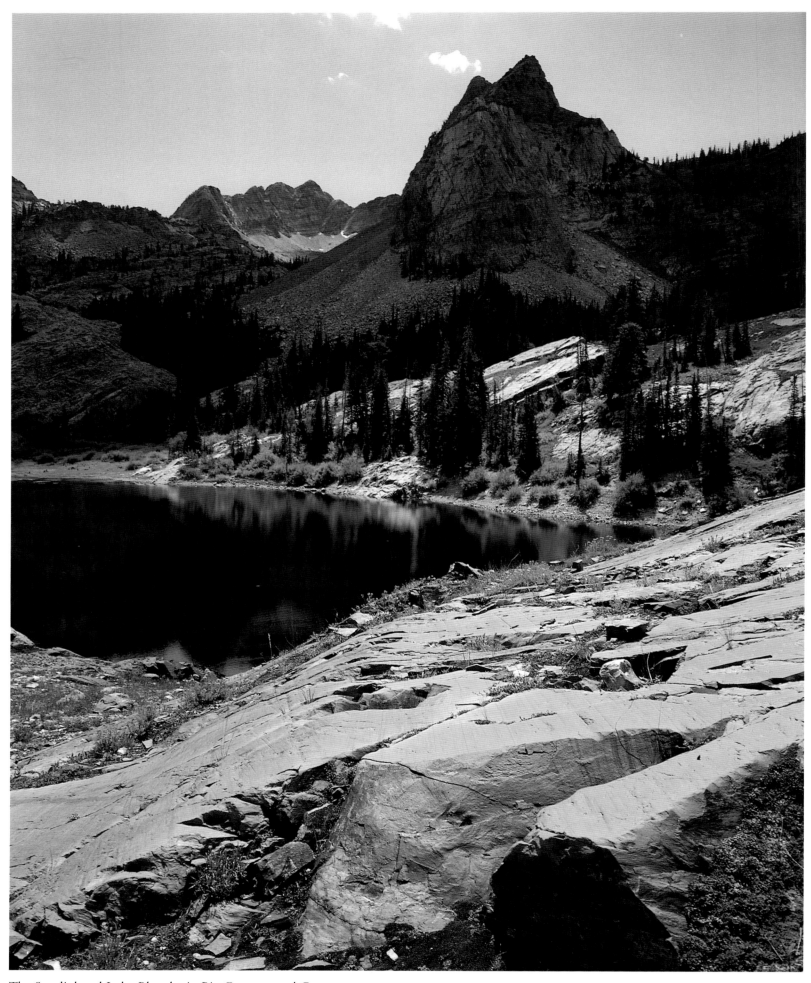

The Sundial and Lake Blanche in Big Cottonwood Canyon

Farther south, the geologic story of the Wasatch is different. Those fantastically contorted layers of limestone, shale, and sandstone in the mountains east of Utah Valley, seen most strikingly in Provo, Rock, and Slate canyons, were once sea-bottom mud. Sediments accumulated to depths of 25,000 feet in the oceans that periodically covered western Utah from 500 million to 250 million years ago. Hardened into layers of rock, they were shoved up and bent into these improbable shapes during a great eastward thrust of the land some 75 million years ago.

The Wasatch Range, generally considered to run from Wellsville Mountain on the north to Mount Nebo on the south, is part of what has been called the backbone of Utah. Running north and south the length of the state and beyond, the "Wasatch Line" is a sort of hinge dividing the state into remarkably different provinces—the Great Basin on the west, the Colorado Plateau on the east. As William Lee Stokes describes it in the *Geology of Utah:* "It is clearly a zone of weakness in the [earth's] crust but it is more than a great fault system and more than a simple earthquake zone. The fact that it has been in existence for at least 800 million years under one guise or another is, in itself, a major phenomenon. Part of the difficulty in describing it lies in the fact that it appears to be the only one of its type on Earth."

Faulting and earthquakes have been major factors in shaping the Wasatch Front, and in all likelihood will be major factors in future life along it. One series of faults thrust up the Wellsville Mountains into what is said to be the steepest mountain range on the continent. The Wasatch Fault system has through the aeons produced a vertical displacement of more than three

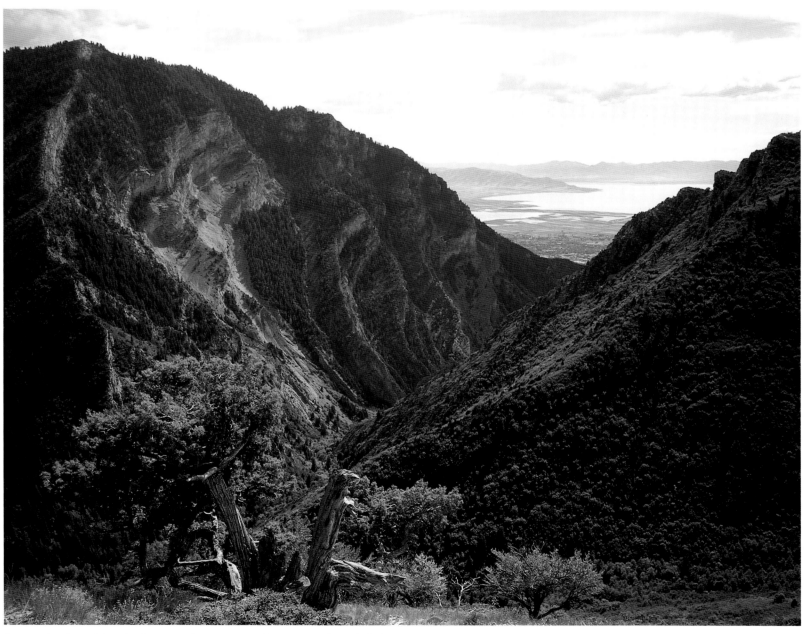

Squaw Peak and Rock Canyon above Provo Canyon and Utah Lake

miles, creating the Wasatch Range itself. Successive faulting and folding have made the geology of those mountains incredibly complicated, especially in the Cottonwood canyons–Park City area, where the axis of the Uinta Mountains joins that of the Wasatch.

One result of that complexity was an international mining scandal. Nature was generous to Utah. Igneous intrusions from deep within the earth left rich bodies and veins of copper, lead, zinc, silver, and gold. Determined to build a stable society based on agriculture and manufacture, Brigham Young discouraged the search for precious metals. Apostle Erastus Snow expressed the Mormon view: *"It is better for us to live in peace and good order, and to raise wheat, corn, potatoes, and fruit, than to suffer the evils of a mining life."*

But in the late 1860s Colonel Patrick E. Connor sent soldiers out from Fort Douglas in a systematic search for minerals. The results were spectacular. The Oquirrh Mountains—or what is left of them after a century of mining—have been called "the richest mountains on earth." Five billion tons of rock and ten billion dollars worth of ore, mostly copper, have been taken from what has long been the world's biggest man-made excavation. What once was a mountain is now a hole half a mile deep and more than two miles across. Daily the great pit grows; so too does a fifty-or-more-square-mile area of underground water polluted by the mining operations. Meanwhile, a few miles away, behind a series of locked gates, Kennecott lays waste vast chunks of the same mountains to feed its heap-leach gold-mining operations.

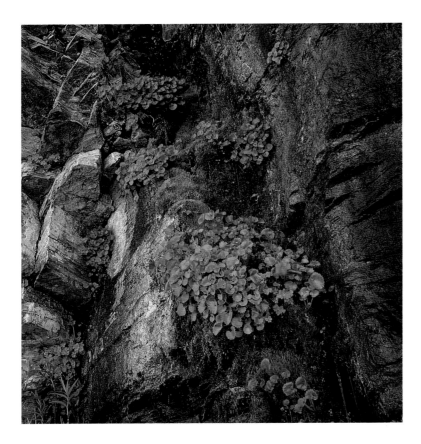

Left: Rock wall, vegetation, and seep, Provo Canyon
Above: Orange clouds at sunset above Lone Peak
Opposite page, right: Salt Lake Valley and Wasatch Mountains with Utah State Capitol

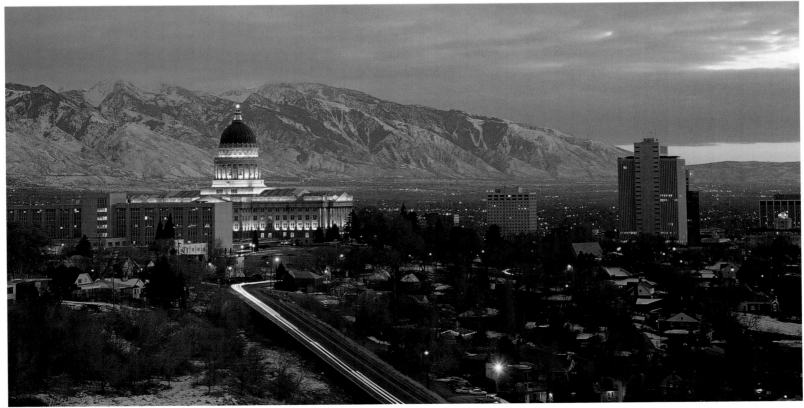

Above: Mount Nebo with farm in winter in foreground
Left: Big Cottonwood Stream, Wasatch Mountains
Opposite page: Sunset, Butterfield Peaks, Oquirrh Mountains

On the opposite side of the Wasatch Range, underground miners took out half a billion dollars worth of lead, zinc, and silver in the Park City area. Park City silver created no less than twenty-three millionaires and built luxury mansions on Salt Lake City's South Temple Street, as well as office buildings, hotels, and the prestigious Alta Club downtown, before rising water and falling prices closed the mines and left the mountains for a future ski industry.

But it was at the head of Little Cottonwood Canyon that two penniless prospectors, R. B. Chisholm and J. F. Woodman, broke through to a lode of solid silver ore and started a mining fever that ended in bitter courtroom battles on both sides of the Atlantic. According to one history, Chisholm and Woodman named their

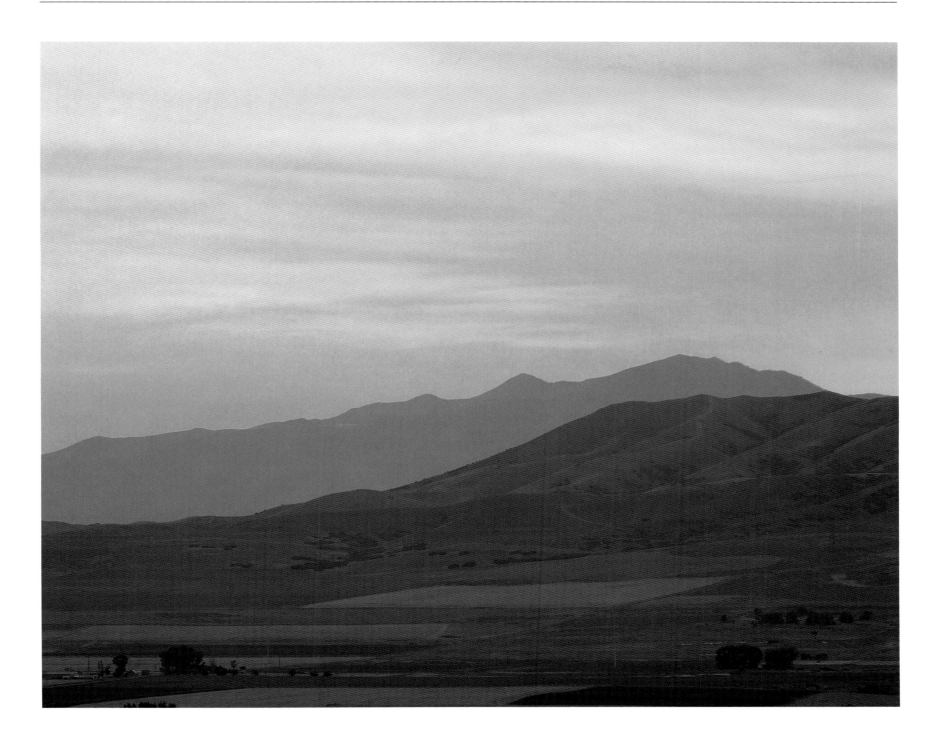

claim Emma "after a lady with whom one or possibly both of them had been illicitly consorting in San Francisco." That was in 1869. By the early 1870s some 5,000 miners were scrambling over the canyon in search of lead and silver. Despite death-dealing avalanches, Alta quickly became Utah's second largest city. The fever spread to the East coast, then overseas. The Emma Silver Mining Company, organized in London, quickly sold out 25,000 public shares. Insiders held an equal number. By 1872, production was such that the chairman told stockholders they could expect thirty to forty percent dividends rather than the promised eighteen. But the vein soon pinched out against one of the Wasatch's many faults, and the company collapsed in a blizzard of lawsuits, charges of swindle, and a resolution by the U.S.

House of Representatives to appoint a special committee to investigate.

It is well to remember that the Wasatch Fault is still there, with a destructive potential rated second only to that of California's San Andreas Fault. Geologists tell us that the question is not whether a disastrous earthquake will hit the Wasatch Front, but when. As recently as 1983 an earthslide that flooded and destroyed the town of Thistle demonstrated the instability of these mountains. And that event involved no earthquake. Hardly imaginable are the landslides that will bury costly homes on the steep Wasatch slopes when the "Big One" hits—to say nothing of the jello-like shaking of ancient lake sediments that will destroy skyscrapers and homes alike in the valleys below.

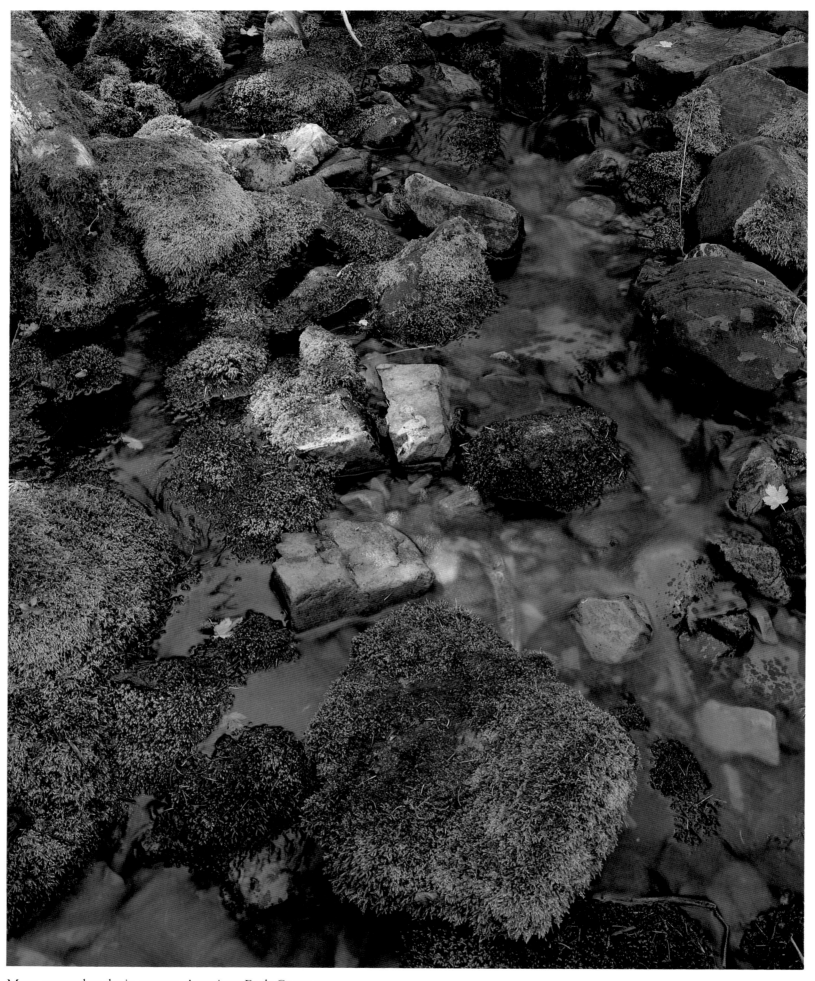

Moss-covered rocks in stream, American Fork Canyon

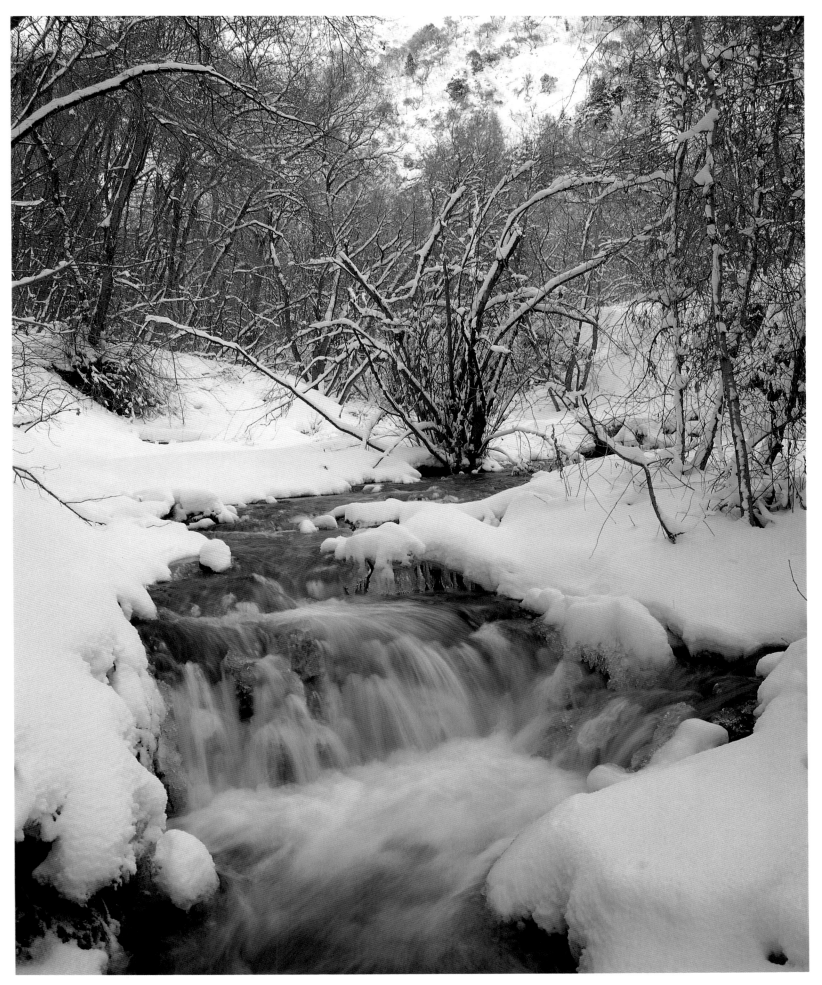

Millcreek Canyon in winter, Wasatch Mountains

The Great Salt Lake

If the mountains define one parameter of life along the Wasatch Front, the Great Salt Lake defines the other. The lake's geologic and human history is discussed elsewhere in these pages. But what is it like to live with it as a neighbor?

Ask Utahns what comes to mind with the mention of the Great Salt Lake, and you'll get responses like: Brine shrimp. Brine flies. You can float in it, but who'd want to when you have to wade out half a mile to find water deep enough? Or, more succinctly, it stinks. From old-timers you may hear nostalgia about the original

Saltair, with its huge dance floor, big-name bands and giant roller-coaster . . . and the romantic open-air train rides to get there on the old Salt Lake Railroad. From industrialists and state planners you may hear about the great mineral wealth contained in its brine . . . and the frustrations of dealing with a lake that refuses to stay put but fluctuates up and down depending on wet and dry cycles. From sailboaters you'll hear about glorious sunsets and about waves that slam like sledge-hammers into boats caught out there in sudden storm squalls. From duck hunters you'll hear about great shoots in the marshes along its eastern shore. From hikers and mountain bikers and picnickers you'll hear about Antelope Island with its panoramic views of the

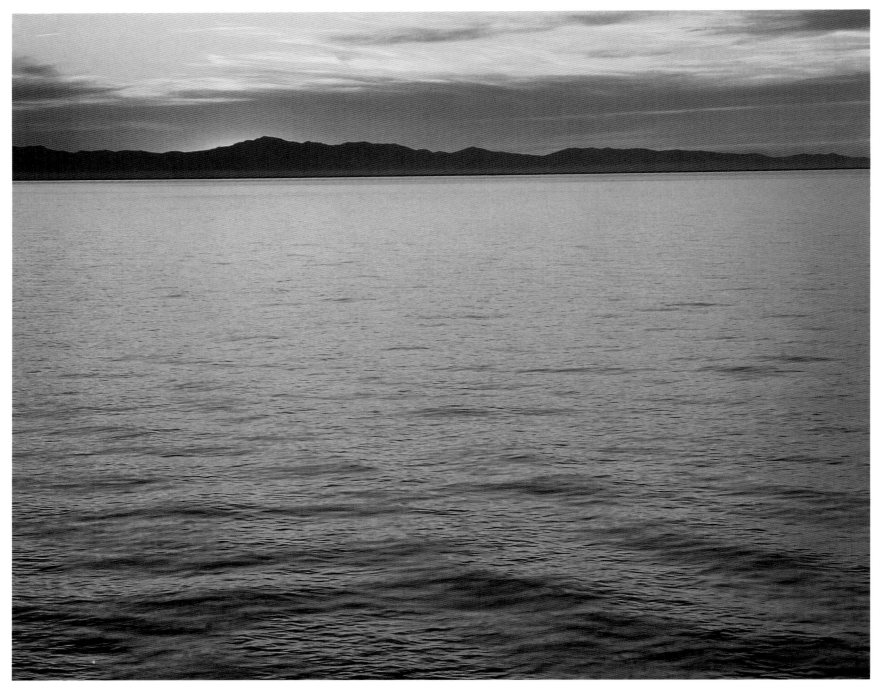

Sunset, Great Salt Lake

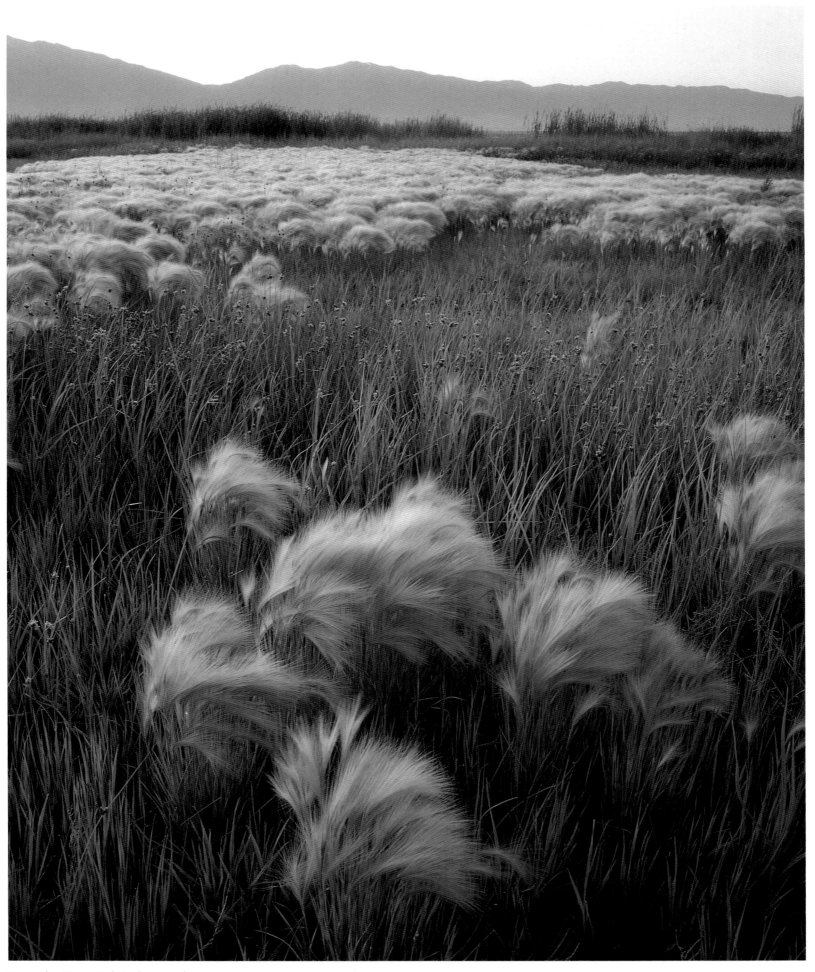

Foxtails, Great Salt Lake marshes

American avocets,
Farmington Bay,
Great Salt Lake

Wasatch Range, the swimming in clear, reasonably deep water off its northwestern tip, and the buffalo and other wildlife in what is becoming a respectable state park wildlife preserve.

For most people, though, the first and lasting impression of the lake is its *deadness*, relieved only by the tiny brine shrimp and the brine flies whose carcasses lie in long, smelly windrows along its beaches. But spend a day with someone like Ella Sorensen, one of Utah's foremost birders, and the lake will never again seem dead. Those much-detested brine flies and shrimp eat algae and sewage, she points out, and keep the lake as clean as it is. "You think it smells out here? Get rid of the brine flies and you'd *really* have a smell." More important from her point of view, the flies and shrimp are the basic foodstuff that make the lake one of the world's great gathering places for shorebirds.

On a midsummer day, 60 percent of the world's population of Wilson phalaropes can be found at the lake's shallows. That's 600,000 birds, 100,000 of them once counted in a single flock in the air at one time. They spend most of the summer on the lake, gorging on brine shrimp and flies to double their weight and build their strength for the 5,000-mile, virtually nonstop flight to wintering grounds in Argentina. Handsome birds they are, cinnamon colored with a white belly and a black stripe across head and neck. Visitors love to watch their feeding swirl—spinning up to sixty revolutions a minute to stir up feed in the muddy shallows.

But the phalarope is only one of the thirty-six species of shorebirds found in what has been called the most diverse ecosystem of its kind in the world. The numbers are awesome. Perhaps the world's largest population of white-faced ibis and one of the largest of avocets—half a million of them—nest here. So does the largest population of California gulls—70,000 of which were counted in a single flock, the largest in history. Some 60,000 long-billed dowitchers have been seen in a single flock, feeding along the shallows like that many tiny sewing machines. The snowy plover is a threatened species in California, but 15,000 of them feed in the salt grass around the lake's edge. Black-neck stilts, killdeer, long-billed curlews, ibis, egrets, great blue herons, yellow-legs, and double-breasted cormorants are here in immense numbers, along with the short-eared owls, marsh hawks, kestrels, peregrine and prairie falcons, and bald eagles that represent the next step up on the food chain. Out on Gunnison Island clusters one of North America's three largest colonies of the American white pelican.

Relatively few people fight the mud and mosquitoes to get out to where the birds are. Unaware of what is out there, they hear no alarm bells in the various proposals to build dikes to convert parts of the east side of the lake to fresh water. But international wildlife experts know the damage that would do and how vital these half-million acres of wetlands are to global birdlife. In 1992 they designated the lake as one of eleven essential sites in the Western Hemisphere Shore-

Fog and frost-covered grasses, Jordan River near Riverton

bird Reserve Network. "Every site is a treasure," said George Finney, network chairman. "Some shorebirds travel from the Arctic all the way to southern South America. They are dependent on these refueling stops. Each site is important to the survival of a species." Clearly, we have a moral and ethical obligation to protect this special place.

Gradually Utahns are learning that there is far more to the east shore marshes than the duck hunting for which the marshes have long been famous. In addition to the federal Bear River Migratory Bird Refuge, no fewer than nine waterfowl management areas surround the lake. Most of them, it is true, are mainly concerned with birds you can shoot. But, at Farmington Bay, the Division of Wildlife Resources has installed board-walks and interpretive signs to help visitors get close to the shorebirds and understand the lake's vital role as part of their global migration network. As such education expands, so will demands for protection of this unique and little-understood legacy and treasure.

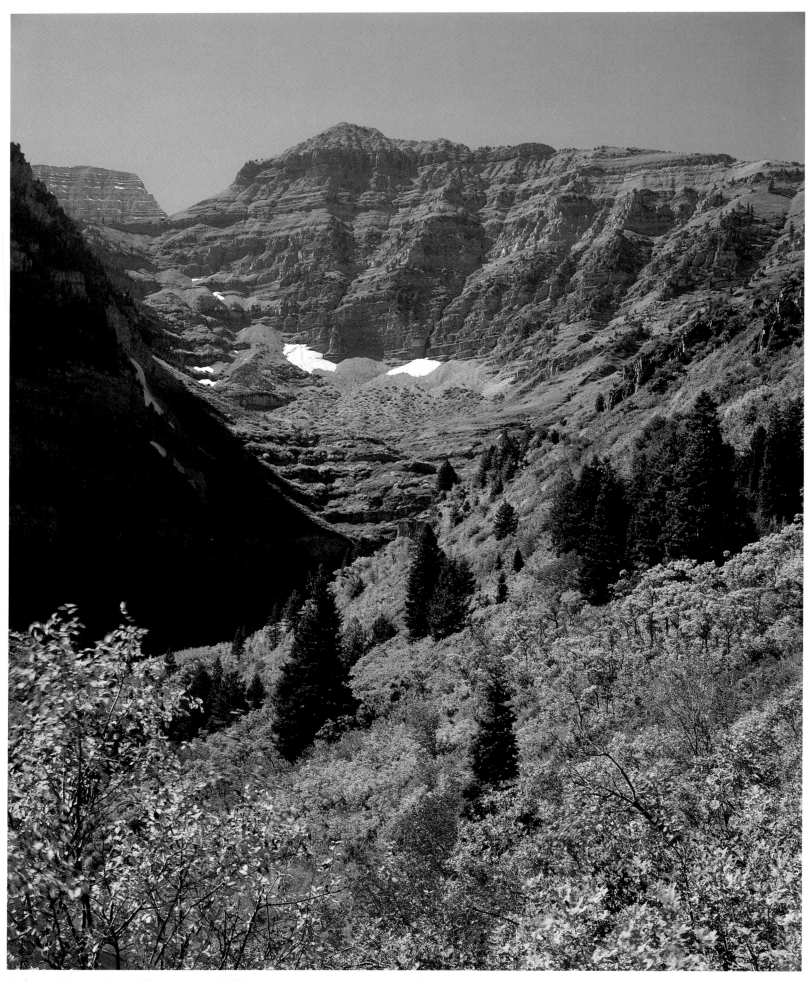

Roberts Horn, Mount Timpanogos Wilderness Area, at autumn from Alpine Loop Road

Epilogue

IN *Cross Creek*, HER BOOK written half a century ago about subsistence farming in North Florida's scrub country, Majorie Rawlings wrote:

"And God called the dry land Earth; and the gathering together of waters called he Seas; and God saw that it was good." This was before man, and if there be such a thing as racial memory, the consciousness of land and water must lie deeper in the core of us than any knowledge of our fellow beings. We were bred of earth before we were born of our mothers. Once born, we can live without mother or father, or any other kin, or friend, or any human love. We cannot live without the earth or apart from it, and something is shrivelled in a man's heart when he turns away from it and concerns himself only with the affairs of men.

That is a truth to ponder as Utah approaches the twenty-first century. The state is changing, fast; in-migration coupled with high birth- and low death rates make it one of the nation's fastest growing. Utah population is projected to increase from around two million people to more than three million in the next twenty-five years. Such growth increases the risk that the affairs of men will weaken our connection with the earth.

More than three million people may not seem like much in a state the size of Utah. That will still be less than thirty-seven people per square mile; only fifteen states are more thinly populated than Utah. Eighty percent of those people, however, live within sixty miles of the state capitol. With its vast open spaces, Utah seems like a rural state; in fact, with eighty-seven percent of its people living in metropolitan areas, it is the sixth most urbanized state in the country. And most future growth is projected to come in urban areas whose highways, water systems, housing, and social services

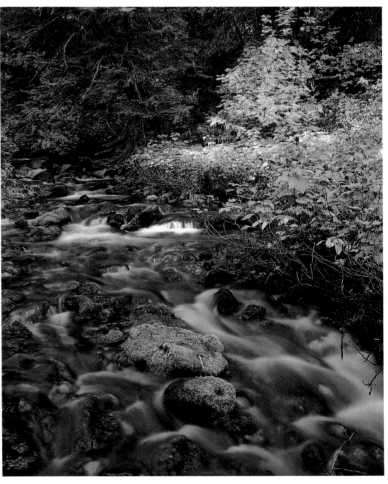

Stream, Wasatch Mountains

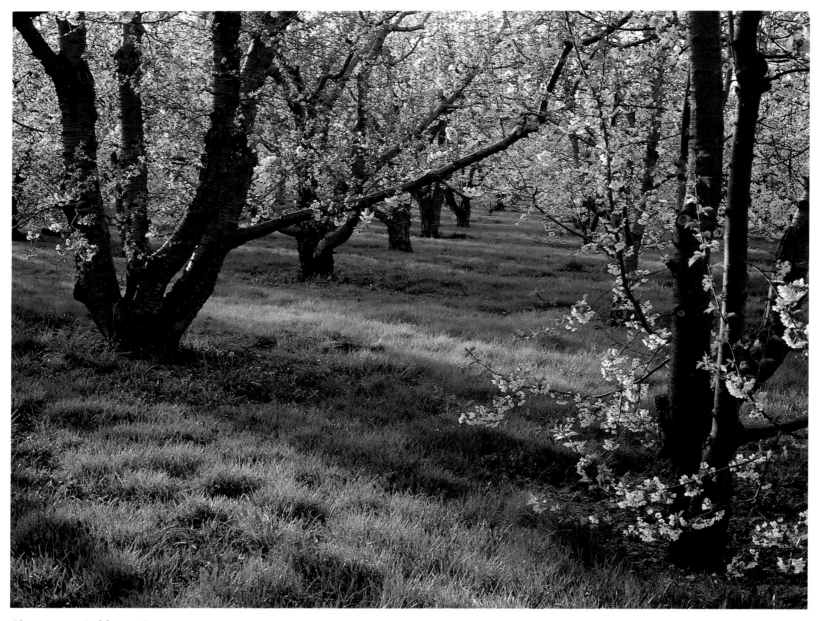

Cherry trees in bloom, Provo

are already overextended. Almost one million of the 1.1 million new bodies expected in the next quarter-century will concentrate along the Wasatch Front, and much of the rest in such already stressed areas as St. George and Moab.

Utahns can be pardoned modest pride in the qualities that bring such growth. Corporations and individuals gravitate to the state's magnificent physical setting; its clean and relatively violence-free cities; its educated and motivated work force; its outstanding educational, cultural, and recreational opportunities; its generally wholesome life-style. A stable and diverse economy helps. *Business Week* magazine recently extolled Utah Valley's software industry and Salt Lake Valley's biomed industry—spinoffs, respectively, of Brigham Young University and the University of Utah—as examples of the kind of entrepreneurship America needs in today's global economy.

Some of the same values, plus unmatched physical beauty and warm winter sunshine, have brought even more dramatic growth to Utah's Dixie. St. George, a sleepy town of 11,000 people in 1980, almost quadrupled its size in fifteen years. If present trends continue, Washington County, with a population of around 50,000 in the mid-1990s, will have five times that number within fifty years. Across the state, the Moab area faces similar growth, and so will other towns as more and more people discover the grandeur of Utah's mountains, lakes, and deserts.

More people mean more jobs, a larger tax base, more political clout—all of which excites chamber-of-commerce types. But with more people also come tough problems. One is to protect the physical environment in the face of both growing population and increasing tourism. Growth means more air pollution during temperature inversions, more homes climbing higher up

Streaked
automobile lights,
Little Cottonwood
Canyon

fragile mountain slopes, more traffic congestion and more demands to build freeways to relieve it, increased demands for water, and, if we're not very careful, more environmental degradation from the dam-building to provide it. Land-use planning and growth control, considered dirty phrases in Utah's past, are important in its future.

Another challenge we face as more people move into the state is the polarity that so often sets neighbor against neighbor, Mormon against non-Mormon. Utah has lost prospective companies and government projects because of the image, if not the fact, that its Mormon-dominated society is exclusionary, not a comfortable place for non-Mormons to live in. Ballot and legislative issues such as liquor laws, prayer in schools, and parimutuel betting often deepen the division.

In his book *Mormon Country*, Wallace Stegner wrote an insightful passage about the Mormon poplar and the people who planted them:

Perhaps it is fanciful to judge a people by its trees. . . . Probably it is pure nonsense to see a reflection of Mormon group life in the fact that the poplars were practically never planted singly, but always in groups, and that the groups took the form of straight lines and ranks. Perhaps it is even more nonsensical to speculate that the straight, tall verticality of the Mormon trees appealed obscurely to the rigid sense of order of the settlers, and that a marching row of plumed poplars was symbolic, somehow, of the planter's walking with God and his solidarity with his neighbors.

In another place and context, I have written: "There is bound to be a difference in a state founded like that. Not that the difference is always good, or that the best qualities have always prevailed; it isn't and they haven't. Discipline can become dependence. Cooperation can become clannishness. A sense of mission can

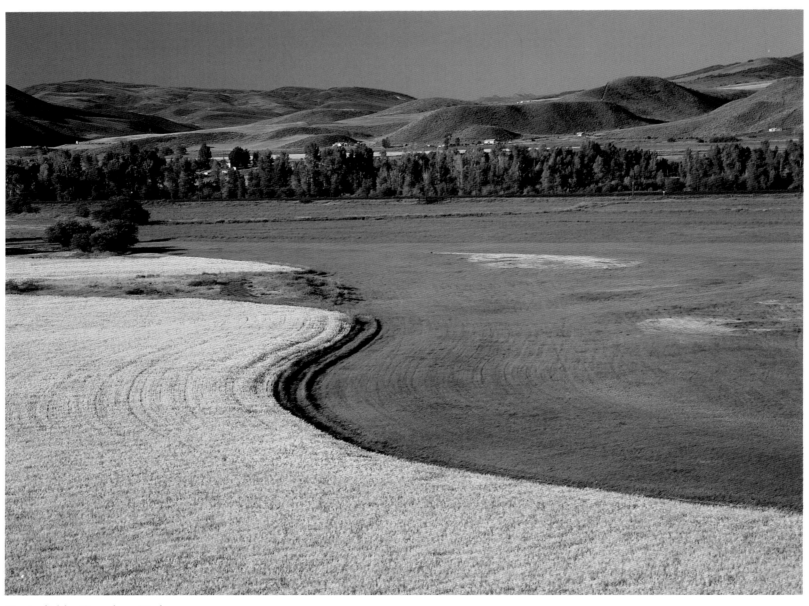

Grain fields, Croydon, Utah

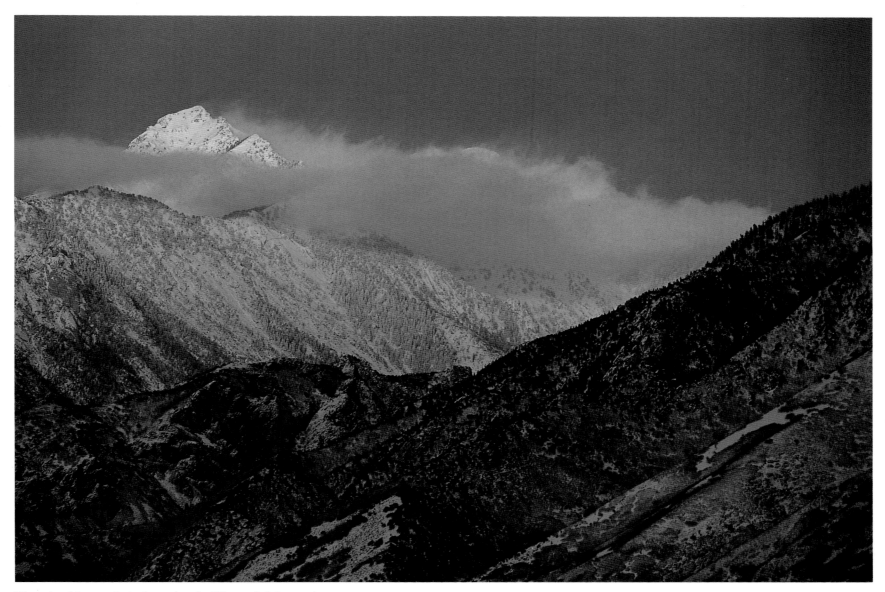

Thunder Mountain in low clouds, Wasatch Mountains

become—or seem to become—smugness. And all these can become deeply offensive to those who come as outsiders and remain outsiders, never feeling a part of or comfortable with the prevailing Utah culture." I wrote then that this was a challenge yet to be fully met. It remains so today.

But such problems involve affairs of men, preoccupation with which can shrivel the soul. Utah's great benison is land enough, as yet unspoiled, where in quest of perspective and renewal the affairs of men can be set aside. More ski lifts and condominiums in our canyons, more asphalt ribbons across wild places, more helicopter flights over national parks and other

scenic treasures provide jobs, attract tourist dollars, broaden the tax base. But solitude and natural beauty are values worth protecting. So is the satisfaction of reaching a mountaintop or a secret place in a desert canyon with one's own leg and lung power; there is soul-renewal in testing oneself against raw nature. Even for those who can't or won't seek out such unspoiled places, there is assurance and rootedness in knowing they exist. In the long run, preserving these values against mushrooming population may be Utah's most important challenge. The closer civilization presses, the greater the need to connect with the land and to live harmoniously with and upon it.

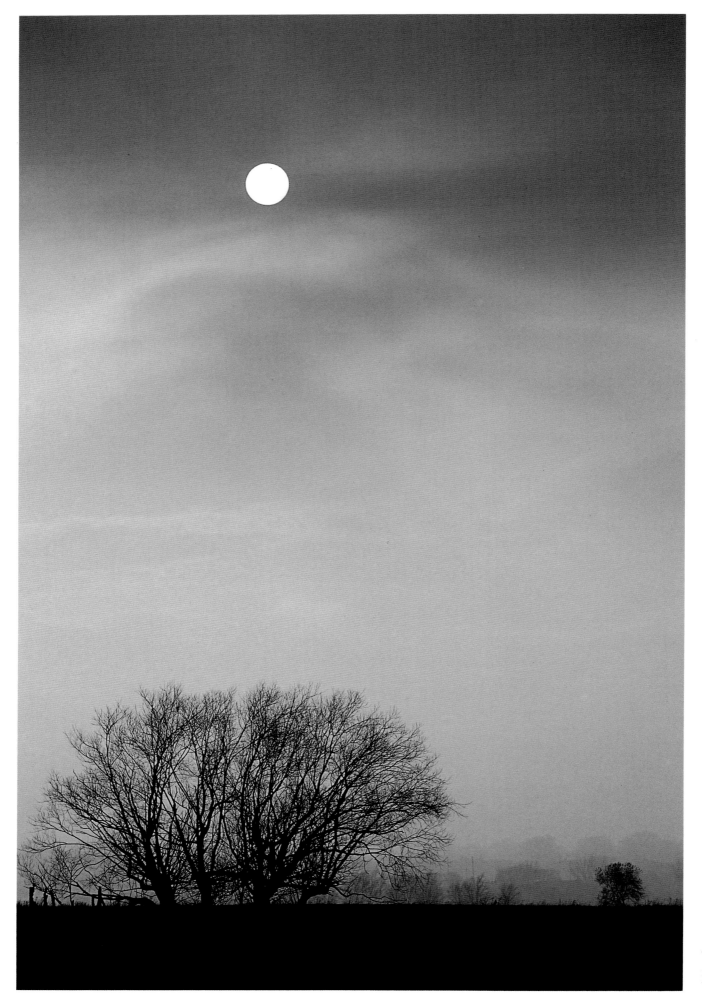

Trees in winter
fog, Highland,
Utah

Notes

Sources of otherwise unidentified isolated quotations

Chapter One

Dr. J. H. Lyman: Quoted in Hafen and Hafen, eds., *Old Spanish Trail.*

John Newberry: in F. A. Barnes, *Canyonlands National Park.*

Chapter Two

Fray Escalante: in Herbert E. Bolton, ed., *Pageant in the Wilderness.*

George C. Yount: in Hafen and Hafen, *Old Spanish Trail.*

John C. Frémont: in Frémont, *Expeditions . . .* vol 1.

George C. Brewerton: in Hafen and Hafen, *Old Spanish Trail.*

John Armstrong: in Donna T. Smart, "The Parley P. Pratt Exploring Company of 1849," *UHQ.*

John Brown: in Donna T. Smart, "The Parley P. Pratt Exploring Company of 1849," *UHQ.*

Solomon N. Carvalho: in Carvalho, *Incidents of Travel and Adventure in the Far West.*

John D. Lee: in *Deseret News*, December 11, 1852.

Robert Gardner: in Mary E. Staheli, *Descendents of Pine Valley Pioneers.*

Mary Dart Judd: in "Sketch of the Life of Mary Dart Judd," ms., Utah Historical Society.

Clarence Dutton: in Dutton, *Physical Geology of the Grand Canyon District.*

Chapter Three

Fray Escalante: in Herbert E. Bolton, ed., *Pageant in the Wilderness.*

Daniel T. Potts: in Hafen and Hafen, *Old Spanish Trail.*

John C. Frémont: in Frémont, *Expeditions . . .* vol. 1.

Edwin Bryant: in J. Roderick Korns, ed., *West from Fort Bridger.*

J. H. Beadle: in Brigham D. Madsen, *Corinne: The Gentile Capital of Utah.*

Correspondent: in Brigham D. Madsen, *Corinne: The Gentile Capital of Utah.*

Chapter Four

Fray Escalante: in Bolton, *Pageant in the Wilderness.*

Joseph Williams: in Hafen and Hafen, eds., *To the Rockies and Oregon. . . .*

Frémont: in Frémont, *Expeditions . . .* vol. 1.

William Lewis Manley: in Manley, *Death Valley in '49.*

John Wesley Powell: in J. W. Powell, *Exploration of the Colorado River. . . .*

Edward Geary: in Edward Geary, *Goodbye to Poplarhaven.*

Chapter Five

Fray Escalante: in Bolton, *Pageant in the Wilderness.*

Don Bernardo Miera y Pacheco: in Bolton, *Pageant in the Wilderness.*

Heinrich Lienhard: in J. Roderick Korns, ed., *West from Fort Bridger.*

Wilford Woodruff: in Thomas G. Alexander, *Things in Heaven and Earth. . . .*

Parley P. Pratt: in P. P. Pratt, *Autobiography.*

Captain Howard Stansbury: Brigham D. Madsen, ed., *Exploring the Great Salt Lake. . . .*

Judge Perry E. Brocchus: in William Mulder and A. Russell Mortensen, eds., *Among the Mormons.*

Solomon N. Carvalho: in Mulder and Mortensen, eds., *Among the Mormons.*

Captain Albert Tracy: in Albert Tracy, *The Utah War.*

Richard F. Burton: in Burton, *The City of the Saints.*

Christoffer J. Kempe: in William Mulder, *Homeward to Zion.*

Wallace Stegner: in Wallace Stegner, "The World's Strangest Sea," *Holiday.*

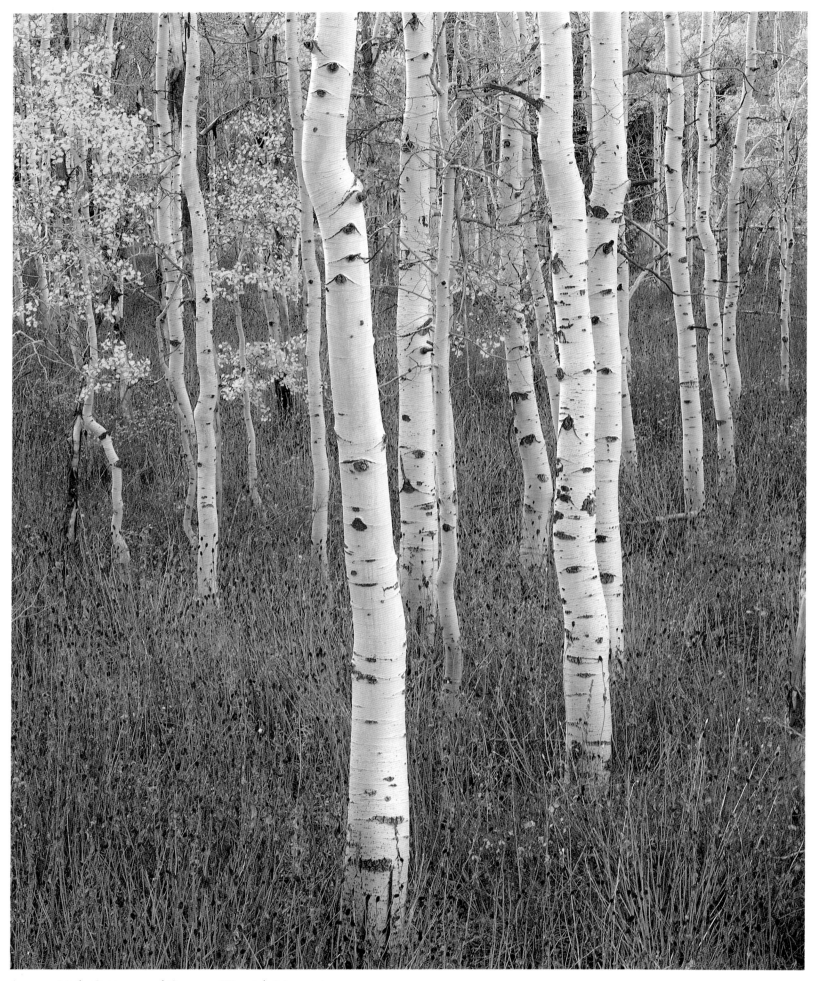

Aspens, Little Cottonwood Canyon, Wasatch Mountains

Photographer's Notes
from the Field

ONE OF EDWARD WESTON'S *Daybooks* entries begins with, "Solitude, at last. . . ." On the last night of the final photographic excursion for this book my field notes start with, "Solitude, again. . . ." I was on the fourth day of a five-day swing through the northeast section of the state, alone. I had spent a day and a half photographing around Flaming Gorge, followed by a 40-mile-dirt-road drive to Browns Park and then another day of scouting and photographing there. This was in turn followed by a long drive back to Vernal where I scouted rock-art sites, photographed a few places in Dinosaur National Monument, and finished with a hike through the sage to find a location from which to photograph Split Mountain with the last light of the setting sun.

This trip was much like many of the hundreds of others I've made over the years. I have been to some incredible places, and have seen them in the most spectacular light and weather. If there are regrets, one has been that most of the time I have seen them alone, without my wife and family. Many times I have longed to have Valerie and the kids with me as I experience these places. But I know that getting up in the predawn and then the long hours of chasing the light until after sunset does not excite them. Waiting for the light, making endless adjustments of camera positions, and searching for the elusive photograph for long hours can be tedious; and while some people think that I enjoy an endless vacation, my family knows it's a lot of work and would generally rather stay home.

On one trip to the Grand Canyon with Valerie and Brett, my only son, we were waiting for the last light at Hopi View. It was a spectacular sight as the mesa and cliffs were bathed in the warm glow of last light. Other people were gathering to witness the ephemeral display. As I anxiously adjusted the camera, calculating exposure and watching for the decisive moment, I looked over to see how Valerie and Brett were enjoying the scene. They were sitting with feet dangling over the rim of the canyon, not even looking at the scene but instead playing a card game. What I didn't realize was they had been watching all the time that I had been adjusting the camera. Photographing required more energy than simply enjoying the view, but in the end they probably enjoyed the experience more.

After photographing Split Mountain, I returned to the truck and began searching for the Island Park road. I drove the twenty miles of dirt road in the twilight to where I planned to photograph the next morning. At about 9:30 P.M. I arrived at the Island Park overlook, parked the truck, rolled out my sleeping bag in the back of the truck, and started to heat some water for spaghetti. I could just barely see the Green River meandering through the islands of cottonwood trees several hundred feet below me. I had floated the river several times through this section, but this was the first time I had seen it from this spot. I pulled out my compass and tried to visualize where the sun would come up, and what the light might do in the morning, and where I might go for the best pictures.

After dinner and clean up, I crawled under my unzipped sleeping bag, opened and used like a blanket. The warm night air required little in the way of cover for sleeping. It was 10:30 now. The alarm was set for 5:30 A.M. to get me up in time to find a location, set up the 4X5 camera and photograph, light willing. But the thoughts racing through my head would not allow me to sleep. I reminisced, and contemplated.

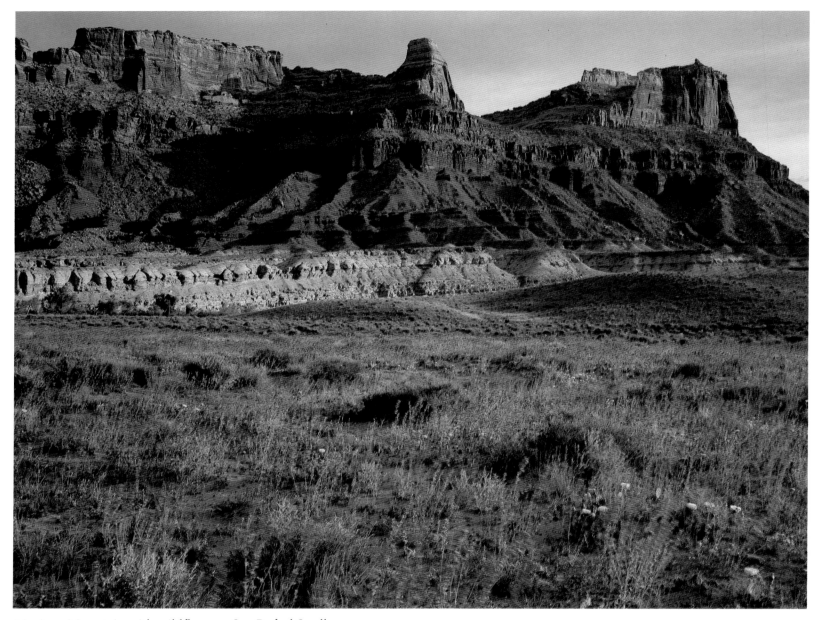

Mexican Mountain with wildflowers, San Rafael Swell

Upon publication of this book, I will be fifty years old. I have been photographing for twenty-five years, mostly in Utah. Utah has been a state for 100 years. Those numbers have become kind of like a personal planetary alignment for me that perhaps is supposed to be followed by some profound words or achievement.

I am a fourth-generation Utahn. My parents, Jim and Gwen Telford, took our family to most of the state's national parks and monuments before I was ten. There were frequent fishing and camping trips in the Wasatch and Uintas which also exposed me to the natural world. Little wonder then that when I picked up a camera I photographed the landscape. Now, twenty-five years later, I am still intrigued by the land, by Utah.

I thought I'd seen just about everything in Utah that a man would like to brag about seeing. After photographing a place for twenty-five years you ought to know it. But then someone like Bill Smart comes along.

"Have you got photographs of Parowan Gap, or Lucin, or Randlett?" or a hundred other places that I hadn't even heard of, let alone photographed. Bill was just one among several, including Frank DeCourten, John Judd, Terry Tempest Williams, Val Brinkerhoff, and a long list of others who must regrettably go unnamed. The list of places in Utah where I haven't been seems to continue to grow faster than the list of places I've been.

It is a vast state of incredible variety. From the isolation and serenity of Browns Park in the northeastern corner of Utah to the Joshua Tree forests of the Beaver Dam Mountains in the southwest. From the secret red rock canyons of the southeast to the alpine forests and lakes of the north, there is endless variety and beauty. Utah invites people from all over the world to see and experience its unique beauty. There is no place quite like it, anywhere.

At 5:30 A.M. the alarm went off. The eastern sky was just beginning to glow. Just enough time to eat the last chocolate donut and drink the last of the orange juice as I rolled up the sleeping bag and packed the truck. Two hours later I had scurried to four different locations, made eight or ten exposures with two cameras and started back to Vernal. My day's work was basically done before most people even get up.

A long trail of dust followed the truck as I drove toward Vernal. My thoughts turned again to the book. Images popped in and out my mind, memories kindled, and words started to flow. I pulled over to the side of the road and jotted in my notebook, drove a few more miles and then jotted more words. The miles flew by but the memories of pictures lingered.

While the photographs included in this volume have been made over the past twenty years, the majority were made during the last two or three. I find talking about technical information unessential to the enjoyment of the photographs. Let it suffice to say, they were made using either a 4x5 camera, a 6x7 cm camera, or an occasional 35mm, using a variety of lenses. I am grateful to Harold Excell at Inkley's and to Fuji Film for supplying the Velvia film used during the last two years of this project. Prior to that, the film used includes Fuji and Kodak professional films in most of the varieties manufactured over the past twenty years.

I can't conclude these words without acknowledging my family and dear wife, Valerie. Thanks for your support and patience while I've been out chasing the light. Let's go dangle our feet over a cliff at sunset, together. And, to Mom and Dad: Thanks for bringing me to this place, Utah.

—John Telford

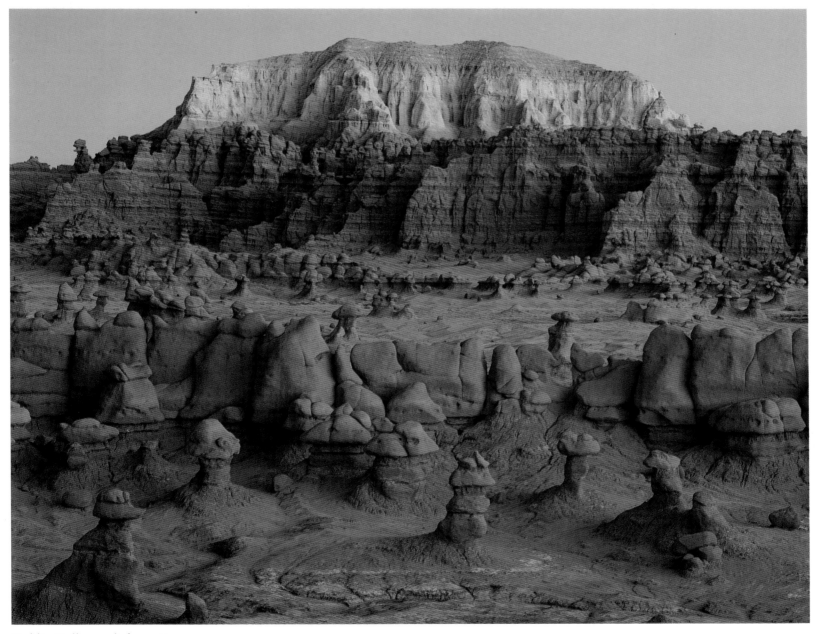

Goblin Valley rock formations

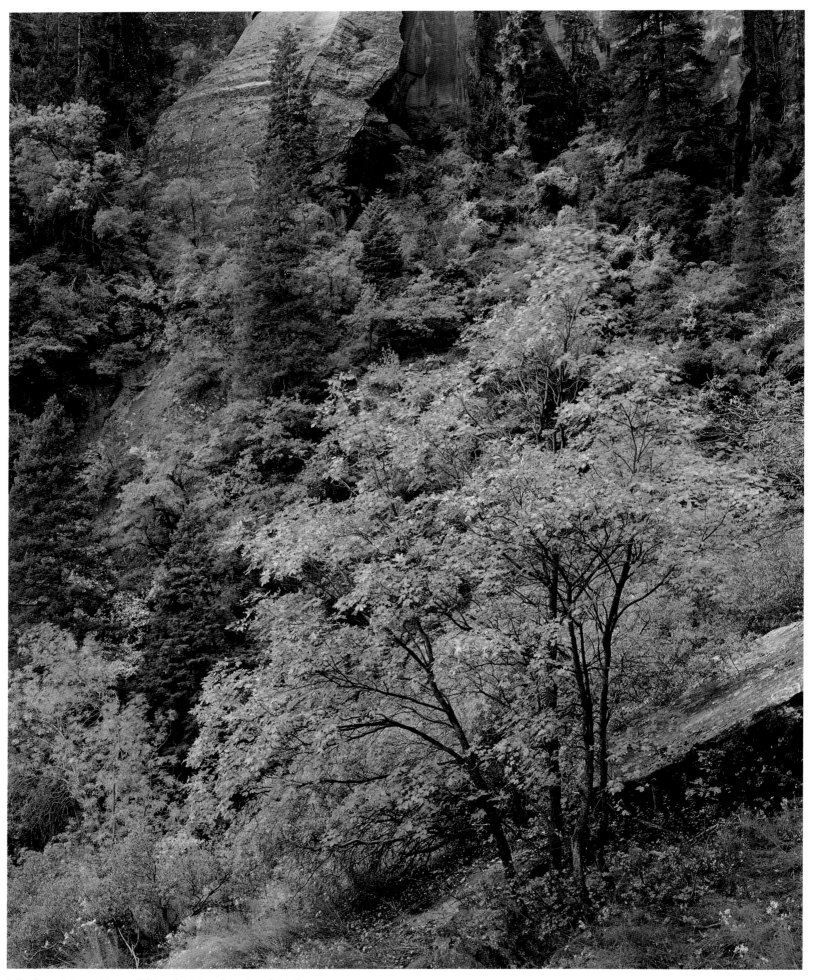

Maple at Upper Emerald Pools, Zion National Park

Bibliography

Alexander, Thomas G. *Things in Heaven and Earth: The Life and Times of Wilford Woodruff, a Mormon Prophet.* Signature Books, 1991.

Auerbach, Herbert S., and J. Cecil Alter, eds. *The Utah War Journal of Captain Albert Tracy.* Utah State Historical Society, 1945.

Barnes, F. A. *Canyonlands National Park: Early History and First Descriptions.* Canyon Country Publications, 1988.

Barton, John D. "Outlaws, Lawmen, Law-Abiding Citizens, and Mormons." *The Outlaw Trail Journal* (Summer 1991).

Bateman, Ronald R. *Deep Creek Reflections: 125 Years of Settlement at Ibapah, Utah.* Ronald R. Bateman, 1984.

Bender, Henry. *Uintah Railway: The Gilsonite Route.* Hoswell-North, 1970.

Bennion, Glynn. "A Pioneer Cattle Venture of the Bennion Family." *Utah Historical Quarterly* (Fall 1966).

Bolton, Herbert E., ed. *Pageant in the Wilderness.* Utah Historical Society, 1950.

Burton, Richard F. *The City of the Saints.* Alfred A. Knopf, Inc., 1963.

Brooks, George R., ed. *The Southwest Expedition of Jedediah S. Smith.* Arthur H. Clark Co., 1977.

Carvalho, Solomon Nunes. *Incidents of Travel and Adventure in the Far West,* 1860.

Clayton, William. *The Latter-day Saints' Emigrants Guide.* Chambers & Knapp, 1848.

Cline, Gloria Griffen. *Exploring the Great Basin.* University of Oklahoma Press, 1963.

Chronic, Halka. *Roadside Geology of Utah.* Mountain Press Publishing Co., 1990.

Dalton, Luella Adams, ed. *History of Iron County Mission.* Simon Benson, undated.

Dutton, Clarence E. *The Physical Geology of the Grand Canyon District.* U.S. Geological Survey, 1882.

Egan, William M., ed. *Pioneering the West 1846–1878.* Howard R. Egan Estate, undated.

Fradkin, Philip L. *Sagebrush Country.* University of Arizona Press, 1989.

Fraser, Saline Hardee. "One Long Day That Went on Forever." *Utah Historical Quarterly* (Fall 1980).

Frémont, John Charles, *The Expeditions of John Charles Frémont,* vols. 1 and 2 and Map Portfolio, Donald Jackson and Mary Lee Spence, eds. University of Illinois Press, 1973.

Garner, Hugh C. "I Remember Josie Bassett Morris of Brown's Park." *Utah Historical Society Newsletter* (Summer 1992).

Geary, Edward A. *Goodbye to Poplarhaven: Recollections of a Utah Boyhood.* University of Utah Press, 1985.

Greeley, Horace. *An Overland Journey in the Summer of 1859.* Alfred A. Knopf, Inc., 1964.

Hafen, LeRoy R. and Ann W. Hafen, eds. *Central Route to the Pacific: Journals of Gwinn Harris Heap, Kit Carson and Others.* Arthur H. Clark Co., 1957.

————. *Handcarts to Zion.* Arthur H. Clark Co., 1954.

————. *Journals of the Forty-Niners.* Arthur H. Clark Co., 1954.

————. *Old Spanish Trail.* Arthur H. Clark Co., 1954.

————. *To the Rockies and Oregon, 1839–42.* Arthur H. Clark Co., 1955.

————. *The Utah Expedition.* Arthur H. Clark Co., 1958.

Jackson, W. Turrentine. "The Infamous Emma Mine: A British Interest in the Little Cottonwood District, Utah Territory." *Utah Historical Quarterly* (October 1955).

Kaczmarek, Marie, "Recollections of Life in Dragon, Utah, 1921–1939." Interview with author. October 1992.

Kirby, Edward M. "Butch Cassidy and the Sundance Kid: An Historical Essay." *The Outlaw Trail Journal* (Summer 1991).

Knight, Hal and Stanley B. Kimball. *111 Days to Zion.* Deseret News Press, 1978.

Knowlton, Ezra C. *History of Highway Development in Utah.* Utah Highway Department, 1960.

Korns, J. Roderick, ed. *West from Fort Bridger.* Utah State Historical Society, 1951.

Levitt, James H., et al. "Mining at Alta: A Further Look." *Utah Historical Quarterly* (Spring 1977).

Madsen, Brigham D. *Corinne: The Gentile Capital of Utah.* Utah State Historical Society, 1980.

Manley, William Lewis. *Death Valley in '49.* Chalfant Press, 1894.

Miller, David E. *Hole-in-the-Rock.* University of Utah Press, 1958.

Miller, David E., ed. *The Route of the Dominguez-Escalante Expedition.* Utah State Historical Society, 1976.

Morgan, Dale L. *The Great Salt Lake.* University of Nebraska Press, 1947.

———. *Jedediah Smith and the Opening of the West.* Bobbs-Merrill Inc., 1953.

Mulder, William. *Homeward to Zion.* University of Utah Press, 1957.

Mulder, William, and A. Russell Mortensen, eds. *Among the Mormons.* Alfred A. Knopf, Inc., 1958.

Nevins, Allen. *Frémont, Pathmarker of the West.* Frederick Ungar Publishing Co., 1933.

Nibley, Preston. *Exodus to Greatness.* Deseret News Press, 1947.

Papanikolas, Helen Z. "Unionism, Communism, and the Great Depression: The Carbon County Coal Strike of 1933." *Utah Historical Quarterly* (Summer 1973).

Powell, John Wesley. *The Exploration of the Colorado River and its Canyons.* Flood and Vincent, 1895.

Powell, Allan Kent. "The Foreign Element and the 1903–04 Carbon County Coal Miners' Strike." *Utah Historical Quarterly* (Spring 1975).

———. "Tragedy at Scofield." *Utah Historical Quarterly* (Spring 1973).

Pratt, Parley P. *Autobiography.* Deseret Book Co., 1936.

Reid, H. Lorenzo. *Dixie of the Desert.* Zion Natural History Association, 1964.

Rhodes, Richard. "The Farther Continent of James Clyman." *American Heritage* (December 1978).

Rogers, Kristen. "William Henry Smart: Uinta Basin Pioneer Leader." *Utah Historical Quarterly* (Winter 1977).

Roylance, Ward J. *Utah—A Guide to the State.* Utah Arts Council, 1982.

Smart, Donna T. "The Parley P. Pratt Exploring Company of 1849." *Utah Historical Quarterly* (Spring 1994).

Smart, William B. *Old Utah Trails.* Utah Geographic Series, 1988.

———. "William H. Smart, Builder in the Basin." *Utah Historical Quarterly* (Winter 1982).

Smart, William B. and Henry A. Smith, eds. *Utah: A Bicentennial History.* Deseret News, 1976.

Smith, Waddell F., ed. *The Story of the Pony Express.* Pony Express History and Art Gallery, 1964.

Staheli, Mary Esther. *Descendants of Pine Valley Pioneers.* The Art Press, 1980.

Stansbury, Howard. *Exploring the Great Salt Lake: The Stansbury Expedition of 1849–50.* Brigham D. Madsen, ed. University of Utah Press, 1989.

Stegner, Wallace. *The Gathering of Zion.* McGraw-Hill, Inc., 1964.

———. *A Sense of Place.* Audio cassette. Audio Press, 1989.

———. "The World's Strangest Sea," *Holiday* (May 1957).

Stewart, George R. *Ordeal by Hunger.* Houghton Mifflin 1960.

Stipanovich, Joseph. "South Slav Settlements in Utah 1890–1935." *Utah Historical Quarterly* (Spring 1975).

Stokes, William Lee. *Geology of Utah.* Utah Museum of Natural History, 1986.

Tennant, William L. *John Jarvie of Brown's Park.* BLM Cultural Resources Series, No. 7, 1981.

Thompson, George A. *Faded Footprints.* Roaming the West Publications, 1991.

Tracy, Albert. "The Utah War: Journal of Albert Tracy." *Utah Historical Quarterly* 13 (1945).

Unterman, G. E., and B. R. Unterman. "Dinosaur Country." *Utah Historical Quarterly* (July 1958).

Wahlquist, Loreen P. "Memories of a Uintah Basin Farm." *Utah Historical Quarterly* (Spring 1974).

Warner, Ted J., ed. *The Dominguez-Escalante Journals.* Brigham Young University Press, 1976.

Ward, Maurine Jensen. "Do Mormons Make Good Neighbors?" *This People* (Spring 1988).

Williams, Brooke. *Utah Ski Country.* Utah Geographic Series, 1986.

Wilson, Ted. *Utah's Wasatch Front.* Utah Geographic Series, 1987.

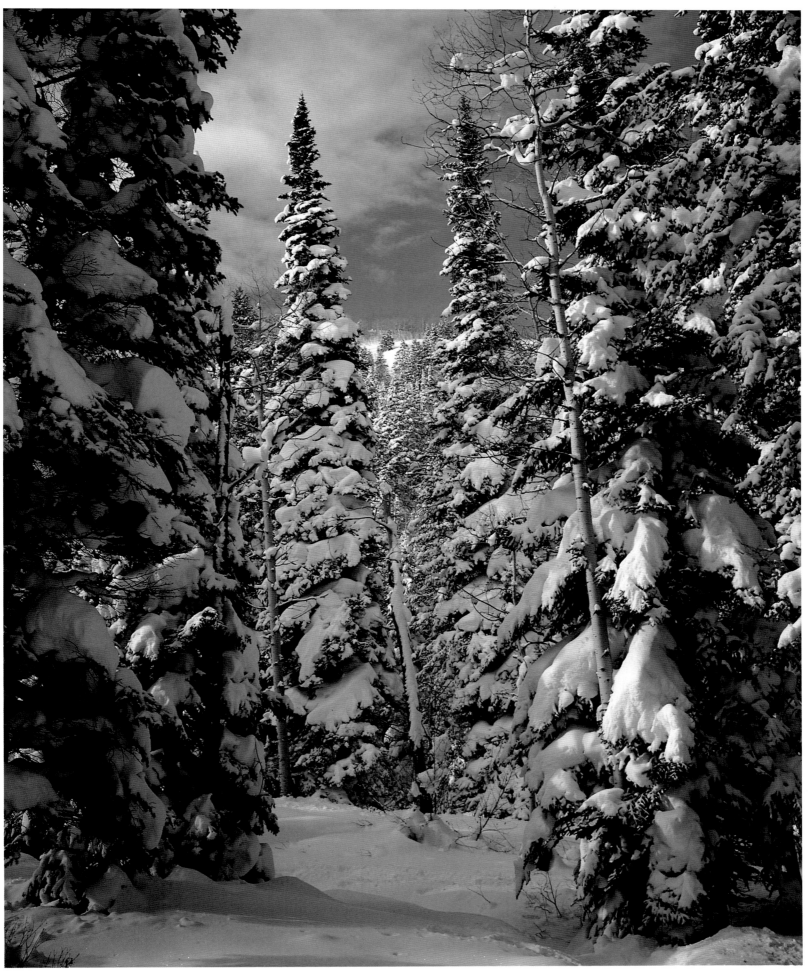

Firs in snow, Big Cottonwood Canyon, Wasatch Mountains

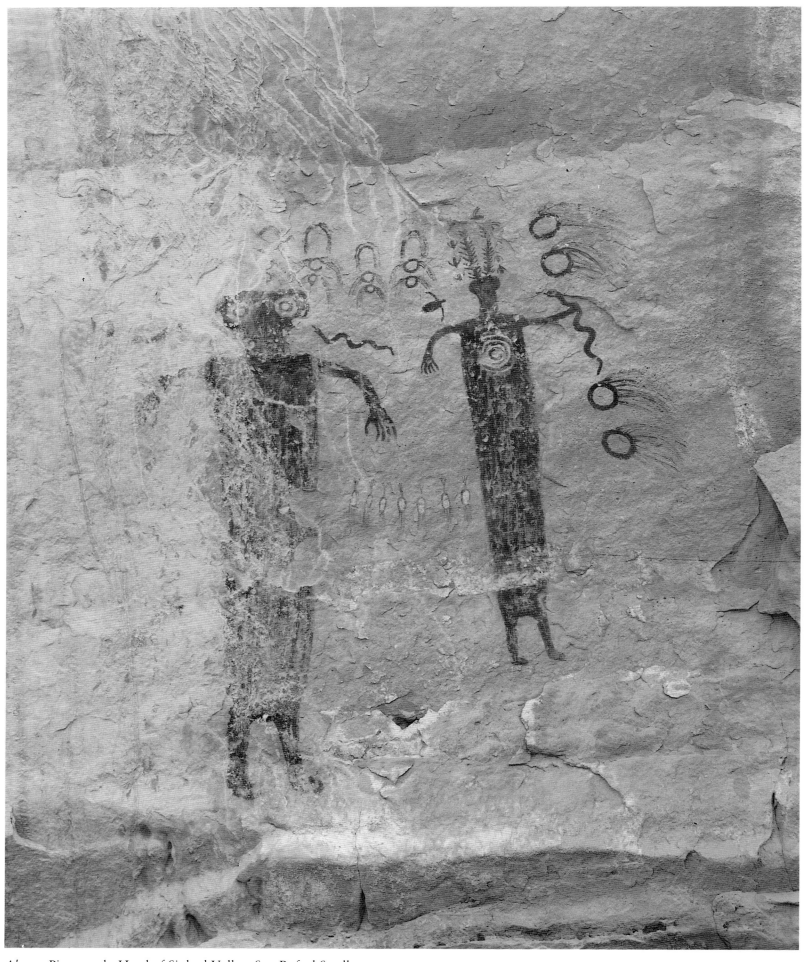

Above: Pictograph, Head of Sinbad Valley, San Rafael Swell
Final page photograph: Star trails above Rainbow Bridge

UTAH: A PORTRAIT

Book design by Richard Firmage, Salt Lake City, Utah

Map by Clarkson Creative, Inc., Salt Lake City

Typeset in Sabon typeface by Accu-Type Typographers, Salt Lake City

Text paper is 150-gsm Biberest Allegro Demi-Matte

Color separations, printing, and binding by
Dai Nippon Printing Company Ltd., Hong Kong